The Fashionable Ear

A History of Ear-Piercing Trends for Men and Women

Ronald D. Steinbach

VANTAGE PRESS
New York

FIRST EDITION

Published by Vantage Press, Inc.
516 West 34th Street, New York, New York 10001

Manufactured in the United States of America
ISBN: 0-533-11237-0

Library of Congress Catalog Card No.: 94-90421

0 9 8 7 6 5 4 3 2 1

Disclaimer

The primary purpose of this book is to provide an entertaining commentary on the history and custom of ear piercing for men and women. The book contains extensive footnotes so that readers may do further research.

This book is not intended to provide legal, medical, metallurgical, business, or any other type of advice. Such advice may only be provided by persons trained and/or licensed in their respective fields. Prior to embarking upon any course of conduct, readers are advised to secure advice from the appropriate professionals.

Readers are cautioned that home piercing kits are designed only for the ears. The information contained in this book applies only to ear piercing, and does not include body piercing. The author believes it is unfortunate that legislators are confusing ear piercing with body piercing, because there are some very important differences.

Contents

Appendices

Acknowledgments

The author wishes to acknowledge the following individuals for their kind assistance with this manuscript:

Katarzyna ("Kasia") Malgorzata Biernacki for her research assistance and comments from reading the manuscript.

Vicki R. Hamamoto for her comments, general assistance, and encouragement in writing the manuscript.

Victoria Lee Pitt in inspiring the idea behind the manuscript.

Linda Collins for sharing her diamond expertise and numerous comments on Chapter 8, Shopping for Diamond Earrings for Men and Women.

Frances Vess, the Manager of the Westminster Mall Piercing Pagoda, Westminster, California, for her information on piercing trends.

Sharon Zondeg and Susan Iseminger with Piercing Pagoda, Inc., in Bethlehem, Pennsylvania, for their comments from reading the manuscript.

Sam Mann, Paul Mann, and Gregory Lane with Inverness Corporation in Fair Lawn, New Jersey, for furnishing their merchant literature and advertising, ear-piercing manual, training video, and metallurgy expertise.

Lars Blomdahl with Blomdahl Medical AB in Halmstad, Sweden, for information on nickel sensitivity and proposed EEC legislation.

Rowland Schaefer with Claire's Boutiques, Inc., in Pembroke Pines, Florida for his input on nickel sensitivity.

Frederick B. Safford, Jr., Corporate Counsel for Studex® in Harbor City, California, and President of the Ear Piercing Manufacturers of the United States Incorporated for his valuable comments on reading the manuscript.

Valerie Winsor and Kathy Wulf for participating in the experiment wearing earrings from Simply Whispers®.

Javier Ruiz for his kind comments, assistance, and encouragement.

My sister, Karen Johnson, for her comments to the manuscript and research assistance, and my brother-in-law Timothy Johnson for his comments.

Finally, to all the people who furnished information but did not want their names used, including an R.E.W.

ONE
Introduction

The subject of ear piercing has previously been considered taboo for a book. Although a small number of books have been written on the topic of earrings, the perspective is basically that of jewelry.

Persons desiring ear-piercing information have had to rely upon information from friends and family and the personnel of ear-piercing salons. Most of the available information comes from personal experience and from the occasional newspaper article.

Much important information has been kept from the consumer with pierced ears. Millions of persons suffer from allergies to nickel worsened by wearing earrings containing nickel and have severely stretched their ear holes from wearing heavy earrings. As a consequence, surgery is needed by millions of females to correct their stretched ear holes.

Ear piercing was out of fashion in the United States from approximately 1900 until the mid-1950s. In the 1950s it was the "bad girls" who revived the fashion, and in the 1970s males started adopting the fashion.

That old institution of American culture, the Sears Roebuck catalog, never felt quite comfortable depicting pierced ears on females. Female models were largely pictured even in recent years wearing clip-on earrings. It is as if the 1950s never arrived for Sears Roebuck and its customers in middle America.

The advertising industry has covered up ear-piercing problems with the air brush and other techniques. Ear holes as well as the slit visible above the earring are routinely airbrushed out of advertising copy. This is because many female models in their late teens and twenties have already so abused their ear holes from wearing heavy earrings that the ear holes have turned into long, red slits that look unsightly. In addition, the redness from infected ear holes is covered with makeup and disguised through other photographic techniques.

Ear holes enlarged from the constant wearing of heavy earrings, and which are often infected, look very unattractive. Healthy and properly maintained ear holes look attractive, and the media are now starting to show them.

Until the 1960s and 1970s, American and Western European cul-

1

ture largely denied the appropriateness of earrings for males. Other cultures that encouraged male earrings or in which females followed different fashions (large ear holes, multiple ear holes, or nose rings) were branded as "ethnic." This was a polite method of referring to their culture as being inferior. A "politically correct" term is to refer to any such disagreeable practice as involving mutilation. Tolerance is not a word typically found in their vocabulary.

The male fashion for earrings has continued unabated in America and Western Europe during the last thirty years. The fashion has also taken root in New Zealand, Australia, Japan, China, India, Israel, and numerous other countries. The influence of American television and movies abounding with male and female actors wearing earrings cannot be denied.

This book is intended to provide useful information on ear piercing and on ear care for males and females as well as for babies. It is also intended to entertain and to provide a social commentary on the ear-piercing custom, which extends back into history for at least the last five thousand years. It is intended to challenge previous taboos and to confront the bigotry of people who form their opinions without any basis in fact. These are the males (and some females) who state: "Earrings are for women!" Males who are uncertain of their own masculinity often resort to fabricating a whole set of complicated rules to allay their fears, and some even resort to physical violence, such as gay-bashing.

This book includes considerable historical research. It is unknown how many historical accounts are based on the entire truth or have been altered to please the sensibilities and current fashions of readers. Present-day writers quote earlier writers, who quoted still earlier writers. Whether the first writer was telling the plain, unvarnished truth is simply unknown. Historical drawings were copied from book to book and were often altered in accordance with then-current fashions and perspectives. Numerous art works have been altered through the centuries to comply with changing social mores.

Virtually all historians have chosen to ignore the custom of ear piercing, even when practiced by male and female rulers. Yet other customs, such as males wearing wigs, high-heeled shoes, and silk stockings over bare legs, usually are commented upon, if only briefly.

As numerous quotations and citations in the book indicate, public debate continues on various matters of great (or trivial, depending

2

upon perspective) importance: Should male students in the elementary and high-school grades be allowed to wear earrings? How many earrings per ear should female students be allowed to wear to school? Should male employees, including policemen, be allowed to wear earrings on the job? Is it unlawful discrimination for female employees to be allowed to wear earrings and for this to be prohibited for male employees? Should ear piercing be regulated by legislation to protect the public safety? Should nickel content in earrings and other jewelry be regulated or prohibited, or should disclosure laws be enacted?

This book is also intended to provoke examination of numerous earring-related issues and to stimulate scholarly discussion and thought. This book is a must for parents, educators, religious leaders, employers, and social scientists.

As the title to this book indicates, the topic that is discussed is fashion. Fashion necessarily involves opinions, and the author freely provides his opinions and commentary herein.

TWO
Thinking of Having Your Ears Pierced?

No Clip-Ons for Males

If a male wants to wear earrings, he needs to get his ears pierced first. Men simply do not wear clip-on earrings, except for female impersonators in television shows or movies. The clip-on hardware is too big and bulky and does not look good from behind the ear. (Most women who wear them have longer hair, which hides the clip-on backing.) Men can wear the magnetic variety, but they are not a wise choice to wear around computers. The variety of magnetic earrings is limited, and they look somewhat hokey.

"Earrings Are for Women!"—Not

Some males will get their ears pierced, and others will think about it for years before getting up enough courage. Television programs and movies are permeated by males who wear earrings. Earrings for men are now an accepted part of our culture. The old adage, "earrings are for women," is fast disappearing. Even the elderly columnist Abigail Van Buren in her "Dear Abby" column disputed the notion that it is feminine for a male to wear an earring. A mother of a twelve-year-old boy had written stating that her son wanted to get his ear pierced, but that her husband "says it is feminine." Abby replied, stating that the husband was "wrong to say it's feminine."[1]

Prejudices Still Exist

Ten to fifteen years ago, a male with an earring was considered shocking. Although the shock value has long since disappeared, prejudices still exist among the older generations. Occasionally these prejudices are confessed to by newspaper columnists. Following are some

1. "Dear Abby," *Chicago Tribune,* August 13, 1992, Tempo, page 19, zone: S.

excerpts from an article by a male writer in the *St. Petersburg (Florida) Times.*[2]

> And maybe it's because I'm forty-something and fighting not to become obsolete, but a man wearing earrings is a question mark for me. So is a man with a ponytail, or hair hanging down his back.

> I could easily rattle off a dozen reasons why I know a man's decision to wear an earring doesn't diminish him in any way. I could list the names of scores of people who prove it. But at the same time, I don't want my son to come home with pierced ears.

> It is hard for me to imagine a man with earrings working beside me in a field full of 30-pound watermelons. It is hard for me to imagine the other men working in that scenario giving him a moment of peace.

> It is hard for me to imagine a man at a jewelry counter trying various earrings, searching for just the right look, a concept that in my eyes doesn't exist.

An article appearing in *The Atlanta Journal and Constitution,* May 30, 1993,[3] reported that a well-known golfer openly displays his prejudices by refusing to sign autographs for males who wear earrings:

> Chi Chi Rodriguez is one of the most giving athletes around, but he will not sign autographs for boys who wear earrings.

An article appearing in the *Orlando Sentinel Tribune,* May 30, 1993,[4] reported the policy as follows:

> . . . but Chi Chi Rodriguez apparently is still at it in his no-earring war. At the recent PGA Seniors in Palm Beach Gardens, Rodriguez refused to

2. "Past Can Confine Us While it Defines Us," by Elijah Gosier, *St. Petersburg (Florida) Times,* July 7, 1993, City Times, page 1. Reprinted with permission.
3. "Inside Golf, Tom McCollister Gold Channel's on the way with busy LPGA schedule," *The Atlanta Journal and Constitution,* May 30, 1993, Sports, Section G, page 2. Reprinted with permission from *The Atlanta Journal* and *The Atlanta Constitution.* Reproduction does not imply endorsement.
4. "Stewart Says Pros Should Treat the Hands That Pay Them with Care," by George White, *Orlando Sentinel Tribune,* May 30, 1993, Sports, page C11. Reprinted with permission.

sign for 10-year-old Brandon . . . because the boy was wearing an earring. "He walked away, sat down and started crying," said the boy's mother, Susan. "It crushed him."

Marge Schott, the sixty-five-year-old owner of the Cincinnati Reds baseball team, was back in the news in May 1994 for stating that her players could not wear earrings because "only fruits" (i.e., homosexuals) wear them. She later attempted to excuse her bigotry by stating that that was the way she was raised.[5] The logic of her excuse is lacking, since she obviously was not brought up in the 1930s with the notion that it was acceptable for a woman to own and operate a baseball team. (A year earlier Ms. Schott was banned from baseball for eight months and fined $25,000 for referring to an outfielder as her "million-dollar nigger.")

The irony of Ms. Schott's comments is that a month later she traded her player Roberto Kelly for Deion Sanders with the Atlanta Braves. Deion Sanders is not only black, but outspoken and he wears earrings![6] However, Sanders is apparently playing baseball without his earrings.[7] Perhaps his salary of $2.5 million for 1994 and $2.25 million in 1995 has something to do with that.[8]

Males wearing earrings may be subjected to greater scrutiny when they cross international borders. It is believed that males wearing earrings may fit the U.S. government secret profile of smugglers carrying drugs or other contraband. As one artist states: " 'I always take my earring off when going through the Peace Bridge,' says Broussard of Hallwalls."[9]

Avoiding a hassle at an international border makes sense, since

5. "Sport around the World: Schott Fires Off Again," by Tony Jefferies, *The Daily Telegraph*, May 23, 1994, page 7. "Schott Is Repugnant, but It's Her Critics We Should Fear," by Pete Dexter, *Sacramento Bee*, May 23, 1994, Main News, page A2. "Schott Misfires Yet Again," *The Toronto Star*, May 20, 1994, Sports, page E5. Numerous other newspapers carried accounts, as did the Associated Press, May 21, 1994, Saturday, PM cycle, Sports News, Joe Kay, AP sports writer.
6. "Names in the Game," The Associated Press, June 8, 1994, Wednesday, PM cycle, Sports News.
7. "Staid, Old Cincinnati May Light Up for Deion," Pat Forde, *The Courier-Journal*, June 1, 1994, Sports; page 1D.
8. "Other Voices Baseball Bombshell: The Sanders-Kelly Trade, Is Cincinnati Ready for Prime Time?" by Paul Daugherty of the Cincinnati Enquirer, *Atlanta Journal and Constitution*, May 30, 1994, Sports, Section D, page 10.
9. "When Worlds Collide; At the U.S.–Canada Border, Musicians and Artists Cross Over Amid Red Tape and Hero Worship," David Montgomery, *The Buffalo News*, May 21, 1993, Gusto, page 22. Reprinted with permission.

there are obnoxious border agents who appear to obtain a perverse enjoyment out of harassing honest and dishonest travelers alike. Sadly, this appears to be more true of U.S. agents than of border agents in Canada, Western Europe, and Australia.

The foregoing prejudices illustrate why males should ultimately not be afraid of getting their ears pierced; it is a symbol in the fight against illogical prejudices and bigotry that are all too pervasive in this world.

A fourteen-year-old girl writing on Prodigy, June 25, 1992, expressed a completely different attitude:

> The information I have found pertaining to guys wearing earrings is practically unanimous! Most women like one earring in the right ear and most guys like to wear an earring. . . . I think guys look sexy with an earring![10]

The prejudices against male earrings may also be used to advantage. For example, a male wearing earrings and especially multiple earrings is more likely to be dismissed from a prospective jury panel during jury selection. The common (mis)conception is that a male wearing earrings is too independent minded and may disregard jury instructions.[11]

Parents Actually Encourage Their Sons

There are mothers who encourage their sons to get their ears pierced and take them to a piercing store! A *Los Angeles Times* article on September 10, 1992, tells the story of a mother who took her eight-year-old son to the ear-piercing salon, and the father was speechless when he first saw the earring.[12] And most of the boys who get their ears pierced say it was relatively simple to convince their parents.[13]

10. Homelife Bulletin Board, Fashion.
11. For example, see "Challenges to Jurors Must Meet New Test; Even-Handed Application of Criteria Required," by Gary Spencer, *New York Law Journal*, July 18, 1994, page 1.
12. "For the Kids/Fashion; The Hole Story; Both Boys and Girls Are Having Their Ears Pierced—and at Younger Ages. Many Children Sport Multiple Earrings," *Los Angeles Times*, September 10, 1992, Ventura County Life; part J; page 12, column 1.
13. "The Hole Story," *The Cincinnati Enquirer*, Gannett News Service, July 17, 1991.

Mothers are usually easier to convince than fathers, because a high percentage of women find an earring to be "sexy" on a male.

Fathers are also getting into the act. The author saw a father signing a consent form for his eight- or nine-year-old son to get his ear pierced. An older son was already wearing two hoops in his left ear. The older son told the author that his father would like to get his ear pierced too but could not because of his employer.

The "Ordeal" Concept

As more males wear earrings, the more other males think about undergoing the "ordeal" of ear piercing. Because many men and boys are afraid of getting their ears pierced, they are accompanied by the girlfriend, wife, or mother for moral support.

The concept of ear piercing as an "ordeal" was popularized by movies in the 1940s and 1950s where a sixteen-year-old heroine would be taken to the bathroom by a girlfriend. The scream of the heroine could be heard in the background as her earlobes were first numbed with an ice cube and then pierced with a needle and a cork backing the ear.

Some books on jewelry also speak of the "ordeal" concept. A female author commented on French fashion in 1765: "Since the ears were left showing whether the hair was dressed high or flat, earrings were almost as indispensable as clothing, in spite of the ordeal of piercing which had to be endured."[14]

Ear-Piercing Procedures

Modern ear piercing is typically done with a plunger, which holds an earring sharpened like a pencil (called a piercing stud), and an earring backing. The plunger handle is pushed by the palm of the hand or by the thumb, or the plunger is spring-loaded and activated by a trigger. The actual piercing takes only a fraction of a second. The pain is not more severe than a pin prick, and less than a shot from a doctor.

14. *Jewellery* by Diana Scarisbrick, The Costume Accessories Series, ©1984, B.T. Batsford Ltd., London. Distributed by Drama Book Publishers, New York. Quotation is from page 38.

A slight soreness is felt for several days, and full healing is normally complete in a month. However, a lump may be felt in the earlobe caused by scar tissue around the earhole. This lump will typically go away after six months to several years. When the lump has gone away, the earhole may remain for the rest of your life even if you stop wearing earrings. The hole will become smaller and less visible, but it may never close up entirely.

Little Sensations from Wearing Earrings

Wearing stud earrings (at least the smaller variety) involves absolutely no sensations to the earlobe. You simply cannot feel that you are wearing earrings. You have to feel your earlobes to tell. If you are wearing smaller hoop earrings, you can ordinarily not feel them either. If you turn your head quickly, you might feel a very slight sensation. If you wear larger hoop earrings, such as one-inch hoops, you will feel some sensation but only when moving your head. Dangling earrings will provide the most sensation. If they are heavy, your earlobe may hurt and be sore at the end of a day from wearing them.

Visibility of Ear Holes without Earrings

If a person gets his or her ears pierced and takes good care of the ear holes, the holes will barely be visible. In the case of unadorned ears, most people will probably not even notice the holes. This appears to be especially true of males who do not have their ears pierced. They typically do not notice the earlobes of other males. Men do not typically wear the heavy earrings that stretch and enlarge the holes. After ten to twenty years of wearing small earrings, the holes should not be much larger than the pinhole size they were after they were first pierced.

If a male is concerned about the ear hole showing, he can insert a tiny ornament known as a nose bone and cover that with flesh-colored makeup. That advice was given by Ramon Rios, the owner of the Los

Angeles boutique Maya located on Melrose Avenue, which is where actor Bruce Willis reportedly had his ear pierced.[15]

No Age Limits

Earrings are no longer exclusively worn by young males. In previous years, the earring generation usually abandoned their earrings when they entered the employment market. However, this is no longer true. More and more males are wearing earrings on the job, and the age at piercing is getting steadily older. Males in their forties, fifties, and even their sixties and seventies are getting their ears pierced. One woman reported June 25, 1992, on Prodigy[16] that her fifty-year-old husband had gotten his ear pierced that year. And several males wrote that they got their ears pierced when they retired! Not to be outdone by males, some women in their eighties and even nineties are belatedly getting their ears pierced to indulge in the pleasure of wearing pierced earrings. *The Buffalo News* printed a letter from a seventy-seven-year-old man who is proudly wearing a small Marine Corps emblem in his ear. He wrote that he earned the priviledge when he crossed the equator on a ship during World War II, but that he was not able to wear an earring during his working career due to unfavorable misconceptions.[17]

One male wrote on Prodigy on January 23, 1992,[18] that he got his right ear pierced at the age of sixty-two when he retired from a government job. He chose his right ear, not because of sexual preference, but because the right side is a person's "male, positive side" and because he did not want to follow the other sheep. Earlier, he wrote that the right side is a person's "Masculine, Positive, White Ocult [sic] side," whereas the left side is a person's "Fem, Negative, Black Ocult [sic] side."

Notwithstanding where fashion has already gone, there are self-

15. "Looks: Piercing Questions; Today, Earrings Are Worn on the Earlobes of Stockbrokers and Stock Clerks Alike," *Los Angeles Times*, February 24, 1991, Sunday, Home Edition, Magazine; page 30.
16. Homelife Bulletin Board, Fashion.
17. "Earrings Rewarded Seafarers Crossing Equator," by LeRoy E. Warrington, *The Buffalo News*, September 9, 1994, Section: Editorial Page: page 2.
18. Homelife Bulletin Board, Fashion.

proclaimed fashion experts who continue to fabricate an extensive list of fashions to be avoided by males over forty, including necklaces, pendants, and earrings. Were this listing to be applied to females over forty most people would regard such comments as utterly absurd and laughable. These critics are caught up in their sense of self-importance, since there is absolutely no logic behind their opinions.

Long Hair No Longer Required

Various articles have associated earrings on males with ponytails. However, long hair is no longer required for the earring "look." The last stand for these people is the assertion that for a male to wear the larger, dangling earrings (one in each ear), he should have long hair! A conservative, smaller dangling earring is now apparently OK with short hair.

Future Predictions

In an article appearing August 10, 1993, in the *Chicago Tribune,* kids were polled about expected fashions twenty years into the future. A surprising 46 percent thought earrings for men would still be popular, whereas only 45 percent thought earrings for women would still be popular.[19]

A male newspaper writer for *The Vancouver Sun* flatly predicted in December 1993: "Earrings are here to stay, especially for younger men."[20]

19. "It's a Funky Future, Readers Predict Life in the Year 2013," by Fayza Mohamed and Mark Caro, *Chicago Tribune,* August 10, 1993, KidNews, page 5; Zone: N, A Look Ahead, KidNews Poll.
20. "Careful What You Give Him—He Just May Wear It, All Year," by Guy Saddy, *The Vancouver Sun,* December 14, 1993, Style; Man Style, Page C1.

THREE
Ear-Piercing Methods and Initial Care

Early History

The first type of ear-piercing method was the awl. This method of piercing is mentioned in the Old Testament of the Bible at Exodus 21:6 and Deuteronomy 15:17. The person whose ear was to be pierced would be stood against a door or doorpost, and the piercing was done with an awl. An awl is a small pointed tool for making holes in leather or wood.

The awl method of ear piercing was depicted in a painting by artist Peter Paul Rubens (1577–1640), titled "Hercules and Omphale," which was painted around 1602 to 1605. Hercules is shown about to have his left ear pierced. Omphale is holding the top of Hercules' left ear, and a person to the right of Hercules is holding an awl in one hand and a piece of string in the other.

After the ear had been pierced, a piece of string was inserted in the hole to keep it from closing. Only after the hole had healed would an earring be inserted.

Ball-and-Point Method of Piercing

In later years a needle was substituted for the awl. This became known as the "ball-and-point" method of ear piercing. The needle was the "point," and a potato or cork was the "ball." This method of ear piercing was used until the 1950s, persisting even into the early 1970s. By that time an earring was generally inserted into the newly pierced hole instead of a piece of string. Since a puncture wound in the earlobe closes so quickly, it was often difficult to find the pierced channel with the earring stud. Additional tissue damage (and pain) would result from inserting the earring stud.

The ball-and-point method was undoubtedly responsible for the concept that ear piercing was an "ordeal." Many women were afraid of getting their ears pierced after hearing about the pain involved.

A most graphic account of the ball-and-point method of ear piercing is provided by author Maxine Hong Kingston in her book *China*

Men published in 1980. The book includes a fictional account of a Chinese man who is captured by women in the "Land of Women." The women force the man to dress in women's clothes, pierce his ears, and bind his feet among other beautification procedures, and make him a servant in the queen's court. The ear piercing after his capture is described as follows:

> A door opened, and he expected to meet his match, but it was only two old women with sewing boxes in their hands. "The less you struggle, the less it'll hurt," one said, squinting a bright eye as she threaded her needle. Two captors sat on him while another held his head. He felt an old woman's dry fingers trace his ear; the long nail on her little finger scraped his neck. "What are you doing?" he asked. "Sewing your lips together," she joked, blackening needles in a candle flame. The ones who sat on him bounced with laughter. But the old women did not sew his lips together. They pulled his earlobes taut and jabbed a needle through each of them. They had to poke and probe before puncturing the layers of skin correctly, the hole in the front of the lobe in line with the one in back, the layers of skin sliding about so. They worked the needle through—a last jerk for the needle's wide eye ("needle's nose" in Chinese). They strung his raw flesh with silk threads, he could feel the fibers. . . .
> . . . They drew the loops of thread through the scabs that grew daily over the holes in his earlobes. One day they inserted gold hoops. . . .
> One day his attendants changed his gold hoops to jade studs . . . [1]

The message behind this book is the pain and agony suffered by women to beautify themselves in a male-dominated culture. Foot binding in China was, of course, a most horrible practice. However, the ear-piercing account is totally exaggerated, even if the prisoner status of the male were disregarded.

A more accurate account of ear piercing was contained in the novel *The Grapes of Wrath,* written by author John Steinbeck in 1939:

> The small gold earrings were in her hand. "These is for you."
> The girl's eyes brightened for a moment, and then she looked aside. "I ain't pierced."

1. "On Discovery," pages 3 and 4; New York: Knopf, 1980.

"Well, I'm a-gonna pierce ya." Ma hurried back into the tent. She came back with a cardboard box. Hurriedly she threaded a needle, doubled the thread and tied a series of knots in it. She threaded a second needle and knotted the thread. In the box she found a piece of cork.

"It'll hurt. It'll hurt."

Ma stepped to her, put the cork in back of the ear lobe and pushed the needle through the ear, into the cork.

The girl twitched. "It sticks. It'll hurt."

"No more'n that."

"Yes, it will."

"Well, then. Le's see the other ear first." She placed the cork and pierced the other ear.

"It'll hurt."

"Hush!" said Ma. "It's all done."

Rose of Sharon looked at her in wonder. Ma clipped the needles off and pulled one knot of each thread through the lobes.

"Now," she said. "Ever' day we'll pull one knot, and in a couple weeks it'll be all well an' you can wear 'em. Here—they're your'n now. You can keep 'em."

Rose of Sharon touched her ears tenderly and looked at the tiny spots of blood on her fingers. "It didn' hurt. Jus' stuck a little."

"You oughta been pierced long ago," said Ma. She looked at the girl's face, and she smiled in triumph. "Now get them dishes all done up. Your baby gonna be a good baby. Very near let you have a baby without your ears was pierced. But you're safe now."

"Does it mean somepin?"

"Why, 'course it does," said Ma. "Course it does."[2]

A macho variation of the ball-and-point method of ear piercing was utilized by motorcycle clubs in recent years as an initiation rite. This method was not only designed to increase the pain for male members, but to increase their anxiety level. The piercing was done by placing a small block of wood behind the earlobe, and then using a hammer to pound a small finishing nail through the earlobe.[3]

An even more extreme method of ear piercing is mentioned by

2. *The Grapes of Wrath* by John Steinbeck, 1939. Contained on CD-ROM, *Library of the Future,* 3rd Edition, Screens 662 and 663: 860, Windows Ver. 3.0.© 1990–94, World Library, Inc., 12914 Haster Street, Garden Grove, CA 92640, 714-748-7197, 1-800-443-0238.
3. Interview by author with a former member of a motorcycle club in Southern California as to his experience in the 1950s.

writer Herman Melville in his novel *Moby Dick; or The Whale* written in 1851: "A sailor takes a fancy to wear shark-bone ear-rings: the carpenter drills his ears."[4]

It is suspected that the word "drill" was only used figuratively, rather than literally.

In cultures without ready access to metal implements, substitutes were used. For example, the Wodaabe people in Niger, Africa, customarily used a thin, sharp thorn for ear piercing. This piercing method continued to be used at least into the 1980s.[5]

1908 Commentary on Ear Piercing in the U.S.

In their 1908 book, *The Book of the Pearl,* authors George Frederick Kunz and Charles Hugh Stevenson commented unfavorably upon jewelers who performed ear piercing in the United States:

> . . . we have the ear piercer, whose vocation, however, is rapidly becoming useless because of the ingenious modern devices for holding the pearls to unpierced ears; and we must consider this eminently desirable when we think of the ear-piercing outfits of the former jeweler, who never disinfected his apparatus, and when we recall the fact that it was always expected that the ear would swell, first, from the crude awl that was used, and, secondly, from the unsterilized instruments.[6]

Present Methods of Ear Piercing

Modern ear-piercing instruments, or "guns," have made ear piercing virtually painless as well as completely sanitary with their disposable inserts containing the piercing studs. A number of individuals, more typically female, claim that their ear piercing was quite painful. This is simply untrue if a piercing gun was used, except for perhaps

4. *Moby Dick; or The Whale* by Herman Melville, 1851. Contained on CD-ROM, *Library of the Future, 3rd Edition,* Screen 814: 990, Windows Ver. 3.0.© 1990–94, World Library, Inc., 12914 Haster Street, Garden Grove, CA 92640, 714-748-7197, 1-800-443-0238.
5. "Niger's Wodaabe: People of the Taboo," *National Geographic,* October 1983, pages 482 to 509. The reference to ear-piercing method is at page 488, right column.
6. *The Book of the Pearl, The History, Art, Science and Industry of the Queen of Gems* by George Frederick Kunz and Charles Hugh Stevenson, originally published in 1908 by The Century Co., Mineola, New York. Quotation is from page 407 of the reprint.

the extra sensitive. The reasons behind such exaggerated claims are usually to brag, to complain, to obtain attention, or to scare the uninitiated. The myth of pain is exposed by the current popularity of multiple ear piercings.

The procedure for the person undergoing ear piercing is to first choose the piercing studs, i.e., type of metal, size of the head of the stud, and color of gemstone, if any. The person is then seated in a chair, and his or her earlobes are cleansed with an antiseptic.[7] The location of the desired piercings are marked with a marking pen and approved by the person. The piercing instrument is lined up with the dots on the earlobes, and the plunger mechanism is activated, which accomplishes the piercing.

The piercing is typically effected by a special earring stud sharpened to a point like a pencil. A plunger mechanism rapidly pushes the earring stud through the earlobe and into an earring clasp (backing) on the reverse side of the earlobe. The piercing takes only a fraction of a second, and the pain is no more than a pinprick and much less than getting a shot from a doctor.

Although designs of the ear-piercing guns have varied in recent years, the concept is still the same. The most recent designs are those that prevent the gun from touching the earlobes. The parts that touch the earlobes, including the piercing earrings, are disposable and come in presterilized, bubble packaging.

Piercing earrings are typically made of surgical steel and are usually gold-plated or are fourteen-karat gold. Titanium piercing studs are becoming popular, especially in Europe and Japan. One piercing chain formerly offered the sleeve method of ear piercing. The piercing device used in the gun was a presterilized, disposable needle with a sleeve over the needle. The gun would insert the needle with the sleeve through the earlobe. The needle part inside the sleeve was removed, and then a regular fourteen-karat gold earring was inserted through the sleeve. Finally, the sleeve was removed from the rear of the earlobe and a fourteen-karat clasp was placed on the earring.

7. In earlier years alcohol or hydrogen peroxide was often used. These substances are not very effective in cleaning the piercing location. A Canadian who performs body piercings uses Benedine, a 10 percent iodine solution, reportedly used to clean skin before surgery. See "With Rachel, it all started with the ears. Five years ago it was her nose. A year ago, it was her navel . . . ," *The Vancouver Sun*, July 3, 1993, Satrev, page C10.

Home piercing kits can be bought at many beauty supply stores. One such kit is manufactured by Inverness® Corporation, Fair Lawn, New Jersey 07410. The cost at one beauty supply store in Southern California was only $7.99. The kit includes the following sealed in plastic: a disposable, plastic ear-piercing plunger, a pair of four-millimeter, twenty-four-karat gold-plated earrings, antiseptic cleansing towelette, earlobe position marker, and aftercare ointment. An instruction sheet is also included. Another such kit is manufactured by Medisept® Corporation, 25311 S. Normandie Avenue, Harbor City, California, and is similarly priced.

The home piercing kits work as represented. Only one thing is lacking: experience by the operator. The instructions are very detailed; however, they are lacking in two aspects: how to avoid a crooked (angled) piercing, and the art of positioning the exact location of the ear piercing.

Some people have ear piercing performed by a medical doctor. While a doctor is an expert on proper sterilization, he or she usually has little or no experience in the art of ear piercing. Some doctors do not use an ear-piercing gun, but rather a sterile needle; then an earring stud is pressed through the puncture wound. A frequent complaint by persons who use a doctor is that the piercing was done crookedly. This is because a straight piercing is most difficult using a needle. (Another complaint probably ought to be the cost charged by the doctor.)

If ear piercing is going to be performed at home, a personal home piercing kit should be purchased. This is the only way to ensure that the piercing is done with a sterile instrument. Immersing a needle in rubbing alcohol or hydrogen peroxide or placing it in a flame will not kill germs such as HIV or hepatitis.

Notwithstanding modern methods of ear piercing, some men (and even some women) continue to get their ears pierced at parties with a safety pin and an ice cube. Party piercings should not be done, because of the lack of proper sanitary conditions and the possibility of contacting blood-borne diseases, such as hepatitis or AIDS.

The Art of Ear Piercing

Choosing the exact location where the earlobes are to be pierced is an art that comes from experience, as well as practical knowledge. A person thinking of having his or her ears pierced ought to first observe

people with pierced ears to determine the proper location for the piercing. Piercing locations on people do vary. Most ears are pierced just right. However, an observant person will note that some ears are pierced too low, too high, too close to the head, or too far away from the head.

If the piercing is too low, there is not enough of the fleshy part of the earlobe below the ear hole to properly support earrings. Such ear holes are more likely to tear or stretch through the earlobe. If the piercing is too close to the head, it will be difficult to wear larger earrings. If the piercing is too far away from the head, it may look like a second piercing. If the piercing is too high, certain types of earrings may not hang properly or cannot be worn at all. These earrings are typically the dangle variety, which have a curvature back under the bottom of the earlobe. Other varieties are extremely small loops, which just clear the bottom of the earlobe, as well as post-type of ear cuffs.

When the locations of the prospective ear holes are marked for piercing, it should be borne in mind that no two ears on an individual are identical. They do vary slightly, and this may require a judgment call as to proper symmetry. For example, measuring the same distance from the head may not work when the earlobe is smaller on one ear. Centering the ear hole on the width of the earlobe may result in a better look than measuring distance out from the head.

One ear piercer informed the author that the ears of males are often pierced a little closer to the head than a female. The reason for this has been that males typically wear smaller earrings. If they do wear larger earrings, they typically are hoops or the dangling variety, which do not create a problem. Females often will wear large earrings on the ear and require more distance from the head to the ear hole. Or, they will wear earring jackets under the studs, which require more room. The largest costume earrings may require that the earrings be worn in the second set of ear holes.

The ears of babies are often pierced a little higher in the belief that the hole will grow down as the ear matures. However, there has not been any study on this. The safest advice is to pierce a little high, since it is better than ear holes that are too low.

The final choice for the location of the ear holes is up to the person whose ears are being pierced, or the parent of a baby or small child. After the professional ear piercer has marked the preferred locations,

the customer is normally given a mirror to approve the location prior to piercing. That choice should be exercised.

The person undergoing ear piercing has absolutely no choice on the angle of the ear piercing. The skill of the ear piercer must be totally relied upon. The angle refers to the exit hole on the back of the earlobe. The pierce should be perpendicular to the plane of the earlobe. In the practical sense, this means that the ear hole should neither angle up or down, nor sideways. An angle up can be annoying, since the earring may fall out of the ear hole before the clasp (backing) can be pushed or screwed on. An angle down, or sideways, will detract from the appearance of the pierce. It should be noted that if the pierce is perpendicular to the plane of the earlobe, there will be a slight downwards angle. This is because of how the ear is normally positioned on the head. If a person is using a personal ear piercer to pierce his or her own ears, or if another untrained person has been recruited for the job, this is the most difficult aspect of piercing.

After a person has had his or her ears pierced, the work should be checked for straightness and location. If the person is dissatisfied in any manner at all, the ear-piercing studs should be removed and the holes allowed to heal. After a month, the holes can be repierced in the same or different location, and with the proper angle. Since ear piercing among females is expected to last for life, and for the indefinite future for males, the person should be totally satisfied before the ear holes are allowed to heal open. If the location of the piercing or the angle is wrong, immediate repiercing can sometimes be done with no problem. This is a judgment call and is based upon the experience of the piercer.

Choosing the Ear Piercer

All ear piercers are not the same. The experience level varies from the first pierce to perhaps ten thousand pierces or more. The training typically consists of on-the-job instruction and reference to an in-house manual. Cosmetology students typically receive brief instruction on ear piercing, as well as proper sanitation methods. However, there are no textbooks available on ear piercing, and none have ever been written.

The ear-piercing customer should not be afraid to ask questions. How long has the piercer being doing piercings? What sanitation procedures are followed to guard against blood-borne diseases? What

training has the piercer received? Is the piercer required to be licensed by any governmental authority?

Proper sanitation begins with good housekeeping procedures. All disposable parts from ear piercings, cotton swabs, and disposable, surgical gloves should be immediately placed into the trash. It is recommended, although not required, that ear piercers should wear surgical gloves to help maintain proper sanitary conditions.

In the movie *Twice in a Lifetime* (1985) actress Ellen Burstyn is shown having her left ear pierced on-camera. The young lady doing the piercing was not wearing any surgical gloves. Although surgical gloves may not have been commonly worn in 1985, the customer should insist upon it today.[8]

Proper sanitation requires the use of a modern, ear-piercing gun. The modern guns are designed so that the only part of the gun that touches the earlobes or even comes close consists of disposable, plastic parts that come in pre-sterilized, bubble packages. With the older guns, the piercing studs and the clasps had to be loaded by touching them with the fingers, and the metal parts of the gun always came into contact with the earlobe. Before a customer agrees to the ear piercing, the customer should ask to see the piercing gun and have the sanitary procedures explained.

The cost of ear piercing is really irrelevant. Having an ear piercing done at an expensive jewelry store or department store as opposed to a costume jewelry store ensures only one thing: the cost will be higher. It will not necessarily be better, more accurate, less painful, or more sanitary.

Initial Ear Care

Two large companies in the U.S. ear-piercing business are Claire's Boutique (also doing business as Topkapi and Dara Michelle) and Piercing Pagoda (also doing business as Plumb Gold). Both companies

8. The ear-piercing scene from the movie could be used with commentary to train personnel in the art of ear piercing. For example, the following criticisms are offered: the piercing location could be considered as being too close to the head for a female, no surgical gloves were worn by the piercer, no sterilization of the earlobe was shown prior to piercing, and the ear piercer was tugging at the bottom of the earlobe as the piercing stud was shot through the earlobe.

distribute written ear-care procedures upon an ear piercing being performed.

The Piercing Pagoda ear-care procedures come in an attractive two-color, tri-folded pamphlet. The front states: "Congratulations, You Did It!, 33% off certificate & easy ear care instructions, See Inside . . ." The instructions from Claire's come on a small piece of paper with small print, which is stapled to a receipt.

A comparison of the two sets of ear-care procedures reveals some differences, but general agreement. Piercing Pagoda recommends "[t]wice a day" the earrings be turned around once. Claire's recommends that the ear studs be turned around "two or three times" twice a day. Piercing Pagoda recommends that its ear-care antiseptic be applied twice a day, and Claire's recommends that its solution be applied "at least twice a day." Piercing Pagoda recommends that the initial piercing studs be left in place continuously for four weeks, and Claire's recommends six weeks. (However, the author has seen a handwritten note by a Claire's clerk recommending "6-8 weeks.") Piercing Pagoda recommends that some type of post earring be worn "at all times" for four to six months after piercing, and Claire's recommends that some type of post earring must be worn "at all times" for five months. The term "at all times" means literally that—twenty-four hours per day, whether at work or school, at home or in bed.

It is very important that during the initial healing period that the earring backings not be pushed on too tightly. The backings should be kept loose so that air can circulate to aid in the healing process. Piercing studs made of base metal usually have backings that lock on at the crease on the post.

Piercing Pagoda recommends that alcohol be avoided in initial ear care. Of course, it hopes to sell its ear-care solution as does Claire's. Because alcohol tends to pull the ear hole closed, it should be avoided. Piercing Pagoda also recommends against using hydrogen peroxide. However, it should be noted that hydrogen peroxide does not pull the ear hole closed: it allows the ear hole to remain open and to heal open. However, according to one ear piercer, hydrogen peroxide causes the gold plating on piercing studs to flake off, which can cause an infection.

Males may be concerned about the above commitments. They may want to wear an earring socially or at home, but not on the job. The question is how closely the above initial care instructions have to be followed. The answer is not too closely. An ear hole can heal open even

if the ear-piercing stud is removed daily during the employment hours, and worn only after work and at night. If a male is concerned about this, the best advice is to get his ear(s) pierced just as he begins a vacation. This will get him one-half way through the minimum four-week period. If this cannot be arranged, leaving the earring in during a weekend may be sufficient. Then, the earring can be removed during working hours, and placed back in after work. This enables most males to wear the earring for approximately sixteen hours per day. If he does this for two or three months, the hole should be healed as well as if he had strictly followed the instructions. During the first one-month period, extreme care must be followed in inserting the earring so that a new channel is not made with each insertion. Once the piercing stud has been initially removed, it should be replaced with a normal fourteen-karat stud with a rounded tip.

That the above method *can* work does not mean that it *will* work for each person. Every one's ears and body healing are different. If it appears that the ear hole has virtually closed, the person may want to try inserting an earring after several days, a week and even several weeks. A partial healing of an open channel for the ear hole may have resulted, especially if hydrogen peroxide has been frequently used. Another possibility is for the person to use the E'arrs'® brand plastic sleeves over the ear studs, to leave the sleeves in place, and to remove only the earrings. The plastic sleeves are almost invisible. Another possible technique suggested by some is to use a large size of clear fishing line through the hole while at work.

Continuing Ear Care

Ear care should continue on a permanent basis after the piercing. This means a gentle washing of the earlobes, front and back, with soap and water whenever a shower or bath is taken. After the initial care period, earrings should be removed for a shower or bath. Otherwise, a proper cleaning will not occur.

Various ear care products are on the market. Several products are Ear Care Gel® marketed by E'arrs®, Inc., and EarWorks™ Gellee marketed by EarWorks. Both products are used by applying a small amount of the gel to the front and back of the earlobe, and by also applying a small amount to the post of the earring prior to insertion.

Additional information on these two products is contained in chapter 18 of this book titled, "Metal Sensitivity and Dealing with the Problem."

Improper ear care may result in unattractive, infected earholes, and redness, itching, soreness, pus, bleeding, and metal sensitivity. By contrast, proper ear care takes only a few moments a day and allows for the full enjoyment of wearing earrings.

Permanence of the Ear Holes

No definitive answer can be given as to the permanence of ear holes after piercing. Some people report problems with the holes partially closing if earrings are worn for only a short period of time, and others report that earrings can still be inserted after years of not wearing any earrings. One woman reported that her mother had her ears pierced as a baby, but that she never wore earrings until she was fifty-two years old. At that time a relative was still able to insert earrings through the ear holes, although she had to work at the task. Another woman reported that she stopped wearing earrings because of metal allergy problems, and her ear holes had not healed up as of twenty-one years later. A sixty-year-old man who had worn an earring for a short time when he was in high school in the late 1940s reported to the author that he could still feel a lump where his ear hole had been.

After the ear holes have initially healed, a slight lump will be noticed when feeling the earlobes. After six months to several years, this lump will gradually disappear. For most people the ear holes are probably permanent at that point in time unless the ear hole gets damaged, i.e., resulting in broken or bleeding skin inside the ear hole. If earrings are not worn for ten to twenty or more years, the ear holes may continue to get smaller until they eventually disappear.

The book *Earrings: From Antiquity to the Present* in commenting upon earring fashions during the 1840s and 1850s casts some light on the permanence question: "Simple single-stone earrings—known as *dormeuses* or 'sleepers' because they were worn at night to prevent the

pierced hole in the lobe from closing—were the only form of earring that continued to be used."[9]

The above quotation raises an interesting question. If earrings were no longer in fashion, why would women want to wear dormeuses at night to keep the ear holes open? One answer is that women enjoyed wearing earrings, even if they could only wear them in bed. Another answer is that they expected earrings to eventually come back into fashion and they did not want their ear holes to grow closed.

9. *Earrings: From Antiquity to the Present*, by Daniela Mascetti and Amanda Triossi, ©1990 Thames and Hudson Ltd., London, and published by Rizzoli International Publications, Inc., New York, at page 82.

FOUR
Piercing Fashions among Men and Women

Historical Perspective

The fashion for pierced ears for females became popular again in the 1950s and 1960s after a period of a number of years. Pierced ears for females had fallen out of fashion when the screw fittings for nonpierced ears were first invented in the late 1890s. However, a book on Victorian jewelry shows a pair of Austrian earrings with screw fittings for non-pierced ears and dates the jewelry as being "mid nineteenth century."[1] The clip-on fitting was developed later in the 1930s.[2] An antique guide states that the ear clip was first patented in 1934.[3]

In the early 1900s, women sought to liberate themselves and to assert their rights to an equal role in society. They abandoned their corsets with metal staves, pinched waistbands, hoops with scores of petticoats, and stopped piercing their ears.

Pierced ears became thought of as part of male dominance, and suffering for male desire.[4] Men did not submit themselves to the "ordeal" of piercing their ears, so why should women? Besides, the newly invented screw-on and clip-on earrings eliminated the need for pierced ears. Eventually women realized that these new inventions were not liberation after all: the earrings were uncomfortable to wear because of the constant pinching of the earlobes (resulting in head-aches) and were easily lost.

1. *Victorian Jewelry* by Nancy Armstrong, ©1976, Macmillan Publishing Co., Inc., New York. See pages 24 and 25.
2. *Earrings: From Antiquity to the Present,* by Daniela Mascetti and Amanda Triossi, ©1990 Thames and Hudson Ltd., London, and published by Rizzoli International Publications, Inc., New York, at pages 132 and 135.
3. *Kovels' Know Your Antiques,* ©1981 by Ralph and Terry Kovel, Crown Publishers, Inc., New York, at page 238.
4. In an article titled "What Women Have Suffered for the Sake of Male Desire" appearing in *The Toronto Star*, Weekend, page K-15, ear piercing was compared to foot binding in China. The article states: "A few intelligent men wrote against foot binding. One such was the eighteenth-to-nineteenth-century writer, Li Ju-Chen. His novel, *Flower in the Mirror*, imagines a country in which the sex roles were reversed. He describes the pain endured by a male 'concubine,' forced to have his ears pierced and his feet bound."

Although pierced ears had fallen out of fashion, pierced earrings were still being produced. Some of the more expensive earrings were of the pierced-ear variety to guard against loss, and because the earring backings were less noticeable with bobbed hair.[5]

With the invention of the modern ear-piercing gun, the discomfort of ear piercing was reduced to the equivalent of a pinprick. True liberation was having pierced ears, which is now firmly established once again as a unisex fashion.

Female Fashion

For perhaps thirty years, the norm for females was a single piercing in each ear. It was not until the 1970s and 1980s that multiple piercing became commonplace. In the 1990s the female fashion is dependent upon the desires of each individual. Some women prefer a single piercing in each ear for simplicity. Some prefer double or triple piercing in each ear. And, some prefer an uneven look, such as two or three in one ear and one in the other. Then there are some who are driven to accumulate five to ten piercings in one or both ears.

A counter fashion has also developed. Some women will wear only a single earring in one ear. This is a takeoff of men's styling in women's wear. The author has seen a young woman with short hair in a combed, boyish look, and wearing a small gold hoop in only her left ear. The fashion looked attractive as well as different.

An article in the *Sacramento (California) Bee*[6] reported on a twenty-three-year-old female singer who wore a single silver hoop earring with jeans, plaid jacket, and a knapsack.

5. *Earrings: From Antiquity to the Present*, Daniela Mascetti and Amanda Triossi, ©1990 Thames and Hudson Ltd., London, and published by Rizzoli International Publications, Inc., New York, at pages. 134 and 135.
6. "Anguished Sound PJ Harvey," by Katherine Dieckmann, *Sacramento (California) Bee*, July 11, 1993, Encore, page EN11.

Male Fashion

When males started piercing their ears in the 1960s, the norm was a single piercing in the left ear.[7] Some homosexual males then sought to show their sexual preference by a single piercing in the right ear.[8] However, there are some reports that in the Midwest, the right-left significance was reversed![9] Then things became more confused. A number of straight men wanted an additional piercing, but they were afraid to pierce their right ear. So they settled for a double piercing in their left ear. The uneven look had become even more uneven: two earrings in one ear and none in the other is just not that attractive. Some males eventually succumbed to another piercing, a single piercing in their right ear. The straight-gay distinction is now history in the fashion-conscious parts of the United States.

As the 1990s got off to a good start, the most popular fashion for men was a single piercing in each ear. The *Chicago Tribune*, December 23, 1991, reported that during the year, "[m]ore guys had their ears pierced (both of them)."[10] *The New York Times*, May 19, 1991, also reported that many heterosexual men were beginning to wear earrings in both ears.[11]

A majority of males getting their ears pierced for the first time are now choosing a single piercing in each ear. The more conservative as well as young boys are still getting a single piercing, more commonly in the left ear. After they have become accustomed to wearing a single earring, many are returning to have their other ear pierced.

There are several good reasons supporting a single piercing in each

7. The left-right distinction has always been completely absurd. In addition to being absurd, it is probably wrong. The left side of the brain is considered to control feminine traits in a person, and the right side, male traits. By analogy, it is interesting to note that Vedic astrologers believe that the left nostril relates to the moon. And the moon relates to the female reproductive system, balancing and protecting the female through her hormonal changes. (See "Why I Wear a Nose Stud" by Koo Stark, *Daily Mail*, January 26, 1994, page 19.)

8. However, not all sections of the United States accepted the right-left rule. For example, in Michigan straight men typically had their right ear pierced.

9. "Real Men Wear Earrings, Lobe Ornaments Pierce Male Market," by Jonathan Karp, *Washington Post*, July 15, 1985, B1, col. 1.

10. "Same Old Clothes, Last Year's Hot Looks Never Left as Fashion Sticks to 1990s Looks," by Genevieve Buck, *Chicago Tribune*, December 23, 1991, North Sports Final Edition, News; page 22; Zone: C; Overnight: Fashion '91. (©Copyrighted Chicago Tribune Company. All rights reserved. Used with permission.)

11. "Piercing Fad Is Turning Convention on Its Ear," *The New York Times*, May 19, 1991, Sunday, Late Edition—Final, Section 1; Part 2; page 38, column 1.

ear. All people are born with two ears, so why pierce just one of them? Symmetry is normal in nature: people have two eyes, two eyebrows, two ears, two hands, two breasts, two legs, and two feet. Although people have one nose, one mouth and tongue, and one sex organ, they are centered on the body. Therefore, a single piercing in only one ear violates the laws of nature, and doesn't look balanced. It looks abnormal. A salesman in a men's clothing store who wears a hoop in each ear was quoted in the *Chicago Tribune*, March 6, 1991: "With just one hoop, you look lopsided."[12] Others might say the male looks like a pirate.

In considering other fashions, an uneven look is atypical. Males wear two shoes, two socks, two pant legs on their trousers, two sleeves on their shirts, and eyeglasses with two lenses. If they wear a sport coat or suit, the coat has buttons on each sleeve, usually two, three, or four on each sleeve. The only exception that comes to mind is that some shirts have only one pocket, typically on the left side. And, the suit coat or sport coat typically has only one pocket, with an optional handkerchief (or corsage) worn on only one side. However, these are located below the center of focus, which is the face.

Males were originally afraid to emulate females with a single piercing in each ear. In fact, males were originally afraid to wear even one earring for fear of being called gay.[13] The one-earring fashion was a psychological attempt to hide the earring from half of the people. The statement made was, in effect, "I'm sufficiently brave to wear an earring, but not brave enough to wear one in each ear." And, "I'm afraid people will think I have feminine (or homosexual) tendencies if I wear one in each ear." What these males did not realize is that each person owns *both* of his ears. To suggest that the right ear is owned (or controlled) by the homosexual or female segment of society is absurd. Fortunately, this "homophobia" is fast becoming history. Earrings have been historically a unisex fashion, and males are fast approaching the accepted female fashion of piercing their ears however they choose.

12. "The Hoop Scoop, Hoop Earrings—on Both Ears—Are the Lobe Jewelry of Choice for Dyno Dudes," *Chicago Tribune*, March 6, 1991, North Sports Final Edition, Style, Page 17; Zone: C.
13. A country music song by the Pirates of the Mississippi contained the lyrics: "Now if you get an ear pierced some will call you gay / But if you drive a pickup they'll say no, you must be straight." As reported in "On the Road Again, and Again; the Pirates of the Mississippi, Trekking Up the Country Charts," *The Washington Post*, August 25, 1991, Sunday, Final Edition, Sunday Show; page G1. Lyrics reprinted with permission from Tom Collins Music Corp.

With few exceptions, earrings are sold in pairs. A single piercing leaves one earring unused.[14] With males adopting the fashion of wearing a matching pair of earrings, one in each ear, those with a number of single earrings will need to replace their earring wardrobe or attempt to match their singles. Since earring designs are constantly changing, if only to the slightest degrees, matching singles is effectively impossible. The only exception might be with diamond earrings, where the original jeweler can probably duplicate a match, or reset the single diamond stone to match the new stone.

As a single piercing in each ear is becoming more acceptable and common for males, some males are beginning to get both ears double pierced, or an uneven number, such as two and one, three and one, three or two. An interesting commentary on uneven numbers among males was posted on Prodigy in early 1993. The writer stated that he had both a Spaniard and an Indian tell him that wearing odd numbers of earrings means that a male is gay, and an even number means that a male is straight.[15]

Male Fashion—Age

The earring fashion initially began among young men. However, as the fashion continues, the earring generations have grown older. Some stopped wearing earrings, but others have continued. Some of the earring wearers are now in their fifties. At the other end of the spectrum are retirees who are getting their ears pierced. These are people who thought that an earring was not compatible with their jobs, and postponed the decision. Once retirement comes, they head for the piercing salons.

The Prodigy bulletin boards have contained notes from several retirees who had their ears pierced after retirement. One sixty-eight-year-old man in Santa Barbara, California, stated that he has his left ear double-pierced, and that he was thinking about the same for his right

14. Some males have solved this problem by having their girlfriend or wife wear the second earring in one of their ears (in an uneven look).
15. Prodigy, Frank Discussion Bulletin Board, Topic: Alternative Lifestyle, Subject: Earrings—Male, January 11, 1993.

ear. A sixty-six-year-old Seattle man wrote in 1992 that he just had both ears pierced after thirty years in a government administrative job.[16]

The earring generations are also getting younger. Although wearing earrings formerly did not start until late high school or more commonly in college, boys in the early elementary grades are now adopting the fashion. And, some parents are even having the ears pierced of their baby boys or when they become toddlers.

16. Prodigy, Frank Discussion Bulletin Board, Topic: Men's Issues, Subject: Earrings, November 6, 1992.

FIVE
Multiple Ear Piercings in One or Both Ears

Early History

When males began piercing their ears in the 1960s and 1970s, females rediscovered the fashion of multiple ear holes in one or both ears.

One mummy in the museum of Turin, which is located in northwest Italy, has two earrings worn on the same earlobe. And painted terracotta idols in Cyprus from 1500 B.C. showed their earlobes pierced two or three times with large hoops in each piercing.[1] The book *Jewelry, 7,000 Years*[2] states that Egyptian women often worn a pair of hoop earrings on each ear. Each hoop earring consisted of a number of triangular tubes soldered together.

The book *Accessories of Dress*[3] contains a drawing of the earring that is shown in the portrait of Bianca Capella painted during the 1600s in Europe. The earring consists of two small hoops inserted through separate earholes, and from which hangs a large earring with three dangling pearls.

Males and females alike among the Virginia Indians at the time of the first colonization had multiple-pierced ears. The women commonly had three holes in each ear, and one male was described as wearing five or six copper pendants in each ear.[4]

1. *Earrings: From Antiquity to the Present*, by Daniela Mascetti and Amanda Triossi, ©1990, Thames and Hudson Ltd., London, and published by Rizzoli International Publications, Inc., New York, at page 11.
2. *Jewelry, 7,000 Years*, edited by Hugh Tait, ©1986 by the Trustees of the British Museum. The 1991 edition referenced in this chapter was published by Harry N. Abrams, Incorporated, New York. See page 42 for the reference and page 46 for the hoop earrings.
3. *Accessories of Dress*, ©1940 by Katherine Morris Lester and Bess Viola Oerke, The Manual Arts Press, Peoria, Illinois, at page 113.
4. *The Book of the Pearl, The History, Art, Science and Industry of the Queen of Gems*, by George Frederick Kunz and Charles Hugh Stevenson, originally published in 1908 by The Century Co., New York, and republished in 1993 by Dover Publications, Inc., Mineola, New York, at page 487 of the reprint.

Cultures with Multiple Ear Piercings

Females of the Wodaabe people in Niger, Africa, customarily have seven to ten holes pierced in each ear, starting at the bottom of the earlobe and extending to the top of the ear.[5] In each hole they wear large hoops (3.5–4 inches, 9–10 centimeters) made out of silver or brass. A *National Geographic* article, October 1983, shows a number of photographs of women with these large earrings,[6] as does the book *Nomads of Niger*.[7] The book's authors comment that the ear piercings are done between the ages of two and four.

A similar fashion was photographed in 1973 in Oman, a country on the eastern most portion of the Saudi Arabian peninsula.[8] The "country girl" was wearing six silver hoops in her right ear, and seven in her left ear. Each hoop was approximately 3 inches (7.5 centimeters) in diameter. The first piercing in her left ear was slit down for at least half an inch (1.25 centimeters), possibly through the bottom of her earlobe, and did not contain an earring.

Author Heather Colyer Ross wrote in 1985 that a Bedouin child on the Arabian peninsula may have her ears double- or triple-pierced at birth.[9]

A young female of the Fulanis people, who live near the Niger River in West Africa, was featured on the cover of *National Geographic* in August 1975.[10] In addition to giant gold ornaments hanging from her ears, she has a number of small gold hoop earrings extending toward the top of her ears. Five gold hoops can be seen in her left ear, and her right ear is mostly obscured, but three hoops are still visible.

A 1979 photograph of a Moorea island lady (near Tahiti) appearing

5. *Nomads of Niger*, ©1983, photographs by Carol Beckwith and text by Marion Van Offelen, Harry N. Abrams, Inc. Publisher, New York, at page 67.
6. "Niger's Wodaabe: People of the Taboo," *National Geographic*, October 1983, at pages 482 to 509.
7. *Nomads of Niger*, ©1983, photographs by Carol Beckwith and text by Marion Van Offelen, Harry N. Abrams, Inc. Publisher, New York.
8. "Oman, Land of Frankincense and Oil," by Robert Azzi, *National Geographic*, February 1973. Photograph of young girl appears at page 223.
9. *The Art of Arabian Costume: A Saudi Arabian Profile*, by Heather Colyer Ross, Second Edition, ©1985, Arabesque Commercial SA, Switzerland, at page 111.
10. "River of Sorrow, River of Hope," by Georg Gerster, Ph.D., *National Geographic*, August 1975, at pages 152-189. The magazine cover is reproduced at page 175 in the article.

in *National Geographic* clearly shows a well-worn second piercing in her left ear.[11] Her right ear is not visible.

A photograph in the October 1990 issue of *National Geographic* showed a Dogon woman from Mali, Africa (formerly French West Africa), wearing nine small, silver hoops in her right ear (her left ear was not visible).[12] She is also wearing a small, silver hoop in her lip, in each nostril as well as through the septum, i.e., the center part of the nose.

Various photographs of the Turkana tribe of northern Kenya are shown in a fashion article appearing in *Esquire Gentlemen,* Special Issue—Fall 1993.[13] Most of the female tribal members are shown wearing multiple hoop earrings. (Some males are also shown wearing earrings.)

Some Mexican Indian Cuetzalan women in the 1960s wore up to three pairs of earrings.[14]

United States—Recent Fashion

One of the earliest reports of multiple ear piercings during the current revival comes from Anchorage, Alaska. Beginning around 1969, a large percentage of female students at the Anchorage High School got a second hole in their left ear only. According to Vicki Andrews, a 1972 graduate of Anchorage High School, the fashion was copied from hippies who came to Alaska from San Francisco. Ms. Andrews today still wears two earrings in her left ear, one in her right ear, or one in each ear if that is her mood.

In 1975, an article appeared in the *Washington Post* about a twenty-year-old female who was wearing six earrings in each ear.[15] According to a public note posted on the Prodigy service[16] Lenise Smith-Walters wrote that she had her ears pierced that way in 1972 "to be different."

11. "The Society Islands, Sisters of the Wind," by Priit J. Vesilind, *National Geographic,* June 1979, photograph is at page 859.
12. "Below the Cliff of Tombs, Mali's Dogon," by David Roberts, *National Geographic,* October 1990, Photographs by Jose Azel. Photograph is at page 114.
13. "Way Out of Africa," beginning at page 166.
14. *Mexican Indian Costumes,* ©1968 by Donald and Dorothy Cordry, University of Texas Press, Austin and London, at page 230.
15. *Washington Post,* April 20, 1975, front page of Style Section.
16. Homelife Bulletin Board, Fashion topic, October 28, 1992.

She wrote that it was rare to see multiple-pierced ears in the mid 1970s. She commented that she was still "proudly" wearing six studs in each ear in 1992.

The *Los Angeles Times* reported in an article appearing September 10, 1992: "It's a mystery . . . why girls want several holes on each earlobe. Equally mysterious is why fashion trends now seem to dictate odd numbers—say, three in one ear and four in the other."[17]

Multiple Piercings as a Sign of Rebellion

When young females first began the multiple fashion, many people viewed this as a sign of teenage rebellion. This was because the fashion was first embraced by rebellious females who wanted to attract attention with their unusual dress and hair styles. Although the fashion is now mainstream with grandmothers and girls nine and ten years old or younger having double-pierced ears, the early connotation still exists.

Newsweek magazine ran an article on drugs in its November 1, 1993, issue.[18] Pictured on page 50 was a female earlobe wearing a dangling, marijuana leaf earring. The earlobe was double-pierced, with the unused second ear hole clearly visible. The subtle message was that rebellious females have double-pierced ears and smoke marijuana. However, to the observant reader with pierced ears, the opposite message may have been received. This is because both ear holes in the photograph were beautifully maintained. Neither ear hole was enlarged or stretched, or infected or red from irritation or metal sensitivity. Most females would be jealous of such good-looking ear holes!

Excessive Number of Piercings

When does ear piercing start to become a compulsion? There is no hard rule, and the term is meaningless anyway.

17. "For the Kids/Fashion; The Hole Story; Both Boys and Girls Are Having Their Ears Pierced—and at Younger Ages. Many Children Sport Multiple Earrings," *Los Angeles Times*, September 10, 1992, Ventura County Edition, Ventura County Life; Part J; page 12; column 1. Reprinted with permission.
18. "Just Say Maybe, Drugs: For a Decade, the Drug Culture Was Demonized. But It's Staging a Strong Return," by John Leland, *Newsweek*, November 1, 1993, at pages 50–54.

The term *compulsion* implies that a person cannot stop or control their behavior. However, there is a limited amount of room on the ear, so it physically has to stop at some point. One female reported that she has nine ear holes on one ear, and only one ear hole in the other ear. The author has seen some young females with earrings that wrap around the entire ear, from top to bottom. That look is excessive.

A female ear is shown wearing ten hoop earrings in *Esquire Gentlemen,* Special Issue—Fall 1993 at page 104. Her trigus (the protruding skin and cartilage at the entrance to the ear canal) is also pierced with a hoop. In addition, the female apparently has a "see-through" hole with sleeve in the first piercing location.

A June 1994 advertisement by a store called Maya, located on Melrose Avenue in Hollywood, California, showed a female ear wearing eleven silver hoop earrings. The hoops got progressively smaller up the ear and they were all of different ethnic designs. The heading above the ear stated: "The Greatest Earring & Ring Show on Earth!"[19] Surprisingly, the ear pictured still had room for two or three more earrings.

The author saw a young male several years ago who obviously had a compulsion. He had twenty or more piercings in one ear and all in the fleshy part of the earlobe. Each earring was a mere speck, and his earlobe literally looked like a pincushion. There does not appear to be any fashion statement in perforating the earlobe in that manner.

Multiple Piercings a Sign of Psychological Problems?

The September 1990 issue of *American Journal of Psychiatry* printed a letter from a Williamsburg, Virginia, doctor under the heading of "Borderline Personality and Multiple Earrings: A Possible Correlation?" The doctor who apparently specialized in psychiatry wrote that over the last six years of his practice: " . . . I have found a strong correlation between having this [borderline personality] disorder and having multiple ear piercings per earlobe. . . . Of the total of 52 borderline patients I saw during this interval, 44 had multiple earlobe piercings." (Reprinted with permission.)

19. Advertisement at lower right corner, page 7, *Los Angeles Reader,* June 24, 1994.

35

The doctor then went on to state that out of several hundred patients with conduct disorder diagnosis, only seven of them had multiple ear piercings. The doctor did not state how many patients had two or three piercings per ear and how many had piercings wrapping around the entire ear.

The doctor *does not* suggest that multiple ear piercing *causes* borderline personality disorder. Were that suggestion to be made, it would be almost as illogical as observing that most females with borderline personality disorder wore miniskirts, and then concluding that wearing miniskirts caused the problem. What the doctor observed was that 84.6 percent of his female borderline personality disorder patients had multiple ear piercings. If 84.6 percent of the general female population had multiple ear piercings, then his observations are meaningless. If 0 percent of the general female population had multiple ear piercings, then the doctor has shown that females with a certain type of troubled personality are more apt to adopt fashions considered shocking to the rest of society. That concept would appear to be logically correct.

Based on the doctor's letter, it appears that Williamsburg, Virginia, was a very conservative small town in 1990, where few females wore multiple earrings. Williamsburg, Virginia, is located in the southeastern part of the state with a population of twelve thousand, based on 1980 census data. It is the home of the College of William and Mary. What the doctor also does not indicate in his letter is whether his patients were college students from other states and cities where multiple ear piercings constituted fashion rather than a sign of rebellion.

Another comment that should be made is that one isolated study does not necessarily prove anything. The doctor's observations could have been the result of random chance.

Most Attractive Multiple Look and Multiple Spacings

Most males and females have sufficient room in the fleshy part of their earlobes for three piercings per ear, and with some, there is room for a fourth piercing. Beyond that, the piercings would be in the harder, cartridge part of the ear. The Inverness® Ear Piercing Training Manual suggests that multiple piercings be placed about three-eighth's inch (nine millimeters) apart, but in no event closer than one-fourth inch (six millimeters) because there would not be enough room for earring clasps or backs. With a three-eighths-inch spacing (nine millimeters),

two nine-millimeter studs could be worn in adjacent ear holes. By way of illustration, a 2.5-carat diamond stone is approximately nine millimeters in diameter. This look is excessive, even with gold balls or pearls, but it indicates the philosophy behind ear hole spacing.

Beyond two piercings per ear, more piercings do not necessarily look better. The multiple earrings must all be coordinated together to look good. An ear with numerous ear holes without the earrings does not look attractive. It can even look like a pincushion. Too often the ear holes are not keep clean and free from infections. Infected holes present a poor appearance for both males and females. Several ear holes per ear without the earrings present an attractive appearance *if* the ear holes are free of infection and redness and have not been torn or elongated from wearing heavy earrings.

A number of females report that after the initial excitement has worn off, they seldom wear more than two earrings per ear. It just becomes too much trouble. Some will allow the extra ear holes to heal up, and others keep them open by inserting the post of an earring from time to time. It is a common sight to see a female with double-pierced ears wearing small stud earrings in the top ear holes and none in the bottom. Although the reason for some is that they just got their second set of ear holes and have to wear the earrings continuously for four to six months, the reason for many is that they were too lazy to insert earrings in the lower ear holes.

Multiple Fashions in the Rest of the World

The multiple fashion among women has even reached Beijing, China. A color photograph appearing in a 1993 newspaper article showed a couple dancing in Beijing. The woman was wearing a medium-size, gold-hoop earring, and a second piercing was visible, although no earring was being worn in that ear hole.[20]

20. "By Dawn's Early Light," *The Orange County Register* (California), September 1, 1993, Focus on China, front page.

Cartilage Piercings

Cartilage piercings are those done above the fleshy part of the earlobe, where there is typically room for three or four piercings per ear. Cartilage piercings maybe more painful and may take longer to heal.

Multiple Ear Piercings by Males

Males have also been adopting the multiple fashion. Singer Ringo Starr (a former Beatles member) currently wears three earrings in his left ear. In his bottom ear hole, he wears a large, dangling cross. In his upper two ear holes, he wears small studs. Singer Bruce Springsteen reportedly has seven ear holes in his left ear and one in his right ear.

The reason for the multiple fashion among males is easy to understand. Straight males started out by having only their left ear pierced, since gays were supposed to have their right ear pierced. When these males decided to get another piercing, they were afraid of having their right ear also pierced by reason of being labeled as gay. That left only the choice of a second piercing in their left ear. When this silly idea of "ownership" of left and right earlobes finally passed, straight males began to have both ears pierced. However, since the multiple look in the left ear had become acceptable, the multiple fashion has continued to grow in popularity.

The most common ear-piercing fashion for males is now a single piercing in each ear. After those piercings have healed, many are getting additional piercings. The most common multiple fashion in Southern California is now three and two, followed by two and one. Some prefer three and one, or two and two. The multiple trend among males was commented upon in the *Washingtonian*, May 1993, as follows: "The trend is to pierce both ears, or double- or even triple-pierce one ear."

A similar trend was noted in Seattle in May 1993: "Now, it's common to see men with all types of earwear—two or three earrings on one ear and even earrings in both ears."[21]

21. "Lend Me Your Ear—What You See and Feel Isn't Always What You Get," by Don Williamson, *The Seattle Times*, May 9, 1993, Issues, Don Williamson, Page A13. Reprinted with permission.

One person commented on Prodigy on June 8, 1992, that his girlfriend's brother wears eight cubic zirconias in his left ear and three small hoops in his right ear.[22]

Coordinating Multiple Earrings

One woman complained that she has a hard time finding two pairs of earrings that look good together, and she usually ends up wearing the same earrings. This is a common complaint, and jewelers ought to take note. Although some earrings come packaged with two matching sets, there are not too many of them.

Many persons with multiple ear holes do not know how to properly coordinate the earrings they wear. Not only do the multiple earrings have to be color-coordinated with the clothing and accessories, but the earrings have to look good together.

Most costume earrings are too large to be worn with a second set. These earrings often extend to or cover the second set of ear holes. Wearing earrings in the second set can look crowded or overwhelmed by the larger earrings. If the person has a third set of ear holes, skipping the second set in favor of the third set usually looks more attractive.

The multiple look is most attractive when smaller earrings are worn together, or are worn with hoops in the first ear holes. Diamonds can be worn together with almost any other gemstones. Some examples are as follows: diamonds with blue sapphires, blue topazes, rubies, garnets, emeralds, peridots, citrines, amethysts, black onyxes, pearls, and opals. These stones can be same sized or progressively smaller in one or both ears. In addition, the stones can be all the same type, such as two or three diamonds per ear.

Many persons wear diamonds in their second ear holes and change the bottom earrings on a daily basis. Gold hoops in the first ear holes with diamonds in the second ear holes is an attractive look.

Hoops can also be worn in multiple fashion; however, the hoops should not be too large. Smaller and thinner hoops usually look the best together. These hoops can be progressively smaller in the upper ear holes or even progressively larger. If hoops are worn together, they

22. Homelife Bulletin Board, Fashion topic.

should all be the same type: hinge hoops with hinge hoops, post hoops with post hoops, and endless hoops with endless hoops, and so on. Also, the hoops should be in the proper proportion to each other.

Gold balls of the same or progressively smaller sizes also look good together. In addition, some dangling earrings are suspended from a gold ball stud. A set of gold balls in the second ear holes would complete the look.

The multiple earrings also have to be color-coordinated. The following examples are given of gemstones that can be worn together: garnet or ruby with blue sapphire, emerald with citrine, blue topaz with blue sapphire, black onyx with a pearl or diamond, emerald with blue sapphire, coral with lapis, turquoise with amethyst, jade with amethyst, citrine with brown topaz, turquoise with aquamarine, and amethyst with aquamarine.

Coordination of multiple earrings is especially important when costume earrings are worn in the first set of ear holes. Because costume earrings are often of a very busy design, simplicity should be the rule in choosing the multiples. Repetition in design or color usually works the best. For example, a costume earring might feature a gold ball stud through the ear hole, with white, red, and blue dangling stars. The gold ball could be repeated in the second ear hole, or a small white, red, or blue stud could be worn in the second ear hole. With silver costume earrings, a small silver ball could be worn in the second ear hole, or a color in the silver earring like a turquoise stone could be repeated.

SIX
Choosing Male and Female Earrings

Choosing Male Earrings

Males typically wear three varieties of earrings: studs, hoops (i.e., referred to by some as loops), and dangles. Studs have been the most popular, with hoops close behind if not already ahead.

Hoops

It has taken nearly thirty years for hoops to gain their current popularity, notwithstanding that one of the first earring wearers was Ringo Starr of the Beatles. He wore a small gold hoop in his left ear; hence the nickname "Ringo." The Beatles launched their first United States tour by appearing on the *Ed Sullivan Show* on Sunday evening, February 9, 1964.

Most males prefer wearing gold hoops, although silver hoops are not uncommon. The size of the hoops are typically one-half to three-fourths inch (1 to 2 centimeters) in diameter and are sometimes referred to in the jewelry trade as baby hoops. This is because the hoops tend to be suitable for babies, i.e., small in diameter and thin in appearance. The largest size worn by males is usually not more than one inch (2 1/2 centimeters), although one and one-half inch hoops (3 3/4 centimeters) are now being seen. If males want to be braver, they usually select a thicker hoop.

Hoops come in several basic styles, all of which are worn by males. Post hoops attach like a stud earring, since the hoop portion is about seven-eighths of a complete circle. Snap-bar or hinge hoops have a flat spot on the top part of the circle, which consists of the hinge mechanism. Endless circle hoops have a thinner wire at the top of the hoop that passes through the ear hole and is inserted back into the hollow portion of the hoop. Hook hoops have a bend or hook in the wire that passes through the ear hole, and this hook springs into an eyelet. Upside down "U" hoops are like the endless circle hoops, except that the wire that passes through the ear hole is an upside down "U," which causes the hoop to hang farther below the bottom of the earlobe.

Snap-bar (or hinge hoops) are highly recommended for both males and females. The reason is that if the hoop is caught in something solid, the hoop will open and come out of the ear rather than tearing the earlobe. Hook hoops are the least likely to open under force and can tear the earlobe and cause an extremely painful injury and require expensive surgery. Snap-bar hoops are also the easiest to insert through the ear hole as well as to remove. By contrast, inserting a one-half-inch (1.25 centimeter) or smaller endless hoop can be quite a chore without making the ear hole sore or inflamed. These hoops are not designed to be removed every day for showering.

The thinnest hoops are gold wires that can be inserted through the ear hole until the hook mechanism is at the bottom of the hoop, which allows for ease of hooking. The hoop is then turned in the ear so that the mechanism is near the back of the earlobe. The next larger size is more like a thin, solid ring, but usually small enough for even the body part of the hoop to pass through the ear hole. The next larger size hoop is usually hollow in the center to prevent the hoop from being too heavy (and too costly, if made from fourteen-karat or eighteen-karat gold). The thickness, size, and design of these hoops vary considerably and extend to hundreds of variations. The large, thick gold hoops worn by Mr. T have not been accepted in the mainstream of men's fashions.

Males usually wear simple gold hoops, i.e., smooth, round, and not too thick. Other styles, such as a Florentine finish or twisted appearance, are acceptable if a simple appearance is presented. Styles are becoming larger, heavier and bolder as men become more accustomed to wearing hoops. Current London fashions are for the larger and bolder hoops. And, current Sydney fashions also call for thick hoops, about three-fourth's inch (two centimeters) in diameter, and one in each ear.

Studs

Studs were the first earrings to be widely worn by males. A small stud is now considered to be a "conservative" earring suitable even for office wear.

The size of stud earrings is typically given in millimeters. A one-millimeter earring is a bare speck and probably will not be noticed in a face-to-face discussion. This earring size is not generally available, since the head of the earring will pass through all but the tiniest of ear

holes. A jeweler can custom make a one-millimeter gold ball earring by heating a gold wire until the tip melts, when it naturally forms a gold ball. A two-millimeter stud is sometimes available at jewelry counters and in jewelry stores and is frequently used for babies. It is barely noticeable in the ear. Neither the one- nor the two-millimeter size of earring is recommended.

The most popular size of stud earrings for males is three to four millimeters. A three-millimeter size is still not very noticeable, and it allows a male with newly pierced ears to become accustomed to wearing earrings. Most males will soon be more comfortable wearing a four-millimeter size. This raises the question of how large can males go. A "comfortable" size, i.e., one that will not induce too many obvious stares, varies with the type of stud earring. A colored gemstone that is five or even six millimeters in size is not too large. A gold ball that is six millimeters in size is similarly not too large. A flat design, such as a gold nugget, of eight to twelve millimeters will not look too large.

Males must realize that regardless of the size they choose, they will not please everyone, so they should please themselves. Earring critics sometimes ridicule small earrings: "Darling little earrings worn by otherwise masculine-looking males."[1] The inference of this quotation is that small earrings look dainty or feminine. Yet if earrings are "too large," whatever that might be, the earrings will be branded as "women's earrings." Since babies wear dainty little earrings, males should probably avoid earrings that are very small, i.e., those that are one or two, or perhaps even three millimeters in diameter. This author recalls seeing a young lady wearing two-millimeter gold ball earrings, and a most feminine appearance was presented.

In considering the appearance of different sizes of stud earrings, several factors need to be considered. A sparkling stone, such as a good quality diamond, will appear to be larger than a stone without much brilliance. A colored gemstone is probably the least noticeable of stud earrings, especially the lighter colors on light skin and the darker colors on dark skin. Shiny, gold balls and diamond-cut gold studs attract attention, while a Florentine finish reduces attention. The height of the

1. "Readers' Great Gripes Festival: Let the Venom Flow," by Mike Royko, *Orlando Sentinel Tribune,* May 26, 1993, Editorial, Page OPN. The same comment appeared in "On Gripe Festival Menu Today: Crabs," *Chicago Tribune,* May 13, 1993, News, page 3, zone: N.

setting is important, since an earring that protrudes more from the earlobe is more noticeable. A flat earring is less noticeable, and a larger size can be worn. Probably the most visible earring on a white male is a black onyx ball. On a black male, a pearl earring would be the most visible, except that pearls have not come back into style for males.

Virtually all colored gemstones can be worn by males. This includes blue topaz, amethyst, perlite, emerald, ruby, sapphire, garnet, opal, and black onyx. Poorer quality rubies may have a pinkish cast and should be avoided. All of these stones look the best if they are color-coordinated with the clothing. Just as a tie should match or be coordinated with the suit and shirt, so should the gemstone earrings. This means blue topaz or sapphires with a blue suit, emeralds to match the green in a tie, or rubies or garnets to match the red in a tie, and black onyx earrings with a gray or black suit. Of special note is that emerald earrings look good with a dark blue shirt, and take on a bluish cast. Amethyst earrings look good with a lavender shirt or tie.

Wearing gemstone earrings means you need to change your earrings with your clothing. Too many males wear only one pair of earrings and are afraid someone will notice if they change their earrings. This concept is changing as males learn that earrings are fashion accessories, just like other clothing items. A man should not wear the same earrings day in and day out any more than he should wear the same suit or same tie for weeks on end.

Gold-ball studs are frequently inserted during the ear-piercing procedure and are worn day and night for the first thirty days. The persons with newly pierced ears are easily recognized by their gold-plated ball studs about 3.5 millimeters in diameter, worn loosely on the earlobes with a large backing, and with some redness evident on the earlobes. Gold-ball studs can and do look attractive, but they look better if they are in fourteen-karat gold and in a size different from the typical ear piercing variety. The sizes that look best on a male are those three to six millimeters in size. Smaller size gold balls may look too dainty on a male. Gold balls do attract attention, especially when they are still new and highly polished.

Diamond studs are very popular among males and are discussed in chapter 8 of this book, titled "Shopping for Diamond Earrings for Men and Women."

In addition to colored gemstones and diamonds (real and synthetic), there are a large number of other stud earrings that males can

wear. These earrings include stars, sand dollars, star fishes, anchors, ships, dollar signs, initials, lightning bolts, gold nuggets, small love knots, open boxes, closed boxes, diamond-cut half balls, dolphins, triangles, crosses, ankhs, diamond-cut shells, and plain and twisted stud hoops, which wrap the bottom of the earlobes.

Dangles

Dangles that are worn by males tend to be smaller and of geometric shapes. They typically are constructed to dangle from a hook, which is inserted through the ear hole. Some are of the post variety, with the dangle attached to a small gold ball. The variety of dangles worn by males include crosses, peace symbols, and daggers, swords and similar items. Most dangles are sold as costume jewelry, are designed for females, and are not too suitable for males. It may take trial and error to find a look that is suitable.

Earring Wardrobes

When males first began wearing earrings, it was common for the same earring to be worn month after month. This approach evidenced a basic insecurity about wearing earrings. If the same earring was constantly worn, people would stop noticing the earring. Changing the earrings means that people will notice.

As the earring fashion continues to grow among males, it is becoming common practice to change the earrings on a frequent, if not daily basis. One newspaper article reported that a young male owned sixty pairs of hoop earrings.[2]

Choosing Female Earrings

Females have thousands of choices for earrings, especially in the costume jewelry area. The earrings may match other jewelry worn at the same time, or they may match the dress, blouse, purse, shoes, or

2. "The Hoop Scoop, Hoop Earrings—on Both Ears—Are the Lobe Jewelry of Choice for Dyno Dudes," *Chicago Tribune*, March 6, 1991, Style; page 17; zone C.

other fashion accessories. In terms of the shape of costume jewelry, one fashion writer gave the following advice:

> The shape of costume jewelry can minimize or enhance one's looks, Friedlander points out. Long faces should opt for big button earrings. Round faces, she says, look best with oval drops or round earrings, triangular faces look best with wide earrings and square faces look best with oval or drop earrings. Oval faces can wear anything.[3]

3. "Fake Jewels: All or None Is the Rule," *The Orange County (California) Register,* March 18, 1993, Look, page E5, written by Liz Rittersporn of the *New York Daily News.* ©*New York Daily News,* L.P. Used with permission.

SEVEN
The Allure of Wearing Hoops

Sailors, Pirates, and Genies

Gold hoops were the earrings of choice of sailors, pirates, and even fictional genies. Several reasons are offered why seafaring men wore gold hoops:

a. Their gold hoop earrings (via the gold content) guaranteed a proper burial if they died in a foreign port;
b. Pierced ears helped prevent drowning at sea;
c. Pierced ears improved eyesight and hearing;
d. Sailors saw the world and other cultures where males wore earrings;
e. Gold hoops showed a comradeship among sailors throughout the world; and
f. Wearing gold hoops helped sailors find sexual favors from females while their ship was in port (i.e., female groupies did not have rock musicians or sports celebrities to pursue).

Growth of Current Fashion

One might wonder why hoops have become so popular with younger men. Although Ringo Starr of the Beatles first arrived in the United States in 1964 wearing a small gold hoop in his left ear,[1] hoop earrings have been worn by males and females for at least 4,500 years.

Hoop earrings have a certain sensuality to them. They are bolder and show more on the ear than small studs. So what are the reasons for the popularity? They just look good on the ear, and females think they look attractive.

When singer George Michael, formerly with the group Wham, first started wearing a medium-size gold hoop in each ear in his music

1. Ringo Starr is still wearing an earring thirty years later. Except he now favors a large dangling cross plus two small studs, all in his left earlobe.

videos, the initial reaction was shock. Many thought that females are supposed to wear the larger, gold hoops, especially one in each ear. After the initial shock subsided and the fashion took hold, more males began wearing larger and thicker hoops. The one-in-each-ear trend is now firmly entrenched in fashion. What was once thought of as a feminine fashion is once again established as a male fashion.

An article appearing in *Rolling Stone*, August 5, 1993, at pages 59 and 60 showed photographs of numerous entertainers wearing gold hoops. Perry Farrell is shown wearing a medium-size hoop in each ear. Nuno Bettencourt has an extremely large hoop in each ear. Lenny Kravitz has one large hoop and three small hoops in his left ear (his right ear is not visible). Bono has a small thick hoop in his right ear (his left ear is not visible). Keith Richards has a medium-size hoop in his left ear and no earring in his right ear. George Michael has a large thick hoop in his left ear (his right ear is not visible). John Mellencamp, Christopher Barron, Ice-T, Brett Anderson, and the Edge are each pictured wearing a hoop in their left ear (their right ears are not visible). Layne Staley has a medium-size hoop in his right ear (his left ear is not visible). And Ozzy Osborne is pictured with a cross dangling from a hoop as well as a stud in his left ear (his right ear is not visible).

In Europe the fashion of wearing a gold hoop earring is popular with even conservatively dressed businessmen.[2]

Unisex Fashion

Hoops are neither a female nor a male fashion. They are more accurately a unisex fashion that make both sexes appear more attractive. William Shakespeare wore a gold hoop in his ear, and so may have Christopher Columbus. No pirate was complete in his "uniform" without a gold hoop in his ear or in both ears.

If most females did not like men to wear hoops, the fashion would not have become popular. When asked why they like hoops on males, younger females typically respond that they find them attractive, that they make a male look sexy, and give a pirate-type of look, and add intrigue.

2. "The Hoop Scoop, Hoop Earrings—on Both Ears—Are the Lobe Jewelry of Choice for Dyno Dudes," *Chicago Tribune*, March 6, 1991, North Sports Final Edition, Style; page 17; zone: C.

Wearing a hoop or hoops by a male makes a statement that he is not afraid to have people see his earring(s). When a male wears a two- or three-millimeter stud earring, people might not even notice that he is wearing an earring. Or it may take five to ten minutes of face-to-face conduct for the other person to notice. Wearing a hoop emphasizes the ear hole, which would be covered by a stud. Any observer can tell that this is a male with his ear pierced. With no earring in place and the ear hole showing, a male might be viewed as being bold, intriguing, and even mysterious. Wearing a hoop highlights these feelings. Curiosity also seems to play a part: males who are thinking of undergoing the piercing gun want to look. Females also want to look. Perhaps it is a feeling of kinship, that the male is part of the pierced-ear "club." And, some females have expressed the perception that a male who has his ear(s) pierced is kinder and gentler.

Females Like Hoops on Males

Females have been very receptive to males wearing earrings and hoops. Most younger females like the fashion, and, they have been a big impetus in spreading the fashion. Males often have their ears pierced to please their girlfriends or their wives. And, a growing number of mothers encourage their sons to pierce their ears. In getting their ears pierced, a majority of males are accompanied by a female. Males want to be attractive to the opposite sex, just like females.

Hoops also make a statement by a male that he is not afraid of his masculinity. He is confident enough to wear hoops, although earrings were generally considered female jewelry not too many years ago.

Most males are simply afraid to get their ears pierced. They are afraid of what other people will say. They are afraid that their employers will frown on wearing earrings. They are afraid of losing their jobs or of losing their customers. They are also afraid the ear hole will show. Therefore, ear piercing and wearing hoops is a very masculine statement: real men are not afraid, and real men do not cry. Macho men who ride motorcycles and belong to motorcycle clubs commonly wear earrings. An earring is a sign of toughness. An earring is a sign of a sailor who has crossed the equator. An earring is a sign of independent thinking. Yet, earrings still have an erroneous perception of being feminine by the older segment of the population.

A male must overcome a psychological hurdle before he gets his

ear(s) pierced. He is told by the piercing place to wear his new earring day and night for thirty days. This will enable nearly everyone he knows to see his earring! How horrible a thought. Yet the same male can safely experiment with wearing other articles of jewelry that until recently have been thought of as being feminine. Several well-known jewelry houses refused until recently to carry gold chains for men. This is because "real men" did not wear necklaces. Yet the timid male experimenting with such fashion could always remove the gold chain and no one would ever know he had worn a gold chain. For this reason the fashion of men wearing gold chains and bracelets has grown much faster than earrings.

Psychological Allure of Hoops

For a male to wear a hoop earring is for him to make a strong statement. Respect for that courage is a common reaction among both males and females. That same respect then encourages other males to get their ears pierced.

For a male to wear a hoop earring is also to attract attention. Many males obviously enjoy that attention from females. It strokes their ego. Since wearing a single, small stud no longer attracts any attention, wearing a medium-size hoop is a means to regain some of that attention.

Another allure of wearing hoops is the pleasure gained. A male may like the look on his ear, and the slight sensation on his earlobe, which is not obtainable from a small stud. The pleasure is also gained from a female commenting that the hoop looks good. Sometimes life's greatest pleasures are the simplest. Do what makes you happy. An increasing number of males are doing exactly that.

EIGHT
Shopping for Diamond Earrings for Men and Women

"Promo" Diamonds

When shopping for diamond earrings, the trap of the "promo diamonds" should be avoided. These are muddy, brown stones with little or no brilliance, although they are technically diamonds. Jewelers would state that the stones are "heavily included" and with a yellow or brown color. These diamonds are advertised for extremely low prices, sometimes even $399 for one carat *total weight* (of both earrings) abbreviated as T.W. The advertisements are designed to lure the unsuspecting or unknowledgeable customer into a store under a "bait and switch" scam. Jewelers refer to this as a "hook." Once the potential customer is there, the store will attempt to convince the customer to buy higher quality diamonds often at an inflated price.

Sometimes, good quality loose stones are sold with the agreement of the store to set the stones in earrings within a day or two. The risk is that inferior stones are substituted when the customer leaves the store. Even if the mounting is done in front of the customer, the person doing the mounting could "accidentally" drop the intended stones and switch them for inferior ones or divert the customer's attention momentarily to accomplish the switch. The best protection against such a fraud is to deal with a reputable jeweler and to refuse to buy *anything* from a "bait and switch" operator. If this type of operator got you into his store under less than honest circumstances, you should not expect to be treated honestly on any other merchandise available for sale.

Maximum Size

Some jewelers will recommend against buying diamond earrings that are too large. The concept expressed is that diamond earrings that are too large divert all the attention away from the face and toward the ears. The opinion of what is too large varies from jeweler to jeweler. The person contemplating a major investment in large diamond earrings should first consider buying the same size in cubic zirconia and

judging the effect from wearing them. (A one-carat cubic zirconia stone is approximately two-thirds the size of a genuine diamond stone, so millimeter size must be compared.)

Most people will run out of funds before they overstep the bounds of what is considered too large. For example, a one-carat diamond earring (two carats T.W.) that is well proportioned will measure approximately 6.5 millimeters in diameter. The price of a VS2-grade diamond in an H color, which weighs at least 100 points, will be in the range of $4,500 to $6,000. This translates into a $9,000 to $12,000 price for a pair of diamond earrings! A person who is willing to spend such a large amount should insist that the diamond stones be weighed in front of them, since the price differential between a stone weighing 95 points and a similar stone weighing a true 100 points (one carat) is very large. Dishonest jewelers can fudge on the true weight because of the large price differential and because the stones have to be removed from the settings to weigh them. If not done with care, the bending of the prongs (usually six for a larger diamond) may be visible, requiring new settings. In addition, the customer should require that the diameter of the stone be measured with a millimeter gauge to see if it is 6.5 millimeters.

The concept of "too large" *might* begin at larger than 2.0-carat-per-ear range for women (4 carats T.W.), and larger than 1.0 carat per ear for men (2 carat T.W.). However, *Newsweek* magazine in 1975 reported on a football player who wore a 1.5-carat diamond in his left ear.[1]

Chart of Diamond Sizes in Millimeters

The following table gives the approximate diameter in millimeters of various carat weights for round brilliant-cut diamonds. The millimeter diameter will vary by the proportion of the cut. If it is a shallow cut, it will appear larger for its weight. If it is cut too deep, it will appear small for its weight. If a diamond is cut either too shallow or too deep, the light refraction will be lessened. This means less brilliance or sparkle. The diamond size is expressed in carats, which is a weight

1. "Year of the Ear," *Newsweek*, May 19, 1975, Life/Style; page 93.

measurement. The number .03 equals 3 points or 3/100's of a carat. The number 1.00 equals 100 points or 1 carat.

Diamond Size	Millimeter Size (approx.)
.03	2.0
.05	2.5
.07	2.7
.10	3.0
.15	3.4
.20	3.8
.25	4.1
.33	4.4
.40	4.8
.50	5.2
.65	5.6
.75	5.9
.85	6.2
1.00	6.5
1.25	7.0
1.50	7.4
1.75	7.8
2.00	8.2
2.25	8.6
2.50	9.0
3.00	9.3
4.00	10.2
5.00	11.0
6.00	11.7
7.00	12.4
8.00	13.0

An interesting observation from the above table is that to double the size (diameter-wise) of a one-carat diamond, a person has to go up to an eight-carat size. The price of such a large stone, of course, would be astronomical. Another such observation is that to double the size (diameter-wise) of a one-quarter-carat diamond, a person has to go to a two-carat size.

Keep Diamond Earrings Clean

Diamond earrings should be frequently cleaned to retain their brilliance and sparkle. The enjoyment from wearing diamond earrings comes from their light flashes, i.e., sparkle or scintillation. These light

flashes are reduced drastically when the diamonds accumulate soap scum, hair spray, and dirt. Although no permanent damage results from wearing diamond earrings in the shower, the earrings accumulate soap scum, especially on the back side of the stone. The big risk is losing a diamond earring down the shower drain, even with the screw-on-type clasps. This is because the screw-on backings turn very easily and can be made to spin with your finger. Hair spray and mousse also add to the dulling of the diamonds.

Diamond earrings should be cleaned after every several days of wear to keep them brilliant and sparkling. This may sound excessive, unless the earrings are viewed with a ten-power magnifying glass (called a "loupe"). The dirt accumulation and scum will then be readily visible. Other good advice is to cover the earrings when using hair spray, or to insert them after hair spray has been used.

Recommended Backings or Clasps

The screw-on backing or clasp is recommended for larger and more expensive diamond earrings. The reason is simple: to prevent loss. Some people may not want to purchase separate jewelry insurance because of the annual cost, and the extra security provided by the screw-on backing will be appreciated. Jewelers will typically include screw-on backings on diamond earrings with a T.W. of somewhere between fifty and one hundred points (0.5 to 1.0 carat).

Even if the diamond earrings have been mounted with ordinary friction clasps, a jeweler can remove the posts and solder on screw-on posts. If diamond earrings are found suitable for purchase but which do not have screw-on posts, the purchaser can usually request the jeweler to convert the posts at a nominal fee or even for no charge.

Some males may like the look of the screw-on clasp. It has a more finished appearance—the backs of male earlobes are typically visible whereas with females they are not visible except with very short hair or hair being worn up. Also, the male may want to impress people that he is wearing a real diamond and not a cubic zirconia, which is usually set in a gold-plated mounting with a friction clasp.

One objection to the screw-on backings is that the posts are thicker than normal post earrings. This is necessary to accommodate the threads on the posts. However, the ear holes can easily be stretched to accommodate the larger post size by wearing E'arrs'® brand of plastic

sleeves over normal posts for several weeks. Infant screw backs have a smaller post diameter, but the posts are usually too short for most adults. Another objection is that the screw-on backings are difficult to handle for someone suffering from arthritis. Those persons may want to stay with the standard friction clasp.

Mountings

Larger diamond earrings, from around fifty points (0.5 carat) per earring, are usually mounted in six-prong settings. The reason for this is the additional security provided. In a standard four-prong setting, one bent or loose prong can mean the loss of the diamond stone. However, in a six-prong setting, several prongs have to be loose or bent before there is substantial danger of loss of the stone. In addition, a six-prong setting will accentuate the round diameter of the stone, while a four-prong setting tends to square off the outline of the stone.

Some people also prefer the six-prong setting because it looks more expensive. This setting is larger than the four-prong, because it is designed for larger stones. Because the setting is larger, the stone is set higher above the earlobe, which creates the illusion of being larger. Printed advertisements for diamond earrings typically show a six-prong setting for even the smaller sizes, although the store sells them in four-prong settings. (This is a more subtle form of "bait and switch" advertising.) If the fine print in the advertisement is read, exculpatory language may be found, such that the illustrations may not be completely accurate. However, the basic honesty of such advertisements is questionable.

Normal Quality of Stones

Jewelers often tell customers that diamond earrings are customarily of a lower grade and color than diamonds used in rings. This is a correct statement. The explanation given is that although a person will often grasp a person's hand for a closer inspection of a diamond ring (especially a diamond engagement ring), they will typically not grab a person's earlobe for a close inspection of a diamond earring. This explanation is usually accepted by most customers, except for the Japanese who believe in purchasing high-quality diamond earrings.

The Japanese buyers have discovered a secret, which will be

shared in this book. Higher quality diamond earrings have much greater brilliance, fire, and sparkle than lower quality diamonds. This is especially true under lower light conditions and under artificial light after darkness has set. Diamonds are usually sold in jewelry stores with high light intensity levels over the display cases. Anyone who doubts this should check the speed of the electric meter servicing a jewelry store! Also, a person should look up at the ceiling and view the numerous spotlights aimed at the jewelry counters. High light conditions help present any diamond stone to its most favorable advantage.

One way to determine the large difference in fire between the finest quality diamond, a moderate quality, and a poor quality is to compare them all at the same time under poor lighting conditions. The difference is truly amazing. A small diamond of the best quality will appear larger because of greater light scintillation.

Since the most common diamond earring size for males is one-quarter carat (25 points or .25 carats) per ear or less, they should consider buying the finest quality diamonds. Females who want to create a truly elegant appearance should do likewise. These better quality diamonds are typically not pre-mounted in earring settings, but are kept loose in the jeweler's safe. A jeweler will be happy to show a customer these loose stones and will mount them in whatever jewelry the customer may desire.

Diamond Grading

Diamonds are graded by the 4 Cs: color, clarity, cut, and carat weight.[2] *Color* means the presence or absence of color. The best quality stones have no color, and lesser quality stones have a slightly yellow, brown, or gray tone. The "fancy color" diamonds are an exception, and their value increases with intensity of the color. For example, a valuable canary diamond may be bright yellow in color. *Clarity* means exactly that. Lesser quality stones have inclusions in them that are visible to the naked eye, or external imperfections, such as scratches or blemishes. Inclusions can mean a feather-type of aberration in the crystal structure of the stone, or carbon spots (black spots) inside the stone.

2. The 4 Cs for diamond grading were established in 1954 by the Gemological Institute of America and Richard T. Liddicoat.

The more visible and the larger the inclusion or inclusions, the lesser the quality of the stone. The *cut* refers to the proportion of the stone. A round stone should not be cut too shallow or too deep when viewed from the side. When a stone is cut to the proper proportion, the stone is better able to bend light, creating more fire, scintillation and sparkle. The *cut* may also refer to the shape of the stone: round brilliant, princess (square), trillion (triangular), marquise, heart, pear, oval and emerald cut. However, shape is not considered to be one of the 4 Cs. The *carat weight* means the weight of the stone. The diameter of the same carat size stone will vary slightly depending upon whether the stone is cut shallow or deep when viewed from the side.

The color-grading scale varies from D through Z, inclusive, with D being the whitest and the most expensive, and Z having the most color and the least value. Colors D, E, and F are regarded as colorless. Colors G, H, I, and J are near colorless. Colors K, L, and M are faint yellow, brown, or gray. Colors N, O, P, Q, and R are very light yellow, brown or gray. And colors S, T, U, V, W, X, Y, and Z are light yellow, brown, or gray.

The clarity scale contain the following six categories: *Fl* stands for flawless, the best category. *IF* stands for internally flawless with minor surface blemishes. VVS_1 and VVS_2 stand for very, very small inclusions. VS_1 and VS_2 stand for very small inclusions. SI_1 and SI_2 stand for small inclusions. And, finally I_1, I_2 and I_3 stand for imperfect (eye-visible inclusions). The small numbers in the foregoing categories do not indicate the number of inclusions, but rather the degree to which the inclusions can be seen under ten-power magnification. All diamonds are graded under ten-power magnification in a face-up position.

Trade-in Offers

Many jewelers will give credit for 100 percent of the original purchase price of a diamond in trade for a larger diamond. This is a very attractive offer for the purchaser. To determine the large losses typically taken by private parties in selling diamond jewelry, one need only consult the classified advertisements in newspapers. A seller often realizes only one-fourth to one-third of the original purchase price. That is why the trade-in offer can be so very valuable.

Diamond earrings are especially subject to the so-called shrinkage factor. When first worn, diamond earrings seem large and conspicuous.

The longer they are worn, the smaller they seem. Purchasers will, therefore, often want to purchase a larger size.

An often repeated statement is that "diamonds are forever." Unlike pearls, which last about three hundred years, diamonds may last forever. However, no one has been around for that length of time to verify that claim! A "used" diamond is indistinguishable from a "new" diamond, assuming there are no scratches on the previously worn diamond, and that it is a modern cut.[3] Normally, a diamond cannot be scratched except by another diamond. Diamonds tell no stories about their history. They may have been smuggled out of the diamond mine by a miner and then sold on the black market. Diamonds may have been involved in smuggling and drug deals. They may have been previously mounted and worn. There is no way to ensure the prior history of a stone, and it really makes no difference.

Diamonds accepted in trade by a jeweler are typically mounted in new settings and placed back in the jewelry cases for sale. Or, the stones may be kept loose in ziplock-type bags in the jeweler's safe for use or sale as needed.

Some stores specialize in estate-type jewelry. This jewelry is typically sold in their original mountings and may include old diamond cuts, such as the old European or old mine cut. The mine cut is a generally round stone with about one-half of the facets of a modern brilliant cut.

Shopping for Diamonds

Prices of diamonds vary substantially. However, a sophisticated buyer will find a much lower price differential, because he or she is comparing like diamonds. The information in this chapter should provide any buyer with a clear advantage, provided the buyer is willing to shop around. The purchase of a larger diamond may be considered to be an "investment." At a minimum it is a major purchase. Prices and qualities should be compared from store to store, and notes

3. The round brilliant cut in use today was developed in 1880 and contains fifty-eight facets. Prior to that time, an "old European cut" was used, and before that, the "old mine" cut was used. Both of these prior cuts contained fewer facets, and the "old mine" cut had substantially fewer facets.

should be taken. A purchaser should not allow himself or herself to be pressured into a purchase at the first store visited. The best advice is to forgo a special sales price if one has not previously done comparison-shopping.

Some department stores advertise huge price discounts on diamonds and other fine jewelry for extended periods of time during the year. In order for these "discounts" to be advertised, the jewelry has to be offered at the "regular" price during certain periods of the year. If one buys at those prices, the person has essentially been victimized! Some shoppers report that price negotiation is still possible during these "regular" time periods. Therefore, do not be afraid to ask for a discount.

The typical price markup on diamond jewelry is 100 percent. This means that the jeweler's cost for diamond earrings priced at $2,000 is only $1,000. Some discount jewelers located in a "diamond district" in a large city may have a much lower markup of perhaps as low as 40 percent. Thus, the diamond earrings, which cost the jeweler $1,000, would be priced for sale at $1,400. Jewelry stores in a shopping mall usually have the highest rent, and they must charge higher prices to cover the rent.

Diamonds as an Investment

Are diamonds an investment? The answer to that should be "no" for most people. Most diamond sales by private individuals result in a large loss, since used jewelry is not readily salable. Diamond jewelry, including diamond earrings, should be purchased for the enjoyment that is provided. If one wants to study diamonds and become a true expert, he or she may make a profit. But the same is true of the stock market, the commodies market, and the futures market.

Anyone considering the purchase of a very expensive diamond must understand that diamond prices are not set in a free market environment. According to an article by Edward J. Epstein appearing in *Penthouse* magazine, June 1983, entitled "Diamonds Are Not Forever," diamond prices are set by a diamond cartel called De Beers Consolidated Mines. The cartel controls the number of diamonds reaching the market by buying up excess diamond inventory to keep prices "stable," which critics would term artificially high. If the cartel ever runs out of money to buy up diamonds (to keep them off the

market), prices may totally collapse. If that happened, one could conceivably buy a fine quality one-carat stone for the price of a dozen roses! In the late nineteenth century, the article stated that "the world price collapsed to just over one dollar per carat, and in the 1880s mine owners abandoned their properties on the assumption that diamonds were all but finished as gemstones" (page 62).[4]

The *Penthouse* article stated that prices had fallen drastically since 1981: "Today, diamond prices are falling. The flawless 'D' one-carat diamond—the hallmark of the industry—plummeted in price from $80,000 in 1981 to a recently quoted one of under $8,000."

Diamond Prices in 1995

The retail price of the "flawless 'D' one-carat diamond" as of early 1995 was approximately $20,000. The diamond cartel was still intact, and the collapse of the diamond market had not occurred. The author is unable to predict future prices of diamonds.

4. "Diamonds Are Not Forever," by Edward J. Epstein, *Penthouse*, June 1983. Reprinted by permission. ©1983, Penthouse International Ltd.

NINE
Baby Ear Piercing

Around the World

In many South American countries, including Colombia, Ecuador, and Peru, the ears of baby girls are routinely pierced at birth by the attending physician. This is such a common practice that any baby without earrings is automatically assumed to be a boy. Pity the poor girl whose ears are not pierced—she will be constantly mistaken for a boy.

In various other parts of the world, the ears of baby girls and even baby boys are pierced at birth. In Italy, baby girls routinely get their ears pierced at birth. The same is true in Puerto Rico. In the southern portion of Spain (referred to the Andalusian portion), "[g]irl babies seem to have their ears pierced by the midwife."[1] In Arabia, a girl normally has her ears pierced at birth.[2] However, silk cords are worn in the ear holes until she is considered old enough to wear earrings. In Ghana, Africa, baby girls routinely have their ears pierced. In India and Pakistan until the 1950s, it was the custom for the previous five thousand years to pierce both ears of baby boys before they were twelve months old. The ears of girl babies in India and Pakistan continue to be pierced by the time they are three months old.[3]

United States Fashion

In the United States, ear piercing is usually not done as part of the birthing process, but at a later date. This later date varies according to the beliefs and desires of the parents and the desires of the youngsters, as they are able to express their own wishes. The ear-piercing salons generally do not do ear piercing of babies until they are six to eight

1. "Davina esta de vacaciones," by Davina Lloyd, *The Times,* August 25, 1992. ©Times Newspapers Limited, 1992. Reprinted with permission.
2. *The Art of Arabian Costume: A Saudi Arabian Profile,* Heather Colyer Ross, Second Edition, ©1985, Arabesque Commercial SA, Switzerland, at page 111.
3. See "Reconstruction of the Middle-Aged Torn Earlobe: A New Method," *British Journal of Plastic Surgery,* (1988) 41, 174–176. The author is S. H. Effendi, Department of Plastic Surgery, Dow Medical College and Civil Hospital, Karachi, Pakistan.

weeks old and have had their first series of shots. This is to allow the babies to put the trauma of birth behind them and to start gaining some weight. Since ear piercing by a medical doctor is not common in the United States, the ear-piercing salons do not want to be responsible for making a medical decision or creating any stress, however slight, on a baby until he or she has become a healthy, bouncing baby.

Popularity of Baby Ear Piercing

No studies could be found as to the percentage of babies in the United States who have their ears pierced. Ear piercing of girl babies is common, but the percentage is probably well under 50 percent except in certain portions of the country. In Rochester, Minnesota, the home of the Mayo Clinic, baby ear piercing is currently very popular and may well be over 50 percent. In Detroit, a medical study in 1992 found that 52 percent of females under age twelve presented to six clinics had pierced ears.[4]

Ear piercing among girls occurs at a continuing process from birth until, by the age of eighteen, it is a rare female who does not have pierced ears. A conservative estimate is that 90 percent have pierced ears by that age. For those females who never had their ears pierced, the decision to do so extends through their 80s.

Choice by Children

Some mothers and fathers believe that their children should be allowed to choose whether to have pierced ears. To some of them, ear piercing is akin to mutilation of the body, and therefore, the child must choose when they are of a sufficient age.[5] To avoid risk of litigation, virtually all ear-piercing salons require a parent or guardian to consent to the ear piercing of a minor. The paradox is that a minor can buy birth

4. "Earrings: A Piercing Question," *American Journal of Diseases of Children* 146:509, April 1992.
5. The claim of "mutilation" is really without substance. The decision to circumcise a baby boy, for example, is many times more major. Yet in the California Committee Analysis Statenet, Copyright 1992 by Information for Public Affairs, Inc., Senate Committee on Judiciary Bill No. AB 1687, Date of Hearing: July 14, 1992 it is stated: "For example, ear-piercing and male circumcision are culturally acceptable forms of mutilation in American society."

control devices, and a female minor may even be able to obtain an abortion, but he or she cannot get their ears pierced![6]

If the parent consents, but the child is unwilling, most ear-piercing salons will not do the piercing. The salons are sensitive to a charge of child abuse as well as to good public relations. A screaming child will frighten others from getting their ears pierced. Ear piercing is generally a pleasant experience for the willing—witness the little girl proudly showing her pretty, new earrings to all who will look.

Baby Boys and Young Boys

The latest fashion trend is for parents to have one or both ears pierced of their baby boys. This may appear shocking at first, because of the newness of the fashion. This development is not really surprising as the earring generation grows into the child-bearing range. If the husband has one or both ears pierced, and the wife likes earrings on males, the next logical step is for Junior to look like Daddy. If the wife thinks that the husband looks good wearing an earring, then the baby boy will certainly look cute with an earring.

When male earrings were first thrust upon the American scene in 1964 by Ringo Starr of the Beatles singing group and for perhaps twenty years thereafter, it was a symbol of rebellion for a male to get his ear pierced. Parents were almost universally opposed to their son getting his ear pierced. This attitude has softened considerably to the point where parents are now actually attempting to convince their sons to get their ears pierced.

One piercing salon employee stated that a mother brought in her three sons, approximate ages four, seven, and eleven, to get their ears pierced. None of her sons wanted their ears pierced; however, the mother said her sons wanted their ears pierced but they did not know it yet! The employee declined to do the ear piercing. If the earring fashion for males continues to grow in popularity, these three boys do not stand a chance of reaching college age without succumbing to the

6. This issue was even argued in the 1992 presidential election campaign. Then President Bush was quoted as saying: "I think it is ridiculous that a 13-year-old girl here in Dallas has to get her mother's permission to get her ears pierced in a mall, but can get an abortion without telling her mom and dad." Proprietary to the United Press International 1992, August 23, 1992, Sunday, BC cycle.

fashion. These boys will face a mother who continually attempts to convince them to pierce their ears, many of the boys' friends will get their ears pierced, and their girlfriends will tell them how nice they will look wearing earrings. And, television and the movies are permeated with actors wearing earrings. Even President Clinton was willing during his campaign for election in 1992 to hobnob with a talk show host who wears earrings.[7]

Emotional Topic

Piercing the ears of babies is an emotional subject for some. They complain that baby ear piercing is solely to satisfy the selfish desires of the parents and most frequently that of the mother who typically makes the final decision. Ear piercing for baby girls is considered more acceptable, the rationalization goes, because 90 to 100 percent of all baby girls will have their ears pierced by the time they become an adult.

Ear piercing for baby boys is only marginally acceptable, because people worry that earrings will go out of fashion for males and they will be left with unwanted ear holes. However, these people are unfamiliar with history. Women stopped piercing their ears around 1900 and did not resume the practice until the mid to late 1950s.[8] Earrings also fell out of favor and common use by women during various other periods of history. If male earrings do fall from the fashion scene, the ear holes tend to get smaller from nonuse, and they may close up by themselves. Also, plastic surgeons can close the holes. Another argument is that there are going to be lots of males in similar circumstances.

Factors to Consider

In deciding whether to pierce the ears of their babies, parents should consider various objective factors. Ear piercing does not hurt a baby, and it is not a traumatic event. In fact, the piercing may be less

7. During his campaign for election, President Clinton appeared on the Arsenio Hall show and even played the saxophone. Arsenio Hall favors wearing a large diamond earring in his left ear, and has also worn an earring in his right ear.
8. The reason was the invention of the clip-on and screw-on earrings for non-pierced ears. It took women nearly fifty years to realize that the clip-on and screw-on earrings were totally uncomfortable and did not "liberate" them.

painful for a baby than for an adult. This is because the nerve centers and endings in a baby are not fully developed. In any event, the pain is less than a shot by a doctor to an adult. Ear piercers and mothers often state that the cause of crying is the noise of the piercing gun, rather than pain.

The important factor is whether the baby leaves the earrings alone after the piercing. If the baby constantly tugs and pulls on an earring or handles it, there is danger of infection, tearing the piercing, or pulling the earring out and swallowing it. Most mothers report that their babies leave the earrings alone and that there is no problem with the piercing. If there is a problem, the piercing studs should be removed and the ear holes allowed to heal up.

Assuming that the decision is made to proceed with piercing, the procedure needs to be considered. Some piercing salons will pierce both ears at the same time if they have two employees available. This is usually done with toddlers, who might refuse to allow the second ear to be pierced. The problem with concurrent piercings is that they are never done exactly simultaneously. The toddler may jerk, which can cause the second piercing to be crooked or off the marked location. One veteran ear piercer stated that she was not convinced it was such a good idea.

Opinions of Medical Doctors

Some doctors and hospitals do baby ear piercing, and others will not. One mother reported that her doctor thought four months old was a good age for ear piercing. Another mother reported that her doctor will do ear piercing, but not until the six-month checkup. One mother who is a registered nurse wrote on Prodigy that she had her daughter's ears pierced at age six weeks.[9]

Writing on Prodigy, Dr. Barton Schmitt of the National Parenting Center stated his opinion that most pediatricians would be opposed to ear piercing in the first three or four months of life because infections can be more serious at that age.[10] His advice was to wait until the child

9. Homelife Bulletin Board, Topic: Parenting Practices, Subject: Baby: Ears Pierced, March 15, 1993.
10. Homelife Bulletin Board, Topic: Parenting Practices, March 8, 1993.

is at least four years of age, because younger children could remove an earring, place it in their mouth, and choke on it.

Several medical cases have been reported where babies have swallowed part of an earring. In one case a twenty-month-old girl suffered from wheezing for a month before an X ray revealed the back of an earring lodged in her bronchial tube. Minor surgery was required to remove the earring part. In another case a nine-month-old girl swallowed part of an earring, but it passed through her digestive tract without causing a problem. Earrings have also caused skin reactions and pressure sores in infants.[11]

Practices of Piercing Salons

Some ear piercing salons want the baby to be at least two months old and have had the first series of immunizations before they do ear piercing.

Young Children

Often heard advice is that ear piercing should be done before the age of one and a half or after the age of five. This is because many children in that age group do not leave the earrings alone, or they have a more difficult time adjusting. This is not to say that ear piercing will be unsuccessful, but that there is a greater chance of problems.

A licensed cosmetologist writing on Prodigy, who has pierced many ears, recommended that ear piercing for both girls and boys be done before six months or after thirteen years of age.[12] She wrote: "All girls want their ears pierced; the little boys are doing it now too. So do it young and get it over with or suffer later. That's my experience." She explained that in her experience children between the ages of five and ten years often get ear infections because they do not properly care for their pierced ears.

11. "Earrings for Toddlers Called a Hazard," by Paul Berg, *Washington Post*, October 21, 1986, WH5, col. 2.
12. Prodigy, Homelife Bulletin Board, Topic: Parenting Practices, Subject: Baby: Ears Pierced, March 28, 1993.

Baby Earrings

If the baby has no problem accepting the earring, the parents need to consider the type of earring. On a baby, it should be a small stud with a safety post. The safety post may be a push-on–screw-off, or screw-on–screw-off variety with a loop covering the post in back so that it cannot prick the baby's neck or head. Some mothers continue to use a piercing type of earring, which has a friction backing sufficiently strong that the baby cannot remove it. One type of backing (or clasp) that is not sufficiently secure for use on a baby or toddler is called La Pausette. It is a round, smooth, and flat backing with a spring mechanism, which clamps on the post at any desired location. The clasp is removed by pressing together the two protruding portions of the mechanism. Although the theory of this type of backing seems safe, it will still come apart with a strong tug.

Since babies tend to grab things, they should not wear dangling or hoop earrings, or any earrings that might get caught and tear the earlobe.

Best Age for Baby Ear Piercing

Another consideration is the proper age to pierce a baby's ear. Very little research has been done on the subject of the growth pattern of a baby's ear. For example, does the ear grow completely symmetrical? This is important in order to prevent the piercing location from changing as the ear grows to adult size. Some piercing salons believe that the ears of babies should be pierced higher than in adults. This is under the belief that the piercing location will eventually be too low as the baby grows.

One ear-piercer stated that the piercing location on young babies should be slightly above the center of the earlobe. She stated further that she used the higher piercings only on babies that were up to six months old. However, one mother reported that the ear-piercing location on her two-and-a-half-year-old daughter was fine at the time, but that the location was now too low.

The only study of ear growth that could be located is a book entitled *The Iannarelli System of Ear Identification* by Alfred Victor Iannarelli, ©1964, The Foundation Press, Inc. The author states: "Once the ear has matured, the anatomical configuration remains constant until

death, barring damage, disease, or surgery. . . .The ear, it may be said, does not reach full maturity until the ninth month after birth" (page 4).

Based on this study, ear piercing should be delayed until the baby girl or boy is nine months old. Otherwise, the shape of the ear and earlobe may change, rendering the piercing in a less than desirable location.

Piercing the ears of infants may well be a wiser decision than piercing the ears of toddlers. A letter was published from a mother in *The Ottawa Citizen*, October 26, 1992, "Pierced Ears: An Agonizing Decision." Kim Callaghan, who had her infant daughter's ears pierced at three months, wrote in part as follows:

> We found out that while ear piercing is painful, it is no more so than the routine tests and injections an infant undergoes. . . . For a baby under six months, crying is additionally due to the loud noise caused by the ear-piercing instrument, but the whole incident is likely forgotten by the end of the day. The older child (the two-year-old, for example) might decide that she wants earrings, but can only endure the injection of one. Trauma results to the child, the parent and the ear-piercing professional when the child has to be physically restrained to complete the procedure.
>
> Keeping the wounds disinfected has to be a matter of habit, which is much more easily accomplished with an infant. In the older child the risk of infection is higher because she balks at attempts to apply antiseptic cream or turn the posts and is more likely to touch the wound or pull on the earrings without having first washed her hands. (Reprinted by permission)

Permanence of Baby Ear Piercings

Some people believe that piercing a baby's ear is more permanent than for an older person. This may be because the ear grows and develops with an ear hole in place. In an older child or adult, the ear may be fully developed when the piercing occurs. This means that the tissue in the earlobe is diverted around the ear hole, rather than growing with the hole. One woman reported that she can leave her earrings out for long periods of time, whereas her friends are not able to do this without the ear holes closing. This comment may be true, however, only because of the number of years that her ears have been pierced.

Another woman reported that she had her daughter's ears pierced

at five weeks. At ten months her daughter would not leave the earrings alone, so the mother removed them. A year later the mother had no problem in putting the earrings back in. She stated that she thought ear holes on infants were more permanent.

Double Piercing Baby Ears

One mother commented that she had her daughter's ears pierced at age one week by her pediatrician, but that she was not going to have them double pierced until her daughter requested it. Another mother commented that although she had her ears pierced five and four times, she was going to let her daughter decide on getting her second set of holes. Since most females will eventually have both ears double pierced, such practice should be less shocking than piercing the ears of boy babies. However, there is a very practical reason not to double pierce, and that is because the holes would grow farther apart as the ear grows.

Negative Comments from Antipiercing Zealots

If the parents have their baby's ears pierced, they may receive some negative comments. This may sound surprising, but there are antipiercing zealots with nothing better to do. They believe that piercing children's ears is "cruel." Some mothers even report hearing such comments from total strangers while shopping. Mothers and fathers should have no hesitancy in telling such strangers to mind their own business. Ear piercing is no different than a number of other child-rearing issues that parents must decide for their own children. There is absolutely no excuse for this lack of tolerance and lack of manners.

Parents Who Refuse to Consent

Some parents refuse to consent to their daughter (or son) having their ears pierced until they turn eighteen, which is the age of majority in most states. The reason that some parents make such a big issue out of such a minor event is unknown. There are certainly more important issues for parents to take a stand on, such as no drugs and no promiscuous sex. When parents adopt unreasonable rules, bigger problems

often result. When a child, especially a daughter, wants her ears pierced and she is old enough to take care of the piercings, there is no logical reason to refuse permission. What some parents do not seem to realize is that proper parenting is more than establishing a set of arbitrary rules.

TEN
Governmental Regulation
of Ear Piercing

The business of ear piercing is almost totally unregulated in the United States.

California

The most populous state of California has neither statutes nor regulations that pertain to ear piercing; however, proposed legislation was amended to exclude virtually all ear-piercing businesses.

A 1975 California Attorney General's Opinion (58 Ops Atty Gen 565) held that ear piercing does not constitute the practice of medicine. Interestingly, the opinion was requested by the State Board of Registered Nursing, and the opinion also held that there were no circumstances that would prohibit a registered nurse from piercing earlobes.

Selected excerpts from the California Attorney General's Opinion highlight the growing popularity of ear piercing in 1975:

> Some California department jewelry stores are offering and performing earlobe piercing services (also referred to as "ear piercing") in conjunction with the sale of earrings. Although the persons who perform the ear piercing on patrons are frequently registered nurses or licensed vocational nurses, in many instances, they are persons who are unlicensed in any capacity. California law, does not require persons who engage in the practice of earlobe piercing to be licensed in any manner. . . .
>
> Earlobe piercing is performed by penetrating the earlobes with a sterile, sharp instrument and takes at the most a few minutes to accomplish. Thereafter, strings or earring posts are maintained through the pierced earlobes until the penetrated tissues heal leaving the earlobes completely pierced for the purposes of inserting and holding earrings (pp. 566 & 567).

The reference to maintaining "strings" in newly pierced ears is interesting. The author of the opinion was male and apparently Hispanic, judging from his last name of Castro. Perhaps he was recounting his cultural heritage at the time he was growing up, rather then current

practices in 1975. The author does not recall ever having seen strings in earlobes, and he has resided in California since 1965.

The California Attorney General's Opinion expressed an awareness of possible problems associated with unregulated ear piercing:

> The aforementioned conclusion is not arrived at without an awareness of the dangers and hazards which have been associated with ear piercing. For example, the Bureau of Communicable Disease Control of the State Department of Health has issued a public document entitled "Guidelines for Earlobe Piercing" which is designed to prevent disease complications such as bacterial infection, contact dermatitis, and the transmission of communicable diseases spread by the blood-borne route. There are also articles in medical journals which have discussed the apparent hazards of ear piercing. See Cheng, "Keloid of the Ear Lobe," *Laryngoscope*, Vol. 82, pp. 673–681; Lovejoy and Smith, "Life Threatening Staphylococcal Disease Following Ear Piercing," *Pediatrics*, Vol. 46, pp. 301–303 (July 1970); Watt and Baumann, "Nickel Earlobe Dermatitis," *Archives of Dermatology*, Vol. 98, pp. 155–158. Nevertheless, an adherence to sound principles of statutory construction compel the conclusion reached. It is not beyond the Legislature's prerogative to regulate the practice of ear piercing as it has electrologists and manicurists if it feels that the public health and safety demands it (p. 570).

Assembly Bill No. 3787 introduced February 25, 1994, by Assembly member Valerie Brown would for the first time have regulated ear piercing in California. This bill passed the Assembly and the Senate but was vetoed by Governor Pete Wilson. In his letter to the Assembly explaining his veto, he stated:

> There is no evidence to suggest there is a public health problem. No case of serious infection resulting from these practices has been reported to the State in recent years. In fact, the California Conference of Local Health Officers sees this bill as unnecessary from a public health perspective.

The bill would have added sections 395 et seq. to the California Health and Safety Code. The Department of Health Services would have been directed to establish sterilization, sanitation, and safety standards for tattooing, body piercing, ear piercing, and permanent cosmetics. Persons engaged in those businesses would have been required to register with the county, and a task force would have been

formed for the purpose of recommending legislation to regulate those areas.

Assembly Bill No. 3787 was amended in the Senate through August 19, 1994, by inserting the following exception for ear-piercing businesses:

"Body piercing" shall not, for the purpose of this article, include piercing an ear with a disposable, single-use stud or solid needle that is applied using a mechanical device to force the needle or stud through the ear.

Arkansas

In 1976, the Supreme Court of Arkansas in *Hicks v. Arkansas State Medical Bd.*, 537 S.W.2d 794, held that ear piercing did not involve the practice of medicine or surgery within the meaning of the Arkansas statute. An earlier opinion to the contrary by the Arkansas attorney general was disregarded as not being binding on the court. The case arose when Edna Hicks, a licensed cosmetician, desired to offer ear piercing as a service to her customers and requested a declaratory ruling from the Arkansas State Medical Board. The board heard testimony from two doctors that dealt with possible adverse effects if ear piercing procedures were not properly carried out. The board found against Hicks, largely based on the opinion of the Arkansas attorney general.

The *Hicks* decision referred to similar rulings in seven other states in the following language:

Although not controlling, we note that in Texas the attorney general, in interpreting a statute similar to our own, ruled that ear piercing did not constitute the practice of medicine. Other states, including Arizona, Virginia, Kansas, New Jersey, Georgia and California, have, through opinions rendered by their respective attorneys general or state medical boards, excluded the piercing of ears as a procedure to be found within the term "the practice of medicine." Appellee has not cited and our research has not disclosed any decisions to the contrary except the decision involved in this appeal (p. 796).

Indiana

Ten years later in 1986, the Court of Appeals of Indiana referred to

the *Hicks* decision and followed it. The case is *State Ex Rel. Medical Licensing Bd. v. Brady*, 492 N.E. 2d 34 (Ind. App. 1 Dist. 1986). The *Brady* case involved an Indiana statute that required all tattooing to be done by licensed doctors.[1] That statute was held to be enforceable. In the decision the court also spoke of ear piercing and held that it was not the practice of medicine. The court concluded: "Consequently, unless ear piercing is performed 'for the intended palliation, relief, cure or prevention of any physical, mental or functional ailment or defect of any person' it will not constitute the practice of medicine" (p. 38).

Under this decision, ears may only be pierced to wear earrings. If an acupuncturist or other person pierces ears to cause weight reduction (such as with staples), a medical license is required.

Connecticut

The only state that previously regulated ear piercing was Connecticut. Their statute was first adopted in 1969, probably after the practice of ear piercing had already become firmly established among young women. As first adopted, the statute restricted ear piercing to medical doctors. Doctors were apparently too busy treating the ill to appreciate the newly legislated monopoly/medical specialty of ear piercing.[2] Two years later in 1971, the statute was amended to also allow ear piercing by registered nurses. It should be noted that neither practical nurses nor licensed vocational nurses were granted this privilege.

The statute was contained in Connecticut General Statutes Annotated, §53-41b, and most recently read as follows:

Any person, other than a person certified as a registered nurse or licensed to practice medicine and surgery in this state, who pierces the ears of another for remuneration, or who advertises or offers so to pierce

1. It would not appear that too many doctors would want to work at a tattoo parlor. Since the state of Indiana could probably not totally outlaw tattooing, it decided to do the next best thing. Price tattoos out of the marketplace. The state of Connecticut has a similar law. Under Connecticut General Statutes Annotated § 53-41, tattooing is restricted to "a licensed physician or osteopathic physician or a technician acting under the supervision of a physician or osteopathic physician".
2. Imagine the pride with which a mother could boast that her doctor son or daughter had decided to practice the new medical specialty of ear piercing!

the ears of another, or any person conducting a retail business, who pierces the ears of another at said place of business, or who advertises or offers to pierce the ears of another at said place of business, shall be fined not more than one hundred dollars or imprisoned not more than ninety days or both.

To constitute a violation of this statute, the ears have to belong to someone else. Therefore, it appears that a person can legally pierce his or her own ears, whether with a self-piercing kit, a sewing needle, a safety pin, or whatever. It also appears that a parent can pierce the ears of his or her child, provided that there is no "chit-chat" beforehand, or words are used prior to the actual piercing, which can be construed as an advertisement or an offer, and provided further that no charge is made for the piercing. The family newsletter had better not express a willingness to pierce the ears of family members, and words such as, "I will pierce your ears, if you want" had better not be used. If the parent merely states before hand, "I am going to pierce your ears. Please sit still!" that is a statement and not an offer. Additionally, it appears that party piercings are still legal, as long as no charge is made. Finally, it appears that a retailer could legally pierce ears at his or her home, as long as no charge was made.

The statute was apparently passed to ensure that ear piercing is done by persons trained in proper sanitation and sterilization techniques. However, training does not necessarily ensure safety. Safety comes from the use of disposable surgical gloves and hand cleansers, from the use of properly designed ear-piercing guns, which employ pre-sterilized ear-piercing inserts, and from training.

Based on information received from an ear-piercing chain that does business in Connecticut, the above statute was apparently repealed effective May 24, 1994.

Georgia

By a decision filed December 3, 1992, in *Miller v. Medical Assn. of Georgia* (1992) 262 Ga. 605, 423 S.E.2d 664, the Georgia Supreme Court held that OCGA § 43-34-1 was unconstitutional. That statute prohibited persons other than doctors, dentists, podiatrists, and veterinarians from performing any surgery, operation, or invasive procedure in which human or animal tissue is cut, pierced, or otherwise altered. The

opinion stated: "All parties concede that the literal language of §
43-34-1 violates due process and equal protection in that it is so broad
that it prohibits much conduct that there is no rational basis to prohibit
. . . including the administering of shots by nurses, the self-injection of
insulin by a diabetic, the drawing of blood, the piercing of ears, em-
balming, and the tattooing of skin, to name a few."

Code of Federal Regulations

Volume 29 of Code of Federal Regulations § 1910.1030, titled
"Bloodborne Pathogens," regulates the safety of employees who are at
risk for coming into contact with human blood in their workplace. This
regulation is very detailed and runs for thirteen pages. It provides for
training of employees, extensive record keeping, and contains facility
requirements, as well as free hepatitis-B vaccination for employees. The
final version of this regulation was published in the *Federal Register* on
Friday, December 6, 1991, vol. 56, no. 235, at pages 63861–64186. The
purpose of this regulation is to eliminate or minimize occupational
exposure to hepatitis-B virus (HBV), human immunodeficiency virus
(HIV), and other blood-borne pathogens. This regulation would un-
doubtedly apply to ear piercers who still use a needle to accomplish
the piercing and would probably apply to the "sleeve" method of
piercing.

Internal Revenue Service

Even the Internal Revenue Service has gotten itself involved in
ear-piercing regulations. Revenue Ruling 82–111, which deals with ear
piercing (as well as hair transplants, electrolysis, and tattoos), holds
that where a taxpayer pays for ear piercing performed by a doctor, that
the expense is not properly deductible as medical care under section
213(e) of the Internal Revenue Code. It is difficult to imagine how the
Internal Revenue Service found time to deal with such an important
issue! It is rare for a doctor to do ear piercings, and the amount charged
is usually quite small relative to any income tax deduction. It is doubt-
ful that additional taxes of any consequence have ever been collected
as a result of the Revenue Ruling.

Israel

Ear piercers in Israel do not have to be licensed according to an article appearing in *The Jerusalem Post,* May 25, 1989.[3] The writer argued for regulation because of a confirmed case of hepatitis B spread by a doctor using infected acupuncture needles. The logic in this argument is lacking, since the infection was spread not by an unlicensed person, but by a health care professional.

Europe

Some regulation of ear piercing has occurred in the European Community. The *British Medical Journal,* Volume 305, 8 August 1992, at page 357 under a section titled "Any Questions" reports as follows:

In 1983 European Community (EC) directives were issued under the Local Government Miscellaneous Provisions Act 1982, which required the registration of people undertaking ear piercing in England and Wales. The directive specified that there should be no risk of transmitted infection. Manufacturers redesigned their ear piercing equipment, and several "gun" systems are now available which use presterilised ear studs and back clasps. In 1987 the Department of Health and Social Security issued a guidance for piercers, which recommended the use of these "gun" systems. Interestingly, there seems to be no EC regulations on this matter. (Reprinted by permission from British Medical Association and R. D. Aldridge, Ph.D., FRCP, AFOM)

The ear-piercing systems sold by Inverness® Corporation and Studex® would appear to comply with the above European Community directives. See chapter 20, "The Ear-Piercing Business."

Food Workers in Europe

The European Common Market has passed food hygiene legislation that specifies that it is unhygienic for people preparing or serving food to wear wrist watches or earrings. Where ears are pierced, sleepers

3. "Poisoned Pins & Needles," *The Jerusalem Post,* May 25, 1989, Health.

must be worn.[4] It would appear, therefore, that males employed in the food business are required to wear small stud or hoop earrings if their ears are pierced. Even if they wanted to stop wearing earrings and let their ear holes close up, they would be prohibited from doing this. At least these workers do not have to wear small plastic bandages over their ear holes! Would that be on both sides?

Canada

In Ottawa, Ontario, minors apparently do not need parental consent to get their ears pierced.[5]

The province of Alberta proposed in November 1994 to regulate and conrol body-piercing, ear-piercing and tatooing businesses.[6]

Protect Yourself

With or without ear-piercing regulation, the person about to undergo ear piercing should satisfy himself or herself that proper sanitation and sterilization techniques are being employed by the person doing the piercing. The wearing of disposable surgical gloves is highly recommendable with the use of presterilized, disposable piercing studs in the piercing gun. The piercing gun should also be sterilized between each use. A person should not hesitate to have the procedure explained and shown to them prior to the ear piercing.

4. "EC: Marketing Week the Iain Murray Column—Why Nanny's Off Her Trolley," Reuter Textline, *Marketing Week*, October 9, 1992.
5. "In the Eyebrow of the Beholder; Mainstream Feels the Strange Allure of Body Piercing," by Francine Dub, *The Ottawa Citizen*, October 23, 1993, News; page A1.
6. "Why Socialize Body Parts?" by William Gold, *Calgary Herald*, November 30, 1994, Section: Commentary: page A5.

ELEVEN
Earring Patents

Social Attitudes Expressed in Patents

A computer search of U.S. patents[1] revealed that numerous patents have been issued for earrings, earring accessories, and ear-piercing guns over the last seventeen years. These patents reflect fashions as they change through the years and are an interesting social commentary on recent times. The following quotations indicate how social attitudes have gradually changed over such years:

It is well known that women, and even some men, consider the wearing of earrings to be a highly cosmetic and fashionable idea. (3,831,597, August 27, 1974.)

Throughout the years, women and, in some cases, men have pierced their earlobes to receive and support a multitude of ear ornaments. (4,146,032, March 27, 1979.)

Presently, many women and some men wish to have their ears pierced, so that they can wear a variety of earrings or other ear ornaments. (4,860,747, August 29, 1989.)

Most ear piercing is done on the premises of stores which sell earrings for pierced ears. [Later in the same patent:] . . . for the person having his or her ear pierced. (4,921,494, May 1, 1990. Note the lack of gender in the first statement, and the unisex character of the second portion of the statement.)

Earrings are common adornments worn by men and women on their person. (4,958,727, September 25, 1990.)

Increasing numbers of both women and men are piercing their ears. As

1. This chapter discusses only patents issued by the U.S. government. Earring patents issued by other countries have not been searched or considered.

a result, the demand for earrings suitable for pierced ears is growing. (5,123,264, June 23, 1992.)

Historically, it has been a common practice to pierce the earlobe so that earrings can be worn. This practice spans all ages, from infants to adults, and both genders. (5,183,461, February 2, 1993.)

Earrings, which are so popular and common among fashion conscious people, are generally retained to the ear by . . . (5,184,482, February 9, 1993.)

Earrings in particular have been used by both sexes, and still are for reasons that are both varied and ornamental. (5,240,120, August 31, 1993.)

It is interesting to contrast the above evolution of social attitudes with a statement in U.S. Patent No. 5,170,642 issued December 15, 1992, to Kentaro Sakata of Tokyo, Japan. In Japan in the early 1990s, ear piercing for women is still only marginally acceptable. Sakata wrote in his patent: "This invention relates to an ear piercing earring for decorating ears of women, and more particularly to a method of reusing an ear piercing earring and an ear piercing earring suitable for reuse."

Patent searching today is now largely done by computers, rather than manual searches at the U.S. Patent Office in Washington, D.C. The Lexis®-Nexis® computer database contains the full text of all U.S. patents issued since 1976. The length of time that a patent protects the owner of the patent is seventeen years. In a September 24, 1992, computer search for ear-piercing patents,[2] a total of 365 patents were found. A number of these related to animals such as identification tags for ears, and some to metallurgy, leaving about 250 relating to human ear piercing and earrings. An update search on May 31, 1994, revealed 44 additional patents, of which only several were unrelated to ear piercing and earrings for humans. What the foregoing figures mean is that the number of earring and ear-piercing patents issued during the past twenty months is more than double the annual average during the

2. The exact search phrase used was: *Ear w/7 pierc!* What the phrase means is that the computer should find all patents containing the word "ear" (i.e., ear, ears, earrings) within not more than seven words distant from words beginning with "pierc," such as "pierce," "pierced," or "piercing."

preceding seventeen years. This increase reflects the growing popularity of ear piercing among females and especially males.

Animal Earrings

The search revealed even one patent for animal earrings! If your dog, cat, or horse simply must wear earrings to be in fashion, you will be interested in Patent 4,353,225 issued October 12, 1982, to Rogers. The patent application states that the earrings are for show animals and were designed to prevent accidental removal by the animal.

An article appearing in *The Washington Post* stated that potbellied pigs purchased from the Designer Pig Corp in Atlanta, Georgia, arrived with earrings in their pierced ears.[3] It is unknown as to whether the pig earrings were produced under this particular patent.

Animal earrings are neither new nor novel. A tomb painting in Egypt in 1200 B.C. showed a family scene, which included a cat and a kitten. The cat is depicted with a silver hoop earring in its right ear.[4] The Greek historian Herodotus reported in 430 B.C. that Egyptians who lived around Lake Moeris and Thebes regarded the crocodile as sacred, and they keep one tame crocodile. "They adorn his ears with ear-rings of molten stone or gold . . . "[5]

Additionally, the Huichol Indians in Mexico pierce the ears of their puppies, and hang tufts of wool from the ear holes.[6]

Ear-Piercing Guns

Numerous patents have been issued through the years for ear-piercing mechanisms and guns, and improvements to such imple-

3. "Pets; Fine Swine; Twisting Tales of Potbellied Piggies," *The Washington Post,* July 25, 1991, Style, page D5.
4. Time-Life Books, *Time Frame 1500–600 BC, Barbarian Tides,* ©1987, at pages 34 and 35.
5. *The History of Herodotus* by Herodotus, ~430 B.C. Contained on CD-ROM, *Library of the Future,* 3rd Edition, Screen 226: 1130, Windows Ver. 3.0. ©1990–94, World Library, Inc., 12914 Haster Street, Garden Grove, CA 92640, 714-748-7197, 1-800-443-0238.
6. *Mexican Indian Costumes,* ©1968 by Donald and Dorothy Cordry, University of Texas Press, Austin and London, at page 151.

ments.[7] The early piercing guns looked much like a pair of pliers, with inserts for placing a pointed earring and a backing.[8] After the ear hole was pierced, a surgical suture, i.e., a string, was passed through the hole and kept inserted until the piercing had healed. Only then was an earring inserted. Later in time, sutures were no longer used, and sharpened, piercing earrings not only made the ear hole, but were left in the ears until the piercings had healed. Then, normal earrings could be worn, and the piercing earrings were disposed of.[9] The more recent piercing devices look more like a gun; however, they still contain a "C"

7. Some of these patents for ear-piercing guns are as follows:

2,343,982, March 1944
2,570,048, October 1951
2,798,491, July 1957
3,187,751, June 1965
3,500,829, March 1970
3,789,850, February 5, 1974, Implement for piercing ear-lobes
3,901,243, August 26, 1975, Ear Piercing Device
3,941,134, March 2, 1976, Apparatus for piercing earlobes
3,943,935, March 16, 1976, Disposable earlobe piercing apparatus
4,009,718, March 1, 1977, Earlobe piercing device
4,020,848, May 3, 1977, Earlobe piercing apparatus
4,030,506, June 21, 1977, Earlobe piercing device
4,030,507, June 21, 1977, Sterile earlobe-piercing assembly
4,079,740, March 21, 1978, Ear lobe piercing system
4,146,032, March 27, 1979, Ear piercing device
4,164,224, August 14, 1979, Disposable earlobe piercing device and method for using the same
4,191,190, March 4, 1980, Earlobe piercing instrument holder
4,527,563, July 9, 1985, Sterile earlobe piercing assembly
4,921,494, May 1, 1990, One-piece earring carrier
4,931,060, June 5, 1990, Device for the injection of posts into ear lobes
4,986,829, January 22, 1991, Ear piercing device
5,004,470, April 2, 1991, Earpiercing cartridge assembly
5,004,471, April 2, 1991, Sterile ear piercing assembly
5,007,918, April 16, 1991, Ear piercing cartridge assembly

8. These pliers were probably copied from the special pliers used with hog rings and upholstery rings. These rings are typically made of copper and shaped like the letter "C" and sharpened at each end. The ring fits into special indentions in each jaw of the pliers, and the handles of the pliers are squeezed tight piercing the tough skin of the pig's snout with the "C" ring. The piercing heals, but if the pig digs in the dirt with his snout, the sharpened ends of the ring causes discomfort.

9. When the earlobe is first pierced, it temporarily swells a little. As it heals, the earlobe returns to normal size and the back clasp no longer fits very snug against the back of the earlobe. If the clasp can be pushed tighter, the pointed post will stab the side of the neck. Some piercing earrings are made so that the portion of the post that remains in the earlobe has a larger diameter than the part that protrudes and fits into the clasp. The reason for that design is to stop the earring post when it is shot by the gun.

section with the sharpened earring on one side and the earring backing in the other side.

The more recent patents involve a design where the gun does not touch the ear except by disposable parts completely surrounding the "C" section. These parts come in sterilized packages and are used only once. The earrings remain in the newly pierced ears, and the other parts are discarded after one use. The fear of hepatitis is mentioned in U.S. Patent 4,527,563 issued July 9, 1985.

A recent U.S. patent issued for an ear-piercing gun was U.S. Patent No. 5,263,960 issued on November 23, 1993. The inventor is Samuel J. Mann, president of Inverness® Corporation based in Fair Lawn, New Jersey. Inverness® Corporation is introducing its improved ear-piercing system based on this patent in 1995. With this new gun, the operator no longer will have to touch the cartridges in order to reverse them for the second ear to be pierced.

Self-Piercing Sleeper Earrings

More popular in the patents than in actual use are the self-piercing mechanisms commonly referred to as "sleepers." These mechanisms enable a person to *slowly pierce* his or her own ears. U.S. Patent 3,760,604 issued September 25, 1973, included a "threaded member." U.S. Patent 3,949,754 issued April 13, 1976, described the operation of the self-piercing ear wire: "slowly and automatically penetrate the ear lobe until it is completely pierced." That patent was designed to eliminate the problem of crooked holes caused by the two pointed ends not meeting in the center of the pierce.

The reason for the "sleepers" not becoming very popular is the torture involved. The piercing pain lasts for hours or days, instead of a fraction of a second with an ordinary piercing gun. Also, it was very difficult to end up with one straight ear hole, instead of a jog in the middle.

Hollow-Shank Piercing Needles

A variation of the ear-piercing gun is the use of a hollow-shank needle or needle with a sleeve. The gun drives the hollow needle or needle with sleeve through the earlobe and leaves the hollow shank portion of the needle or the sleeve still inserted through the earlobe.

Virtually any earring post can then be inserted through the hollow shank or sleeve. The shank or sleeve is then removed from the neck side of the earlobe, and a clasp placed on the earring post. This invention allows the use of normal fourteen-karat gold earrings, which do not have to be discarded after the piercing has healed.

The hollow-shank-needle method of ear piercing was issued U.S. Patent 3,831,597 on August 27, 1974. This patent contemplated that the needles would come in sterile packages and be disposed of after each use. A novel variation is contained at U.S. Patent 4,286,600 issued September 1, 1981, where a "thermoplastic sleeve" is inserted through the earlobe "having a boss on each end," the second one being created by a heating element after the piercing. The claimed advantage was that a conventional earring could be worn while the wound was healing. The patent states that this sleeve could be left in place permanently, or removed.

Improved Earring Clasps

Numerous patents have been issued for improved earrings and the backings, which are referred to as clasps or clutches.[10] However, it does not appear that many of these patents have met with much market success. The market today consists mainly of several varieties of earring backings or clutches for post earrings: the friction or butterfly clasp, the bullet type of clasp, the screw-on post, and the push-on–screw-off clasp. The screw-on post is typically used on expensive, diamond stud earrings, and the push-on–screw-off clasp is used for baby earrings.

A safety earnut is described in U.S. Patent 4,397,067 issued August 9, 1983. The purpose of the invention is to provide a shield that prevents the earring post, which may protrude from a normal clasp, from poking the neck or head. The clasp for the screw-on posts typically contains such a shield; however, the posts on some varieties can be screwed through the shield and not just into the shield.

10. U.S. Patent 4,580,417 issued April 8, 1986 contains a listing of patents issued for improved post and clutch construction.

The New York Times reported May 7, 1993,[11] on a patent issued for a T-lock earpost: "The post and back are all of one piece. When inserted, the earring's post and locking mechanism is L-shaped, with the short end of the L fitting in the ear lobe. To lock it in place, the long end is pushed upward, making a T-shaped form."

The article reported that the patent number is 5,201,197 and that the inventor was a jewelry maker, Johann G. Bakker, forty-eight, of North Hollywood, California. Based on a review of the actual patent, the issuance date was April 13, 1993.

U.S. Patent No. 5,297,997 issued March 29, 1994, covers a hand held device (i.e., die) that cuts threads onto regular earring posts. The problem with this device is that the earring posts will be weakened by cutting threads. It should be noted that screw-on posts sold by jewelers are typically thicker than normal posts to compensate for the loss of strength.

Hoop Earrings

U.S. Patent No. 245,297 was issued in 1881 to Heckman for a hinged ear wire that locks into a side portion of the hoop. Although the author did not review this early patent, it sounds very similar to the hinge hoop in common use today.

Earring Novelties

Earring novelties have been issued various patents. U.S. Patent 5,031,419 issued July 16, 1991, is for perfumed earring clasps. (The idea for a perfume compartment in earrings goes back at least to Etruscan times in Italy.[12] This was 2,000 to 2,700 years ago! What is the patent office doing?) A number of patents have been issued for illuminated earrings, such as Christmas bulbs that light. U.S. Patent 4,741,179 issued May 3, 1988, is for a multipost earring for wear on multiple-pierced

11. "Patents" by Teresa Riordan, *The New York Times*, May 7, 1993, Section D, page 2, column 4, Financial Desk. Copyright ©1993 by The New York Times Company. Reprinted by permission.

12. *Earrings: From Antiquity to the Present*, Daniela Mascetti and Amanda Triossi, ©1990 Thames and Hudson Ltd., London, and published by Rizzoli International Publications, Inc., New York, at page 14.

ears. Another double-post earring was issued U.S. Patent 4,489,572 on December 25, 1984. A nipple decoration device was issued U.S. Patent 4,625,526 on December 2, 1986.[13] A spiral earring for double-pierced ears was issued U.S. Patent D 324,350 on March 3, 1992.

Another novelty is an earring watch, U.S. Patent 4,444,515 issued April 24, 1984. Apparently, the U.S. Patent Office was unaware that Van Cleef & Arpels had designed a watch earring in the mid-1940s.[14] If a person dislikes wearing a wristwatch, this might be a real alternative. The only problem is that the watch would have to be removed from the earlobe each time the person wants to check the time. Equally novel is a combination earring and finger ring described in U.S. Patent 4,291,551 issued on September 29, 1981. It is unknown as to what the market appeal might be for such an invention. A U.S. patent has also been issued for combined sunglasses and ear pendants, 4,153,346, May 8, 1979.

A patent has also been issued for pierced earrings that contain a liquid visible therein. U.S. Patent 4,148,199, issued April 10, 1979. A fashion that never quite made it is a combined tiara (a headdress) and earrings, which was issued U.S. Patent 3,898,868 on August 12, 1975. Apparently, the U.S. Patent Office was unaware of a similar Russian fashion that was popular nine hundred years ago, and referred to as "kolty" or temple rings.

Magnetic Earrings and Nonpierced Varieties

Some earrings contain the potential for substantial mischief. These are the magnetic earrings typically sold for those too timid to have their ears pierced, or for those males experimenting with the fashion. The problem is that magnetic earrings and computer data do not mix. Magnets should not be brought anywhere near computers or computer data, and it is now a rare office that is not computerized. U.S. Patent 4,059,971 for magnetic telephone earrings was issued November 29, 1977; however, this patent predates the common usage of computers.

13. Nipple rings are available through Sweater Bumpers, P. O. Box 1854, Los Lunas, New Mexico 87031, 505-865-1488. It is unknown whether any of them are covered by this patent.
14. *Earrings: From Antiquity to the Present*, Daniela Mascetti and Amanda Triossi, ©1990 Thames and Hudson Ltd., London, and published by Rizzoli International Publications, Inc., New York, at pages 170 and 171.

Various patents have been issued for the nonpierced ear, including adhesively secured earrings (U.S. Patent 4,974,430, December 4, 1990). Ear cuffs were issued U.S. Patent 4,599,874 on July 15, 1986. A pierced earring look is behind the wire system described in U.S. Patent 4,406,296 issued September 27, 1983. And a hoop earring for nonpierced ears is described in U.S. Patent 3,599,444 issued August 17, 1971.

Ear-Hole Cleaning Floss

Several patents have been issued that contain promise, but which apparently have not been made available in the marketplace. One of these is a "cleansing floss for pierced ear lobes," U.S. Patent 4,798,216, January 17, 1989. The idea of this patent is to clean and disinfect the ear hole with a string saturated with an astringent. Dabbing the ear hole from the outside with a disinfectant does not cleanse the hole, which can receive surface bacteria, dirt, and microscopic debris. It would seem that an ear-hole infection could be cleared up faster with proper cleaning and disinfecting of the ear hole. U.S. Patent 4,497,402 was issued February 5, 1985, for a similar idea. The summary for the earlier patent states that it "includes an absorbent string, a firm tip disposed at the end of the string, a package for the string and the tip, and an antiseptic fluid disposed in the package in contact with the string."

For a brief interlude in history, silk earstrings were wore through pierced ear holes. Although the primary function of such strings was adornment, one unintended result was that the earstrings became dirty from being pulled through the ear holes. The following lines appear in a play by Marlowe:

> Yet for thy sake I will not bore mine eare
> To hang thy durtie silken shoo-tires thru.[15]

This unusual custom may have come to England from Denmark with Anne, mother of Prince Henry. A portrait of Christian, king of Denmark, wearing the ear string hangs at the Hampton Court palace located fourteen miles (twenty-three kilometers) from central London.

15. *Accessories of Dress,* ©1940 by Katherine Morris Lester and Bess Viola Oerke, The Manual Arts Press, Peoria, Illinois, at page 114.

Earring Sleeves

The E'arrs® brand of plastic earring sleeve is produced pursuant to U.S. Patent 4,067,341 and Canadian Patent 1,106,630. These sleeves are designed for sensitive ears and fit over the post of a post earring or hinged hoop earring, and the portion of a wire hook earring that passes through the ear hole. The sleeve is cut to size and can be used with the plastic backs also furnished. The sleeves are constructed with a lip that keeps the solder joint from coming into contact with the earlobe. This invention allows most persons to wear inexpensive, costume earrings without the danger of ear infections. Another use for the plastic sleeves is to slightly stretch the diameter of the ear hole to allow a person to wear the screw-on posts commonly found on diamond stud earrings. The larger variety of screw-on posts may not fit through a smaller ear hole, or the threaded posts may damage a small ear hole. The E'arrs® Pierced Ear Protectors are packaged in a dark blue, plastic box and are widely available where earrings are sold.

Treatment for Weight Loss and Substance Abuse

Part of the folklore surrounding ear piercing is that it contributes to loss of weight. Whatever may be the merit or lack of merit in such a claim, U.S. Patent 4,320,760 issued March 23, 1982, discusses the use in acupuncture of staples and rings that pierce the ear for the treatment of obesity. As stated in the patent: "When acupuncture points are continuously stimulated for long periods of time the patient will acclimate to the stimulation." It would appear, therefore, that if ear piercing is done in an acupuncture point, the benefits are only temporary.[16]

Although the above patent did not mention acupuncture of the ears as a treatment for substance abuse (i.e., drugs and alcohol), such treatment is apparently quite successful. The procedure is for the acupuncturist to affix four one-half-inch steel needles into each person's earlobes, where they remain for forty-five minutes. An article appearing in *The San Diego Union-Tribune,* September 19, 1993, reported dramatic success with this method of treatment. A program in Portland,

16. An interesting inquiry is whether the wearing of heavy or dangling earrings would provide the requisite stimulation of acupuncture points in the ears.

Oregon reported that 88 percent of the substance abusers were still clean and sober one year after admission to the program.[17] An article concerning acupuncture for substance abuse also appeared in *Consumer Reports*, January 1994.[18]

Curious Facts Contained in Patents

Some of the patents contain curious and little known facts. U.S. Patent 3,910,065 issued October 7, 1975, states that earlobes (female, no doubt because of the time frame) at the area for the (first) pierce are typically 0.14 inches thick. Expressed in metrics, this would be 3.56 millimeters. The invention described in the patent provides for a sleeve of about 0.03 inch in diameter to pass through the ear hole, which equals 0.76 millimeters. Several U.S. patents state that the usual diameter of the hole in a pierced earlobe is one-tenth centimeter, which is 1 millimeter.[19] See U.S. Patent 4,242,886 issued January 6, 1981, and 4,139,993 issued February 20, 1979. A U.S. patent issued for telephone earrings, 5,123,264 issued June 23, 1992, states that the diameter of a "J-shaped hook" that is to be inserted through the ear hole would be "approximately 0.05 inches." This translates into 1.27 millimeters, which is a size that would stretch the size of some ear holes.

These claims of patent lawyers and engineering types prompted the author to obtain some measurements of his own. What he found was as follows: (a) the diameter of the post of a good quality fourteen-karat earring was approximately 0.75 millimeters,[20] (b) the diameter of the larger, screw-on post was approximately 1.05 millimeters, and (c) the diameter of a good quality post earring with an E'arrs® brand plastic sleeve slipped over was approximately 1.2 millimeters. In U.S. Patent 5,297,997, issued March 29, 1994, to Timothy J. Covi, the inventor

17. "Needles Pierce Drug Abusers' Wall of Misery," by Jack Williams; *The San Diego Union-Tribune,* September 19, 1993, Local; Ed. 1,2; page B–1.
18. "Alternative Medicine: The Facts," *Consumer Reports,* January 1994. See subtitle "Acupuncture" at pages 54–59.
19. This explains why one-millimeter size stud earrings are generally not available. The smallest size usually sold is two millimeters.
20. Some of the less expensive fourteen-karat gold earrings sold at special promotional events, or at discount stores, have smaller diameter posts to save on gold costs. However, the smaller the diameter of the posts, the more likely they are to bend or break as well as to elongate the ear hole.

claimed that there were at least seven different sizes of earring posts: 0.70 millimeters, 0.75 millimeters, 0.80 millimeters, 0.85 millimeters, 0.90 millimeters, 0.95 millimeters, and 1 millimeters.

Another curious fact is contained in a U.S. patent that promotes the use of a double-woven chain as a substitute for a solid post in newly pierced ears. The patent, 4,259,850, issued April 7, 1981, states that a newly pierced ear will not close up around a *double*-woven chain and that the chain allows for antiseptic to more easily pass through the new ear hole.

Patent Gobbledegook

In reviewing the large volume of material for this chapter, the author was impressed with the following legal gobbledegook contained in U.S. Patent 4,719,544, issued January 12, 1988:

> ... It is generally understood and accepted that pierced ears generally contain a penetration channel, such as that shown at 50 in ear portion 12 in FIG. 2. Such a penetration channel is generally a through hole characterized by the absence of skin or other human body material to allow the acceptance of various post or wire portions of pierced earrings designed to variously attach the decorative earrings to the pierced ear.

Despite its excess verbiage, the above statement is not even accurate. Pierced ears by definition *always* have a hole through them!

Nonpatented Earrings

Although this chapter covers earring patents, not all novel ideas are protected by patents. A lighted earring that has been sold in Las Vegas, Nevada, for the last several years incorporates several novel ideas. The earring is a cylindrical, metal tube about 2 inches long, and a little less than 3.5 millimeters (0.25 inches) in diameter. The bottom is a red bulb, which is activated by a swinging motion or contact with the hair or neck of the wearer. The packaging states, "Made in Japan." No patent information is contained on the earring or in the packaging, so

presumably, no patent has been obtained. The packaging is similar to that for fishing lures. Now for the fish story! Spare batteries, which are sold by the store, are fishing-lure batteries. Apparently, a fishing lure has been converted into a feminine lure to attract males!

TWELVE
Litigation for Right to Wear Earrings

Police Officers in Peotone, Illinois

Does a male have the inherent right to wear earrings? Not if he is a police officer in Peotone, Illinois. This is true regardless of whether he is on duty or even *off* duty. This startling decision of the U. S. Court of Appeals for the Seventh Circuit is the case of *Rather v. Village of Peotone* (1990) 903 F.2d 510. The case involved Marvin Rather and Gary Zybak, two police officers who got their ears pierced and who wore either a gold- or silver-stud earring about one-eighth inch in diameter, which is about three millimeters. The officers filed suit as the result of reprimand letters being placed in their files and Officer Rather's demotion from sergeant to patrolman, with reduced pay. The charges were wearing a stud earring on duty and off duty in violation of the village police manual,[1] and also for public intoxication and failure to complete assignments.

Background of Dispute

An Associated Press story on June 5, 1990, gave some additional background on the controversy. The two officers had their ears pierced in December 1986 and wore plastic strips over the earrings during the initial healing period while they were on duty. The reprimand came in January 1987, together with the demotion and pay cut for Officer Rather.

Holding of Court Decision

On appeal the officers argued that they should at least be entitled to wear earrings when off duty and not in uniform. The Court of

1. There was nothing in the police manual that specifically discussed the subject of male officers wearing earrings. The charge was based only upon general language, which allowed for interpretation.

Appeals disagreed, holding that Peotone was a "small community" and that the people in charge of the police structure and the public viewed the wearing of ear studs by male officers as having "an adverse impact on police effectiveness."

The hostile tenor of the court decision is illustrated by the following excerpts from the decision:

> That earrings or ear studs were not specifically prohibited in the regulations is of no consequence, . . .

> Plaintiffs have not argued they have a right to wear ear studs while vacationing outside the general Peotone area and not subject to call, and we do not decide that question.

> Plaintiffs also argue that the only interest in prohibiting the wearing of ear studs while off duty is to promote Peotone's conservative viewpoint and narrow-mindedness and to suppress individuality, but that such an interest is not legitimate. That is an astounding argument. (The above quotations all appear at page 516 of the decision.)

The decision also states:

> Plaintiffs have identified no police force anywhere where police officers wear ear studs on or off duty, nor identified any other particular group that does (page 517).

Although the officers may not have *identified* any police force that permits the wearing of ear studs by police officers *in their brief* to the Court of Appeals, the remainder of the statement is factually untrue. Police undercover officers have worn earrings for years in various cities. The wearing of earrings by off-duty officers is generally not regulated. And officers are not prohibited from having pierced ears.[2]

The opinion in the case was written by Harlington Wood Jr., Circuit judge. His personal disdain for males wearing earrings comes across from the question that begins his opinion: "Male police officers wearing earrings?" A more tolerant approach was expressed by Senior Circuit

2. The decision did not involve any claim by the village of Peotone that the two officers had to let their ear holes close up, either naturally or surgically.

judge Fairchild in a concurring opinion. Some excerpts from his opinion are as follows:

> I do not take issue with the propriety of a police department regulation prescribing a uniform to be worn on duty and prohibiting the use of personal ornaments while on duty.... The problem which gives me pause is that the judgment now being affirmed upholds a prohibition against the wearing of ear studs by male police officers while off duty, at least in the particular town where this case arose (page 517).

> I reach this conclusion reluctantly because of the likelihood that this is just an instance of *bias against those who do not conform* (Emphasis furnished, at page 518).

This last remark summarizes the reality of the case!

Uncertainties in Decision

The decision is unclear as to whether the two officers may wear earrings in the privacy of their own homes. Perhaps the drapes and blinds have to be drawn first so that no one might see them. At a minimum, it would appear that they can wear ear studs to bed, provided they do not sleep with the light on. And, they probably cannot wear earrings in the rear yards of their homes.[3]

Commentary on Court Decision

An interesting sidelight to the main opinion is the court commenting that Officer Rather was undergoing marital difficulties. It appears that the village of Peotone took advantage of those difficulties by getting evidence from the estranged wife that she disapproved of her husband's ear stud. Of what possible relevance is that? And the court stooped to dignifying an old stereotype by stating that Rather's estranged wife "accused both plaintiffs of being 'gay' " (page 514).

A sad commentary on the village of Peotone is its utter waste of public funds in pursuing their position. Might not its attorney's fees

3. Rear yards are typically not fenced in the U.S. Midwest.

have been better spent on law enforcement, or in teaching tolerance? It should be remembered that the two officers had retreated from their original position of wanting to wear earrings while on duty, and only wanted to wear them *off duty*. Senior Circuit judge Fairchild, in his concurring opinion, referred to evidence that there was little public reaction to the earring studs until the lawsuit was publicized.

Neither the two officers nor the village apparently made any arguments concerning sexual discrimination. For example, does the village allow female officers to wear earrings, either on duty or off duty? Regardless of which century the village wants its residents to reside in, it may not engage in sexual discrimination.

A hostile editorial about the filing of the suit by the two officers appeared in the *Chicago Tribune* on February 16, 1987.[4] The story editorialized that "the issue is trivial" and that the judge should decide against the officers. The argument of trivialness applies equally well to the village of Peotone. Why was the village so concerned about a speck of an earring on a police officer while he was not on duty? Are police officers hired to enforce community standards of dress? The answers to these questions are frightening. When police officers are trained and hired for their intolerance, it is no surprise that cases of police brutality and unprovoked beatings occur. Police officers should be trained to treat all persons with dignity and respect, regardless of race, sex, religion, sexual preference, and dress, such as beards, mustaches, earrings, length of hair, and clothing fashions.

When the U.S. Court of Appeals released its decision, the Associated Press ran a story on June 5, 1990, titled "Policemen Can't Wear Earrings On or Off-Duty." Patrolman Gary Zybak was quoted as saying that he was not quitting the force or leaving Peotone, a small community surrounded by cornfields forty-five miles south of Chicago. Patrolman Zybak had lived in the community then for twenty-two years. The news story spoke of "hometown values" as having prevailed, and that earrings may be fine "on pirates and punk-rockers."

4. *Chicago Tribune,* February 16, 1987, Editorial; page 10; zone: C, The Annals of the Law. ©Copyrighted Chicago Tribune Company. All rights reserved. Used with permission.

Another Police Officer in Trouble

Officers Marvin Rather and Gary Zybak were not the first police-men to get into trouble for wearing earrings. The United Press International carried a story on August 15, 1981,[5] about police officer Stephen Dodge in Fitchburg, Massachusetts, who was given a five-day suspension without pay for wearing an earring while on duty. The story quoted the officer as stating that he was not going to remove the earring and that "[i]t was never a male-female issue; I had my ear pierced simply because I wanted to have it pierced." Subsequent news accounts as to how the controversy was resolved were not located.

Seattle Police Wearing Earrings

Although no specifics were given, an article appearing in *The Seattle Times,* May 9, 1993, reported that even policemen were "openly sporting earrings."[6]

San Diego Police Wearing Earrings

A male wrote on Prodigy in 1992 that the San Diego police chief had *unsuccessfully* attempted to enforce a rule that no male officer could wear earrings while at any police station or substation.[7]

Palm Beach Sheriff's Deputies

Undercover sheriff's deputies for Palm Beach County in Florida are apparently allowed to wear earrings. An article appearing in *The Dallas Morning News,* May 8, 1994, reported on two officers searching passengers on a Greyhound bus for illegal weapons and drugs. The one

5. BC cycle, Section: Regional News; Dateline: Fitchburg, Mass.
6. "Lend Me Your Ear—What You See and Feel Isn't Always What You Get," by Don Williamson, Issues, Don Williamson, page A13. Reprinted with permission.
7. Prodigy, Frank Discussion Bulletin Board, Topic: Men's Issues, Subject: Earrings, November 6, 1992.

officer was described as wearing "shorts and a colorful T-shirt and sporting a gold earring."[8]

High School Student in Midlothian, Illinois

In 1987, a high school student in Midlothian, Illinois, brought a suit in U. S. District Court, challenging a rule forbidding boys to wear earrings, arguing that the rule violated his First Amendment right of free expression. The federal judge dismissed the suit, calling the policy "rational."[9]

Baggage Handler for USAir

In June 1994, airline baggage handler John A. Coia, forty-nine, of Aston, Pennsylvania, filed suit in federal court against his employer USAir for its rule forbidding men, but not women, from wearing earrings and pony tail hairstyles. The case is *Coia v. USAir,* No. 94–3307, assigned to Senior U.S. District judge Donald W. Van Artsdalen. The attorneys for Coia are Joseph Lurie and Robert T. Murphy of the law firm of Galfand, Berger, Lurie, Brigham & March in Philadelphia. A spokesman for USAir refused comment on the suit.[10]

American Civil Liberties Union

Persons who are discriminated against for wearing earrings ought to contact their local chapter of the American Civil Liberties Union for possible assistance. An article about school earring policies appeared May 30, 1994, in *The Atlanta Journal and Constitution,* and mentioned the case of a male high school student who was suspended in part for wearing a small silver stud in his ear. That article contained the follow-

8. "Big wheel on the bus; Greyhound CEO travels incognito to check out service" by Terry Maxon, Section: Business; Page 1H. Reprinted with permission of *The Dallas News.*
9. "Violence in Schools," by Sarah Glazer, *CQ Researcher,* September 11, 1992 at pages 787–803. A footnote in that article indicated the source was Harlan Draeger, "Judge Backs School Ban on Male Earrings as 'Anti-Gang,' " *Chicago Sun-Times,* December 2, 1987, page 23.
10. "Baggage Handler Sues Airline over Coiffure Equality," *Pennsylvania Law Weekly,* June 6, 1994, News in Brief; page 29. See also "Baggage Handler Sues Airline over Coiffure Equality; Plaintiff Chastised by Supervisors, Suit Says," *Intelligencer,* June 2, 1994, Local News; page 9.

ing quotation from an ACLU representative: " 'I wish that kid in Henry had called us,' said Teresa Nelson, executive director of the ACLU's Georgia chapter. 'Who worries about earrings any more? Practically every criminal defense attorney I know wears one.' "[11]

11. "Students Pushing Dress Codes to the Limit, Fashion Freedoms Vary for Students" by Julie K. Miller, *The Atlanta Journal and Constitution*, May 30, 1994, Local News; Section C; page 1. Reprinted with permission from *The Atlanta Journal* and *The Atlanta Constitution*. Reproduction does not imply endorsement.

THIRTEEN
Employers and Earrings

Job Interviews

The usual advice for job interviews in the business world is for males to take out their earrings. Then, if hired, the individual can take the cue from other employees and wear earrings if others do.

Employers usually do not discriminate against ear holes. What employers want are employees who will show their subservience by removing them for the interview, and for the job if that is company practice.

Females may also have earring problems on job interviews. "Some major turn-offs are ... men with earrings or women with multiple earrings."[1] One consultant giving a fashion seminar for city of San Diego employees in December 1993 is reported to have advised workers that "women who wear multiple earrings may give a dope-smoker impression."[2]

One woman expressed her opinion on March 3, 1992, in a note posted on the Prodigy Homelife Bulletin Board under Fashion: "Double pierced ears aren't really mainstream. Don't do something you'll regret eventually—for the sake of today's junior high fashion statement."

Not only is the above statement inaccurate, it also involves name calling, i.e., "junior high fashion." Current estimates are that one-half of women with pierced ears have them double pierced.

Women may also encounter problems by wearing earrings that are too large to an interview. A group training youth in Harlem, New York, on job-interviewing skills advises against wearing earrings larger than a quarter.[3]

1. "From Dorm Room to Boardroom, The Interview Suit," by Kris Worrell, *The Atlanta Journal and Constitution,* May 16, 1993, Style, Section L, Page 1. Reprinted with permission from *The Atlanta Journal* and *The Atlanta Constitution.* Reproduction does not imply endorsement.
2. "Image Seminar Offends Some City Workers," by Philip J. LaVelle, *The San Diego Union-Tribune,* March 18, 1994, News; Ed. 1,2,3,4,5,6,7; page A–1.
3. "Striving in Job Market; Groups Runs Boot Camp for Unemployed," by David Plank, *Newsday,* August 13, 1993, Business; Page 43.

Multiple-Pierced Ears by Women

Notwithstanding restrictions against male students wearing earrings in various school districts, several women teachers have reported no problem with wearing several earrings per ear in the classroom while teaching.

One male stated February 2, 1992, on the Prodigy Homelife Bulletin Board under Fashion that he refused to date ladies who had more than one piercing per ear. His rationale was that "people with multiple piercings are a bit strange and strange comes with problems."

Employment Discrimination

One woman from California candidly admitted on Prodigy on January 13, 1992,[4] that she would be "less likely to buy from or hire a man with an earring or a woman with multiple earrings." Such discrimination is probably in violation of the California Unruh Act. In other Prodigy notes, this woman stated that she did not have pierced ears herself.

A week later a person who identified himself as an attorney stated on Prodigy that it was permissible in most states to discriminate against a person because of his or her dress or because they had pierced ears. He went on to state that people with unusual fashion quirks are viewed by employers as nonconformists rather than as team players. An extreme example of paralyzing conformity (formerly, hopefully) enforced by a company is that of IBM, where male trainees who violated the white shirt rule were supposedly asked: "Do you have an attitude problem or a laundry problem?" The obvious inference to the offending employee is that he would not advance with the company if he were perceived as having an "attitude problem."[5]

An article appearing in the *Chicago Tribune* discussed the question asked by an employee of a suburban police department whether it was unlawful discrimination for female employees to be allowed to wear small stud earrings, where the males were prohibited from wearing any

4. Homelife Bulletin Board, Fashion.
5. "America's Errant Empires," by Jolie Solomon, *Newsweek*, September 27, 1993, page 53. Reprinted with permission.

earrings. Jackie Lustig, the general counsel for the Illinois Department of Human Rights, was quoted as stating: "It is up to the employer to prove the policy is nondiscriminatory."[6]

The article did not state whether the policy applied to uniformed police officers or to civilian employees of the department.

Although there are bigoted people living in society, a certain amount of talk is exactly that. Society attempts to pressure conformity by scare tactics: "You can't get a job if you wear an earring or too many earrings to a job interview." "People will think you had a rebellious youth." "You will be embarrassed explaining to your grandchildren why you have so many holes in your ears." "People will laugh at you [or think you are gay] if you wear an earring."

The simple truth is that most employers hire employees who are eager and willing to work, have adequate job skills, have a neat personal appearance, have the ability to communicate, and are endowed with basic intelligence.

Historical Perspective

When women first began piercing their ears in the 1950s, some employers had policies regulating or prohibiting earrings. Eastern Airlines prohibited its female flight attendants from wearing any earrings at all![7] In the office and banking environments, females were not to wear dangling earrings. The dangle variety was considered proper only for evening wear. Only small studs were permitted to be worn during the day. One woman who started working for a bank in 1972 recalls a dress code that prohibited certain types of earrings.[8]

Company Earring Policies

Some employers have regulations as to the type and number of

6. "Policing the Dress Code," by Lindsey Novak and Lauren Spier, *Chicago Tribune,* March 6, 1994, Jobs; Page 1; zone: C; Workplace solutions. The telephone number for the Illinois Department of Human Rights was given as 312-814-6200.
7. "Eastern Airlines Pilot Wives Club Still Gliding Along," by Judy Bailey, *The Atlanta Journal and Constitution,* March 13, 1994, Extra; Section J; page 7.
8. Prodigy, Health & Lifestyle Bulletin Board, Topic: Men's Issues, Subject: Men—Pierced Ears? March 31, 1993.

earrings worn by males as well as by females. Other companies are more lenient.

Beringer Vineyards, Napa, CA

This winemaker apparently has no prohibition against male employees wearing an earring. A male employee working with the public in the gift shop was observed wearing a gold hoop earring during August 1993. Visitors did not appear to be bothered by the earring.

Blockbuster Entertainment

Blockbuster Entertainment, which owns Blockbuster Video, Sound Warehouse, Blockbuster Music, Music Plus, Record Bar and Tracks, announced a new rule effective June 1, 1994, that prohibits earrings on male employees. Also, their hair must be trimmed to within two inches of their collars. Female employees may wear earrings, but only one per ear.[9]

Boeing Company

This airplane manufacturer reportedly has a liberal dress code that permits either gender to wear earrings. Other permissible items of dress for either gender include lipstick, pantyhose, foundation makeup, slacks, blouses, sweaters, flat shoes, and clear nail polish![10]

British Rail

In preparation for privatization of the company, the regional companies that run British Rail issued strict codes for personal dress in November 1994. Forbidden are earrings for men, and for women,

9. "Business Briefs," *The Plain Dealer*, May 24, 1994, Business; page 1C.
10. "Avon (expedition) Calling on Natives in Amazonia," by Chuck Shepherd, *The Toronto Star*, March 19, 1994, Life; page H3. The article stated that a "still-male transsexual suing under the Washington state anti-discrimination law" was turned down in his bid to wear a pink pearl necklace. Query, whether the judge would have found a *white* pearl necklace acceptable?

earrings must be no larger than a 10 pence coin.[11] [The 10 pence coin measures 28.5 millimeters in diameter (approximately 1 1/8 inch).] Women are permitted to wear only one earring per ear.[12] Also forbidden for men are patterned socks, pony-tails, large rings and flashy watches.[13] A British female newspaper writer commented that the purpose of many of the dress codes appears to have been written to perpetuate 1950's suburban prejudices.[14]

Colleges and Universities

Colleges and universities are champions of liberal thought and ideas, and male professors are usually allowed to wear earrings. Associate professor Sereno at the University of Chicago was reported in a news article to wear a turquoise post earring.[15] The dean of admissions at Georgetown Law School in Washington, D.C., was observed wearing a small diamond stud during the summer of 1993.

Costco Wholesale

A twenty-year-old male reported on the Prodigy service in late 1992[16] that his employer Costco Wholesale did not discourage their male employees from wearing earrings. He wrote that he wore three earrings in his left ear.

Disneyland and Disneyworld

Both Disneyland and Disneyworld have a stringent dress code for both males and females. Their training program "explains to Disney

11. "You're Socked; Railmen Rage at Dress Code; BR Staff Face Sack for Wearing Wrong Colour Socks," by Kevin Maguire, *Daily Mirror,* November 14, 1994, Section: News: page 16.
12. "Taling the Scruff with the Smooth; Bosses Have Become Dress Dictators, Telling Us What to Wear and How We Should Look," by Jim Fyfe, *Sunday Mail,* December 18, 1994, page 24.
13. "Face Facts," by Christa D'Souza, *Sunday Times,* December 18, 1994, Section: Features.
14. "Dressed to Send Signals; Were the Rail Companies Wrong to Impose Fussy Rules on Staff? Sandra Barwick Reports," by Sandra Barwick, *The Independent,* December 15, 1994, Section: Comment: page 19.
15. "It's Off to the Sahara to Find Dinosaur Bones," by Douglas Holt, *Chicago Tribune,* August 12, 1993, Chicagoland; page 2; zone: N.
16. Frank Discussion Bulletin Board, Men's Issues, November 10, 1992.

recruits why women can't wear dangling earrings, red nail polish, eyeliner or eyeshadow; and why facial hair, heavy after-shave and anything but neatly tapered, symmetrical hair is out for men."[17] A waitress at the Disneyland Hotel in early 1994 expressed additional earring restrictions: one small earring per ear, and they must be worn in the bottom ear holes.[18] It goes without asking that earrings on male employees are strictly verboten. However, in a television commercial aired in Southern California in February 1994, Disneyland featured a sports celebrity who was actually wearing an earring in one ear!

Effective June 22, 1994, Disney eased its dress code. Women can now wear earrings one inch (twenty-five millimeters) in diameter. Although a Disney spokesperson compared this to the size of a U.S. quarter, such a coin is approximately seven-eighth inch in diameter. However, dangling earrings, hoops, and more than one earring per ear are still prohibited, as are earrings on men. In addition, female employees can for the first time wear nail polish, eyeliner, and eye shadow in neutral colors. In 1971, the Disney dress code was revised to allow women for the first time to wear earrings, provided they were plain stud earrings no larger than one-quarter inch (6 millimeters) in diameter. In 1987, earrings up to three-quarter inch (eighteen millimeters) in diameter were permitted.[19]

Golden Gate Bridge

Female tolltakers on the Golden Gate Bridge in San Francisco were ordered in spring 1994 to stop wearing long dangly type earrings. The official line about the policy was that they could be "dangerous." An unnamed official who commented off the record stated that dangling earrings were not "uniform-type earrings" and made the ladies look like cocktail waitresses.[20]

17. "Disney School Fashions Workers in Its Image," by Cheryl Hall, *The Dallas Morning News,* May 9, 1993, Business, Ideas at Work, Page 1H. Reprinted with permission of *The Dallas Morning News.*
18. The utter depravity expressed by a female employee wearing small stud earrings in only her second ear holes must be considered too shocking and scandalous for most park visitors!
19. "Disney's All-American Look Now Includes Eye Shadow; the Company's Dress Code Goes through One of Its Most Thorough Overhauls in 35 Years," by Leslie Doolittle, *The Orlando Sentinel,* June 29, 1994, A Section; page A1.
20. "Caen on the Cob," by Herb Caen, *The San Francisco Chronicle,* May 3, 1994, News; Page C1.

Great America Amusement Park

The Great America amusement park hires 2,500 seasonal employees. Their grooming policy allows only two sets of earrings, with one a stud and the other no larger than a quarter.[21] Although the article does not state, it appears that this policy applies to females. Their policy with respect to males was not stated.

I.B.M.

Earrings, including one in each ear, have been tolerated on young males at the IBM facility located in Rochester, Minnesota. The *Wall Street Journal* reported on May 24, 1994, that IBM has no official policy against earrings (or nose rings).[22]

Law Firm of Powell, Goldstein, Frazer & Murphy, Washington, D.C.

According to *The Insider's Guide to Law Firms*[23] appearing for sale in the fall of 1993, two male partners wear earrings and some wear flamboyant ties in the Washington, D.C., law firm of Powell, Goldstein, Frazer & Murphy.

London Metal Exchange

The London Metal Exchange announced new rules in early 1994 that prohibited male members from wearing earrings and female members from wearing T-shirts or leggings.[24]

21. "Getting a Job, Dressing to Impress Is Key to Success in Interviewing," by Mary Gottschalk, *Orange County (California) Register,* September 13, 1992, Accent, Page H3.
22. "Labor Letter," by A. Nomani, Sr., Section A; page 1, column 5.
23. Mobius Press, P. O. Box 34505, Washington, D.C. The book was reviewed in "Rookies Reveal the Inside Scoop on Elite Law Firms," by Saundra Torry, *The Washington Post,* November 8, 1993, Financial; page F7; Lawyers.
24. "Heavy Metal," by Jon Ashworth, *The Times,* February 23, 1994, Business.

McDonald's Restaurants

McDonald's fast-food restaurants prohibit male employees from wearing earrings on the job.[25]

NFL Coach Don Shula

National Football League coach Don Shula is one of the NFL's all-time winningest coaches. A writer for *USA Today*[26] suggested that his winnings are attributable to his practice of adapting through his thirty-one-year career as a coach. Back in the 1970s, one of his players showed up for practice wearing a diamond earring. Shula merely growled, "Yeah, I just noticed that one of your damned earrings is missing." That was the end of the discussion.

Sam's Club Division of Wal-Mart Stores Inc.

An article in the *Chicago Tribune*, July 19, 1993, reported on the sale of five Pace Warehouse Clubs to Sam's Club, a division of Wal-Mart Stores Inc., the nation's number 1 retailer. The Sam's Club employee manual forbids men from having hair longer than their collars or from wearing earrings.[27]

Sea World of Florida

At Sea World of Florida female employees can only wear one earring per ear, including small hoops.[28]

25. "Five Percent of Men Sport Earrings," by Doug Cress, *The Atlanta Journal and Constitution*, August 5, 1993, Living; Section E; page 5.
26. "Shula Adapts over Time to Reach Coaching Peak," by Bryan Burwell, *USA Today*, October 29, 1993, Sports; Commentary; page 7C. Copyright 1993, *USA Today*. Reprinted with permission.
27. "A Tougher Pace as Sam's Takes Charge," by John Schmeltzer, *Chicago Tribune*, July 19, 1993, Business; page 2; zone: C.
28. "Disney's All-American Look Now Includes Eye Shadow; the Company's Dress Code Goes through One of Its Most Thorough Overhauls in 35 Years," by Leslie Doolittle, *The Orlando Sentinel*, June 29, 1994, A Section; page A1.

Whole Foods Market Inc.

Whole Foods Market Inc., the nation's largest chain of natural food stores based in Austin, Texas, has a liberal policy regarding earrings. It permits nose rings, multiple-pierced earrings, and tattoos.[29]

Whole Foods Market in North Chicago

The Whole Foods Market located on the North Side of Chicago has subsequently limited pierced earrings to not more than two in each ear, and one facial piercing.[30]

Banning Earrings for Females as Well as Males

One method of dealing with the perceived problem of male employees wearing earrings is to banish them also for female employees. The fear of some employers is that banning only male earrings may amount to sexual discrimination, and subject them to lawsuits. This policy was reportedly adopted by a Minnesota supermarket because a male employee was going to file a discrimination suit.[31] In Britain, sex-discrimination cases have been won by males banned from wearing earrings at work when female colleagues were allowed to.[32]

Unisex Earring Regulations

Several ear piercers in Southern California reported to the author that some employers have adopted dress codes that prohibit both male and female employees from wearing only one earring. If males wish to wear earrings, they must have both ears pierced and wear a matching pair, one earring in each ear. Such a regulation would appear to prevent

29. *Investor's Business Daily*, June 30, 1993, Leader's Success, page 1.
30. "Piercing Trend Not for Hard of Earring," by Mary Schmich, *Chicago Tribune*, July 17, 1994, Chicagoland; page 1; zone: N.
31. Prodigy, Health & Lifestyle Bulletin Board, Topic: Men's Issues, Subject: Men—Pierced Ears? March 21, 1993.
32. "Bearded Ladies Need Not Apply; What Can You Do If You Think Your Looks Have Cost You Your Job? Emma Brooker Finds Out," by Emma Brooker, *The Guardian,* May 12, 1994, The Guardian Features Page; page 13.

arguments and strife related to the sexual preference of earring-wearing employees.

Plastic Strips Covering Ear Holes

A male writing on Prodigy claimed that a supermarket chain in the San Francisco area was requiring male employees to not only remove their earrings, but to also wear a plastic strip over their ear holes.[33] The writer did not state whether the plastic strip had to cover both the front and rear of the ear holes! Such a policy would be the converse of regulations adopted in the European Common Market, which require all persons with pierced ears to wear a small stud earring in each ear hole while serving food.

33. Prodigy, Health & Lifestyle Bulletin Board, Topic: Men's Issues, Subject: Men-Pierced Ears?, March 21, 1993 and March 24, 1993.

FOURTEEN
Military Regulations regarding Wearing Earrings

U.S. Regulations

The U.S. Air Force issued a rule in 1985 prohibiting its male personnel from wearing earrings, either on duty or off duty. However, women personnel were allowed to wear earrings both on duty and off duty. In July 1990, the ruling with respect to males was reversed (at least covering servicemen stationed in Germany), and males were allowed to wear earrings while *off* duty only. According to an article appearing on Reuters on July 16, 1990, with the headline, "U.S. Airmen Can Wear Pierced Earrings Off Duty," and datelined Bonn, Germany, air force servicemen stood out in the community since a large percentage of local Germans were wearing earrings. One airman stated that the old rule was difficult to enforce. Apparently the hole in the earlobe was not the problem, but wearing an earring in the hole was!

A wife of an Air Force Special Operations officer wrote in late 1992 on Prodigy that her twenty-six-year-old husband has an ear hole as do most of his peer group. She commented that although the wearing of earrings is not condoned at any time, the air force does not kick officers out for having an ear hole.[1]

In 1989, the Marine Corps commandant in San Diego ruled that male marines were not to wear earrings, whether on duty or off duty. In an article appearing May 29, 1991, in the *Los Angeles Times*,[2] it was reported that scofflaws could be found in the shopping malls adjacent to Camp Pendleton. One marine was quoted as stating: "They used to get an earring when they crossed the equator for the first time. Since we can't wear earrings, we have to get something else." The romance of the sea of older days when Melville wrote about Billy Budd wearing a single gold earring is apparently gone for the moment.

1. Prodigy, Homelife Bulletin Board, Topic: Parenting Practices, Subject: 15 Year Old Earing (sic), December 21, 1992.
2. "San Diego at Large: Do Real Marines Have Nipple Rings?" *Los Angeles Times,* San Diego County Edition, May 29, 1991, Metro, Part B, page 1.

Regardless of the rules, sailors continue to get their ears pierced. An article appearing in *The Seattle Times* on June 26, 1991, reported that the navy had docked. Four sailors from a minesweeper had lined up at a mall boutique called Topkapi to get their ears pierced. However, the article continued, "Navy guys will have to keep the earrings in their pockets while they're on duty."

In Charleston, South Carolina, one ear piercer reported in 1993 that 35 percent of her customers are navy men.[3]

According to an article appearing in *Navy Times,* the navy permits males to have pierced ears but not to wear their earrings on duty.[4]

One ear piercer stated that she uses clear plastic inserts for males in the military and that the plastic inserts apparently pass military inspections.

Civilian employees at the Pentagon do not come under any earring ban, however. "We don't pay attention to that," a spokesman for the Pentagon was quoted as saying in May 1993.[5]

Regulations Affecting Female Soldiers

Lest females are bemused by male soldiers wanting to wear earrings, it was not too many years ago that the military first allowed female soldiers to wear small earring studs while on duty. According to an article appearing in *The Washington Post,* September 16, 1983,[6] the army announced at San Antonio, Texas, that women soldiers could wear small stud earrings. The female writer wondered whether the military could discriminate in its earring policy if the Equal Rights Amendment had been passed. She wrote: "Presumably the earring fad will fade away before the Army has to send men into combat wearing earrings." Since this writer apparently had never studied earring history, she did not know that males from numerous cultures wore earrings into battle and that their fighting ability was not impaired.

3. The Associated Press, May 29, 1993, Dateline: Charleston, S.C., Keyword: Military Pullout.
4. "A Navel Ring Isn't Such a Novel Idea in Naval Circles," by Becky Garrison, *Navy Times,* October 31, 1994.
5. "White House Studs Lend Their Ears," by Jeremy L. Milk, *Washingtonian,* May 1993, Capital Comment. Reprinted with permission.
6. "Earrings," by Judy Mann, *The Washington Post,* September 16, 1983, page B1. ©1983 *The Washington Post.* Reprinted with permission.

Fashion for females, however, has its limits in the military. Women may only wear one set of earrings (one in each ear) while on duty. Multiple earrings are reserved for off-duty hours.

Navy women, however, may only wear stud posts that are not larger than 6 millimeters in diameter.[7]

Canadian Regulations

The Canadians also have a problem with male earrings. As of October 1992, the Royal Canadian Air Cadets, which is composed of males and females aged twelve to nineteen years old, allowed girl cadets to wear small gold or pearl studs. However, boys with pierced ears had to take their earrings out before they came to cadets.[8]

Dutch Regulations

The Reuters World Service reported July 11, 1994, that the Dutch army has decided to "discourage" long hair and earrings among new conscripts, claiming that those fashions hurts its international image. The long hair look was first permitted in 1971. The decision stops short of ordering its soldiers to cut their hair and stop wearing earrings.[9]

French Foreign Legion

According to a June 27, 1993, Associated Press story, the French Foreign Legion apparently does not permit the wearing of earrings. The article commented about a person who recently enlisted: "He's new to military life—as two recently closed earring holes attest."[10]

7 "A Navel Ring Isn't Such a Novel Idea in Naval Circles," by Becky Garrison, *Navy Times*, October 31, 1994.

8. "There's No Life Like Air Cadets, as More and More Girls Are Discovering," *The Vancouver Sun*, October 9, 1992, Friday, Features; page C1.

9. "Long Hair for the Chop in Dutch Army," *Reuters World Service*, July 11, 1994, Monday, BC cycle, Dateline: The Hague, July 11.

10. Associated Press, June 27, 1993, International News, Dateline: Bagnols-Sur-Ceze, France. Reprinted with permission.

Israeli Army

Israeli army regulations currently prohibit earrings for male soldiers. Two soldier editors and a soldier photographer were disciplined for placing a picture of a male paratrooper wearing an earring on the cover of an Israeli army magazine. The soldier photographer was given a twenty-one-day prison sentence, which was suspended, for professional insensitivity and negligence.[11]

11. Photo of Israeli Soldier's Earring Means Trouble," *Reuters World Service,* November 16, 1994, Dateline: Jerusalem.

FIFTEEN
Earrings in the Schools

U.S. Schools

The controversy over male students wearing earrings to school parallels the dispute over male students with long hair. By 1992, the earring dispute had generally been resolved in favor of allowing male students to wear earrings if female students were given that right. The interesting part of the earring dispute is that parents, especially mothers, have been so supportive of their sons.

The essence of the earring dispute is twofold: (a) the belief by school administrators and school boards that earrings are not appropriate attire (i.e., fashion) for male students, and (b) a secondary belief that earrings on male students are somehow morally offensive. Since morals are typically based on religious beliefs, chapter 24 in this book, titled "Earrings and Religion," should be read at this point by school administrators, school board members, and by judges. That chapter soundly refutes the belief that earrings on males are morally offensive.

In a 1989 book, funded in part by grants from the Smithsonian Institution Special Exhibition Fund and from the National Cosmetology Association, titled *Men and Women: Dressing the Part*, one of the chapter authors comments upon the personal prejudices of those involved in the decision-making process related to long hair on males but equally applicable to earrings on males:

> However, the local judges who ruled on the cases often betrayed their own personal prejudices in their decisions. For example, an Indianapolis judge ruled that one boy should have his hair cut because it "would normally be described as feminine in style." He further stated that the trimming would not alter the young man's "opinions and beliefs, personality and individuality." Essentially the judge, like principals and superintendents, believed he had the right to define masculine appearance and the authority to enforce it.[1]

1. *Men and Women: Dressing the Part*, Edited by Claudia Brush Kidwell and Valerie Steele, ©1989, Smithsonian Institution Press, Washington, D.C., at pages 152 and 153.

The unanswered question is "Why?" Why should judges have the power to define fashion? Is it not silly and totally absurd for balding, male judges to define hair styles? This is especially true in Britain and other Commonwealth countries where judges and trial attorneys (termed "barristers") still wear the ridiculously silly, powdered, curled, and hot to wear white wigs during court proceedings! A more totally absurd fashion for the beginning of the twenty-first century cannot be contemplated. Perhaps the extra heat generated by the wigs adversely affects their reasoning ability.

It is submitted that there are many, many more legitimate educational issues for principals, school administrators, and school boards to deal with. These issues are the lack of an environment where students can learn, violence against teachers and students in the classrooms and on the school grounds, and guns being carried by students in their pockets and purses. Yet educators seem to delight in experimenting with the latest educational "fashions," such as new math, and "back-to-basics school" where the clock is turned back to the 1950s for student dress requirements. Of course, earrings on male students are forbidden in those basics schools.[2] In addition, fundamental elementary and intermediate schools in Santa Ana, California, prohibit girls from wearing earrings longer than one inch or more than two earrings per ear.[3] Consider that these girl students would be typically only five to fourteen years old, and that two earrings per ear is considered to be conservative practice, which equates into no earrings on boys!

An undertow to the male earring controversy is the psycological fear by many males that earrings on male students reflect on their own lack of masculinity. The concept is that earrings (or long hair) feminizes males. Some school coaches quit coaching rather than be associated

2. See for example, "Back-To-Basics School Proposed for Ventura," *Los Angeles Times*, January 8, 1994, Metro; Part B; page 1; column 5; Metro Desk. The article comments: "No boys wearing earrings" in the proposed school. (Perhaps in 1950s style, the girls should also be prohibited from wearing pierced earrings!) The boys would be required to wear collared shirts and slacks, and the girls would have to wear dresses or long pants. Female teachers would have to wear dresses and male teachers would have to wear ties and jackets. Reprinted with permission.

3. "3 Santa Ana Schools Stir Praise, Controversy; Education: Some Hail the 'Fundamental' Program for Its Dress Code, Discipline, Academics; Others Call It Elitist," by Jodi Wilgoren, *Los Angeles Times*, February 21, 1994, Section A; page 1; column 3; Metro Desk.

114

with long-haired players. The following perceptive observation was made:

> Tony Simpson, a football coach at North Short Junior High School near Houston, Texas, wrote on the subject for the *Texas High School Coaches Association Magazine* in 1973. He stated that American coaches should not allow themselves to be represented by male teams that looked like females. He intimated that the appearance of his team reflected on his own masculinity.[4]

High School and Junior High Disputes

An unusual story came out of Garland, Texas, in 1981.[5] Principal Gary Reeves told the students that he would allow male students to wear earrings if most of the student body were in favor of the change. Two students, one male, and the other female, gathered seven hundred signatures calling for the change. Principal Reeves's forward thinking was expressed as follows: "But we didn't feel like it was worth our time as administrators worrying about seven or eight students wearing earrings." Unfortunately, too many school administrators and school boards made a big fuss over nothing and eventually came to the same conclusion.

Various newspaper accounts from the 1980s reported that male students had been suspended from school for having worn an earring to class.

In Weatherford, Texas, in 1984, the school board upheld a fourteen-year-old boy's suspension from a school event for wearing an earring. Faye Donaldson, the board's president, was quoted as stating: "In our society it is not appropriate for men to wear earrings, and not in Weatherford especially."[6]

In Akron, Ohio, in 1984, a seventeen-year-old student at North High School was threatened with a three-day suspension for having

4. *Men and Women: Dressing the Part,* edited by Claudia Brush Kidwell and Valerie Steele, ©1989, Smithsonian Institution Press, Washington, D.C., at page 155.
5. United Press International, AM cycle, Regional News; Distribution: Texas; Dateline: Garland, Texas.
6. "Punishment of Youth for Earring Is Upheld," *New York Times,* May 27, 1984, 44(L), col. 6. Copyright ©1984 by The New York Times Company. Reprinted with permission.

worn a tiny gold earring to class.[7] The school dress code did not specifically ban earrings on male students but only banned items of "distracting influence."

The Associated Press on February 26, 1985[8] carried a story centered in Southaven, Mississippi. Southaven High School principal, J. R. Baird, was reported to have signed an affidavit to have a student arrested on a trespass charge for wearing an earring to class. The student hired attorney Ron Lewis. The news story reported that the matter had been settled with the student being allowed to wear his earring to classes, the five-day suspension from school being removed from his files, the trespassing charges being dropped, and the student being allowed to make up missed schoolwork.

It would appear that the Southaven school board may have been concerned about a possible suit for wrongful arrest, as criminal charges for what amounts to wearing an earring seems to be more than a little heavy-handed. The story reported that the mother of the student was supportive and was even trying to persuade her ten-year-old son to also get his ear pierced.

In south Chicago High School District 228, the school board passed a discipline policy in early 1984 that included a ban on male jewelry, supposedly to nip an area gang problem in the bud. Other prohibited items were jackets with gang symbols or colors, and even a certain brand of tennis shoes. Sgt. Michael Cushing of the Chicago Police Department Gang Crimes Unit was quoted in the *Chicago Tribune* article of March 6, 1987,[9] as follows: "Some gangs do use earrings, yet. They also use hats, colors, necklaces, shoes and shoelaces. But just because a person is wearing something like an earring does not necessarily mean anything."

The article reported that a number of boys were agitating for the right to wear earrings to school, a right long enjoyed by girls. One boy was quoted as stating that a teacher had told him that boys could wear earrings if they also wore skirts or dresses like girls! A planned protest

7. United Press International, AM cycle, Regional News; Distribution: Ohio; Dateline: Akron, Ohio.
8. "Earring Student Back in School, with Jewelry," AM cycle, Domestic News.
9. "Teen Boys Beat Drum for Right to Wear (Left Only) Earrings," Eric Zorn, *Chicago Tribune,* March 6, 1987, Sports Final Edition; ChicagoLand; page 1; zone: C. © Copyrighted Chicago Tribune Company. All rights reserved. Used with permission.

by boys to wear skirts and earrings was called off because the weather was too cold for their bare legs. Instead, the student leader stated plans to hire a cheap lawyer.

A 1986 article appearing in the *Los Angeles Times*[10] describes the emotionalism caused by the triviality of a teenage boy wearing an earring to school: "Teen-age pregnancy and abortion, teen-age drug use, teen-age suicide—and thirteen principals have to have a closed-door session because a teen-age boy goes out with his dad, each has an ear pierced, and the boy wears an earring to school."

An article appearing several days earlier in the same newspaper gave additional details of the dispute.[11] The thirteen school principals had voted to overturn a 1985 school dress code and allow male earrings on a case-by-case basis. Earrings considered obscene, unsafe, or disruptive would still be prohibited, and disputes would be decided by all the principals. The boy's mother was quoted as saying: "There is nothing in the dress codes sent out that said earrings could not be worn by girls or boys." And, "Again, there is discrimination. Boys can't wear dangling earrings, but girls can."

At a rural north Alabama high school, three boys were suspended from classes in 1986 after wearing earrings.[12] The school's code prohibited dress in a manner that "disrupts the educational process." However, it appears that it was actually some of the teachers who were disrupting the educational process. One boy who wore an earring said a teacher taunted him by saying, "Look at the girls with the earrings." The school principal was quoted in the article as stating, "I feel that young men should dress like young men and young ladies should dress like young ladies."

Initially, earrings on male students were thought of as being offensive to community norms. This concept was expressed as late as 1989 in the community of Reardan, Washington. Elementary science teacher Brian McCall was quoted by United Press International as saying: "What this is all about is we're trying to preserve this community's

10. "Boy's Earring," *Los Angeles Times*, September 28, 1986, Sunday, Orange County Edition, Metro; Part 2; page 14; column 4; Metro Desk. Reprinted with permission.
11. "Suspended 8th Grader Can Return to School Wearing Earring; Principals Vote to Void Section in Dress Code," *Los Angeles Times*, September 20, 1986, Orange County Edition, Metro; Part 2; page 6; column 1; Metro Desk.
12. United Press International, January 8, 1986, AM cycle; Regional News; Dateline: Salem, Ala.; Keyword: Earrings.

norms. I don't want to speak for the district, but personally, I think this little community needs to hold on to those kinds of things."[13]

The mother of an eighth-grade boy kicked out of class for wearing an earring protested that children are taught it is all right to look different and that children should learn to make their own decisions. If the Reardan school district advocated such teaching, they were not practicing what they preached.

The article reported that after the mother mentioned she was going to contact the American Civil Liberties Union, a compromise was reached where the boy was allowed to wear his earring except during physical education.

In Albany, Missouri, an earring dispute erupted when the principal banned earrings for boys effective January 4, 1989.[14] The reason for the ban was an outbreak of name calling, pushing, and shoving between boys who wore earrings and those who did not. The school dress code gave administrators the right to ban things "disruptive to the educational process." The mother of two boys who wore an earring argued that the ban was sexual discrimination against boys. The article reported that the father had his own ear pierced to show solidarity with his sons.

In Georgia, the school board in Habersham County lifted the ban on boys wearing earrings. *The Atlanta Journal and Constitution* reported April 5, 1992, as follows:

> Boy showered with gifts of earrings. Tenth-grader Grandon L. ——— was back in class last December after Habersham County school officials lifted his nine-day suspension and backed down on its policy forbidding boys from wearing earrings.
>
> Since then, Grandon has received about two dozen earrings as gifts from classmates, and a number of other boys at Habersham Central High School have started wearing them. . . .

13. "School Mobilizes against Earrings," United Press International, November 21, 1989, Tuesday, BC cycle, Domestic News.
14. "Students Give Up Earrings at School So They Don't Flunk," The Associated Press, January 12, 1989, AM cycle, Domestic News, Headline. Reprinted with permission.

Grandon was suspended when he was caught wearing a jeweled stud in his left ear. He and his parents argued that the ban violated his civil rights because girls are allowed to wear earrings—and the school board agreed.[15]

The Atlanta Journal and Constitution reported in an earlier story on December 6, 1991, that metropolitan Atlanta school systems generally permit male earrings, leaving specific policies to each school. Clayton County bans earrings in elementary and middle schools, but not high school.[16]

The case of high school student Grandon L. ——— was also reported in this earlier article. The article stated that his parents argued that the school policy of allowing girls to wear earrings at school, but not boys, constituted sexual discrimination. The earring of Grandon L. ——— that created all the controversy was a two-millimeter stud—a mere speck! A valid inquiry is why the school officials wasted so much effort over so little, instead of dealing with more legitimate educational concerns.

In Arlington, Texas, the school board decided to allow boys to wear earrings. *The Dallas Morning News* reported May 20, 1993,[17] that the new policy would allow boys to wear small earrings. However, no dangles or hoops would be allowed. The article also stated that in Dallas the school board prohibited male earrings several years ago, but that the Plano and Fort Worth school districts leave the issue up to each school.

The *Times-Picayune* (New Orleans, Louisiana) reported June 7, 1994, that the Plaquemines Parish school board approved a dress code that prohibits boys from having hair that extends beyond the top of their shirt collar. One school board member Fred Fitzgerald apparently equated longer hair with immorality: "Thank you for putting some morals back in our kids," he said to Carroll Perlander, the superintendent. Another rule approved by the board at the request of the super-

15. "News Update People and Events That Made Headlines 'My Neighbors Love Me; I Ain't Going Nowhere,' " *The Atlanta Journal and Constitution*, April 5, 1992, State News; Section G; Page 2. Reprinted with permission from *The Atlanta Journal* and *The Atlanta Constitution*. Reproduction does not imply endorsement.
16. "High School Rebel Finds a Cause; Parents Support Teenager's Refusal to Remove Earring," *The Atlanta Journal and Constitution*, December 6, 1991, Local News; Section F; page 1.
17. "Dress Code Would OK Earrings for Boys; School Trustees to Vote on Issue in June," by Robert Ingrassia, *The Dallas Morning News*, May 20, 1993, Arlington, Page 1Y.

intendent was a rule that prohibits girls from wearing more than one earring in each ear.[18]

In Jefferson County, Kentucky, *The Courier-Journal* reported July 12, 1994, that Waggener High School was given the go-ahead to proceed with plans to make itself more traditional. The article stated that "traditional" schools stress homework, strict discipline, and dress codes and patriotism. A more apt description might be that these schools attempt to return to the 1950s. Surprisingly, the dress code for this high school does not prohibit boys from wearing earrings or limit the length of their hair, but it does limit earrings to their ears.[19]

Elementary Grades

Earrings on male students have also created a stir in the elementary grades. An article appearing April 9, 1991, in the *St. Petersburg Times* concerned the case of a Crystal River resident and her two sons, David age ten and Nathan age five.[20] The Citrus Springs Elementary School had banned earrings on boys two years earlier under the guise that they were a safety hazard. The older boy complained to the principal that he could not remove the earring from his newly pierced ear without the hole closing. The principal, Archie Dabney, suggested to the boy that a piece of burned broom straw, coated with petroleum jelly, would keep the hole open.[21] Instead, the mother claimed that her son had gotten an infection and demanded that the school system should pay the forty-five-dollar doctor bill. The article stated that the policy would remain in effect for the rest of the school year and that the school board might discuss changes in the dress code that summer.

18. "Rule Goes to New Lengths: Long Hair Out in Plaquemines," by Sandra Barbier, *Times-Pica-yune*, June 7, 1994, Metro; page B1.
19. "Waggener's Bid to Be Traditional Creates a Site-Based Dilemma," by Beverly Bartlett, *The Courier-Journal*, July 12, 1994, Metro Edition, News; page 1B.
20. "Earrings on Boys Still Face School Ban," *St. Petersburg Times*, April 9, 1991, Citrus Times; page 3.
21. A female wrote February 27, 1992 on Prodigy, Homelife Bulletin Board, Fashion, that an "old wive's tale" for curing an infected ear was as follows: "Cut a piece of broom straw about 3/4" long–1" long, burn the tips slightly with a match or lighter and quickly put the fire out. Insert in the hole in your ear. From time to time move the broom straw around." *This advice should not be followed!* The broom straw is undoubtedly contaminated with numerous germs, and a momentary burning will not sterilize it.

An article appearing March 30, 1991, in the same newspaper[22] reported that the county school dress code applicable to both boys and girls only prohibited "any jewelry (spiked bracelets, earrings, etc.) considered hazardous to students' safety." The individual elementary school took the further step of prohibiting earrings for boys. The article also reported that the school principal had given the young boy the piece of burned straw from a broom, which was coated with petroleum jelly. If the broom had been previously used for sweeping, the broom straw could not have been in a sanitary condition. (That common broom straw would likely be contaminated with germs was recognized by author Willa Cather in her 1913 book *O Pioneers!*)[23]

The *Chicago Tribune* reported on October 5, 1993,[24] that an eleven-year-old boy in Rochester, Indiana, had sued the Caston school district over the dress code that prohibited boys from wearing earrings. A judge not only upheld the dress code, but reportedly stated that earrings were basically a female thing! The boy's family had assistance from the Indiana Civil Liberties Union and were planning an appeal. An earlier article in the same paper stated that the school board had prohibited male earrings as not being consistent with the community's stand-ards.[25]

Recommended Policy

Instead of completely abolishing earrings on male students, at least one school adopted a "suggested no-earring policy for boys."[26] This policy was adopted by the Doig Intermediate School in Garden

22. "Earrings Fall Out of Fashion," *St. Petersburg Times,* March 30, 1991, Citrus Times; Page 1. Reprinted with permission.
23. *O Pioneers!* by Willa Cather, 1913. Contained on CD-ROM, *Library of the Future, 3rd Edition,* Screen 172: 248, Windows Ver. 3.0. ©1990–94, World Library, Inc., 12914 Haster Street, Garden Grove, CA 92640, 714-748-7197, 1-800-443-0238. The context of the comment is as follows: "Marie wore a short red skirt of stoutly woven cloth, a white bodice and kirtle, a yellow silk turban wound low over her brown curls, and long coral pendants in her ears. Her ears had been pierced against a piece of cork by her great-aunt when she was seven years old. In those germless days she had worn bits of broom-straw, plucked from the common sweeping broom, in the lobes until the holes were healed and ready for little gold rings."
24. "In Your Face," *Chicago Tribune,* October 5, 1993, Kidnews; page 3; zone: C.
25. "Judge Orders Pupil: No Earrings for Boys," *Chicago Tribune,* October 1, 1993, News; page 3; zone: M.
26. "Santa Ana Boy Pierces School Policy," *The Orange County (California) Register,* September 27, 1990, Community, page 1.

Grove, California, in 1985. Although compliance was voluntary, about twenty-five boys wore earrings in 1990. A mother who was a legal assistant for a law firm complained that it was unfair for the school to "discriminate against my son because he is a boy." Her son was then fourteen years old.

Banning Earrings as "Gang Related"

As 1993 drew to a close, the artifice of banning all male earrings on the grounds that they were "gang related" became established. If the same rationale were applied across the board to other articles of clothing, the dress code would soon require total nudity for both male and female students. The danger is that bigoted school administrators, who may be more interested in imposing their ideas on students than in educating them, may feel they have free reign to be however arbitrary and capricious they choose under the guise of "gang related." To claim that only gang members wear earrings is factually incorrect. If a certain gang wears a certain color of jacket, then that color of jacket might be banned, but certainly not all jackets. The same rationale applies to certain types of earrings on males, but certainly not all earrings. An example of this might be banning earrings in the form of guns (which have been adopted by some gangs).

The whole idea of banning certain items of clothing is self-defeating. As soon as a gang's symbol of identification is banned, they will merely adopt a new symbol.

In the Dallas, Texas, area, "[e]arrings, hats and bandannas on boys are forbidden at some schools and tolerated at others."[27]

Regulating the Number of Earrings on Male Students

As the fashion for piercing both ears has grown among male students, the next logical step[28] for school districts is to ban more than one earring. Hanover Central High School in Cedar Lake, Indiana,

27. "Clashes about Clothes; Schools Struggle with Dress Codes," by Dan Shine, *The Dallas Morning News*, November 14, 1993, Sunday, Home Final Edition, News; Page 33A. Reprinted with permission of *The Dallas Morning News*.
28. The reasoning is: If it is a new fashion, it must be banned!

bears the dubious honor of being the first high school to do this which has been located by the author. However, the *Chicago Tribune* reported on October 11, 1994, that fifty students walked out in protest over the rule.[29] It is wondered whether the school rule regulates *which* ear the one earring has to be worn in.

Acceptance of Earrings in European Schools

Time magazine reported in the July 9, 1990, issue[30] on the Felix Dzerzhinsky School in Erkner, a suburb of East Berlin, six months after the Berlin Wall had fallen. The Dzerzhinsky school had students ages six to sixteen. The article commented on a sixteen-year-old student who wore "two tiny hoop earrings glistening in each ear." He apparently wore those earrings without any problems (at least after communism had fallen) and even gave a student announcement one morning to the entire school.

In Prague, Czechoslovakia, students fired thirty-seven out of thirty-nine instructors at the Prague Academy of Fine Arts after the fall of communism. The students then hired a new outspoken rector, Milan Knizak, age fifty, "a long-haired multimedia artist who sports three earrings in each ear." *Time* magazine, April 23, 1990.[31]

Canadian Schools

An article appearing in *The Gazette (Montreal),* June 21, 1993,[32] contained a quote from a ninth-grade, male student: "An earring in your nose is OK, but you can't have a chain running from it to the earring in your ear."

29. "Tough News. In Your Face." *Chicago Tribune*, October 11, 1994, Section: Kidnews, page 3; Zone: C.
30. "We Are All Talking More," Germany, *Time*, July 9, 1990, at page 83. Reprinted with permission.
31. "Expelling the Ghosts of Marx and Lenin," Education, *Time*, April 23, 1990, at page 70. Reprinted with permission.
32. "School Uniforms Becoming a Trend; Hundreds More Students in Montreal High Schools Are Going to Be Dressing Alike," by Sheri South, *The (Montreal) Gazette*, June 21, 1993, News; page A1/Front. Reprinted with permission from Sheri South.

Australian Schools

St. Matthew's School in Canberra expelled a thirteen-year-old Australian boy for wearing a stud earring. He took his case to human rights authorities, claiming sex discrimination. After a ten-month battle, the Roman Catholic school as well as the Catholic Education Office apologized for the dismissal and changed school rules to allow boys to wear earrings.[33]

Japanese Schools

In Japanese schools, *girls* are still forbidden to wear pierced earrings to school. A Japanese girl who appeared on CNN news on November 30, 1993, stated: "We are not allowed to wear different colored shirts, no perms, no makeup, no pierced earrings."[34]

Notwithstanding the stigma still attached to pierced ears, increasing numbers of young Japanese females and even some males are getting their ears pierced. One Japanese boy stated in the same news broadcast that they are given a hard time by school administrators for merely getting their ears pierced (much less wearing them to school).

Another article indicated that some Japanese schools prohibit all earrings on girls (apparently including the clip-on variety). The article stated that a Japanese homeroom teacher slapped a high school girl in the face in front of the classroom for breaking the school rule against wearing earrings.[35]

A male seventeen-year-old high school student at Tokyo Metropolitan Hachioji Koryo High School was apparently pressured to voluntarily withdraw from the school in part because he refused to remove

33. "Boy Wins Sex Bias Action against School," Reuters, Limited, October 15, 1993, Dateline: Canberra, Australia.
34. CNN News, November 30, 1993, headline: "Japanese Schools Slowly Lightening Up on Students."
35. "Kids Returning from Abroad Belong to 'Third Culture,' " by Juliette Walker, *Japan Times* (Tokyo, Japan), March 18–24, 1991, page 7, and contained on the CD-ROM issued by Social Issues Resources Series, Inc.

his pierced earrings after repeated orders from teachers. The other reason was for bringing a jackknife to school.[36] The same newspaper article conflictingly reported that the student had been flunked.

36. "Students Protest Classmate's Expulsion," *Mainichi Daily News*, December 13, 1994, Section: page 16; Demestic.

SIXTEEN
Ear-Piercing Litigation

Causes of Litigation

Litigation may result when something goes wrong in the ear-piercing process such as a person fainting and falling after the ear piercing, a serious infection resulting, or the claim that a disease was communicated by the ear-piercing process.

The incidence of litigation over ear piercing appears to be virtually nonexistent, based on a computer search of all state and federal appellate decisions.[1]

The person contemplating ear piercing can largely guard against the first two types of problems. The person feeling faint should sit down and place his or her head down until he or she no longer feels faint. As to a serious infection, this is rare if the person follows the printed instructions typically given by the store or jewelry department doing the piercing. With regard to the third problem area, a person's chances of being hit by lightning are much greater than contacting a disease from the ear-piercing process where the piercing is done by a store doing piercing. This is said not to minimize the risk, but merely to state the chances for a serious problem.

Fainting after Ear Piercing

The Florida case of *Ole, Inc. v. Yariv* (1990) 566 So.2d 812, involved the claim that the piercing store had failed to take adequate precautions after ear piercing, and that the person had fainted and fallen, sustaining personal injuries. The issue before the Florida District Court of Appeal was whether the store being sued should have the right to defend the lawsuit. The store had not timely filed a legal response to the suit. Several paragraphs from the decision give the factual background:

1. The search phrase used in a Lexis® search conducted on November 20, 1992, was *ear w/5 piercing*. The search found twenty-one cases, only several of which dealt with personal injuries allegedly resulting from ear piercing.

Ole owns and operates small jewelry kiosks set up in retail shopping center malls which perform the service of ear-piercing. Ole has a long-standing commercial arrangement with Caflon, Inc., a distributor which supplies the piercing gun and earring studs used by Ole. Caflon also maintains insurance which is intended to cover Ole as well as other similar users of Caflon's products.

It appears on this record that Ole was a fairly trouble-free vendor, having experienced few claims or complaints over the years, and none of substantial magnitude. When a claim was received, the standard practice was to forward the claim to Caflon, which would in turn submit the claim to insurance personnel. For over a decade, and until the present case, that practice had worked smoothly (page 813).

The court concluded that the default judgment against Ole, Inc. in the amount of $7 million should be set aside, and that it should be allowed to defend the case. It is difficult to imagine an ear-piercing case that might actually be worth such a large sum.[2] One person familiar with the facts of the case stated that the young girl had claimed that she had contracted epilepsy as a result of the fall. Another person familiar with the case informed the author that upon the trial the claim of epilepsy was disproved by experts.[3]

Insurance Coverage

Another ear-piercing case comes from California. The case is *Hollingsworth v. Commercial Union Insurance Company* (1989) 208 Cal.App.3d 800. The issue before the California Court of Appeal was whether ear piercing was a "professional service" excluded from coverage under an insurance policy. Hollingsworth was an individual who operated a business by the name of Merle Norman Cosmetics–Eastland, a cosmetics store. On June 7, 1984, a minor had her ears pierced at the store by one of Hollingsworth's employees. A lawsuit was subsequently filed on behalf of the minor, claiming that the ear piercing had resulted in serious injury and disfigurement. The California court

2. Contrary to any concept of fairness, some trial judges will award whatever sum is requested on a default judgment. This appears to have been the case here. Such a practice is a sad commentary on the justice system.
3. Interview by author with Frederick B. Safford, Jr., corporate counsel for Studex®.

held that the insurance company did not have to defend the litigation and that ear piercing was a professional service.

The *Hollingsworth* case emphasizes the need for any business that engages in ear piercing to make sure their insurance policy provides coverage for this activity. The case is also interesting for the insight that it provides into the operation of the ear-piercing business. Several excerpts from the decision follow:

Commercial moved for summary judgment based upon the terms of the insurance policy and the manner in which the injury to Davis occurred. In opposition, Hollingsworth submitted her own declaration describing her business and the ear-piercing operation she offered her customers. In pertinent part, she stated: "5. As of June, 1984, I employed two girls to sell our products and do ear-piercing. They were paid $3.65 per hour as a base wage, and a small percentage of their sales, which if added to their base wage amounted to about $4.00 to $4.50 per hour. When I hired them, I did not require that they have a high school education or that they have any special knowledge of my business or of ear-piercing.

"6. In March, 1984, the representative of the manufacturer of the ear-piercing tool visited my Studio and spent no more than twenty (20) minutes demonstrating to me and my employees how to use the tool. Neither I nor my girls took any classes or special training in ear-piercing and, to my knowledge, the manufacturer's representative had no special training, nor was he licensed. The tool was simple to operate, was non-electric, and required no particular skill.

. . .

"8. We pierced ears for free if the customer purchased one set of earrings from us. We did not give any discount on the earrings if the customer did not need an ear-piercing. . . . "

Another insurance coverage case is *Amer. Nat. Fire Ins. v. Esquire Labs of Ariz.*, 694 P.2d 800 (Ariz.App. 1984). That case involved a process of surgically implanting artificial hairlike fibers into the human scalp. One paragraph of the insurance policy was quoted in the decision, which excluded coverage for ear piercing:

. . . the insurance does not apply to bodily injury or property damage due to the rendering of or failure to render any cosmetic, ear piercing,

tonsorial, massage, physiotherapy, chiropody, hearing aid, optical or optometrical services or treatments (p. 809).

Breach of Employer Regulations

The case of *Alston v. Bythedale Child Hosp.* (1994), 1994 U.S. Dist. LEXIS 5034, 64 Fair Empl. Prac. Cas. (BNA) 1056, involved a claim of illegal employment discrimination. The plaintiff claimed that she pierced the ear of at least one patient during her work at the hospital and was fired for doing so after unsuccessfully seeking permission on a second occasion. Although the issue in the case was whether the plaintiff was entitled to pro bono counsel, the court did volunteer that " . . . the conceded use of a hospital workplace for ear piercing is at least potentially hazardous and properly prohibited."

Dearth of Reported Decisions

Cases involving ear piercing other than the several discussed above could not be located. This does not mean there were not other cases, since decisions in the trial courts are not generally available to legal researchers. The court files would have to be physically examined, one by one, at each courthouse in each county throughout the United States.

The dearth of reported decisions would generally mean that there is not much litigation involving ear piercing, and the injuries sustained are usually not too severe.

SEVENTEEN
Medical Complications and Benefits from Ear Piercing

Medical complications from ear piercing are relatively rare. And, when they occur, they generally are the result of failure to comply with the ear care instructions provided by the ear-piercing salon.

Contact dermatitis (sensitivity to nickel) is not caused by ear piercing. It is the result of subsequent wearing of earrings containing nickel. This subject is discussed in chapter 18 in this book titled "Metal Sensitivity and Dealing with the Problem."

Risk of Infections

A newly pierced ear that has become infected with everyday type of germs will grow red, sore, swollen, and full of pus. The earring should be removed and medical attention obtained at the first sign of the infection becoming a problem. This is especially true of babies.

One emergency room doctor reported that he saw too many cases of botched and infected *home-pierced* ears.[1] This is probably because sterilized needles were not used. A severe infection can even result in the loss of the pinna (external ear) and require plastic surgery.

Minor infections can often be cleared up with over-the-counter household medications. One possible solution suggested by a professional ear piercer is to place a small hinge or snap-bar hoop in the infected earhole. This allows the ear hole to breathe better. This might explain why small hoops are commonly used in new piercings in Australia.

Serious Infections

Ear piercing carries a risk of serious infection. The possible infec-

1. Prodigy, Health & Lifestyle Bulletin Board, Topic: Medical, Subject: Baby: Ears Pierced, March 8, 1993.

tions from blood-transmitted diseases include hepatitis and AIDS.[2] That is the reason to *refuse* to undergo ear piercing at parties, in prisons, and anywhere a common needle is used. If the person performing the piercing does not use disposable surgical gloves, is on alcohol or drugs, or does not use a fresh pre-sterilized ear-piercing stud from a bubble package for each piercing, do not allow your ears to be pierced. It is the equivalent of unprotected sex with a total stranger.

Do not use a sewing needle, a safety pin, or previously used piercing stud to pierce your ear. These implements cannot be safely sterilized by immersing in rubbing alcohol or chlorine bleach, by placing in a flame, or by boiling. Even a new sewing needle or safety pin purchased from a store may be contaminated by prior handling. Proper sterilization requires expensive equipment and extremely high temperatures for half an hour or more. There is probably not a single ear-piercing salon that has such equipment. That is the reason that all reputable piercing salons utilize only presterilized piercing studs from bubble packages, which are used one time only. In addition, the personnel use new disposable surgical gloves for each ear piercing.

Special Risks of High Ear Piercings

One medical article concluded that ear piercing that traverses cartilage "increases the risk of infection which may produce severe cosmetic deformity." (See "Hazards of ear-piercing procedures which traverse cartilage: a report of *Pseudomonas perichondritis* and review of other complications," *British Journal CP,* November 1990, Vol. 44, No. 11, at page 512.)

Trigus Piercings

A young female was observed by the author who had her trigus pierced. This is the protruding skin and cartilage at the entrance to the

2. An article titled "Canadian Died of Aids after Acupuncture, Says Embassy," appeared in *The Reuter Library Report,* December 8, 1987, Tuesday, AM cycle. The article stated in part: "It said Canadians abroad should avoid procedures involving skin penetration, such as acupuncture, ear piercing and tattooing, wherever sterility was not assured by unquestionable medical supervision."

ear canal. If this location for piercing becomes popular, it should be done by a medical doctor. Any infection at that location would probably involve risk to hearing and a very serious medical problem.

Earlobe Keloids

Earlobe keloids may result from ear piercing. The other causes are burns, surgical procedures, lobular avulsion, and any form of trauma. A keloid is a kind of fibrous tumor forming a hard, irregular, clawlike growth upon the skin. In the Detroit study of six clinics, 3 percent of females under age twelve had keloid problems.[3] In an article titled "Carbon Dioxide Laser Excision of Earlobe Keloids; a Prospective Study and Critical Analysis of Existing Data," *Archives of Otolaryngology—Head and Neck Surgery* 1989; 115: 1107-1111, September 1989 (copyright 1989, American Medical Association), the article concluded that the cause of keloids remains mysterious. The data for the article came from thirty-eight patients treated at the New York (NY) Eye and Ear Infirmary from 1986 to 1988. All patients were female, the majority were black and Hispanic, and none were white. The article stated: "In vitro studies have shown that keloids from blacks have a higher rate of collagen synthesis, as compared with the rate of collagen synthesis in keloids from a population of whites." (Reprinted with permission.) Three of the patients reported a reoccurrence of keloids during pregnancy.

Acupuncture Points in the Ear

One woman writing on Prodigy stated that there were between 150 and 200 acupuncture points in the ear. Another writer who identified himself as a doctor (the type was not stated) stated that he was opposed to ear piercing. He claimed that the constant stimulation of meridian points in the ear could upset the energy balance of the body.[4] He did not state how stimulation could exist after the piercing had

3. "Earrings: A Piercing Question," *American Journal of Diseases of Children* 1992; 146: 509, April 1992.
4. Prodigy, Health & Lifestyle Bulletin Board, Topic: Medical, Subject: Baby: Ears Pierced, March 19, 1993.

healed into an open ear hole channel. Another writer on the Prodigy Religion bulletin board claimed that a person had died from wearing five earrings, and that piercing ear meridians on a continuing basis can kill a person.[5]

The purpose of including the foregoing paragraph in this book is not to give credence to the tales, but to alert people to misinformation that circulates from time to time. With perhaps a billion persons (1,000,000,000) or more undergoing ear piercing during the last five thousand years, medical science has never identified any genuine health hazard from ear piercing, other than the possibility of infections and metal allergies.

Sharing of Pierced Earrings

The sharing of pierced earrings among friends should be avoided according to an article by Dr. Howard Seiden, appearing December 23, 1993, in *The Toronto Star*.[6] The reason for this advice is the health risk if the earrings are contaminated with blood. This blood contamination can result not only from the earring post being inserted through an infected ear hole, but also from finger contact with blood, which then touches the earring. Finger contact with blood can result from a nick while shaving body or facial hair, using dental floss, brushing teeth or gums, by a noise bleed, or by any number of daily occurrences. Dr. Seiden recommended that if earrings are borrowed, they should be sterilized with alcohol and chlorine bleach before use.

"No Try-On Laws"

Dr. Seiden also recommended that earrings be bought from a store that adheres to the "no try-on law." Although people often refer to laws that supposedly prohibit customers from trying on pierced earrings, the author was not able to find any such law in the California statutes or the California Administrative Code. The author believes that the

5. Prodigy, Religion Bulletin Board, Topic: Latter-Day Saints, Subject: Male Earrings Here!!, February 28, 1993.
6. "Strange Tidbits on Life's Quirks," by Dr. Howard Seiden, *The Toronto Star*, December 23, 1993, Life; page D3.

bulk of such "laws" are actually store policies. Besides, these "laws" or "policies" are frequently broken. Jewelry stores often allow favorite customers and store personnel to try on pierced earrings. And, the more expensive the earrings, the more likely that the store will allow the customer to try on the earrings.

U.S. Patent No. 5,309,737 was issued on May 10, 1994, for a device that would indicate whether the pierced earring and clutch have ever been disassembled. The purpose behind such a device is to indicate to customers (and merchants or jewelers) whether the earrings have been tried on or worn. The inventor[7] stated in his patent that some customers purchase pierced earrings, wear them once or twice, and then return them for a refund or exchange. The patent continues that "many persons who wear earrings develop infections around the pierced holes in their ears, often causing blood and other bodily fluids to be received onto the post and clutch of the earring."

Because of the above possible problems, the cleaning of even new earrings is a good idea. However, tough germs, such as the hepatitis-B virus, will not be killed by such cleaning. The AIDS virus is much easier to kill than hepatitis B, and is more likely to be killed by immersion in chlorine bleach. Both germs will die a natural death if the earrings are simply not worn for the requisite number of days or months. Although clip-on earrings are not mentioned by Dr. Seiden, there is no reason that his advice should not be followed just the same. This is because a high percentage of clip-on earrings are worn by females with pierced ears.

Medical Benefits from Ear Piercing

Ear piercing in the form of ear staples or acupuncture may provide several medical benefits. Ear staples that pierce the ear at acupuncture points have been used for the treatment of obesity. Acupuncture of the ears has also been used, and apparently quite successfully, as a treatment for substance abuse.[8] The procedure is for the acupuncturist to affix four one-half inch steel needles into each person's earlobes, where they remain for forty-five minutes.

7. Marcos Fountoulakis of Cranston, Rhode Island.
8. "Needles Pierce Drug Abusers' Wall of Misery," by Jack Williams; *The San Diego Union-Tribune,* September 19, 1993, Local; Ed. 1,2; page B–1.

Acupuncture for substance abuse was discussed by *Consumer Reports* in their January 1994 issue.[9] The article stated that acupuncture as a treatment for drug addition was first discovered in 1972 by a Hong Kong neurosurgeon. Acupuncture apparently causes the body to release chemicals known as endorphins, which have neurochemical effects similar to those of opium. Withdrawal symptoms and cravings abate within minutes of acupuncture treatment to the ears. The article states that almost four hundred programs in the United States and Europe are now in operation utilizing acupuncture to the ears as treatment for drug and alcohol addiction.

U.S. Patent No. 5,176,009 was issued on January 5, 1993, to residents of the Federal Republic of Germany for open hoop earrings. The inventors claim that acupuncture effects result from the constant flow of electricity from one side of the open hoop, and through the outer ear to the other side of the hoop.

9. "Alternative Medicine: The Facts," *Consumer Reports,* January 1994. See subtitle "Acupuncture" at pages 54–59.

EIGHTEEN
Metal Sensitivity and Dealing with the Problem

Introduction

Dermatitis is the inflammation of the skin. Contact dermatitis is an inflammation caused by the skin coming into contact with a substance that causes an inflammation. Nickel is the most common contact allergen in many countries.

No one is sensitive to nickel at birth. The sensitization starts through skin contact with metallic nickel and nickel salts. Nickel must be in a soluble state to pass the horny layer and enter the epidermis where it can cause skin disease. The surface of metallic nickel is corroded by water and sweat. Nickel ions thus formed enter the skin. The corrosion resistance of different nickel alloys is variable, and this will affect their sensitizing properties. The stratum corneum barrier restricts most of the metal ions and only minimal amounts of nickel will pass an undamaged horny layer.

Nickel is a moderately strong allergen. The risk of becoming sensitized is related to the concentration of allergen, the area exposed, and the time of exposure. Other factors of significance are the mode of exposure of the skin to the allergen, humidity, pH, bacterial flora of the skin, and the presence of other chemical substances.[1]

The same text also comments about a possible genetic relationship to the development of nickel dermatitis:

The development of contact allergy requires both an allergen and presupposed a genetically susceptible individual. . . . The importance of genetic factors for allergic contact sensitization has only been investigated to a limited extent.

If a group of individuals is exposed to a potent sensitizing chemical

1. *Nickel and the Skin: Immunology and Toxicology,* Edited by Howard I. Maibach, M.D., and Torkil Menné, M.D., ©1989, CRC Press, Inc., Boca Raton, Florida. See Chapter 12, "Occupational Nickel Dermatitis," by Torkel Fischer, at page 120.

(for example poison ivy or epoxy resin), only a proportion is sensitized by the first exposure. Repeated exposures will sensitize still more, but probably not all individuals in the group. . . . Thus, in both human and animal studies, great individual variations in susceptibility to sensitization are found, and in certain individuals there seems to be a complete refractoriness to develop contact allergy.[2]

One medical study suggests that prolonged exposure raises the frequency of sensitization to nickel.[3] The same text states: "Therefore, even if the individual has a genetic predisposition, nickel sensitization only takes place if there is a relative massive cutaneous exposure." (At page 105)

Symptoms of Earlobe Dermatitis

Metal sensitivity from wearing earrings will show the following symptoms at the earlobes: redness, swelling, itching, soreness, rash, scaling or crusting of the skin, drainage from the ear hole, and difficulty in inserting an earring. One woman reported to the author that her infections extended down into the glands of her neck.

Percent of People with Sensitivity

The estimates of the percentage of people with metal sensitivity problems relating to earrings vary. One estimate reported in the Minneapolis *Star Tribune* was that 10 to 15 percent of people with pierced ears will develop an allergic reaction to nickel.[4] Another estimate reported in *The Vancouver Sun* was 15 percent.[5] A study in Great Britain revealed the following figures *among people with skin problems:*

2. *Nickel and the Skin: Immunology and Toxicology,* Edited by Howard I. Maibach, M.D., and Torkil Menné, M.D., ©1989, CRC Press, Inc., Boca Raton, Florida. See Chapter 10, "Genetic Aspects of Nickel Sensitization" by T. Menné and N. V. Holm, at page 102.
3. *Nickel and the Skin: Immunology and Toxicology,* Edited by Howard I. Maibach, M.D., and Torkil Menné, M.D., ©1989, CRC Press, Inc., Boca Raton, Florida, at page 76.
4. "Nickel Usually Is the Metal that Triggers an Allergy," *Star Tribune,* Section: Variety, Fixit, Page 9E.
5. "Allergy Means Earring Trove Isn't Worth a Plugged Nickel," by Lisa Tant, *The Vancouver Sun,* April 26, 1994, Style, Elements of Style, Page C2.

The study involved 600 patients referred to a dermatitis clinic at the Royal Hallamshire Hospital, Sheffield. It found that 30 per cent of women with skin problems had nickel sensitivity, compared with 4.4 per cent of men. Of the women under 30 with pierced ears, 46 per cent displayed nickel sensitivity compared with 29 per cent of women in the same age group without pierced ears.[6]

An article appearing October 1994 in *American Journal of Diseases of Children* stated that it has been estimated that 2.5 percent of schoolchildren 5 to 13 years of age have nickel sensitivity. The article also stated that since 1969, nickel sensitivity has been on the increase in the general population as a result of environmental factors that influence sensitization.[7] Since 1969 there has been a large increase in ear piercing, and in 1965 the U.S. introduced its 75 percent copper, 25 percent nickel-clad 10-cent and 25-cent coins, which previously had been nickel-free. In 1971 the 50-cent coin was also changed to the same clad composition. Other countries have also switched from silver to nickel coinage in the last half century.

A recent study in Denmark showed 11.1 percent nickel patch-test positive females in the Gentofte region, however, in the age group 15–34 years, the figure rose to 19.6 percent.[8] (A positive patch test does not mean that all those persons have allergic contact dermatitis. However, it is thought that those persons are at risk of developing allergic contact dermatitis if exposed at a concentration exceeding a person's threshold level.[9])

In a 1982 to 1983 study of 8-, 11-, and 15-year-old Swedish schoolgirls, 9 percent of the schoolgirls who were patch tested for nickel sensitivity tested positive. Of those with pierced ears, the percentage was 13 percent. Only 1 percent of those with unpierced ears tested positive. Among those with pierced ears, 11 percent of those with one

6. *The Independent*, May 5, 1992, Newspaper Publishing PLC referring to an article published in the *British Journal of Dermatology*. Reprinted with permission.
7. "Allergic Contact Dermatitis in Children," by William L. Weston, M.D., and Janet A. Weston, M.D., *American Journal of Diseases of Children*, October 1984, 138: 932-936.
8. "The Effect of Repeated Open Exposure to Low Levels of Nickel on Compromised Hand Skin of Nickel-Allergic Subjects," by C. F. Allenby and D. A. Basketter, *Contact Dermatitis*, 1994, 30, 135–138, at page 135.
9. "Nickel Sensitization and Ear Piercing in an Unselected Danish Population," by Niels Henrik Nielsen and Torkil Menné, *Contact Dermatitis*, 1993, 29, 16–21, at page 19.

hole per ear tested positive, and 19 percent of those with more than one hole per ear tested positive.[10]

The percentage of persons with nickel sensitivity is higher among those exposed to nickel in their employment:

> The frequency of contact allergy to nickel among our patients, in a department of occupational dermatology, is 30% among females and 8% among males, while figures on nickel allergy for the general population are 10% for females and 1% for males.[11]

An article appearing in *The Jerusalem Post,* May 17, 1992, indicates that nickel sensitivity has become increasingly common among men who pierce their ears and wear earrings containing nickel.

Nickel Legislation

As the result of numerous studies involving nickel dermatitis, several European countries have adopted regulations aimed at preventing or reducing nickel sensitization in the general population. In addition, the European Economic Community has regulations under consideration.

The country of Denmark adopted a regulation effective January 1, 1992, which outlaws the sale of earrings containing nickel with mobility above .5 µg per cm^2 per week (it appears that each earring in a pair can release this amount of nickel). The regulation also applies to ear-piercing studs, rings, necklaces, bracelets, watch cases and bands, eyeglass frames, and buttons, buckles, rivets, zippers, and metal ornaments in garments that come in frequent contact with the skin. The full text of this regulation, which has been translated from Danish, appears in Appendix B to this book.

10. "Ear Piercing—a Cause of Nickel Allergy in Schoolgirls?" by Birgitta Larsson-Stymne and Lena Widström, *Contact Dermatitis* 1985, 13, 289–293, at pages 290 and 291.
11. "Cold-Impregnated Aluminum, a New Source of Nickel Exposure" by Carola Lidén, *Contact Dermatitis,* 1994, 31, 22–24, at page 24.

In 1990, Sweden adopted a regulation prohibiting ear piercing with an ear piercer or ring containing more than 0.05 percent nickel. And in Germany, effective June 1991, objects containing nickel must be labeled "Contains nickel and may cause an allergic reaction."[12]

Proposed European Economic Community regulations obtained by the author would consist of three provisions. The first provision would prohibit ear-piercing studs (or first earrings inserted after piercing if pierced by other than a stud) from containing more than 0.05 percent nickel "expressed as mass of nickel to total mass." The second provision would prohibit nickel release from jewelry and related items such as eyeglass frames, clothing buttons, rivets, and zippers from releasing nickel at a rate greater than 0.5 $\mu g/cm^2/week$. The final provision covers coated or plated items, such that the nickel release cannot exceed 0.5 $\mu g/cm^2/week$ for a period of 3 years of normal use of the product. A proposed reference test for release of nickel is 5 pages long, and requires "[a]n atomic absorption spectrophotometer or other suitable instrumental analysis capable of determining a concentration of 0.01 mg/1 nickel."

Nickel Release Sufficient to Elicit Dermatitis Symptoms

One study indicated that a nickel release of as little as 0.05 μg could elicit dermatitis symptoms in *nickel sensitive* persons with healed ear holes. The authors then theorized: "It is probable that this amount of nickel would induce contact allergy when released in the fresh holes."[13] Another writer commented that there is insufficient knowledge about the minimum dose of nickel that would trigger a reaction in a sensitized individual.[14]

Of the people sensitive to nickel, the degree of sensitivity varies from individual to individual. A person may experience sensitivity even though the Denmark test for nickel mobility is passed. Once a

12. "Nickel in Jewellery and Associated Products," by Carola Lidén, *Contact Dermatitis*, 1992, 26, 73–75, at page 74.
13. "Nickel Release from Ear Piercing Kits and Earrings," by Torkel Fischer, Sigfrid Fregert, Birgitta Gruvberger, and Ingela Rystedt, *Contact Dermatitis*, 1984, 10, 39–41, at page 41.
14. *Nickel and the Skin: Immunology and Toxicology*, Edited by Howard I. Maibach, M.D., and Torkil Menné, M.D., ©1989, CRC Press, Inc., Boca Raton, Florida. See Chapter 12, "Occupational Nickel Dermatitis," by Torkel Fischer, at page 120.

sensitivity problem has developed, it usually gets worse from repeated exposure to nickel. By way of illustration, if a certain pair of earrings causes a reaction after wearing them all day, as the problem gets worse, the same reaction may result from wearing the earrings for only an hour. If a problem is detected, the offending earrings should be dealt with or eliminated before the sensitivity becomes a larger problem requiring medical attention.

Sensitivity to a metal often becomes apparent after ear piercing. One dermatologist wrote in the *British Medical Journal* that the medical literature reports a significant correlation between ear piercing and the development of nickel sensitivity. His opinion was that the act of piercing was unlikely to be responsible for the nickel sensitivity, but that it was caused from the subsequent wearing of earrings containing nickel.[15]

Nickel Content in Jewelry

Nickel is widely used in jewelry, watches, and eyeglass frames. A recent article in *Contact Dermatitis*[16] discussed the nickel content of various metals. It stated that the nickel content in stainless steel or surgical steel varies from 0.5 to 30 percent and that the most common alloy contains 8 percent nickel. White gold usually contains 10 to 15 percent nickel, and is used to turn the gold white. German silver is an alloy with 60 to 65 percent copper, 20 to 30 percent zinc, and 10 to 15 percent nickel. Solders for gold, silver, and other alloys often contain nickel. Some silver items are nickel coated to prevent tarnish. Gold plating may be alloyed with nickel or cobalt, and may have a nickel coating underneath. Hard gold plating contains nickel. This method is used to give karat gold a different color, especially gold necklaces. (The author has a fourteen-karat gold chain that appears to have been coated with eighteen-karat gold to make it look more expensive.) On rare occasion sterling silver (92.5 percent pure) may contain nickel. The term "Rhodiated" has been corrupted so that it often means nickel plated.

15. "Any Questions," by R. D. Aldridge, Senior Lecturer and Honorary Consultant Dermatologist, Edinburgh, *British Medical Journal*, August 8, 1992, Vol. 305, at page 357.
16. "Nickel in Jewellry and Associated Products," by Carola Lidén, *Contact Dermatitis* 1992, 26, 73–75.

Nickel is contained in or used as a coating on many costume earrings; i.e., so called "cheap earrings." Even fourteen-karat yellow gold earrings may contain nickel. Purity standards in effect in different countries often set forth only the percentage of pure gold. Fourteen-karat gold must contain 14/24ths pure gold, and eighteen-karat gold must contain 18/24ths pure gold. The other elements are usually not restricted. One manufacturer commented to the author that karat yellow gold alloyed in the United States typically contains no nickel, but that foreign gold often contains some nickel. Yellow gold is commonly alloyed with copper and silver. Gold jewelry is not available in twenty-four-karat since pure gold is too soft for jewelry and especially earring posts.

Nickel Release from Stainless Steel Earrings

A study published in 1984 in *Contact Dermatitis*[17] tested various stainless steel earrings from the Swedish market for the release of nickel. The nickel release was determined by storing the studs/clasps at room temperature in 0.5 ml of synthetic sweat at pH 6.4 for one week, and the nickel content was determined by graphite furnace atomic absorption spectrophotometry. The results were as follows:

Description of Earrings	Nickel Released
Ear-Piercing studs and clasps	
8 brands of stainless steel studs/clasps	0.05–3.0 µg
2 brands of stainless steel studs/clasps	15 and 19 µg
6 brands of gold-plated studs/clasps	0.04–0.15 µg
7 brands gold-plated studs/clasps	6–25 µg
3 brands of silver-plated studs/clasps	0.05–1.0 µg
"hypoallergenic" studs/clasps[18]	0.005 µg
Unused earrings	
1 stainless steel earring	2.3 µg
2 gold-plated earrings	2.6 and 7.5 µg

17. "Nickel Release from Ear Piercing Kits and Earrings," by Torkel Fischer, Sigfrid Fregert, Birgitta Gruvberger, and Ingela Rystedt, *Contact Dermatitis*, 1984, 10, 39–41.
18. Marketed in the U.S. by H & A Enterprises.

2 silver-plated earrings	0.05 and 0.1 μg

Earrings causing dermatitis

6 earrings	14–442 μg

The study noted that the nickel released was for one stud/clasp. The above study shows a wide divergence in nickel release. It should be noted that this study is approximately twelve years old. The nickel release from stainless steel earrings presently being sold in various marketplaces is unknown.

A recent study of nickel release from several grades of stainless steel was published in *Corrosion Science* in 1993.[19] Rather than merely testing stainless steel earrings available in the marketplace with unknown compositions and formulations, the researchers instead tested samples of AISI 303, 304, 316L, and 430 stainless steel. A table in the article gave the nickel content of the samples: AISI 303, 8.449 percent; AISI 304, 8.647 percent; AISI 316L, 11.29 percent; AISI 430, 0.109 percent. The researchers also used a sample of pure nickel (99.79 percent) and nickel-plated steel.

The researchers conducted various tests, including patch tests on 50 nickel-sensitive patients. The circular samples were 1.5 centimeters in diameter.

The leaching levels of nickel from the pure nickel and nickel-plated steel samples were reported in the order of 100 μg cm^{-2} week^{-1}. For AISI 304, 316L and 430, the leaching levels were reported to be around 0.1 μg cm^{-2} week^{-1} in the most corrosive solutions and often beyond the detection limit of 0.014 μg cm^{-2} week^{-1}. For the AISI 303 stainless steel, the nickel release was reported close to 0.5 cm^{-2} week^{-1}.

On the patch tests, 96 percent of the nickel-sensitive patients were reported intolerant to the nickel-plated steel, 14 percent intolerant to AISI 303, and zero percent intolerant to AISI 304, 316L, and 430.

19. "Nickel Release from 304 and 316 Stainless Steels in Synthetic Sweat. Comparison with Nickel and Nickel-Plated Metals. Consequences on Allergic Contact Dermatitis," by P. Haudrechy, J. Foussereau, B. Mantout, and B. Baroux, *Corrosion Science*, Vol. 35, Nos 1–4, pages 329–336, 1993.

Dealing with Nickel Sensitivity

The first avenue of dealing with nickel sensitivity is not to aggravate the problem. Unfortunately, too many females continue to wear earrings that cause sensitivity problems. Some females engage in a continuing cycle of clearing up their earlobes, wearing earrings containing nickel, clearing up their earlobes, and so on.

> It is surprising how often girls will continue to wear ear rings and tolerate the discomfort of the eczema they know they produce. Murno-Ashman, MacDonald and Feiwel (1975) reported that three nickel sensitive women with pierced ears continued to wear their ear rings until they dropped out leaving them with ear lobes permanently split in two.[20]

When the problem has grown sufficiently severe that a person experiences drainage from the ear hole, the continued wearing of earrings containing nickel is unwise. "[N]ickel . . . readily dissolves in whole blood and in synthetic sweat" (Chapter 4).[21]

Other than avoiding earrings that cause the problem, there are other actions which can be taken.

Clean the Earrings

If earrings containing nickel are periodically removed and the surface wiped clean of corrosion product, the chances of dermatitis occurring is reduced.[22]

Avoid White Gold

If a person is sensitive to nickel, white gold should be avoided. This is because modern white gold usually contains a fair percentage

20. *Contact Dermatitis* by Etain Cronin, ©1980, Longman Group Limited, Churchill Livingstone, Edinburgh, London, and New York, at page 355.
21. *Nickel and the Skin: Immunology and Toxicology,* Edited by Howard I. Maibach, M.D., and Torkel Menné, M.D., Phd., ©1989, CRC Press, Inc., Boca Raton, Florida. See Chapter 13, "Nickel Allergy and Hand Eczema," by D. S. Wilkinson and J. D. Wilkinson, at page 142.
22. *Nickel and the Skin: Immunology and Toxicology,* Edited by Howard I. Maibach, M.D., and Torkil Menné, M.D., Phd., ©1989, CRC Press, Inc., Boca Raton, Florida. See Chapter 4, "Nickel Alloys and Coatings: Release of Nickel," by L. G. Morgan and G. N. Flint, at page 53.

of nickel. According to one source, the range of composition of the alloy is wide, but a common alloy in the U.S. contains approximately 75 percent gold, 17 percent nickel, 2 percent copper, and 5 percent zinc.[23] A study of 18 nickel-sensitive women who were patch tested with white gold discs 7 millimeters in diameter and containing 2.5 percent to 15 percent nickel was reported in *Contact Dermatitis*.[24] All of the subjects showed at least one positive patch-test reaction. The nickel release of these white gold discs varied from 0.09 to 0.82 µg. The nickel release from rhodium-plated discs was 0.04 to 0.54 µg. The nickel release was measured by graphite furnace atomic absorption spectrophotometry, the detection limit of which is 0.005 µg/ml. All of the dimethylglyoxime tests were negative.

Avoid Yellow Gold Soldered with Flux Containing Nickel

Some fourteen-karat yellow gold earrings may not contain any nickel at all, yet a nickel sensitivity may be triggered. The reason may be that the fourteen-karat post was soldered to the main part of the earring with solder flux containing nickel. Gold solder may show as a discoloration on the gold post. If the solder is buffed off, the metal sensitivity to the particular earrings may be reduced or eliminated.

Wear Silver Earrings

Silver earrings usually do not contain any nickel. Silver jewelry is often alloyed with 90 percent silver and 10 percent copper, as were the majority of silver coins minted by the United States. Sterling silver contains slightly more silver at 92.5 percent and 7.5 percent copper. The disadvantages to silver earrings are that they tarnish (turn black) from lack of use or polishing, and the posts and clasps bend easier. Because of the relatively low price of silver, more women should consider buying large silver earrings to replace some of their costume jewelry. The tarnish problem can largely be eliminated by storing them in airtight plastic bags.

23. Ibid., page 49.
24. "Contact Sensitivity to Nickel in White Gold," by Torkel Fischer, Sigfrid Fregert, Birgitta Gruvberger, and Ingela Rystedt, *Contact Dermatitis* 1984, 10, 23–24.

Wear Titanium Earrings

Titanium is claimed by some people in the industry to be a proven allergy-free metal. Because there is some evidence as well as a belief that some Japanese are allergic to gold, at least one ear-piercing supplier is marketing titanium ear-piercing studs in that market. Titanium earrings are not generally available; however, a number of gift shops carry various styles. Most titanium earrings are of a dangle variety, and purchasers should make sure that the hook that goes through the ear hole is also made of titanium. The author observed in one gift shop that many hooks appeared to be made of a base metal which may have contained nickel.

Wear Plastic Ear Hole Sleeves

Another possible solution is to buy and wear the plastic ear protectors marketed by E'arrs, Inc. These ear protectors are sleeves which fit over the metal post of a problem earring to form a barrier between skin and metal. The sleeves are cut to size by the purchaser and include a plastic backing which fits snugly over the metal post. The front of the sleeve includes a small flange which tends to keep the solder joint away from the earlobe. These sleeves may also be used with hoop- and hook-type earrings. The concept of these sleeves is to simply keep the earring from coming into contact with the skin of the earlobe.

E'arrs® Ear Care brand of ear protectors are widely available at many stores. The product comes in a dark blue or dark green plastic box and is typically hung on racks with costume earrings. (Shoplifters often remove the contents and leave the box, so check to make sure that the contents are present before you make your purchase.) This product may allow the continued wearing of earrings that cause metal sensitivity. The sleeves do cause the post to become thicker; however, this is not a problem except for those with very tiny ear holes. If the sleeves are too large to be comfortably inserted through the ear hole, they can be lubricated prior to insertion. The ear holes will adjust to the larger size within a week or two.

Coat Posts with Fingernail Polish

Another possible solution for the continued wearing of nickel

earrings or other problem earrings is to use clear fingernail polish to coat the earring posts. Some recommend that the fingernail polish be allowed to cure for a month before the earrings are worn. E'arrs, Inc., utilizes a similar concept with L'Protect™, a clear coating that is applied to earring posts.

Coat Posts with Ear Gel

A person suffering from contact dermatitis or just sore ears may find relief by using Ear Care Gel® marketed by E'arrs, Inc. The gel comes in a tube containing .25 fluid ounces (7.39 milliliters) and sold recently for $5.00. The packaging card states on the front, "Fast, soothing relief from sensitivity due to metal contact," and "Dermatologist Tested!" The back of the card states, "For daily use in the promotion of healthy, infection free earlobes and prevention of sensitivity caused by earrings. Scientifically formulated and clinically tested."

Ear Care Gel™ is a nongreasy product that is virtually odor-free. The latter is especially important for males with pierced ears. The instructions state that the gel should be applied to the earlobe and earring post and wire. The contents of the gel are listed as, "water, propylene glycol, ethyl alcohol (SDA-40), polyacrylic acid, triethanolamine, aloe, benzalkonium chloride, hydrocortisone (0.5 percent), methyl and propyl paraben, color." (By comparison the ear-care solution marketed by Claire's Boutique contains only benzethonium chloride in a 0.13 percent concentration.) The tube for Ear Care Gel™ also states, "Also effective for other areas irritated by jewelry contact."

Neomycin, one of the main ingredients in Neosporin®, may cause an allergic reaction in some people.[25] If a flare-up results from Neosporin®, a hydrocortisone ointment might be tried instead. It should be noted that Ear Care Gel™ by E'arrs® described above contains 0.5 percent hydrocortisone.

EarWorks™, a company based in Sacramento, California, recommends that its product called Gell'ee (containing aloe) be used on earring posts prior to insertion through the ear hole as well as on the earlobes. The packaging card states that use of the product will "allow

25. "Handling Tick Repellants," by Ridgely Ochs, *Newsday*, May 2, 1992, Part II; Personal Health; Page 25.

you to wear almost any earring without discomfort or irritation," and the product tube states, "Protects Your Ears Against Irritation and Inferior Posts." The listed ingredients are: petrolatum, mineral oil/lanolin, dimethicone, vitamin E-tocopherol, jojoba oil, wheat germ oil, propyl paraben, aloe, and allantoin. The product has a slight medicinal smell, although it probably is not noticeable when it is worn, and is also somewhat greasy.

Earrings for Sensitive Ears

One company that specializes in the marketing of earrings for sensitive ears is Roman Research, Inc. The trademark used is "Simply Whispers®." This company states in its catalog that it uses 24-karat gold electroplating over 100 percent surgical stainless steel used for medical instruments, and that the earring assemblies are fused together in a process that uses no irritating solders. The company states that its earrings have been proven hypoallergenic in laboratory tests by dermatologists. The earrings come with a "Lifetime Comfort Guarantee." The company is located at 33 Riverside Drive, Pembroke, Massachusetts, 02359-1910, and may be reached at 1-800-451-5700. The earrings range in price from $4.00 to $17.00. The company will send a free catalog containing hundreds of styles of earrings.

Simply Whispers® earrings were worn at the request of the author by two different women with sensitive ears. Both reported no further problems, although one even experiences problems with wearing a wrist watch.

Another company with a somewhat similar approach is Superior Jewelry Co., 8935 Rossash Road, Cincinnati, Ohio, 45236. The company markets its earrings under the trademark of "Soft Touch™" Earrings for Sensitive Ears. The company uses 24-karat gold plating over surgical stainless steel (surgical stainless steel only on silver styles), and advertises a "Lifetime Guarantee Against Discomfort!"

Test Earrings for Nickel

A person with a nickel sensitivity problem may want to purchase a dimethylglyoxime testing kit to test jewelry objects for nickel. One such kit is known as Allertest™-Ni, and is available through Allerderm Laboratories, Inc., P. O. Box 931, Mill Valley, California, 94942-0931,

1-800-365-6868, and credit cards are accepted. The kit consists of two plastic vials of chemicals.[26] The test is conducted by placing three or four drops from each vial on a cotton swab tip and rubbing the tip against the earring for fifteen seconds. If the cotton tip turns strawberry-red in color, the presence of nickel is indicated. The instructions indicate that enough chemical is included for thirty tests. The kit costs $10.50, plus shipping and handling charges. The Danish regulation specifies the same chemical test as is available from Allerderm Laboratories. See the full text of the regulation contained in Appendix B to this book, and especially the last section labeled "Appendix—Method of Analysis."

The Allertest™-Ni kit was ordered by the author and the price with shipping came to a total of $14.00. The address label from Allerderm Laboratories, Inc., stated: "Contact Dermatitis & Hand Protection Specialists." The kit included a "Patient Order Form for Nickel Detection Kit." That form is apparently dispensed to dermatologists for their distribution to patients. In testing various earrings, the author obtained some positive tests.

If a person desires to use an object containing known nickel for control purposes, a U.S. five-cent coin (commonly referred to as a "nickel") minted from 1938 to 1942 and 1946 to the present contains 25 percent nickel and 75 percent copper. The clad surfaces on more recent U.S. ten-cent, twenty-five-cent and fifty-cent coins also contain 25 percent nickel and 75 percent copper. The one franc and two franc coins from France contain 99.9 percent and 99.8 percent nickel.[27]

The dimethylglyoxime test has been criticized as insufficient to give adequate information about nickel release to a highly sensitized individual.[28] According to one study, only about 10 μg or more released nickel can be detected with dimethylglyoxime.[29] According to other

26. One vial contains 10 percent ammonium hydroxide and the other vial contains 1 percent dimethylglyoxime in denatured alcohol.
27. *Nickel and the Skin: Immunology and Toxicology.* Edited by Howard I. Maibach, M.D., and Torkil Menné, M.D., Ph.D., ©1989, CRC Press, Inc., Boca Raton, Florida. See Chapter 4, "Nickel Alloys and Coatings; Release of Nickel," by L.G. Morgan and G.N. Flint, at page 49.
28. "Contact Sensitivity to Nickel in White Gold," by Torkel Fischer, Sigfrid Fregert, Birgitta Gruvberger, and Ingela Rystedt, *Contact Dermatitis* 1984, 10, 23–24.
29. *Nickel and the Skin: Immunology and Toxicology.* Edited by Howard I. Maibach, M.D., and Torkil Menné, M.D., Ph.D., ©1989, CRC Press, Inc., Boca Raton, Florida. See Chapter 9, "Clinical Concepts in Nickel Testing" by K. Lammintausta and H. I. Maibach, at page 93.

researchers, the dimethylglyoxime test appears irrelevant to determine which alloys can induce nickel tolerance. They report that the acid etching in the test destroys the passive film of stainless steels and reduces their corrosion resistance, an important property which enables them to be safe with regard to nickel allergy.[30]

Avoid Wearing Earrings Containing Nickel in the Summer

Earrings containing nickel should be especially avoided during the hot and humid months of the summer. This is because a hot and humid climate increases nickel corrosion from nickel plated and nickel alloy articles.[31] One young woman reported to the author that her sensitivity was experienced much more quickly and more severely when she spent the summer in humid Washington, D.C., as opposed to Southern California.

Avoid Foods High in Nickel

Some researchers believe that persons allergic to nickel might benefit by eating less of the mineral. Foods high in nickel include apricots, chocolate, coffee, beer, tea, and nuts.[32] Cooking foods high in acid in stainless steel pots results in a significant nickel enrichment. In addition, the first tap water may be contaminated with nickel from standing in pipes and fittings.[33] However, other researchers consider it unlikely that nickel in food can influence the course of nickel dermatitis.[34]

30. "Nickel Release from 304 and 316 Stainless Steels in Synthetic Sweat. Comparison with Nickel and Nickel-Plated Metals. Consequences on Allergic Contact Dermatitis," by P. Haudrechy, J. Foussereau, B. Mantout and B. Baroux, *Corrosion Science*, Vol. 35, Nos 1–4, pages 329–336, 1993, at page 335.
31. *Nickel and the Skin: Immunology and Toxicology*. Edited by Howard I. Maibach, M.D., and Torkil Menné, M.D., Ph.D., ©1989, CRC Press, Inc., Boca Raton, Florida. See Chapter 11, "Epidemiology of Nickel Dermatitis," by T. Menné, J. Christophersen, and A. Green, at page 110.
32. "Ear Piercing Can Spark Allergy to Metals," by Paul Berg, *Washington Post*, June 11, 1986, WH5, Col. 3.
33. *Nickel and the Skin: Immunology and Toxicology*. Edited by Howard I. Maibach, M.D., and Torkil Menné, M.D., Ph.D., ©1989, CRC Press, Inc., Boca Raton, Florida. See Chapter 12, "Occupational Nickel Dermatitis," by Torkel Fischer, at page 119.
34. Ibid., page 176.

Earrings Advertised as "No Nickel" or "Nickel Free"

Within the last several years, the author has noted numerous costume earrings in Southern California stores which are labeled on the sales cards as "nickel free" or "no nickel." Most consumers probably would believe that the earrings contain no nickel, i.e., 0.0 percent or something close to that.

In reading the sales card on one pair of earrings that proclaimed "Nickel Free" on the front, the author noted the following disclaimer on the reverse side: "This earring is plated by a new process that eliminates nickel, the main irritant to the skin." Therefore, it would appear that "nickel free" meant only that the plating on the earring was nickel free.

The author found other earrings which stated "no nickel" and "303 surgical steel" on the front of the packaging card. The reverse side of the card stated: "Engineered with the finest quality 303 surgical steel and plated with 24kt gold. No Nickel." Since 303 surgical steel contains 9 percent nickel[35] according to one source, and 8.449 percent nickel[36] according to another source, the meaning would appear to be that the plating does not contain nickel. Another pair of earrings stated "nickel free" and "24kt gold over surgical steel."

Other earrings found by the author merely stated "nickel free" or "no nickel" without any disclosure that it was only the plating which was nickel free. The author was told by one jewelry manufacturer that it had recently assayed earrings advertised as "nickel free." ("Assayed" means that the earrings were heated until the metal liquified, and the percentage of different metals was measured.) These "nickel free" earrings were found to contain 8 to 12 percent nickel! This percentage of nickel may pass the nickel test discussed previously in this chapter, so the nickel content is impossible to discover without destroying the earrings.

Many earrings are advertised merely as being "hypoallergenic."

35. *Nickel and the Skin: Immunology and Toxicology*. Edited by Howard I. Maibach, M.D., and Torkil Menné, M.D., Ph.D., ©1989, CRC Press, Inc., Boca Raton, Florida. See Chapter 4, "Nickel Alloys and Coatings: Release of Nickel," by L. G. Morgan and G. N. Flint, Table 3 at page 50.
36. "Nickel Release from 304 and 316 Stainless Steels in Synthetic Sweat. Comparison with Nickel and Nickel-Plated Metals. Consequences on Allergic Contact Dermatitis," by P. Haudrechy, J. Foussereau, B. Mantout, and B. Baroux, *Corrosion Science*, Vol. 35, Nos 1–4, pages 329–336, 1993, See Table 1 at page 330.

According to some dermatologists, that term has little meaning.[37] They suggest wearing earrings with surgical steel posts. Although surgical steel typically contains nickel, the steel binds the nickel in such a way that it should not cause an allergic reaction. Some people, however, report problems with wearing surgical steel earrings. Regardless of dermatologists' and other experts' opinions, the important thing to wear what works for you.

Sensitivity to Other Metals

Most of the literature on sensitive ears deals with allergic reactions to nickel. However, some people may be allergic to gold, silver, or virtually any other metal. One newspaper columnist wrote that she was sensitive to gold-plated jewelry, as well as solid silver, sterling silver, and surgical stainless steel.[38] Medical reports from Japan indicate that some Japanese may be sensitive to gold. Although one article indicated that sensitivity was rare, reported cases have been increasing in recent years as ear piercing becomes more common in Japan.[39] These medical articles are especially interesting since only a low percentage of Japanese women currently have pierced ears.

Visit Your Dermatologist

If left untreated, allergic contact dermatitis may last fourteen to twenty-eight days after avoidance of the allergen.[40] If the sensitivity problem persists or becomes more severe, a visit to a dermatologist should be arranged.

37. "Handling Tick Repellants," *Newsday,* Nassau and Suffolk Edition, Part II Personal Health, page 25.
38. "E'arrs a Way to Beat the Itch," by Dinah Lee, *The Straits Times,* October 1, 1992, Life, Fashion, Page 10.
39. "Gold Dermatitis Due to Ear Piercing: Correlations between Gold and Mercury Hypersensitivities," by Junko Osawa, Kazuko Kitamura, Zenro Ikezawa, Takeshi Hariya, and Hiroshi Nakajima, *Contact Dermatitis,* 1994, 31, 89–91, at page 91.
40. "Allergic Contact Dermatitis in Children," by William L. Weston, M.D., and Janet A. Weston, M.D., *American Journal of Diseases of Children,* October 1984, 138, 932–936.

NINETEEN
Correction of Enlarged or Torn Ear Holes

Historical Perspective

Pierced ear holes feel the effect of gravity and tugs and pulls as millions of women in the current earring generation are finding out through personal experience. This is not a new problem. Roman writers such as Pliny, Seneca, and Petronius (who lived in the first century A.D.) wrote about *auricolae ornatrices*, women who attended to the problems of patrician ladies caused by the wearing of large and heavy earrings.[1]

Roman males also suffered from torn earlobes. The Greek writer Plutarch (A.D. 46 to 120) in *Caius Marius* tells the story of a Roman general by that name who "fell distracted" and who was thrown into prison. While there, some tore off his clothes, "and others, whilst they struggled for his golden earring, with it pulled off the tip of his ear."[2] It is suspected that this account is slightly exaggerated, and what really happened is that his pierced ear hole was torn through the bottom of the earlobe.

Maximum Weight of Earrings

Girandole earrings (similar to an upside-down candelabra) became popular in Europe in the mid-1700s. Some of these earrings were so heavy that jewelers soldered an extra loop on the earrings for a ribbon to be tied from the earrings to the hair to help support the weight. Other variations for dealing with extremely heavy earrings were an extra hook over the top of the ear. Some of these earrings weighed thirty-nine grams or more for each ear. In commenting upon such heavy earrings, the authors of *Earrings, from Antiquity to the Present*

1. *Earrings, from Antiquity to the Present*, by Daniela Mascetti and Amanda Triossi, ©1990 Thames and Hudson Ltd., London, and published by Rizzoli International Publications, Inc., New York, at page 19.
2. *Caius Marius*, by Plutarch, A.D. 75, translated by John Dryden. Contained on CD-ROM, *Library of the Future*, 3rd Edition, Screen 17: 78, Windows Ver. 3.0. ©1990-94, World Library, Inc., 12914 Haster Street, Garden Grove, CA 92640, 714-748-7197, 1-800-443-0238.

claim that a weight of twenty-two grams per earring is considered to be as heavy as a woman can comfortably wear (page 45).[3]

So that the above gram weights are meaningful, the following comparisons are given. A U.S. silver dollar produced from 1878 to 1935 weighs 26.73 grams in uncirculated condition, a U.S. half-dollar dated 1971 and later weighs 11.34 grams, and a U.S. quarter dated 1965 and later weighs exactly one-half as much or 5.67 grams. Two silver dollars hanging from each ear would not feel very comfortable, nor would even one. The claim that earrings as heavy as 22 grams each can be *comfortably* worn is simply incorrect.

Many jewelers have electronic scales for weighing gold chains and other jewelry. They often will weigh jewelry such as earrings upon request. One woman reported to the author that she has two pair of heavy, sterling silver earrings. One pair is a jointed fish skeleton, which was purchased in Mexico, and the other is a cut-out cat mounted on a silver hoop, which was purchased from QVC. Both pair of earrings hang from hooks through the earlobes. After wearing either pair of these earrings all day long, she reported that her earlobes became sore. These earrings were weighed at 7.8 grams each for the fish earrings and 7.9 grams each for the cat earrings. These weights are almost halfway between the weight of a U.S. quarter and a half-dollar. Were these earrings to be worn every day, month after month, it would not take long for the ear holes to become elongated.

Cause of Elongated and Torn Ear Holes

The constant wearing of heavy earrings is the biggest cause of elongated ear holes. Heavy earrings that are suspended from a wire hook will do the most damage. The reason for this is that the wire on a hook is usually thinner than the post on a stud, or the post of a snap bar or hinge hoop. The thicker the post or wire that suspends the

3. The heaviest earrings that have been documented are those of the Masai people who live in Kenya, Africa. Married Masai females wear earrings "which often weigh more than a pound." *The National Geographic Magazine*, October 1954, "Spearing Lions with Africa's Masai," by Edgar Monsanto Queeny, pages 487 to 517. See photograph at page 492. It appears that the one pound is total weight. The earrings consist of extensive beadwork, about 6 inches in diameter (15 centimeters), and are worn in each ear through an extremely large hole towards the top of the ear. Reprinted with permission.

earring from the earlobe, the more weight that can be safely supported. For example, the large ear holes of King Tutankhamun, a pharaoh of Egypt from 1,361 to 1,352 B.C., allowed the wearing of extremely heavy earrings without any tearing of the ear holes.

The wearing of heavy earrings too soon after piercing contributes to elongated ear holes. The usual advice given by piercing salons is that small studs should be worn exclusively for the first three months, then lightweight hoops may be worn, and gradually the heavier earrings.

A multitude of traumas, i.e., tugs and pulls on the earrings, through the years also stretch the ear holes. Small babies are attracted by earrings, especially hoops and the dangle variety. The ear hole can tear if the baby pulls hard enough. Catching a comb or hairbrush in the earring can also cause a slight tear. Catching an earring in a shrub or tree branch can cause an immediate tear. Even if various tugs and pulls do not cause a tear, they tend to stretch the ear hole. Persons engaged in sports should avoid wearing earrings, except for small studs. Motorcycle riding without a helmet and with the wind whipping dangle or hoop earrings will also cause serious trauma to the ear holes.

A practice that should be avoided is wearing earrings to the hair dresser or barber. It is all too easy for a comb to become caught in an earring. In addition, permanent wave solutions are harsh chemicals that will turn sterling silver earrings black, and damage certain gemstones, such as opals and especially pearls.

Another cause of elongated ear holes may be spousal abuse. An article appearing in the *Chicago Tribune* reported on a woman's "twisted and lumpy ears" caused by her husband ripping out her earrings whenever he got angry.[4]

One female wrote January 25, 1992, on Prodigy[5] that she used to wear eight pairs of earrings in only three sets of ear holes. This means that she probably wore three earrings through each of the first and second sets of holes, and two earrings in her third set of holes. Although two earrings can probably be inserted through most ears that have been pierced for a while, this practice will rapidly increase the elongation of the ear holes and should be avoided.

Enlarged ear holes are not caused by wearing earrings to bed. In

4. "Swaying in the Wind," by Nina Burleigh, *Chicago Tribune,* March 18, 1990, Section 6, page 1.
5. Homelife Bulletin Board under Fashion.

fact, "sleeper" earrings have been worn to bed for a number of centuries to keep the ear holes open. The term "sleeper" refers to any small, stud earring that can comfortably be worn in bed. If earrings are worn to bed, sexual partners should not be allowed to tug or pull on the earrings during lovemaking. Small studs are usually not a problem, because the backing will come off with any pressure. With hoops and the dangle variety, excessive pulls will damage the ear holes.

Elongated ear holes are not only unsightly, but can result in the loss of an earring when the ear hole becomes large enough for the backing (clasp) of a stud earring to pass through. In its extreme form, the earrings will cut through the bottom of the earlobes and result in earlobe flaps.

The biggest tragedy of the recent earring generations (i.e., mid-1950s to the 1990s) is that very little attention has been paid to maintaining the ear holes in an attractive condition. (The mothers of these females either did not have pierced ears or discovered the effect too late to caution their daughters.) The advertising field has sidestepped the problem with its young female models by merely airbrushing out ear holes or the elongated portions of the ear holes.[6]

On male models the usual solution is to show only the nonpierced ear in the advertising copy. The rest of the earring generations are on their own.

Surgery

Fortunately, there is a relatively simple medical solution for the problem. The earlobes are first numbed by a doctor with a local anesthetic. The ear holes are then excised (i.e., cut around the inside perimeter so that a fresh wound is created) and then stitched closed in a relatively simple office procedure.

The stitches are removed in seven to ten days, and healing time is about a month. During this time no earrings can be worn, including

6. Ear holes are rarely shown in advertising copy. If the female model is not wearing earrings, the ear holes are airbrushed out of the photographs. (It is totally amazing how many females in advertising do not have pierced ears!) Yet, the next page of the same advertisement may show the same model wearing pierced earrings. Video clips apparently are more difficult to airbrush, since ear holes are frequently visible. The only difference is that the earlobes, if shown, are only visible for a fraction of a second.

clip-ons. The scar is fairly inconspicuous. After one to three months of healing, the earlobe can be repierced. The typical advice is to repierce at a slightly different location.

A young female who underwent the surgery reported that it was not done in a hospital but at a surgical center. The procedure took about half an hour, and she reported very little pain. After a week the stitches were removed, and three months later her ear was repierced. The person reported hardly any scar after the healing.

Another patient reported that the surgery took about twenty minutes, and the doctor placed about five small stitches in her earlobe. She came back a week later for a checkup, and her stitches were removed two weeks after the surgery. She was advised to wait another four weeks for the earlobe to heal before repiercing. The patient reported only a little line of a scar. She was advised by her doctor to rub a Vitamin E salve on her earlobe to help minimize the scar. This salve is available at most drugstores.

Although the procedure is relatively simple, the price is not. Commonly quoted prices in Southern California in the early 1990s are $275 to $600 per ear hole.[7] This fee typically covers the surgery as well as follow-up visits.

Physicians specializing in several specialties may undertake earlobe surgery. These specialties include plastic surgeons, ear-nose-throat specialists (otorhinolaryngology), as well as dermatologists. One woman in the Los Angeles area interviewed by the author had her surgery done by her ear-nose-throat doctor. The charge for one ear was $300. She reported that a dermatologist she contacted quoted a fee of $500. She had not contacted a plastic surgeon. Any person needing this surgery should check around before choosing a doctor. At a minimum the person should make sure that the doctor has had previous experience with this type of surgery.

Dr. Lori Hansen, a facial plastic surgeon in Oklahoma City, Oklahoma, was quoted in *The Gazette (Montreal)*, August 1, 1991:

"I've been amazed at how many cases we've been getting, and it's because there's been a trend" toward heavier earrings. During her first

7. Pity the poor young female with eleven or twelve ear holes per ear who wants to tidy up her ears. She better ask for a volume discount from the plastic surgeon.

years of practice in the mid-1980s, Hansen never saw a torn ear lobe. Now she patches up one a week. "I think it began with the trend toward short hair. When your hair is short you don't have any other way to dress up (the face) but earrings."

Her most common patient is "the woman who's worn weighty, long, dangly earrings for years and they've just worked their way through the ear lobe."[8]

The foregoing article stated that Dr. Hansen wore pierced earrings only for special occasions. Such conservatism appears to be a reaction to the problems that she sees on a continuing basis and was not given as advice. Advice given in the article, however, is that the earlier a plastic surgeon is consulted, the easier the condition is to repair.

Dr. Nancy L. Silverberg, a board-certified dermatologist in Newport Beach, California, discussed earlobe surgery in the *Orange County Register,* June 26, 1991, and stated: "Enlarged holes in the ears are common and becoming more so as big earrings come into style. Elongated holes pose no health danger. Deciding whether to repair them and at what point it should be done varies for each person."[9]

Another problem which surgeons are seeing is where ear holes have torn from one hole into another, because of too many piercings in an ear. This is where a person gets three or four piercings per ear, and then decides to add new holes between the existing holes. This type of surgery can be much more expensive to repair.

Some insurance plans cover ear-hole surgery. If the torn earlobe resulted from a sudden trauma, such as catching an earring in a tree branch, medical insurance is more likely to cover the cost. If the stretched ear hole is simply the result of wear and tear through the years, insurance coverage is less likely.

Advertising of Earlobe Surgery

That stretched and elongated ear holes have become a major

8. "Hula-Hoop-Sized Earrings Send 'Torn' Women to Plastic Surgeons," *The Gazette (Montreal),* August 1, 1991, Living; page F6. Reprinted with permission from Dr. Lori Hansen.
9. "The Weight of Fashionable Earrings Can Cause Elongated Lobe Holes," by Susan Kelleher, *Orange County (California) Register,* June 26, 1991, Accent, page E1. Reprinted with permission from Dr. Nancy L. Silverberg.

problem for females is evidenced by the following advertisement that appeared in the *Los Angeles Times,* View Section, Orange County Edition on February 22, 1993:

TORN EAR LOBES?
We're The Experts
Board Certified
Ear Surgeon
1-800-734-FACE
Free Consultation
Appropriate Insurance Accepted

The person answering the above telephone number stated that the cost per ear was approximately $600. She explained the procedure, stating that two layers of stitching were performed: one on the inside of the tear and the other on the outside.

The tragedy is that more people are not aware of the simple surgical procedure, and the relief provided.

Closing of Unwanted Ear Holes

Surgery is by no means limited to females. Males may also require or desire ear-hole surgery. An article appearing in the *St. Petersburg (Fla.) Times,* July 18, 1990, stated that young men who had their ears pierced while in college could have plastic surgery to remove the ear hole when they entered the business world.

Females who get carried away with large number of ear piercings and then later regret them can also get the extra holes closed surgically.

Increased Media Attention

Fortunately, the problem of stretched ear holes is receiving more media attention as of late. The November 1991 issue of *Cosmopolitan* carried a short article on page 114 under "beauty helpline." The article suggested caution when engaging in "potential lobe-ripping behavior," such as pulling clothing over the head, styling hair, and playing with babies who tend to grab.

The *Toronto Star,* July 6, 1991, reported: "Plastic surgeons are doing more and more repair jobs on women's ear lobes due to problems with

pierced holes" (Section: Life, page G2. Reprinted with permission.) Hopefully increased media attention will prevent the need for surgery among people with newly pierced ears. In addition, millions of potential patients will learn of relief available to them.

Some news articles speak of "earlobe age." The concept is misleading, since it is based on the inevitable stretch of ear holes. A female reporter for the *Chicago Tribune* wrote: "But I'm at least 15 years behind my peers as far as drag on my lobes. I didn't get mine pierced until I was almost 30, when my mother finally said I could. Even though I'm 40, I have an equivalency earlobe age as young as 25."[10]

If a person wears only small studs, the ear holes should not stretch even after years of wearing earrings. If heavy earrings are only worn occasionally, ear-hole stretch should be minimal.

10. "Feeling the Pinch? It's Still Better Than Stitched Ears," by Bonnie McGrath, *Chicago Tribune*, September 29, 1991, Womanews, page 7, zone: CN. © Copyrighted Chicago Tribune Company. All rights reserved. Used with permission.

TWENTY
The Ear-Piercing Business

According to one estimate, ear piercing is a $200 million a year, worldwide industry.[1] It is unknown as to how accurate this figure is. Assuming that the average cost of ear piercing is $20, this translates into 10 million people paying to get their ears pierced each year. If the average cost is $10, then the figure rises to 20 million people. In addition, there are the cultures and instances where ear piercing is done at home by friends and relatives.

The author has chosen to portray in this chapter two large ear-piercing chains and two large ear-piercing equipment suppliers that do business in the U.S.

Claire's Boutiques

Claire's Boutiques, Inc., which is based in Pembroke Pines, Florida, 33027, at 3 S.W. 129th Avenue, Suite 400, operates 1,037 stores under the names of Claire's Boutique, Topkapi, and Dara Michelle. The chain operates out of small stores in most shopping center malls.

The chairman and chief executive is Rowland Schaeffer, an entrepreneur in his mid-seventies. When he bought the chain twenty years ago, it had only about twenty-five stores. Schaeffer expects to have 2,000 stores within five years.

The stores specialize in inexpensive women's accessories, including earrings, belts, handbags, ties, necklaces, and hair supplies. The core customers are teenage girls, although earrings are now being sold for male customers.

Ear piercing is typically done towards the back of the stores, hidden from the view of shoppers walking in the shopping malls.

The chain has been selling male earrings for several years. Originally, a small selection of earring singles were sold as unisex earrings. Later, earring pairs were also labeled as unisex.

1. California Committee Analysis Statement for Assembly Bill 3787 (Valerie Brown) as amended in Assembly, May 23, 1994.

Piercing Pagoda

Another large ear-piercing chain is Piercing Pagoda, Inc., which is based in Bethlehem, Pennsylvania, at 3910 Adler Place, telephone 215-691-0437. This chain of approximately 300 stores covers most of the United States and operates mainly out of kiosk-type stores situated in the pedestrian areas of shopping malls. The chain also operates stores under the name of Plumb Gold, as well as fine jewelry departments for other stores. A listing of all their stores appears at Appendix D of this book.

These stores are unique in that the ear piercing is done in full view of mall shoppers. The psychology of this is that shoppers who stop or tarry to watch a piercing often return to have their ears pierced.[2] Friends and relatives often photograph the ear piercing, and a carnival-type atmosphere sometimes prevails. Female shoppers sometimes indicate their approval, especially of males getting their ear or ears pierced, welcoming them to the pierced-ear club. Males often watch a piercing while trying to get up enough nerve to have their own ears pierced.

Piercing Pagoda specializes in 14-karat gold earrings, including real and simulated gemstones. Their prices are in the discount realm, since they purchase direct from jewelry manufacturers. In many cases, Piercing Pagoda's prices are as low or lower than the discount stores. In addition, it has a "Buy 5 Get 1 Free Jewelry Club!" where the value of the free item is based on the average price of five purchases.

The company offers "free" ear piercing for the price of the piercing studs. Ear-piercing customers have their choice of 14-karat studs by Inverness® Corporation and 24-karat gold-plated piercing studs by Studex®.

Piercing Pagoda was one of the first national retailers to recognize the large market potential for male earrings. A large percentage of its earring inventory is suitable for wear by males. In addition, it was one of the first retailers willing to sell earring singles by breaking up pairs. This practice dates back to the early 1970s. The price of a single is one-half of the price of a pair, plus a surcharge of only one dollar. Although a high percentage of males now have both ears pierced, the

2. The Inverness Ear Piercing Training Manual recognizes this fact: "People who watch a piercing often become customers too." At page 4.

162

sales of earring singles has remained steady. This is probably explained by the fact that though the market for male ear piercing is expanding, men frequently start with a single piercing.

The salespersons at Piercing Pagoda are experienced in assisting male customers in selecting earrings for themselves. In addition, they have been trained to make their male customers feel comfortable.

Ear piercings at Piercing Pagoda have grown from 345,000 in 1986 to over 500,000 in 1990. At some locations of Piercing Pagoda, ear piercings for males are now 40 percent or more of their business. During the last seven years, the percentage of ear piercings for male customers has doubled.

Ear piercings for males and the sale of earrings for wear by males has become big business for Piercing Pagoda.

Inverness Corporation

Inverness Corporation is one of the world's leading supplier of quality ear-piercing instruments and supplies. It is currently the only supplier of 14-karat gold piercing studs, although it also sells 24-karat gold-plated piercing studs. Through 1993 the company sold piercing studs and supplies for piercing the ears of 130 million persons in over forty-five countries. The company is located at 17-10 Willow Street, Fair Lawn, New Jersey, 07410, Telephone 1-800-631-0860 or 201-794-3400, and Fax 201-794-6814.

The Inverness® 2000 Ear Piercing System is designed to ensure completely sterile ear piercings. The piercing studs and clasps are contained in disposable plastic capsules that slide into the piercing instrument. It is only these plastic capsules that touch the ears. These capsules come in sterilized packages, and are removed and inserted into the piercing instrument by the operator. Sales literature on the Inverness 2000 system directed to the jewelry trade is reprinted with permission at Appendix E of this book. The author does not endorse or recommend any ear-piercing system.

The Inverness® ear-piercing studs are made of 14-karat gold or are 24-karat gold plated. Inverness claims that its 14-karat gold piercing studs as well as its gold-plated studs and clasps are now manufactured free of nickel in the alloy portion. (A company spokesperson stated to the author that its gold-plated studs are a modified form of AISI 430

stainless steel with reduced nickel.) The Inverness® 2000 System uses hand pressure to do the piercing, rather than a spring mechanism.

Inverness® has taken an active part in training retailers in the proper use of their piercing instrument. They have prepared a training video as well as a training manual, and they have a professional trainer available to assist retailers with training sessions.

The company stresses safety and quality in its ear-piercing instruments and supplies. The Inverness® system was mentioned in the July 1994 issue of *Seventeen* magazine in its "Beauty Workshop Q + A" column (reprinted with permission):

> The Inverness system, used by thousands of stores across the country, is ultrahygienic since the earrings are loaded into the piercing instrument in disposable capsules that are never touched by human hands. Another plus: Inverness starter earrings come in about 30 styles and have microfine, pointed posts (the part that goes through your ear) so they don't make an unnecessarily large hole.

In its sales literature distributed in 1993, Inverness® recognized the following "Ear Piercing Market Trends":

• Younger piercings
• Men
• Multiples for men and women
• Smaller earrings
• Unbalanced look (anything goes)
• Ear piercing as a statement, rite of passage, creative expression

In mid-1994 Inverness® launched an advertising campaign in *Vogue, New Woman, Beauty Handbook, Glamour,* and *Self* magazines to promote the Inverness® Personal Ear Piercing kit as well as to promote the Inverness name. The packaging for the personal ear piercer was redesigned and features the head of an attractive young female in a reclining position, with the nose of an attractive young male coming from the top of the photograph and nearly touching the bridge of the nose on the female. The female has three studs in her left ear, and the male has one stud in his left ear. In a brochure directed towards jewelers and ear-piercing salons, the claim is made that "[o]ver 97% of all women and 20% of men will pierce their ears . . . "

The Inverness® ads were found by the author in the April 1994

issue of *Glamour,* Advertising Section, 1/6 page; March 1994 issue of *New Woman,* Advertising Section, 1/6 page; and Walgreens Drug Store's *Beauty Handbook* (no date on the cover which pictures supermodel Niki Taylor). This ad was a full page in size and featured a blow-up of the same picture contained on the packaging of the product. The single stud in the male model and the three studs in the female model were very visible. The advertising copy concludes with the following:

> So if you're one of the millions of men or women with earrings on your mind, go to it and do it, the safe and easy way—with the Inverness Personal Ear Piercer.

Studex®

Studex U.S.A., Inc., together with its affiliates, is another of the world's leading suppliers of quality ear-piercing instruments and supplies. The company is headquartered at 25311 S. Normandie Avenue, Harbor City, California, 90710, telephone 1-800-24K-STUD or 310-539-0232, and fax 310-530-7252. The company has corporate affiliates in Australia (Bagatelle of Australia, telephone 61-2-564-1433, fax 61-2-560-7728), Canada (Bagatelle of Canada, telephone 416-678-1913, fax 416-678-9366), Germany (Studex Europa GMBH, telephone 49-9126-1088, fax 49-9126-1089) and the United Kingdom (Studex Mfg. UK. Lt., telephone 44-929-554026, fax 44-929-554036). Studex® also has offices in Japan, Moscow, Beijing, Rio de Janeiro, and Mexico City, with other offices planned.

Studex® specializes in 24-karat gold-plated surgical steel ear-piercing studs. It also manufactures a line of "no nickel" ear-piercing studs. Its guns are spring loaded and trigger released, and no hand pressure is required.

Studex® does all of its own manufacturing for worldwide sales at a plant located in Harbor City, California. The company reports that during the last several years production output exceeded 40 million ear-piercing studs (i.e., 20 million sets) per year with a capacity for over 72 million. The company is bullish on ear-piercing trends among females as well as males, and anticipates production will soon be at 70 million.

Dr. Tomo Takahashi of Tokyo, Japan, is the president of Studex of

Japan, and serves as a technical consultant for Studex U.S.A., Inc., in the development of new product lines. He is an extensive lecturer and researcher in the area of ear piercing.

Studex® places its priority on providing safe and hygienic ear piercings. The company emphasizes that its Studex® Ear Piercing System is a true one-handed operation, which ensures more hygienic piercings. Studex® is a member of the Ear Piercing Manufacturers of the United States, a non-profit corporation formed to promote safe ear-piercing practices. The corporate counsel for Studex®, Fred B. Safford, Jr., currently serves as its first president.

Studex U.S.A., Inc., in conjunction with Medisept, Inc., has recently placed on the market the Medisept® Personal Ear Piercer System. This system is a personal ear-piercing kit which includes two piercing instruments, each loaded with a single ear-piercing stud. The advantage of this system is that there is no finger contact in reversing the sterilized cartridge for the second piercing. The system is designed for a single use only and is then disposed of.

Sales literature on the Studex® system directed to the jewelry trade is reprinted with permission at Appendix F of this book. The author does not endorse or recommend any ear piercing system.

TWENTY-ONE
Marketing of Male Earrings

Earring Statistics

If this were a chapter on national statistics on earring sales to males, the chapter would be very short. According to Simone Lipton, a spokeswoman for Jewelers of America, there are no national statistics for earrings sales to men.[1] Ms. Lipton stated in 1990 that the earring fashion was the hottest in cities like New York, Los Angeles, and Chicago.

The only unisex statistic that could be found was that earring sales are usually four times that of necklace sales.[2]

Definition of the Market

No one really knows what percentage of males in the United States have one or both ears pierced. People in the jewelry business will often hazard a guess, but that is what it is. These "guesses" typically vary from 5 to 20 percent. In a July 13, 1993, article in *The San Francisco Chronicle*,[3] the following statistic was given: "One in five men have pierced ears."

In an August 5, 1993, article in *The Atlanta Journal and Constitution*, the Jewelers of America association was reported as having estimated that approximately 5 percent of all American males have pierced ears and that that percentage was growing.[4] This statistic was then picked up by a number of other newspapers and republished.

A medical study of men and women living near Copenhagen, Denmark, published in 1993 reported the following percentages of men

1. "The Piercing Blitz; The Look That Was Once Radical for Men Has Become So Conformist That Even Self-Described Conservatives See Earrings as Commonplace," *Newsday*, September 11, 1990, Nassau and Suffolk Edition, Part II; page 4.
2. "A Choker for Every Neckline; Winner by a Neck; Chokers, Baubles Capture Attention," *The Hartford Courant*, June 29, 1993, Lifestyles, page D8.
3. "Lifestyles of the Nervous '90s," by Alice Kahn and Shann Nix, *The San Francisco Chronicle*, July 13, 1993, People, page C3. ©*San Francisco Chronicle.* Reprinted by permission.
4. "5 Percent of Men Sport Earrings," by Doug Cress, *The Atlanta Journal and Constitution*, August 5, 1993, Living; Section E; page 5.

with pierced ears: ages 15–34, 30.5%; ages 35–49, 6.9%; and ages 50–69, 0.0%. For women the percentages were: ages 15–34, 91.5%; 35–49, 57.5%; and 50–69, 42.9%.[5]

Market Successes by Piercing Pagoda

Until 1992 the market for male earrings was almost ignored. Perhaps the most notable exception was Piercing Pagoda, Inc. with its chain of three hundred stores. It had discovered that the sale of single earrings was big business.

London

In London the advertising of male earrings had begun in 1990, if not earlier. The author recalls seeing a catalogue for a London jewelry store in July 1990 that contained a separate section for male earrings. Pictured in the catalogue were nine-karat gold hoops about three-quarter inch (two centimeters) in diameter. The store, which was located at the entrance to the Kensington underground station, included a separate section in its display case for male earrings.

According to an article appearing in *The Times (London)*, February 24, 1993,[6] midmarket jewelers, such as Ratners, Ernest Jones, and H. Samuel, are replete with male earrings and other male jewelry. It was also reported that the Elizabeth Duke of Argos catalog lists five different earring styles for males.

Department Store Advertising in the United States

With male ear piercing reaching to 50 percent and more of the ear-piercing business in some parts of the United States, the sale of singles became almost inevitable to smart business people. However, as more retailers started selling earring singles, the fashion for a majority of males has swung to having both ears pierced.

5. "Nickel Sensitization and Ear Piercing in an Unselected Danish Population," by Niels Henrik Nielsen and Torkil Menné, *Contact Dermatitis*, 1993, 29, 16–21, at page 18.
6. "A Fashion Near the Knuckle," *The Times (London)*, February 24, 1993, Features.

The first advertisements for male earrings in the United States that were found by the author were by the Broadway department store in Southern California for Valentine's Day 1992. Featured were magnetic earrings, with the notation that post earrings (a euphemism for pierced earrings) were also available. A sales clerk for the store stated that the male earrings were selling very well and were mostly sold out. The earrings were displayed near one of the sales counters in the men's clothing section.

Earlier, for Christmas 1991, the JC Penney store in the Laguna Hills, California, had set aside diamond earring singles in its male jewelry section. A male employee stated that males were buying diamond earrings up to one-half carat (50 points) in size.

As of early 1993, even the conservative retailer Sears Roebuck was selling earring singles (at least in its Laguna Hills, California, store). The singles that were advertised and sold were all of the variety that males typically wear. Other stores selling earring singles, unisex earrings, or male earrings included Bullocks, Montgomery Ward, Target, Payless Drugs, and Kmart.

An advertisement for Montgomery Ward Gold 'N Gems with prices good through April 10, 1993, included at arbitrary page 47 a small box for "14K Gold Singlet Earrings." Featured were five small gold hoops (including three hinged hoops), a cubic zirconia stud, a small cross, and a cubic zirconia stud with a small dangling cross.

In a Sears minicatalog of fine jewelry, fragrances and lingerie marked for post office delivery in Southern California on December 4, 6, 7, 1993, six separate "14k gold singlets" were shown on the tenth page (counting the cover as page 1). The singlets shown are a small ball, a cross, a lightning bolt, a dangling peace symbol (with a hammered texture), a smaller hoop with an inverted "U" wire, and a dangling sword on a wire, which hooks into an eyelet. All of these earrings are styles worn by males.

Simply Whispers

Roman Research, Inc., sells earrings under the trademark "Simply Whispers®." Their catalog for Holiday 1993 included for the first time a full page titled "Great for Gals & Guys, Single or Multiple Piercings New!" (page 33). This was its first catalog attempt to sell earrings to males. The earring styles shown are not exactly in the mainstream of

current male fashions, with some exceptions. These exceptions include a small peace symbol, a small anchor, a musical note symbol, and a spade and club (like in a deck of playing cards) in a black tone. Definitely out is a dangling heart with a bow on top of it! Also objectionable to most males is a dangling, double heart, and a medium-size hoop with a strung pearl and two gold balls.

On other pages of the Simply Whispers® catalog, the company shows a large variety of other styles, some of which are suitable for wear by males. These styles include virtually all of the birthstone colors in two-, three-, four- and five-millimeter sizes, gold and silver balls, post hoops (called "haloes" in the catalog), and post-style ear-clips and some smaller gold hoops. Roman Research, Inc., is located at 33 Riverside Drive, Pembroke, Massachusetts 02359-1910, and may be reached at 1-800-451-5700 for a free catalog.

TWENTY-TWO
Earrings and Ear Holes in Advertising and Other Media

Ear Holes in Advertising

Males

Since male models frequently have their left ear pierced, the right ear is often shown instead in advertising copy. Or the ear hole is simply airbrushed out of the photograph.

The problem is more difficult for movies, since airbrushing is not practical. The usual solution is to avoid showing closeups of the pierced ear. Ear holes are generally not a problem for contemporary movies. In period movies, ear holes on male actors look out of place, since they are not historically correct. In *A River Runs Through It* by Columbia Pictures, 1993, actor Craig Sheffer played older brother Norman. During most of the scenes, the actor's ear hole in his left ear was quite noticeable, and the film even showed several closeups of the left side of his face including his left ear, despite the film depicting life in the 1920s and the 1930s.

An advertisement from the U.S. Mint for the 1994 Silver Proof Set showed a male graduate in his cap and gown sans any earrings, but with an ear hole clearly visible in his right ear. (His left ear was not shown in the photograph.)

Females

The most common American practice for female models is for them to wear earrings, or for the ear holes to be airbrushed out if no earrings are worn. In addition, the elongated slit appearing above the earring on abused ear holes is frequently airbrushed out. Advertisers apparently believe that empty ear holes are not attractive. In contrast to American practice, French fashion magazines show empty ear holes nearly as often as airbrushing them out. However, abused or infected ear holes are not shown, just the attractive-looking ones.

The American practice is starting to change. The cover of the

171

magazine *Celebrity Hairstyles* for February 1994 shows a female wearing a tiny hoop with a dangling diamond (or cubic zirconia) in her first ear hole. Her second ear hole is empty and quite noticeable in the photograph.

In the magazine *Elle* for November 1993, the article "Spirit of the Andes" shows a female model with a very prominent, empty ear hole.

Earrings in Advertising

Male models wearing earrings were gradually creeping into printed advertising copy, as well as television commercials, by the early 1990s.

One notable exception was superstar Elton John who removed his earring for a Pepsi Light television commercial, which ran in early 1993. Since an earring in Elton John's right ear is part of his image, it was conspicuous by its absence.

By contrast, Willie Nelson was allowed to wear his diamond stud in a clever television commercial for Taco Bell which ran in early 1993.

Because females have generally been more receptive to earrings on males, advertisers in women's magazines can be somewhat bolder, if they choose.

An advertisement on behalf of Gitano watches appeared at page 65 of the August 1992 issue of *Seventeen*. A young male pictured in the advertisement was wearing a small hoop in his left ear.

An unusual advertisement appeared in the March 1993 issue of *Vogue* magazine on behalf of Sanyo, Carol Cohen, and Nordstrom. The ad depicted a group of four conservative-looking men in their thirties surrounding a somewhat younger female. All were dressed in beige raincoats and white T-shirts showing at the open raincoat collars. One male is wearing a small hoop earring, and the female is wearing no earrings and her ear holes are visible. What makes the ad unusual is that Sanyo Fashion House based in New York is a subsidiary of Sanyo Shokai Ltd., Tokyo, Japan. Since the Japanese frown on pierced ears even on their females, advertising copy by their American subsidiary showing pierced ear holes on a female and a hoop earring on a male is making quite a statement.

Although it is only indirect advertising, a story appearing in the *Los Angeles Times Magazine,* Sunday, April 11, 1993, on "hip-hop" fashion showed two young male models, one of whom was wearing a hoop

nose ring! Another photograph showed a larger, gold hoop earring being worn by another male model. (The story contained information as to where to buy the fashions.)

Earrings on Male Models in Clothing Advertisements

Sears Roebuck took a bold step in a small advertising catalog sent to its customers in mid-August 1993.[1] Page 21-1 pictured five young males in a group with the caption at the bottom of "back 2 campus." One of the males was wearing *two* small gold hoops in his left ear.

A week earlier retailer JC Penney in an advertising supplement to *The Orange County (California) Register,* August 8, 1993, showed a young male wearing a small, but thick gold hoop in his left ear. The supplement was titled "Back 2 School Sale," and showed the male on page 2.

Earrings on Males in Television Programs and in Movies

The television program *Deep Space 9* features Bajoran men (and women) who all wear a huge earring in their right ear. The earring consists of a bottom portion large enough to be a transmitting device, and a top portion connected via a chain.

The Fox television network was airing the western *The Adventures of Brisco County, Jr.* in the fall of 1993. The character Lord Bowler is a tall black man with longish hair who wears an earring.

The Sinbad Show also aired on Fox television during the 1993–94 season, and featured thirty-six-year-old actor and comedian Sinbad who wears a medium hoop earring with attached dangle in each ear. Sinbad (born David Adkins) is a black man with very short hair and no sideburns. During one show, Sinbad got into an argument with a female sports referee. She started taking off her earrings so she could engage in a physical altercation with Sinbad, who started doing likewise.

The movie *Lassie* released in mid-1994 is old-fashioned in a lot of ways; however, a modern touch is added with Matt and his eighth-

1. This catalog was received in Orange County, California, and bore the notation "Sears AC-266B." Prices were good for August 15 to August 28, 1993.

grade girlfriend exchanging earrings.[2] The apparel company Osh Kosh B'Gosh is commemorating the movie with a line of children's coordinates featuring Lassie's image. Company spokeswoman Cindy Herman noted:

> It's a perfect match for all the right reasons. Lassie is a tradition, like Osh Kosh B'Gosh. We share the same heritage and values.[3]

It is wondered whether that comment applies only to the dog or also to Matt and his girlfriend exchanging earrings!

As male earrings proliferate on television programs, they are getting larger. As one writer commented, "They need to get bigger ones so you can see them on TV."[4]

The Fox television series *New York Undercover,* which debuted in the fall season of 1994, featured two undercover cops each wearing an earring in his left ear: Malik Yoba as Det. J.C. Williams and Michael DeLorenzo as Det. Eddie Torres.

In the fall 1994 debut of *Beverly Hills 90201,* actor Brian Austin Green was wearing two hoops in his left ear and one hoop in his right ear. All of the hoops were of the same diameter.

Ear Piercing for Young Females in Movies

The movie *My Girl 2,* released midyear 1994 by Columbia Tristar Home Video, presents a mostly historical view of ear-piercing attitudes some twenty years ago. The movie begins in Madison, Pennsylvania, in 1974. A twelve-year-old or thereabouts girl flies to Los Angeles to visit her uncle to research information for a school project about her deceased mother.[5] The girl's father initially objects to her traveling

2. "Good Movie, Good Movie; Heartwarming 'Lassie' Keeps Legend Alive," by Roger Ebert, *Chicago Sun-Times,* July 22, 1994, Weekend Plus; Page 41; NC.
3. "Hot Props; Forever Young," by Rose Apodaca Jones, *Los Angeles Times,* Orange County Edition, July 21, 1994, Life & Style; Part E; page 4; column 6; View Desk. Reprinted with permission.
4. "Soccer Features Passion, Players with Great Hair," by Kyle Petty, *The Atlanta Journal and Constitution,* July 17, 1994, Sports; Section G; page 2. Reprinted with permission of *The Atlanta Journal* and *The Atlanta Constitution.* Reproduction does not imply endorsement.
5. The movie stars Dan Aykroyd, Jamie Lee Curtis, Anna Chlunsky, Richard Masur, Christine Ebersol, and Austin O'Brien.

alone to Los Angeles, stating, "You don't send a child alone to Los Angeles. She could come back with her ears pierced, her legs shaved and God knows what else."

The girl is shown around Los Angeles by the son of the uncle's girlfriend, who is about the same age as the girl. The inevitable happens and the girl succumbs to getting her ears pierced at a store in Hollywood. As the girl and boy are walking into the store for the ear piercing, the boy complains, "This is a totally barbaric custom." The camera then breaks to a scene after the piercing, and the girl asks, "So aren't you going to say anything about my earrings?" The boy responds, "I already did. It's a totally barbaric custom. But on you—it looks good."

As the girl and boy return to the uncle's house in the evening, the uncle and girlfriend are waiting for them. The girlfriend says to the girl, "And you, I don't suppose your father gave you permission to pierce your ears, did he?" The girl responds meekly, "Not exactly." The girlfriend continues, "He'll never let you visit us again if I send you home hairless and full of holes."

On the plane home, the girl opens her knapsack to look for a surprise hidden by the boy. Inside is a small box with a pair of dangling earrings with the note: "In memory of barbaric customs, Love, Nick." In musing to herself, the girl states, "Life is full of barbaric customs. I just hope they all end with a kiss like that."

Once home, the father merely states, "Hey, what's on your ear?" In the closing scene, the girl muses, "Dad's getting used to my pierced ears."

TWENTY-THREE
Short Stories Concerning Earrings

The First Lady and First Daughter

Hillary Clinton, President Clinton's wife and the First Lady, does not have pierced ears. According to an article appearing in *The Washington Post,* January 11, 1993,[1] Hillary Clinton "[w]hen she got to high school . . . rejected offers to have her ears pierced with a needle and potato, according to her best friends."

Also, Bill Clinton told *People* magazine during his election campaign that he would not let his then twelve-year-old daughter get her ears pierced.

Chelsea Clinton, however, listed as her immediate goal, "to get ears pierced" in an article appearing January 20, 1993, in *The Boston Globe.*[2] The seriousness of that reply is evidenced by comparing it with her long range goals of "astronautical engineer, space exploration." Chelsea celebrated her thirteenth birthday on February 27, 1993, but her parents did not relent to the ear piercing.

In a June 10, 1993, article appearing in *The New York Times,* the columnist writes: "We learn that Chelsea will be allowed to pierce her ears any day now."[3]

However, according to a spokesperson for the White House, Chelsea Clinton still did not have her ears pierced as of February 17, 1995.

1. "The Education of Hillary Clinton," *The Washington Post,* January 11, 1993, Style, Page B1. ©1993 *The Washington Post.* Reprinted with permission.
2. "Fun Facts about the First Family," *The Boston Globe,* January 20, 1993, City Edition; Living; page 27. Reprinted courtesy of *The Boston Globe.*
3. "Critic's Notebook; Getting to Know Mrs. Clinton in Both Her Hats," by Walter Goodman, *The New York Times,* June 10, 1993, Section C, page 17, column 1, Cultural Desk. Copyright ©1993, The New York Times Company. Reprinted with permission.

Large Ear Holes

"The coolest kids are piercing holes in their ears then stretching and, ouch, enlarging the holes." *USA Today,* September 29, 1992.[4]

Metal Detectors

The legal newspaper headline was, "Love Your Earrings: What Caliber Are They?" A woman was reported attempting to go through security to attend a hearing before U.S. District judge Gary L. Taylor in Santa Ana, California. She nearly had to do a striptease to stop the metal detector from going off. She finally succeeded when she removed her earrings. However, she was irritated when the earrings broke as she attempted to put them back on.[5]

Yugoslavian Rock Star

Bora Corba, a rock star, poet, and Serbian patriot from Belgrade, Yugoslavia, wears five earrings in his pierced left ear.[6]

UFOs and Ear Piercing

Even aliens from outer space are getting in on the piercing fashion. Annie C., a Brownie leader, was driving home at night when she was abducted by a UFO. The article appearing in *The Christian Science Monitor* stated:

> When she awoke, three and one-half hours had elapsed and she was on her way home. She could not account for that time, except her ears had been pierced.
> Her life, unlike Bobby C.'s, went along fine after this. She started wearing fancy earrings, got several dates, until she had a second "encounter" and had her nose pierced. Since then she's been in seclusion,

4. "New 'Dracula' Cloaked in Lush and Lusty Fashion," *USA Today,* September 29, 1992, Life; Page 8D. Copyright 1992, *USA Today.* Reprinted with permission.
5. "Slices, Just Don't Use Your Robe for a Tent," *Los Angeles Daily Journal,* April 15, 1993, Section II, page 1.
6. "Rocker Rails against Milosevic Regime," *The Times,* June 20, 1992.

running the Brownie troop via her Apple computer and a phone hookup.[7]

Why People Pierce Their Ears

A female writer who does not have pierced ears speculated as to the reasons for ear piercing:

Does their value indicate an acceptable way of revealing wealth? Are they sexual in nature, providing constant stimulation of a sensitive body part? Are they a holdover from tribal days, an honorable rite of self-mutilation? Or all of the above?[8]

Don't Wear Gold Earrings in the Pool

According to an article appearing in the *Chicago Tribune*, chlorine in swimming pools can eat away at gold.[9] Although there may be some truth in that claim, it is doubted that any serious problem would result. It is well recognized that fabrics in bathing suits eventually become weakened from exposure to pool chlorine, especially if the suit is not rinsed in clean water after use; however, any metal including gold is a lot more durable. A more practical reason not to wear expensive earrings while swimming in pools is to guard against loss. Although the gold settings in earrings might not be damaged, fragile stones such as opals and pearls probably would be adversely affected by pool chlorine.

Unfit Mother

A woman who lived in the Bronx section of New York was consid-

7. "Tales from the Centerville Woods," by Howard Mansfield, *The Christian Science Monitor*, March 2, 1988, Opinion; page 11. Reprinted with permission from Howard Mansfield. The account is fictional and is intended as humor.
8. "What's a Goddess without Her Earrings?," by Kathleen Krull, *Chicago Tribune*, September 13, 1992, Final Edition, Womanews; page 8; Zone: CN; Other Voices.
9. "Brighten Up, Household Cleaners Can Put the Sparkle Back into Your Fine Jewelry," *Chicago Tribune*, July 24, 1991, Style; page 8; zone: CN.

ered an unfit mother in part because she allowed her son to get his ear pierced. From *Newsday,* July 29, 1989.[10]

Better Husbands

Comedienne Rita Rudner quips that her husband is a guy who "thinks health food is anything you eat by the expiration date." And he has another shortcoming—he doesn't have a pierced ear. "Men who have had their ears pierced are better prepared for marriage," she explains. "They've experienced pain and bought jewelry."[11]

Michelangelo's Party

Famous artist and sculptor Michelangelo threw a party for his friends in the A.D. 1500s. One of the guests included fellow artist Cellini, who described in his autobiography dressing up a friend to impersonate a woman at the party: "In his ears I placed two little rings, set with two large and fair pearls: the rings were broken; they only clipped his ears as though they had been pierced."[12]

Clip-on earrings were not invented until approximately 1934, so Cellini had to improvise.

Bikinis and Earrings

Is there anything unusual about bikini-clad young ladies wearing earrings? Only if they were pictured in A.D. 400! The March 1976 issue of *National Geographic* contained a photograph of a 1,600-year-old mosaic unearthed in a villa near Piazza Armerina located in south central Sicily. The mosaic shows two young female gymnasts cavorting across the scene wearing garments virtually identical to present-day bikinis. The tops are tube-type with no straps. An earring appears to

10. "A Mother Wins Back Her Sons, Boys to Leave Foster Homes," *Newsday,* July 29, 1989, City Edition, News; page 3.
11. "Here Come the Academy (Yawn) Awards," *Newsday,* March 26, 1989, TV Plus; Screening Room; page 4. Reprinted with permission.
12. *Earrings: From Antiquity to the Present,* by Daniela Mascetti and Amanda Triossi, ©1990 Thames and Hudson Ltd., London, and published by Rizzoli International Publications, Inc., New York, at page 21.

be visible on the ear of one of the young ladies. This same mosaic has been pictured by other authors.[13]

My Earring Got Caught in Her Hair

A man charged with rape in Ireland claimed that his earring came off after it got tangled in his victim's hair. The victim, however, a nineteen-year-old woman, testified that during the struggle she pulled an earring from his ear.[14]

Erotic Writings

The earlobe is supposedly subject to erotic stimulation. But is the following erotic?

That's what men said when their lips were crushed against your earhole on the dance floor . . . [15]

Or how about the following prose?

Each kiss sensitized her to the next, each kiss was followed by a studious exploration of her face with his lips, first her ear lobes, from which he removed her earrings one by one before he took each dainty lobe and sucked it . . . learning it with his lips, his tongue and his grazing, careful teeth.

The above quotation is apparently from the book *Scruples Two* by Judith Krantz. In commenting upon the above quotation, Alex Witchel, writing in *The New York Times*, states: "Now, that's impressive. How

13. See *5000 Years of Fashion* by Mila Contini, ©1979, Chartwell Books, Inc., Secaucus, New Jersey, at page 26. See also *20,000 Years of Fashion*, Expanded Edition, by Francois Boucher with a chapter by Yvonne Deslandres, ©1987, Harry N. Abrams, Incorporated, New York, at page 122.
14. "Woman Consented to Sex, Trial Told," *The Irish Times*, June 19, 1993, Home News, page 7; and "Legal Arguments during Rape Trial," *The Irish Times*, June 17, 1993, Home News, page 2.
15. "Eating Children: The Shrinking Woman; Jill Tweedie Discovered Men at Finishing School, and Also What Girls Would Have to Do to Wind Them around Their Little Fingers," by Jill Tweedie, *The Guardian*© May 19, 1993, The Guardian Features Page, Page 8. Reprinted with permission.

many men even think of removing earrings, much less with their lips? I wonder if her ears are pierced."[16]

The Latest Actor Sporting an Earring

The news media continued reporting on celebrities who wear earrings through mid-1993. *Newsday* reported on May 18, 1993:[17] "SPOTTED: Jim Belushi at SCORES, the East-Side baseball and buns joint, sporting a discreet earring we don't remember seeing before."

Earring Crimes

Newsday, May 9, 1993, carried an article about street crime in Brooklyn, New York, involving earrings. A male suspect was snatching bell earrings from the ears of teenage girls. His method of attack was to sneak up behind a young female, pull out both earrings at the same time, and then run away. He had stolen so many earrings worth $110 a pair that high school girls started calling him the "Brooklyn Bell Robber."[18]

Nixon an "Earring Man"

Author Betty Beale in her book *Power at Play* recounts her career as the society columnist for the now defunct *Washington Star.* Former president Richard Nixon reputedly told the columnist that he liked her earrings and added: "I'm an earring man, myself."[19]

16. "Potboilers; True Confession: Steamy Books Are Best in the Heat," by Alex Witchel, *The New York Times,* July 25, 1993, Section 14; page 4; Column 1; Summer Times Supplement. Copyright ©1993 by The New York Times Company. Reprinted by permission.
17. "Inside New York," *Newsday,* May 18, 1993, News, page 13. Reprinted with permission.
18. "Up to His Ears in Snatchings," by Ellis Henican, *Newsday,* May 9, 1993, News, In the Subways, page 6.
19. As reported in "A Memoir of the D.C. Swirl," by Joe Dirck, *The Plain Dealer,* August 15, 1993, Arts & Living; page 101. Reprinted with permission.

Glad to Be a Male

The following appeared in a column in *The New York Times* on November 17, 1993:

Overheard by Alice King of Georgetown, Conn., on a crowded Madison Avenue bus one recent morning, this dialogue between two boys, about 8 and 11, on their way to school.

8-year-old: I'm glad I'm a MAN!
11-year-old, bored but trying to be polite: Why?
8-year-old: Don't have to wear EARRINGS!![20]

Ladies at a Party Talking about Their Earrings

There is nothing unusual about ladies talking about their earrings. The twist to this story is the scene depicted in a wall painting from ancient Egypt:

From numerous tomb pictures, one is led to believe that the ancient Egyptian woman was just as interested in these trinkets of fashion as is her modern sister. "Ladies at a Party, Talking about Their Earrings," Figure 120, after Wilkinson, is a vivid picture of the examination and animated conversation sometimes carried on over these fashionable ornaments.[21]

Don't Forget Those Earrings or You'll Feel Naked

Egyptian paintings depict dancing girls at banquets as wearing only earrings and narrow belts![22]

20. "Metropolitan Diary," by Ron Alexander, *The New York Times*, November 17, 1993, Section C; page 2; column 1; Living Desk. Copyright ©1993 by The New York Times Company. Reprinted by permission.
21. *Accessories of Dress*, ©1940 by Katherine Morris Lester and Bess Viola Oerke, The Manual Arts Press, Peoria, Illinois, at page 107.
22. *Historic Costume For the Stage*, ©1935, 1961 and 1963 by Lucy Barton, Walter H. Baker Company, Boston, at page 10.

Financing of a Military Campaign

Pearl fever reached its height in Rome. The historian Suetonius reported that the Roman general Vitellius paid for an entire campaign by selling just one of his mother's earrings. Pliny the Elder wrote in his *Historia Naturalis* that by the first century B.C. pearls were first in value among all precious things.[23]

What happened to the other pearl earring is unknown.

"Cut Her Little Ears Off"

The extremely high price of earrings led Habinnas in Petronius' *Satyricon* to declare at the time of Julius Caesar that "if I had a daughter I'd cut her little ears off."[24]

Think and Wear Earrings at the Same Time

Women on women:
"The more educated a man, the less likely he is to believe that women can think and wear earrings at the same time."

—Aileen Burdord Mason, Toronto medical researcher, 1990.[25]

Statues with Real Earrings

Quite a number of statues and busts of the Roman period, and some of an earlier time, have the ears pierced for the reception of earrings, and it is highly probable that pearls were used for this decoration. Among these are the busts of Pallas and Juno Lanuvina in the Vatican; that of Eirene, a marble copy of a work of Cephisdotus, in the Glyptothek, Munich; and the Venus de Medici in the Uffizi, Florence. . . . We may note, however, four female figures in the Gallerie des Empereurs in the

23. "The Pearl," by Fred Ward, *National Geographic,* August 1985, at page 201. Reprinted with permission.
24. *Jewellery of the Ancient World,* by Jack Ogden, 1982, Rizzoli International Publications Inc., New York, at page 6.
25. "Modern Myths," *The Ottawa Citizen,* July 5, 1994, News; F.Y.I.; Opinions; Page A9. Reprinted with permission.

Louvre Museum, with the ears pierced for the reception of earrings (Nos 1195, 1202, 1230, and 1269).[26]

Earring Compliments

A female writer for *The Baltimore Sun* reported that when a woman is complimented on her earrings she will reach up and touch her earlobes because she will not be able to remember what earrings she put on.[27]

Reach for Those Earrings

Another female stated that women will often reach for their lipstick and earrings as soon as they wake up from surgery. She commented that they were not doing it for the doctor or the UPS man.[28]

26. *The Book of the Pearl, The History, Art, Science and Industry of the Queen of Gems,* by George Frederick Kunz and Charles Hugh Stevenson, originally published in 1908 by The Century Co., New York, and republished in 1993 by Dover Publications, Inc., Mineola, New York. Quotation is from pages 407 and 408 of the reprint.
27. "The Truth Lies Somewhere Outside the Shower Curtain," by Susan Reimer, *The Baltimore Sun,* January 10, 1995, Section: Features, page 1D.
28. "We All Buy Idea that Fake Beauty's Better than None," by Susan Swartz, *Santa Rosa (Calif.) Press, Democrat,* appearing in *The Houston Chronicle,* December 6, 1994, Section: Houston; page 3.

TWENTY-FOUR
Earrings and Religion

A common misconception is that the Bible warns males against the practice of wearing earrings. A review of both the Old Testament and the New Testament discloses no such warning or prohibition. As one conservative newspaper columnist wrote: "I seriously doubt there's anything in the Bible that warns against men wearing earrings, but there should be."[1] Consider carefully the last phrase of this quotation. The practice of some ministers and churches to refuse entry to males who wear earrings is a bold attempt to add to God's Word. The newspaper columnist was a little more candid with his remark that in his opinion the Bible should have prohibited earrings on males. It is questionable how a church-sponsored boy's group can in fact promote "Christian love" and "brotherly love" among its members when it prohibits its members from wearing earrings. Such a rule would appear to create division among its members rather than harmony.

Christianity and Judaism

Earrings

It will come as a surprise to most Christians and Jews to learn that Moses, one of the people closest to God,[2] may have worn earrings. When Moses was up on Mount Sinai receiving the Ten Commandments from God, the people complained to Aaron (the brother of Moses) that Moses had not returned from the mountain and they wanted a new god to lead them. In *The Living Bible* (Exodus 32:1,2) the following is written:

"Give me your gold earrings," Aaron replied.

1. "Goodbye to a Good Old Boy/Columnist Lewis Grizzard Connected 'from the Heart,' " by Mark Mayfield and Tom Watson, *USA Today,* March 21, 1994, Life; page 1D. Copyright 1994, *USA Today.* Reprinted with permission.
2. Moses and Elijah appeared in the transfiguration of Jesus mentioned at Matthew 17:1–3. This would certainly confirm the great status of Moses before God.

So they all did—men and women, boys and girls. Aaron melted the gold, then molded and tooled it into the form of a calf.

Most Christians and Jews are familiar with the story of the golden calf. The new slant from *The Living Bible* translation is that *men* also wore earrings. The King James Version skirted the issue by implying that only young males wore earrings:

And Aaron said unto them, Break off the golden earrings which are in the ears of your wives, of your sons, and of your daughters, and bring them unto me.[3]

The translators of the King James Version of the Bible were undoubtedly conservative, religious people who regarded the then fashion in England for male earrings to be vain foibles. The King James Version was completed in 1611.[4] This translation avoided encouraging the earring fashion by intimating that earrings were worn only by young males. *The Living Bible* confronts the issue head on, perhaps because it has a 1971 copyright and by that time some men had begun wearing earrings. The *Easton's Bible Dictionary* states simply: "Earrings were ornaments used by both sexes (Exo 32:2)."[5]

Only one book could be found that mentions this account of male earrings. In *Jewels and the Woman: The Romance, Magic and Art of Feminine Adornment*, Marianne Ostier comments: "When Moses was up in the clouds on Mount Sinai receiving the Ten Commandments on tables of stone, Aaron in the valley, preparing to make gods for the people, said unto them: 'Break off the golden earrings, which are in the ears of your wives, of your sons . . . '"[6]

Another book does mention the biblical account, but shrouds the

3. The giving of the Ten Commandments and the building of the golden calf have been dated by some biblical scholars in the King James Version of the Bible as being 1491 B.C. The period of the captivity of Israel in Egypt is given as from 1600 to 1300 B.C. in *Halley's Bible Handbook*, 24th Edition, ©1965, page 117. These dates obviously conflict, since the building of the golden calf occurred after Israel escaped from Egypt.
4. Earrings for males were still in fashion in England at that time. After Charles I, king of England, went to the gallows in 1649 wearing a large pearl, drop earring in his left ear, earrings gradually fell out of fashion.
5. By M. G. Easton, ©1993, Ellis Enterprises Incorporated.
6. *Jewels and the Woman: The Romance, Magic and Art of Feminine Adornment*, by Marianne Ostier, ©1958, Horizon Press, New York, at page 128.

sex of those wearing earrings: "And, during the trek to Canaan under Moses' leadership, the Hebrews gave their earrings to Aaron, who used them in making the famous golden calf."[7]

Another reason why Moses probably wore earrings (and one in each ear) is that he was raised in the house of Pharaoh (Exodus 2:10), and upper-class Egyptians and pharaohs commonly wore earrings at that time. Rameses II, the pharaoh during the time that Moses lived at the court of Egypt, wore an earring in each ear. When the mummy of this pharaoh was unwound in 1886, a commentator by the name of Maspero wrote: "The ears round, standing far out from the head, and pierced, like those of a woman, for the wearing of earrings."[8]

As will be discussed later, male and female slaves may have worn only one earring as a badge of their slavery.

Another example of subsequent fashions possibly influencing Bible translators is the first mention of earrings in the Bible, at least in the King James Version. That reference is at Genesis 24:22. Abraham had requested his oldest servant to look for a wife for his son Isaac, and the search resulted in Rebekah being found. The servant gave Rebekah several gifts, including a "golden earring." Several recent translations state that the earring was actually a nose ring! The New King James Version and the New International Version both translate *earring* as "nose ring." Although *The Living Bible* continues the use of the term *earring,* a footnote states: "gold earring, literally, 'nose-ring.' "

An example of the possible difficulty in distinguishing between an earring and a nose ring in the translation from the original Hebrew text is illustrated by the word *shanf.* The author of *Palestinian Costume and Jewelry* states that a *shanf* [origin of word is not stated] is a variety of earring that is worn through the upper part of the ear, rather than through the earlobe. Additionally, it may be worn as a nose ring.[9]

When an early writer commented upon the special significance of earrings in the Bible by referencing the story of Rebekah, little did she know that she was probably writing about nose rings!

The Rebekah-Isaac story continues at Genesis 24:30 and at 24:47

7. *Accessories of Dress,* ©1940 by Katherine Morris Lester and Bess Viola Oerke, The Manual Arts Press, Peoria, Illinois, at page 108.
8. *Easton's Bible Dictionary,* by M. G. Easton, ©1993, Ellis Enterprises Incorporated.
9. *Palestinian Costume and Jewelry,* by Yedida Kalfon Stillman, ©1946, University of New Mexico Press, Albuquerque, New Mexico, at page 103.

with earrings or nose rings again mentioned. An interesting association between earrings and idols appears at Genesis 35:4, where it is stated that they were buried together. In *The Living Bible* the following appears:

> So they gave Jacob all their idols and their earrings, and he buried them beneath the oak tree near Shechem.

It is probable that these earrings took the form of their idols or were symbols of evil, and that is why the earrings were buried. For example, serpent-shaped earrings would be symbols of evil or demons. God later accepted offerings of jewelry, including gold earrings, so there does not appear to have been anything inherently wrong with earrings.

The golden calf story referred to above continues at Exodus 32:2,3, and 32:24. Several chapters later at Exodus 35:22, it is written that golden earrings were brought as offerings to God:

> Both men and women came, all who were willing-hearted. They brought to the Lord their offerings of gold, jewelry—earrings, rings from their fingers, necklaces—and gold objects of every kind [*The Living Bible*].

The inference from this quotation is that men were still wearing earrings, despite the earlier melting down of gold earrings and other jewelry for the golden calf.

In Numbers 31, reference is made to the war waged against Midian. At verse 50, earrings are again referenced in the offering made to God:

> . . . So we have brought a special thank-offering to the Lord from our loot—gold jewelry, bracelets, anklets, rings, earrings and necklaces. This is to make atonement for our souls before the Lord [*The Living Bible*].

The word *earring* does not appear again in the Bible until the story of Gideon appears at Judges 8, where another war is described with the kings of Midian. At verses 23 and 24 the following is written:

> But Gideon replied, "I will not be your king, nor shall my son, the Lord is your king! However, I have one request. Give me all the earrings collected from your fallen foes," for the troops of Midian, being Ishmaelites, all wore gold earrings [*The Living Bible*].

The story continues in the next several verses, and the value of the earrings contributed is given as approximately US $25,000 (apparently based on 1971 gold prices). According to the *Harris' Theological Wordbook of the Old Testament*,[10] the Ishmaelite soldiers wore drop-shaped earrings.

Also of interest is that some 322 years earlier, Moses had married a Midian woman by the name of Zipporah (Exodus 2:14–22). She was the daughter of the priest of Midian who was named Reuel. Moses had run away into the land of Midian, because he had killed an Egyptian and the pharaoh had ordered Moses executed. Moses resided in the land of Midian for several years until the pharaoh died. Then God appeared to Moses in the burning bush, and Moses returned to Egypt with his wife and sons to lead his people (Exodus 4:20). It is probable that Midian males were already wearing earrings at the time of Moses, and this undoubtedly included his wife's family and father-in-law.

The next reference to an earring is at Job 42:11 in the King James Version. The verse states that God restored the wealth of Job twofold and his family and friends feasted with Job. "[E]very man also gave him a piece of money, and every one an earring of gold." Based on the King James translation,[11] it appears that Job wore an earring in one ear. Notwithstanding, Job was highly regarded by God.

At Proverbs 25:12, the next reference to earrings appears. The metaphor language of the King James Version is as follows:

As an earring of gold, and an ornament of fine gold, so is a wise reprover upon an obedient ear.

In the Song of Solomon at 1:10–11, only the New International and *The Living Bible* versions use the word *earrings*. From *The Living Bible*: " 'We shall make you gold earrings and silver beads.' "

The next reference is at Isaiah 3:16–23. *The Living Bible* states:

10. By R. Laird Harris, ©1980, Moody Bible Institute of Chicago. See entry for "neTipa. Pendant."
11. The New King James Version as well as *The Living Bible* translate *earring* as a "gold ring." Perhaps those Bible translators just could not fathom one of God's favorites having pierced ears and wearing earrings! It should be recalled that there is nothing in the Bible directly stating that Moses had pierced ears and wore earrings; therefore, the issue can be ignored.

Next, he will judge the haughty Jewish women, who mince along, noses in the air, tinkling bracelets on their ankles, with wanton eyes that rove among the crowds to catch the glances of the men. . . . Gone shall be their scarves and ankle chains, headbands, earrings, and perfumes, their rings and jewels, and party clothes and negligees and capes and ornate combs and purses; their mirrors, lovely lingerie, beautiful dresses and veils.

The charm of the above verses is that they describe certain women who lived approximately 2,760 years ago!

Later in Isaiah 3:18–21, the following appears:

In that day the Lord will take away . . . the earrings, The rings, and nose jewels [King James Version].

The next to the last reference in the Bible to earrings is at Ezekiel 16:11–13:

I gave you lovely ornaments, bracelets and beautiful necklaces, a ring for your nose and two more for your ears, and a lovely tiara for your head. . . . You looked like a queen, and so you were! [*The Living Bible*].

The final reference in the Bible to earrings is at Hosea 2:13:

For all the incense she burned to Baal her idol and for the times when she put on her earrings and jewels and went out looking for her lovers, and deserted me: for all these things I will punish her, says the Lord [*The Living Bible*].

It is interesting that the words *earring* and *earrings* appear only in the Old Testament. There is not a single reference in the New Testament. The significance of that will be left to biblical scholars.

Ear Piercing

There are only two biblical references to ear piercing. At Exodus 21:6 the following reference occurs with regard to piercing one ear of male slaves:

. . . then his master shall bring him to the judges. He shall also bring

him to the door, or to the doorpost, and his master shall pierce his ear with an awl; and he shall serve him forever [New King James Version].

An awl is a small pointed tool for making holes in leather or wood. The best way to visualize the size of the hole made by such a tool is to look at the holes stamped in a man's or woman's leather belt. The holes made by an awl may have been approximately three millimeters in size compared with the small three-fourths of a millimeter size of a recently pierced ear today, and the one-millimeter size that ear holes adjust to after earrings have been worn for six months to a year.[12]

It would appear that the pain caused by an awl piercing an earlobe would be much more painful than the ear-piercing guns used today. The larger size hole made by an awl would probably not close up, even if an earring were never worn.

The above biblical reference is interesting for several reasons. There is no mention that an earring was worn in the ear hole. The inference is that only one ear was pierced. And the masculine gender is used.

The second reference to ear piercing is at Deuteronomy 15:17 and includes both male and female slaves. *The Living Bible* states:

.... then take an awl and pierce his ear into the door, and after that he shall be your slave forever. Do the same with your women slaves.

This reference is clearly to the "ball and point" method of ear piercing. The earlobe is placed against a hard surface, i.e., a door, and the awl is driven through. As in the previous reference, apparently only one ear was pierced with an awl.

The *Theological Wordbook of the Old Testament* contains an interesting commentary on ear piercing, and the significance of one ear over the other. The authors write:

Since the ear represents hearing and obedience, it is involved in important symbolic actions. If a slave chose to serve his master permanently, his ear was pierced with an awl (Ex 21:6: Deut 15:17; cf. Ps 40:6 [H 7]). By

12. The application for U.S. Patent 4,139,993 issued February 20, 1979, for an earring stay states that most pierced earlobe openings can admit a tube of one-tenth centimeter in size. This would translate into one millimeter.

this legal act, the slave was bound to obedience for his entire life. At the ordination of Aaron and his sons to the priesthood, some blood from the sacrificial ram was placed on the lobes of their right ears, thumbs, and big toes (Lev 8:23-24; Ex 29:20). Similar was the case of a person cleansed from leprosy. Blood as well as olive oil was applied to his right ear, thumb, and big toe on the eighth day of his purification ceremonies (Lev 14:14, 17). Earrings were apparently given by the groom to the bride at a marriage (Ezk 16:12) (The 'earring' for Rebekah [Gen 24:22 KJV] was a nose ring), but they are associated with idolatry in Gen 35:4. The Israelites tore off their gold earrings so that Aaron could make a golden calf (Ex 32:2-3). As a sign of complete rejection, the ears and nose were mutilated by the rampaging enemy (Ezk 23:25).[13]

Although the left ear is the ear of choice for the vast majority of males who wear only one earring, the correct ear for straight men based upon symbolism from the Old Testament is the *right* ear. At the consecration of Aaron and his sons mentioned at Leviticus 8:23–24, it is written:

And he [i.e., Moses] took some of its blood and put it on the tip of Aaron's right ear, on the thumb of his right hand, and on the big toe of his right foot.
 Then he brought Aaron Aaron's sons. And Moses put some of the blood on the tips of their right ears, on the thumbs of their right hands, and on the big toes of their right feet [New King James Version].

See also Exodus 29:20 where the same ceremony is described, and the right ear is also referenced. A similar ceremony is described at Leviticus 14:8:

The priest shall take some of the blood of the trespass offering, and the priest shall put it on the tip of the right ear of him who is to be cleansed, on the thumb of his right hand, and on the big toe of his right foot [New King James Version].

For Christians, it is clear from the New Testament that the right

13. Quotation is from *The Bible Library* on CD-ROM, published by Ellis Enterprises, Incorporated, ©1988. No page number is available.

side is a symbol of salvation, whereas the left side is a symbol of eternal damnation. See Matthew 25:31–33 and 25:41:

> But when I, the Messiah, shall come in my glory, and all the angels with me, . . . And I will separate the people as a shepherd separates the sheep from the goats, and place the sheep at my right hand, and the goats at my left. . . . Then I will turn to those on my left and say, "Away with you, you cursed ones, into the eternal fire prepared for the devil and his demons" [*The Living Bible*].

Straight men should choose to wear a single earring in their *right* ear. The right ear is a symbol of correctness, purity, sanctification, doing good rather than evil, and closeness to God. If only a single cross, Star of David, or other religious symbol earring[14] is to be worn, it should be worn in the right ear.

(In addition to these symbolic reasons for the right ear, a very practical reason to pierce the right ear is comfort when cradling a telephone headset. Most people are right-handed and hold the telephone headset with their left hand against their left ear. Earring posts can create discomfort by poking against and irritating the skin behind the earlobe.)

Conservative Christian Beliefs

Some conservative Christians argue that Deuteronomy 22:5 prohibits males from wearing earrings. That verse from *The Living Bible* reads:

> A woman must not wear men's clothing, and a man must not wear women's clothing. This is abhorrent to the Lord your God.

However, this argument lacks merit for several reasons. First, earrings are jewelry; they are not clothing. (The King James Version states: "Neither shall a man put on a woman's garment.") Second, the prohibition at Deuteronomy 22:5 was given shortly after the Ten Commandments and the building of the golden calf, and male earrings were

14. This would include symbols of Judaism because of the Old Testament passages referenced.

then entirely acceptable as male attire. Third, the argument is name calling, since earrings are a unisex item of jewelry. This was true in biblical days, as well as in secular history.

Conservative Jewish Beliefs

Some conservative Jews believe that ear piercing is wrong for both sexes. One young lady observed that most of the females in her synagogue have pierced ears, notwithstanding that some rabbis believe that ear piercing is prohibited by the Torah.

One passage relied upon by these rabbis is contained in the Torah/Deuteronomy 14.1, which reads:

> You are the children of the Lord your God. You shall not gash yourselves or shave the front of your heads because of the dead.

The other passage is Leviticus 19.28, which similarly reads:

> You shall not make gashes in your flesh for the dead, or incise any marks on yourselves: I am the Lord.[15]

The author has argued that cutting of the flesh is prohibited only in connection with funeral rites and that ear piercing does not involve cutting or gashing. Also, that ear-piercing is not a mark. In arguing this position on the Prodigy Religion Bulletin Board, one response was that the phrase "for the dead" could be ignored under the tenet of "rabbinic exegesis." Under this tenet of interpretation, a phrase in a sentence can be ignored under some circumstances.

Another argument raised by some Jews is that pierced ears are associated with slavery, and that a woman's ears are pierced as a symbol of being man's possession. Although that argument finds weak support in the Old Testament, i.e., Exodus 21:6 and Deuteronomy 15:17, it unravels in the situation where both husband and wife have pierced ears. Such earrings could be viewed as part of the marriage promise, one to the other.

15. Both of these quotations are from the Torah, published by The Jewish Publication Society of America, the new translation.

Adam and Eve

It is possible that ear piercing may have originated with Adam and Eve while they were still living in the Garden of Eden. There is an ancient Jewish legend that Eve's ears were pierced upon her expulsion from the Garden of Eden.[16] The ear piercing was supposedly done as a symbol of her slavery to Adam.

The reason for the ear piercing is at odds with both Christian and Jewish theology, since Eve was never regarded as the slave of Adam. Instead, her status was more of a partner than anything else.

Legends are usually based upon a factual kernel, which is that Eve probably had pierced ears while living in the Garden of Eden. It is not too farfetched to speculate that Adam also had his ears pierced. Ezekiel 28:13 *suggests* that Adam and Eve wore all types of precious stones as jewelry while living in the garden of Eden:

> Thou has been in Eden the garden of God; every precious stone was thy covering, the sardius, topaz, and the diamond, the beryl, the onyx, and the jasper, the sapphire, the emerald, and the carbuncle, and gold: the workmanship of thy tabrets and of thy pipes was prepared in thee in the day that thou wast created [King James Version].

Although the above quotation refers to the king of Tyrus (see verse 12 preceding), the inference remains that Adam and Eve wore jewelry while living in the Garden of Eden. Because they were unclothed while living there, the wearing of extensive jewelry, including earrings, appears more likely.

The Fall of Lucifer

The Hebrew myth concerning the fall of Lucifer (i.e., Satan) also lends credence to the speculation that Adam and Eve had pierced ears in the garden of Eden. This myth is as follows:

(a) On the Third Day of Creation God's chief archangel, a cherub by name Lucifer, son of the Dawn ("Helel ben Shahar"), walked in Eden amid

16. *The Buyer's Guide to Affordable Antique Jewelry, How to Find, Buy and Care for Fabulous Antique Jewelry*, by Anna M. Miller, ©1993, Citadel Press, New York, at page 78.

blazing jewels, his body a-fire with carnelian, topaz, emerald, diamond, beryl, onyx, jasper, sapphire and carbuncle, all set in purest gold.[17]

If Lucifer, an angel created by God, in fact strolled through the Garden of Eden with "blazing jewels" and his "body a-fire," it seems logical to assume that he wore earrings. If so, this increases the probability that Adam and Eve also wore earrings.

Hinduism

Custom and Practice

Hinduism actively encouraged both sexes to get their ears pierced. The ear piercing was regarded as enabling a closer religious experience. Male babies in India routinely got *both* ears pierced before they were one year of age. This practice lasted for around five thousand years for males, and only ended in the large cities during the late 1940s. The reason for stopping the practice was not religious, but to more closely emulate fashion in the West. In the outlying villages, the practice still continues at the present time to some extent. As ear piercing has become popular in Europe and the United States and Canada, ear piercing among males in the large cities has once again started to become popular.

The earrings that males wore were typically quite large judged by current fashions in the United States. Several black-and-white photographs of Indian males are contained in *Time Frame* A.D. *1850–1900, The Colonial Overlords* by Time-Life Books, ©1990 at page 20. The Maharajah of Udaipur is shown wearing a one-and-a-half-inch hoop with three large beads in each ear. The eldest son of the Gaekwar of Baroda is shown wearing a square block of four pearls (or similar color orbits) which cover the entire bottom portion of each earlobe.

The painting *The Maharajah Duleep Singh*, painted in 1854, is shown in the book *Artists' Jewelry: Pre-Raphaelite to Arts and Crafts*.[18] The

17. *Hebrew Myths: The Book of Genesis,* by Robert Graves and Raphael Patai, ©1964, 1983 edition by Greenwich House, New York, at page 57.
18. *Artists' Jewelry: Pre-Raphaelite to Arts and Crafts*, by Charlotte Gere and Geoffrey C. Munn, ©1989, Antique Collectors' Club, England, at page 78.

Maharajah, who was a close friend of Queen Victoria from the age of sixteen, is depicted in all his finery wearing a two-inch (five centimeters) diameter hoop in each ear, plus a pendant approximately three-quarter-inch (two centimeters) long, dangling from each hoop.

Most people probably do not realize that Mahatma Gandhi (1869–1948), who won freedom for India, had pierced ears. If one locates a good quality picture of him, the ear holes are clearly visible. A photograph in *The World Book Encyclopedia* ©1979 shows a fairly large hole in his right ear. The hole is located higher on the earlobe than is the custom in the Western world.

If one has male friends from India who are forty years of age or older, chances are some of them have pierced ears even though they may not have worn earrings for many years.

Hindu Gods and Earrings

Various male Hindu gods are described as wearing earrings. The sun god is described with the following qualities:

> He has a neck like a tortoise shell, he wears bracelets and a diadem which illumine all the quarters of heaven (Mahabharata 3.17077). His earrings are the gift of the mother goddess Aditi (ibid. 3.17118).[19]

The god Yama, the Lord of Death, is described as follows:

> His face is charming, smiling. He wears a crown, earrings, and a garland of wild flowers. (Padma Purana, Kriyayogasara: adhyaya 22. [200]).[20]

The following language is attributed to the god Visnu:

> My arms are adorned with armlets. I wear a garland, a shining diadem, and earrings shaped like sea monsters.[21]

19. *The Myths and Gods of India,* by Alain Danielou, ©1985, 1991, Inner Traditions International, Rochester, Vermont, at page 95.
20. *The Myths and Gods of India*, by Alain Danielou, ©1985, 1991, Inner Traditions International, Rochester, Vermont, at page 133.
21. *The Myths and Gods of India*, by Alain Danielou, ©1985, 1991, Inner Traditions International, Rochester, Vermont, at page 152.

The significance of Visnu's earrings is described as follows:

Shaped like sea-monsters (makara), the earrings of Visnu represent the two methods of knowledge, intellectual-knowledge (Sankhya) and intuitive-perception (Yoga).[22]

A relief sculpture of Visnu done in the seventh century and located in the Dasavatara temple in Deogarh (located in central India) shows Visnu wearing extremely large earrings.[23] These earrings are larger than the largest earrings worn by women in the Western world today.

The god Rama is described as having two arms and "large earrings" and also a precious necklace.[24]

Then there are the nagas, who are linked with the antigods. "They are represented as half-human, half-serpent. They are possessed of great courage and are quick and violent. They are handsome and wear jewels, crowns, and large earrings."[25]

Laws of Manu (Hindu)

The Laws of Manu (Hindu) is the oldest book in the Hindu religion. It dates back to approximately 1500 B.C. With reference to a "Snataka," he is commanded as follows:

36. He shall carry a staff of bamboo, a pot full of water, a sacred string, a bundle of Kusa grass, and (wear) two bright golden ear-rings.[26]

The significance of the gold earrings is not explained; however, it would appear to equate to godliness and purity.

22. *The Myths and Gods of India*, by Alain Danielou, ©1985, 1991, Inner Traditions International, Rochester, Vermont, at page 158.
23. *The Myths and Gods of India*, by Alain Danielou, ©1985, 1991, Inner Traditions International, Rochester, Vermont. See photograph of sculpture on inside front cover.
24. *The Myths and Gods of India*, by Alain Danielou, ©1985, 1991, Inner Traditions International, Rochester, at page 175.
25. *The Myths and Gods of India*, by Alain Danielou, ©1985, 1991, Inner Traditions International, Rochester, at page 308.
26. Laws of Manu (Hindu), 1500 B.C. Translated by G. Buhler and appearing in *Sacred Books of the East*. Contained on CD-ROM, *Library of the Future, 3rd Edition*, Screen 114: 438, Windows Ver. 3.0. ©1990-94, World Library, Inc., 12914 Haster Street, Garden Grove, CA 92640, 714-748-7197, 1-800-443-0238.

Islam

The Muslim religion is comparatively new among religions, having originated with the prophet Muhammad who lived 1,400 years ago.

Current Muslim thought as expressed in the United States is that ear piercing is not proper for males, although it is quite acceptable for females. Somewhat paradoxically, the Arab expression "to have a ring in one's ear" is synonymous with slavery![27] In A.D. 1258 the popular Persian poet Sheykh Moslehodd Sadi (A.D. 1184–1291) wrote: "The slave with a ring in *his* ear, if not cherished will depart"[28] (emphasis added).

The Qur'an (formerly Koran) contains no specific prohibition against males wearing earrings. The word *earrings* is not found even once in the entire Qur'an.

Under Islamic law that which is not specifically prohibited is permitted. The Qur'an at Surah 6:138–141 speaks against people who invent taboos and superstitions and attribute them to God. In the Qur'an at Surah 6:150–153, the burden of proof is on the person who claims something is unlawful. God decides, not human beings. ["Say— For Allah's is the final argument—Had He willed He could indeed have guided all of you." At verse 150.][29] There are hadiths (traditional accounts of things said by Muhammad) that prohibit the practice of tattooing, but none on ear piercing. There are also hadiths that mention females wearing earrings, but nothing in those hadiths indicate that earrings are prohibited for males.

The Qur'an cautions males against dressing like women, and women like men. The clothing worn by men today in the Muslim world is feminine judged by Western standards. In Saudi Arabia men still wear long, white robes called "thobes." By Western standards, they are long dresses. And, Muslim men and women alike in Indonesia still wear skirts called sarongs.

The historical point in time for consideration of whether clothing

27. *The Buyer's Guide to Affordable Antique Jewelry, How to Find, Buy and Care For Fabulous Antique Jewelry* by Anna M. Miller, ©1993, Citadel Press Book, New York, at page 78.
28. *The Gulistan of Sa'di* by Sheikh Muslih-uddin Sa'di Shirazi, A.D. 1258. Contained on CD-ROM, *Library of the Future, 3rd Edition,* Screen 43: 416, Windows Ver. 3.0. ©1990–94, World Library, Inc., 12914 Haster Street, Garden Grove, CA 92640, 714-748-7197, 1-800-443-0238.
29. *The Meaning of the Glorious Koran,* An Explanatory Translation by Mohammed Marmaduke Pickthall, published as a Mentor Book, New York.

is male or female appears to be the time of Muhammad. Muslims seem to have a problem considering world history (especially that of non-Arab people) either prior to or subsequent to the life of Muhammad in determining what is male dress and what is female dress.

The typical male Muslim response in the United States to the current fashion for men to wear earrings is: "Men don't wear earrings."[30] And earrings are for women and designed to make women look more attractive. That response ignores changing fashions and new items of clothing. Somewhat ironically, that argument contradicts the rule permitting Arab men to wear kohl, i.e., eye makeup, because Muhammad, the founder of the Islamic faith, did. In addition, that response conceals the custom for various tribal men on the Arabian peninsula to wear silver earrings in one or both ears, which custom continues to the present time.[31]

In addition to earrings, other jewelry items are also unacceptable for Muslim males. The list includes all gold jewelry, because gold (like silk clothing) is believed to be for women. A silver ring is acceptable, because Muhammad wore a signet ring for signing documents. (He could not read or write.) A silver necklace is apparently also permissible, although few males wear such an item of jewelry.

Muhammad (A.D. 570?–632) was born at Mecca, which is in present day Saudi Arabia. In *The Meaning of the Glorious Koran* by Mohammed Marmaduke Pickthall,[32] the following is written in the Introduction, Part I, page ix: "The Meccans claimed descent from Abraham through Ishmael. . . . "

This claimed descent is supported by other sources. In *Hebrew Myths: The Book of Genesis*, the authors wrote: "The sons of Midian also moved to South Arabia."[33]

According to the Old Testament of the Bible at Judges 8:24, it is stated that "the troops of Midian, being Ishmaelites, all wore gold earrings" (*The Living Bible* translation). It is interesting to note that

30. "In the United States, Ties to the Middle East Survive," by Donna Abu-Nasr, The Associated Press, May 7, 1993. The quote is from a Palestinian mother of three who immigrated to the United States in 1990.
31. *The Art of Arabian Costume, a Saudi Arabian Profile*, by Heather Colyer Ross, Second Edition, ©1985, Arabesque Commercial SA, Switzerland, at pages 111 and 114.
32. A Mentor Book, New York.
33. *Hebrew Myths: The Book of Genesis*, by Robert Graves and Raphael Patai, ©1963 and 1964, from 1983 edition, Greenwich House, New York, at page 180.

Muhammad's ancestors had not only worn earrings, but earrings made of *gold*.

In addition to the present day custom for Arabian tribal men to wear silver earrings, there is historical evidence that other Muslim males wore earrings in past centuries.[34] This may have been the result of old customs lingering on after conversion to Islam. However, knowledge is hampered by the tradition in Islamic society not to bury goods or jewelry with the dead. In addition, pictorial representations were rare before the A.D. 1400s.[35]

Buddhism

Most people have probably never realized that statues of Buddha almost always depict him as wearing two very large earrings. The earrings are not only large, but actually huge. If earrings are not shown, the pierced earlobes appear very elongated (two to three times their normal length) from wearing very heavy earrings.

Siddhartha Gautama, the founder of Buddhism, was born in 560 B.C. in what is present-day Nepal. At the age of twenty-nine, he left his wife and children to go on a religious quest. He ended up in northern India. He became a wandering teacher and attracted many disciples before his death at 480 B.C. at the age of eighty.

Buddhism is not a religion of rules and regulations. Many of the concepts expressed are noble ones and cannot be argued with by people of any religion. The subject of male earrings appears not to have been dealt with. If emulation has any importance, then male earrings are permissible.

34. See chapter 25 of this book, titled "Ear Piercing—Antiquity to Middle Ages."
35. *Jewelry, 7,000 Years* edited by Hugh Tait, ©1986 by the Trustees of the British Museum. The 1991 edition referenced in this chapter was published by Harry N. Abrams, Incorporated, New York. See comments at page 145.

TWENTY-FIVE
Ear Piercing—Antiquity to Middle Ages

Knowledge concerning ear piercing and earrings from the beginning of history to the Middle Ages comes largely from a small number of mummified corpses, from jewelry discovered in burial sites and in occasional caches, from sculptures and reliefs, and from artist renderings. Some cultures did not bury possessions with the dead, so less is known about those cultures. Early writings about the subject are virtually nonexistent, except for several references in the Old Testament of the Bible.

Based on information that follows, ear piercing may have originated in Western Europe, and not in Western Asia or the Orient as some believe.[1] It is more likely that ear piercing developed concurrently throughout the world and among both males and females alike. Some believe that ear piercing may have originated among men, and that Cleopatra may have been the first woman with pierced ears.[2]

Antiquity

Large Ear Holes

On September 19, 1991, a German couple by the names of Helmut Simon and Erika Simon were hiking in the Alps near the border between Austria and Italy. What they stumbled across in melting ice was the oldest mummified corpse ever discovered. Two different laboratories ran radiocarbon analyses and dated the corpse from between 3,500 and 3,000 years B.C. This translates to 5,000 to 5,500 years old. The corpse, discovered at an elevation of 10,530 feet, was that of a male in

1. These contradictory positions are taken by authors Daniela Mascetti and Amanda Triossi in their book *Earrings: From Antiquity to the Present*, ©1990, Thames and Hudson Ltd., London, and published by Rizzoli International Publications, Inc., New York. Compare Preface, page 7, and chapter 1, page 10.
2. Prodigy, Frank Discussion Bulletin Board, Topic: Men's Issues, Subject: Earrings, November 7, 1992.

his late twenties or early thirties. He was dressed in animal skins, with a cape of grass and leather shoes stuffed with grass.

According to an artist's illustration and a facial reconstruction appearing in a *National Geographic* story,[3] the male had a one-quarter to three-eighths-inch (seven to eleven millimeters) hole in his right earlobe. It is a fair assumption that the left ear was also so perforated. The article was silent as to the ear piercing and the ear ornaments that might have been worn by this individual, who might have been either a shepherd, itinerant trader, shaman, prospector or outcast.

The previous oldest mummified corpse was that of King Tutankhamen found in a pyramid in Egypt. He was a pharaoh from 1361 to 1352 B.C. and died at the age of eighteen. Therefore, his corpse is 3,347 years old. A gold mask of his likeness discovered in his tomb shows him with a one-quarter to three-eighths-inch hole in each earlobe through which it is believed he wore large, gold earrings.

Other Egyptian pharaohs were also pictured or sculpted with large holes in each earlobe. A sculpture of Akhenaten who became a pharaoh in 1365 B.C. is shown in Time-Life Books, *Time Frame 1500–600 B.C., Barbarian Tides* at page 47 with large ear holes.[4] A wall panel from the tomb of Sannedjem shows him in a side view with a large hole in his right earlobe (page 49).

The 1963 book *Jewels of the Pharaohs* comments that Amenophis II had small perforations in his ears, and that Maiherpra, Tuthmosis IV, and Tutankhamen had a large hole in each ear. The author writes: "It has been assumed that such earrings were worn by boys only until the age of puberty, when they were laid aside. Tomb paintings and reliefs exist, however, showing that on occasion adult men wore earrings."[5] The key phrase in this quote is "[i]t has been assumed." Without hard evidence, such an assumption appears to be an attempt to conform history with subsequent fashions.

Author Christine Hobson describes the large ear holes used by Egyptians: "From the reign of Amenhotep II in the Eighteenth Dynasty, men as well as women wore earrings. These were stud-mounted for use in pierced ear lobes. The holes made in the ears were stretched using

3. "The Ice Man, Lone Voyager from the Copper Age," by David Roberts, *National Geographic,* June 1993, pages 36–67.
4. ©1987.
5. *Jewels of the Pharaohs,* ©1963 by Cyril Aldred, at page 35.

a series of larger and larger studs until quite large discs, up to 19mm (3/4 in) in diameter could be worn."[6]

No other author was found who suggested that the Egyptians had such large ear holes.

A terra-cotta death mask from a Phoenician tomb in Carthage, 700 to 500 B.C., has the typical large-size hole in each earlobe. The mask would appear to represent a male (page 108, *Time Frame 1500–600 B.C., Barbarian Tides*, Time-Life Books).

The fashion for large ear holes apparently also extended to females. A king by the name of Piye from ancient Nubia (which covered southern Egypt to the Sudan) captured all of Egypt in 730 B.C. Recovered from the tomb of one of Piye's wives was a small pendant from which hung a gold head of Hathor, goddess of beauty, mounted on a ball of rock crystal.[7] The goddess pendant has similar large ear holes in each ear. This image would indicate that women had large holes in their earlobes like the men.

Large ear holes are present on various artwork from Central America. One figurine of the god Xipe Totec has earlobe holes (both ears) stretched to one inch in size (were he human size).[8] Another figurine shows him with ear holes about one-quarter to three-eighths inch in diameter. A figurine of Tezcatlipoca also depicts him with similar size ear holes.[9] And a figurine of the goddess Tlazolteotl also shows her with the same size ear holes.[10] Mayan figurines typically show large earrings or ear plugs in both ears on males.[11] Males also wore ear flares, which consisted of a doughnut type of ring held onto the earlobe with a flared plug about five-sixteenth-inch long.[12] An Olmec jade pendant (1000–100 B.C.) from Mexico shows similar large

6. *The World of the Pharaohs, a Complete Guide to Ancient Egypt*, ©1987 by Christine Hobson, Thames and Hudson Inc., New York, at page 87.
7. "Out of Africa: The Superb Artwork of Ancient Nubia," by David Roberts, *Smithsonian*, June 1993, at pages 90–101.
8. See photograph in *Time Frame A.D. 200–600, Empires Besieged*, Time-Life Books, ©1988, page 146. See also photograph of statue at page 140 with one-quarter-inch size holes.
9. *Time Frame A.D. 1400–1500, Voyages of Discovery*, Time-Life Books, ©1989, pages 150, 151, 154 and 155.
10. *Time Frame A.D. 1400–1500, Voyages of Discovery*, Time-Life Books, ©1989, page 146.
11. See photographs in *Time Frame A.D. 200–600, Empires Besieged*, Time-Life Books, ©1988, on pages 152 and 153.
12. *Jewelry, 7,000 Years*, edited by Hugh Tait, ©1986 by the Trustees of the British Museum. The 1991 edition referenced in this chapter was published by Harry N. Abrams, Incorporated, New York. See photograph at page 123.

ear holes and even a pierced nasal septum.[13] These large ear holes would fit the ear plugs that have been discovered.

[It should be noted that large ear holes did not die out in antiquity. In some cultures large ear holes survive even to the present time. For example, a photograph of an Ethiopian woman appeared in the December 1970 issue of *National Geographic* at page 856. She had a large ear hole in her left ear, and she appeared sans earrings. Her right ear was not visible. Also, there were some reports of women stretching their ear holes in the United States in the early 1990s.]

Early Earrings

The earliest archaeological evidence of earrings dates to 2500 B.C. (4,500 years ago) from the royal graves of Ur in what is present-day Iraq.[14] The earrings that were discovered there included gold crescents, in single or double form.

The grave of a wealthy man in Ur (c. 2100 B.C.) included a pair of gold spiral earrings (or hair rings). These ornaments, which are of a simple, elegant design, are shown on page 31 of the book *Jewelry, 7,000 Years*.

In commenting upon the fashion in Babylonia and Assyria for males to wear earrings, the authors of *Accessories of Dress* stated:

> The earliest home of the really artistic earring was Babylonia, then later Assyria, where men wore it as a symbol of rank. Kings and nobles as well as soldiers wore these accessories, usually pendants in the form of long, pear-shaped drops or cones attached to a heavy ring or crescent. During the reign of the later kings they were made in the form of a cross or a group of balls. The most popular materials used were gold and silver. The Persians, Phoenicians, and the pre-Hellenic peoples of the Aegian wore superb earrings.[15]

13. See page 81 of *Jewelry, 7000 Years,* edited by Hugh Tait, ©1986 by the Trustees of the British Museum, 1991 Edition, Harry N. Abrams, Incorporated, New York.
14. *Earrings: From Antiquity to the Present,* by Daniela Mascetti and Amanda Triossi, ©1990, Thames and Hudson Ltd., London, and published by Rizzoli International Publications, Inc., New York, at page 10.
15. *Accessories of Dress,* ©1940 by Katherine Morris Lester and Bess Viola Oerke, The Manual Arts Press, Peoria, Illinois, at page 107.

A female author writing in 1991 did not think of Assyrian males wearing heavy, gold or silver earrings to be effeminate. On the contrary, she wrote: "[B]ulky, gaudy jewelry not only shows their wealth, it enhances their husky, warlike, masculine physiques."[16]

Various Egyptian earrings from 1500–900 B.C. have been discovered. In *Jewelry, 7,000 Years,* the authors write about the popularity of earrings among both sexes:

> It was during this time that both earplugs and earrings became far more common, worn by men as well as women . . . the earring was a new form of jewellery which first appeared during the latter part of the Second Intermediate Period among the Pan-Grave people, who were Nubian in origin although they settled in Egypt. Varied forms now include leech shapes and open hoops, some with suspension loops (page 42).

The tomb of Seti I, king of Egypt from 1318–1304 B.C., shows figures of several Libyans, one of whom is wearing a hoop-type of earring with a squared type of bottom.[17]

A carved slab from the palace of Ashurnasirpal II (883–859 B.C.), which was located at Nimrud in northern Iraq, shows Ashurnasirpal himself wearing earrings. Only the left side of his face is visible, with an extremely thick hoop earring, and a 2.5 to three-inch (approximate) dangle from the hoop. This slab is now in the British Museum in London.[18]

The body of a man preserved in a salt quarry since approximately 600 B.C. was found in early 1994 in the western Iranian village of Chehrabad, which is near the city of Zanjan. The corpse still had a gold earring in his left ear. The earring resembled the patterns of Persepolis and the Apadana palace.[19] The discovery was reported by Iran's IRNA news agency.[20] This would seem to indicate that the earring fashion

16. *Let There Be Clothes,* ©1991 by Lynn Schnurnberger, Workman Publishing, New York, at page 31.
17. *Accessories of Dress,* ©1940 by Katherine Morris Lester and Bess Viola Oerke, The Manual Arts Press, Peoria, Illinois, at page 74.
18. *Earrings: From Antiquity to the Present,* by Daniela Mascetti and Amanda Triossi, ©1990 Thames and Hudson Ltd., London, and published by Rizzoli International Publications, Inc., New York, Preface at page 7.
19. "Iran," proprietary to the United Press International, April 21, 1994, International.
20. "2,600-Year-Old Man Found Salted Away," *The Orange County (California) Register,* January 19, 1994, World/Science, page 17.

extended from royalty down to common laborers in a salt mine. The French news agency *Agence France Presse* reported that the earring was "another indication that he lived in the pre-Islamic age, as Islam prohibits men from wearing gold or other jewellery."[21] This statement is not entirely correct, as Muslim males can wear a silver ring and some tribesmen on the Arabian peninsula to the present day wear silver earrings.

A massive staircase found amid the ruins of a palace at Peresepolis (begun in 520 B.C.) located in present-day Iran contains a relief depicting envoys bearing flowers. One-third of the male envoys are wearing a thick, hoop earring in their right ears (their left ears are not visible).[22] Although envoys are typically from foreign lands, one writer commenting about the Persians themselves stated that "[e]arrings were general for men (and probably women)."[23]

The top of an Etruscan (Italy) clay funeral urn shows what appears to be a male figure wearing a gold-colored hoop earring in each ear. The gold hoops are about seven-eighth-inch in diameter and three-six-teenths-inch wide. These holes are about one-half the size of the large ear holes previous discussed. (See photograph at page 110 of *Time Frame 1500–600 B.C.*, *Barbarian Tides*, Time-Life Books.)

A fresco painted for the Assyrian monarch Tiglath-Pileser II around 700 B.C. shows an infantryman of the Assyrian army walking behind the wheel of a chariot. The infantryman is shown with a large, gold-colored hoop earring in his right ear (the only ear that is visible). (See page 18 of *Time Frame 1500–600 B.C.*, *Barbarian Tides*, Time-Life Books.)

According to Hindu beliefs, ear piercing for men (both ears) and women in India extends back five thousand years.

Early Greek Times

Both men and women in early Greek times wore earrings. The

21. "26-Century-Old Man's Upper Body Found Intact in Iran," *Agence France Presse,* January 19, 1994, International News. Reprinted with permission.
22. "Iran, Desert Miracle," by William Graves, *National Geographic,* January 1975, see photograph at pages 4 and 5.
23. *Historic Costume For the Stage,* ©1935, 1961 and 1963 by Lucy Barton, Walter H. Baker Company, Boston, at page 34.

purpose was not only ornamentation, but also protection against evil spirits.[24] The Greek philosopher Plato (428–347 B.C.) mentions "golden earrings" in his will,[25] and the female authors intimate that the philosopher wore them. The same authors write that a record states that Xenophon (430–354 B.C.), an ancient Greek historian and soldier, criticized "one Apollonides because 'his ears were bored' " (page 109). In addition, a vase in the Vatican Library shows Achilles, a Greek god, wearing earrings (page 109).

An article appearing June 11, 1994, in *The Daily Telegraph* sheds additional details on the story about Xenophon:

> There is, indeed, a record of a soldier being dismissed from Xenophon's army in 401 B.C. because he had "pierced ears just like a Lydian." In Lydia and Scythia, however, men liked to display their wealth by wearing necklaces, earrings and bracelets as well as rings. This is known because jewels have been found on male skeletons in tombs while others are clearly designed for men because of their size or because, unlike the women's jewellery which was full of suggestive images of desire, men's jewellery is patterned with wars and warriors, mythic monsters, lions or rearing horses.[26]

Lydia is now western Turkey, and Scythia is southern Russia.

Another author comments about the earring fashion in ancient Greece as follows: "Earrings were fashionable and were sometimes worn by high-ranking young men as well as by women, children and servants. The ears were pierced and the earrings made of the most precious metals available, and sometimes decorated with rose shapes."[27]

Whether Alexander the Great wore earrings is unknown, but some of his colleagues probably did.[28]

24. *Accessories of Dress*, ©1940 by Katherine Morris Lester and Bess Viola Oerke, The Manual Arts Press, Peoria, Illinois, at page 108.
25. *Accessories of Dress*, ©1940 by Katherine Morris Lester and Bess Viola Oerke, The Manual Arts Press, Peoria, Illinois, at page 109.
26. "Telegraph Magazine: As Touched by Midas," by Leslie Geddes-Brown, *The Daily Telegraph*, June 11, 1994, Page 38. ©Leslie Geddes-Brown/The Daily Telegraph plc, London, 1994. Reprinted with permission.
27. *Costume of the Classical World*, ©1980 by Marion Sichel, Batsford Academic and Educational Ltd, London, at page 40.
28. CNN Television broadcast, *Late Edition*, 5:00 P.M. E.T., June 12, 1994. Remarks by Bruce Morton.

Roman Times

No less a man than Julius Caesar (100?–44 B.C.) wore earrings according to one source. Author Marianne Ostier writes: "As the Roman Republic grew effeminate with wealth and luxury, earrings were more popular among men than women; no less a 'he-man' than Julius Caesar himself brought back to repute and fashion the use of rings in the ears of men."[29]

That earrings were worn by Roman males is hinted at in another book titled *20,000 Years of Fashion*:

Jewels—necklaces, pendants, trinkets, bracelets, rings, armlets and anklets—were worn by both sexes, but most of all by women.

* * *

These tendencies towards luxury became more marked in the third and fourth centuries AD, with a predominance of Syrian styles represented by large gems; heavy pendants were hung from necklaces made of massive cylindrical pieces, or ear-rings (*crotalia*) composed of three of (sic) four beads—criticized by Ovid—were hung with heavy pendants, while bracelets developed into multiple convolutions.[30]

Publius Ovidius Naso (43 B.C.–17 A.D.), who was known simply as Ovid, was a famous Roman poet who was ordered into exile by Augustus in 7 A.D. His place of exile was in Romania on the Black Sea. It is unclear whether Ovid was criticizing the practice of Roman men wearing earrings or the cost of earrings worn by females. However, in Ovid's narrative poem *Metamorphoses* written in 8 A.D., the following line appears: "A silver boss upon his forehead hung, And brazen pendants in his ear-rings rung."[31]

Another author comments upon Roman males wearing earrings

29. *Jewels and the Woman: The Romance, Magic and Art of Feminine Adornment*, by Marianne Ostier, ©1958, Horizon Press, New York, at page 128.
30. *20,000 Years of Fashion*, expanded edition by Francois Boucher with a chapter by Yvonne Deslandres, ©1987, Harry N. Abrams, Incorporated, New York, at pages 124 and 125.
31. *Metamorphoses* by Ovid, 8 A.D. Contained on CD-ROM, *Library of the Future, 3rd Edition*, Screen 525: 857, Windows Ver. 3.0. ©1990–94, World Library, Inc., 12914 Haster Street, Garden Grove, CA 92640, 714-748-7197, 1-800-443-0238.

during a later period: "Like the earlier Grecian men, some of the younger men of Rome attempted to adopt earrings, but Emperor Alexander Severus (222 A.D.) bitterly opposed it."[32]

Early Centuries A.D.

One of the earliest portraits painted is that of a young woman from Hawara, Egypt, who lived about 200 A.D. She was painted wearing various jewelry, including a single gold hoop in each ear. Each hoop was set with three beads, a black stone surrounded by two pearls. The painting was found with other realistic portraits of men, women, and children with mummies. (See *Jewelry, 7,000 Years*, at page 88.)

The Avar people in Hungary and the Ukraine (500–600 A.D.) wore some heavy and ornate earrings that hung from a gold loop bent to fit through the ear hole. *Jewelry, 7,000 Years* states that the largest of the three types shown were "sometimes found in 'princely' burials." (See photograph at page 104. The inference appears to be that males wore earrings.)

Males of the Mochica people in Peru, South America, wore ear ornaments. This was during the time frame of A.D. 300–800. (See photographs in *Jewelry, 7000 Years*, at page 83.) These ornaments were nearly two inches in diameter and were attached to a hollow wooden plug. Another photograph of ear ornaments from Peru appears at page 128. Both pair measure approximately one and three-quarter inches in diameter, and one ornament shown still has cotton wrapping around the plug portion, apparently used as packing to secure the plugs in the earlobes. These ear plugs are dated as being A.D. 1000–1500. A gold figurine from the same time frame found in Tehuantepec, Mexico, depicts a male figure with very large ear holes and very large earrings (page 134). (An article with pictures on the Moche civilization also appeared in the September 27, 1993 issue of *Newsweek* beginning on page 68.)

32. *Accessories of Dress*, ©1940 by Katherine Morris Lester and Bess Viola Oerke, The Manual Arts Press, Peoria, Illinois, at page 111.

Male Maya Indians who lived in the Yucatan Peninsula area of what is now southern Mexico, Guatemala, and Belize favored wearing large jade ear ornaments. (A photograph of such ear ornaments appears in the October 1989 issue of *National Geographic* at page 484.[33])

Padma Sambhava, who brought Buddhism to the Himalayan lands in 800 A.D., is shown in a mammoth embroidery with greatly elongated earlobes (stretched to perhaps four times normal length), and wearing three-and-a-half- to four-inch (nine–ten centimeters) gold hoops with a number of dangles from each hoop.[34]

Centuries before Genghis Khan began his raids of conquest and plunder, nomads from the Mongolian plains terrorized settlements on the China border. One early Chinese painting depicts four nomads on their horses, one of whom is shown wearing a hoop in his right ear with a dangle hanging from the hoop. The left ear is not visible. (This painting is reproduced in *Time Frame A.D. 600–800, The March of Islam*, Time-Life Books.[35])

In Iran earrings were so popular that "Sassanian kings had engravings of themselves, wearing their earrings, set as signet stones upon their fingers."[36] The Sassanian kings ruled Iran from A.D. 224 to 651.

Earrings were acceptable in early Islam cultures. A painting shown in Time-Life Books *Time Frame A.D. 1300–1400, The Age of Calamity*, ©1988, at page 137 shows a horseman hawking. He is shown with a drop earring in his left ear. (The right ear is not visible.) The caption for the painting states: "Painted in Chinese style by a Persian or Turkish Muslim artist. . . . Hawking from horseback was a favorite pastime of warrior elites in all Islam lands."

The Arabian Nights Entertainments was published in English in a four-volume set in 1955.[37] The title sheet to volume II (the only volume the author could obtain) states that the miniature paintings in the book were made by Arthur Szyk. This person is not identified, nor is the time period given when the paintings were done. Volume II contains twenty

33. "Copan, a Royal Maya Tomb Discovered," by Ricardo Agurcia Fasquelle and William L. Fash, Jr. with photographs by Kenneth Garrett, *National Geographic*, October 1989, at page 484.
34. "Bhutan Crowns a New Dragon King," by John Scofield, *National Geographic*, October 1974. The embroidery is pictured at pages 354 and 355.
35. ©1988, at pages 96 and 97.
36. *Jewels and the Woman: The Romance, Magic and Art of Feminine Adornment*, by Marianne Ostier, ©1958, Horizon Press, New York, at page 128.
37. ©1955 by The George Macy Companies, Inc.

color paintings. Every painting that contains males (i.e., eighteen out of twenty) shows one or more of them wearing earrings in both ears. The earrings are large *gold* hoops, or several dangling varieties. Although the earrings are visible in the paintings, they do not stand out. Unless a person were looking for the earrings, he or she might not even notice them.

The paintings all have an ornate border around them, with Arabic writing in the border at the bottom. It is believed that the earrings depicted on the males in these paintings are historically accurate. Various tribal men on the Arabian peninsula were wearing traditional *silver* earrings in one or both ears as late as 1985.[38] Current Muslim thought is that males should wear only silver jewelry, following the example of prophet Muhammad. And, gold jewelry is reserved for females. It is suspected that males continued to wear gold jewelry for centuries after the death of Muhammad.

Because the paintings were done in 1955 or earlier, the artist could not have been influenced by the recent male fashion for earrings. *National Geographic* reprinted three of the paintings (without comment about the earrings) to help illustrate an article "In The Wake of Sindbad," appearing in its July 1982 issue.

The Arabian Nights stories were written in Arabic between A.D. 1300–1500 A.D., and the stories are of Arabian, Indian, or Persian origin. The stories were translated into English by Sir Richard Burton, an English explorer who lived from 1821 to 1890.[39]

Also of confirming interest is that in the play *Salome,* written in 1893 by playwright Oscar Wilde, a young Syrian captain commits suicide. A page (servant) laments: "I gave him a little box of perfumes and ear-rings wrought in *silver,* and now he has killed himself!"[40] (emphasis added).

The Inca empire in South America reached its height in A.D. 1525. It reached along the western coast from Quito, Ecuador, in the north to several hundred miles south of Santiago, Chile. A photograph of a gold

38. *The Art of Arabian Costume, a Saudi Arabian Profile,* by Heather Colyer Ross, Second Edition, ©1985, Arabesque Commercial SA, Switzerland, at pages 111 and 114.
39. *The New Grolier Multimedia Encyclopedia,* ©1992, Grolier Electronic Publishing, Inc.
40. *Salome* by Oscar Wilde, 1893. Contained on CD-ROM, *Library of the Future, 3rd Edition,* Screen 20: 59, Windows Ver. 3.0. ©1990–94, World Library, Inc., 12914 Haster Street, Garden Grove, CA 92640, 714-748-7197, 1-800-443-0238.

figure appears in the December 1973 issue of *National Geographic*. The text accompanying the photograph states: "Perforated lobes of a gold figure (left) identify an *orejon,* or 'big ear'—one of the Inca nobility, who alone were allowed to wear huge golden earplugs."[41]

The gold figurine is interesting, since the elongated earlobes are similar in appearance to those pictured on early Buddhists. On the previous page of the same article (page 767), a figurine depicts an Inca surgeon doing brain surgery. The surgeon is shown wearing earplugs that are so large they cover both of his ears.

Another source states that it was only the *male* nobility in the Incas that were allowed to wear ear spools.[42]

Byzantine Period

The Byzantine Empire was the continuation of the eastern portion of the Roman Empire. The empire was based in Byzantium, later renamed Constantinople (now Istanbul, Turkey), with Greek as its principal language. The Empire extended time wise from A.D. 324 until its fall in A.D. 1453.

Mosaics of the Byzantine period typically depict males as well as females wearing large and elaborate earrings.[43] Various drawings and photographs of mosaics are shown in *Ancient Greek, Roman and Byzantine Costume & Decoration.*[44] A drawing of Emperor Basil II (A.D. 958–1025) wearing a medium-size hoop in each ear is shown at page 154, Figure 165. It appears from most of the drawings and photographs that the male earrings were actually suspended from headdresses, rather than from the earlobes in a style similar to "kolty" rings worn by males of the Russian aristocracy.

41. "The Lost Empire of the Incas," by Loren McIntyre, *National Geographic,* December 1973. Photograph and text at page 768. Reprinted with permission.
42. *An Illustrated Dictionary of Jewelry,* ©1981 by Harold Newman, Thames and Hudson Ltd., London, at page 107.
43. *Accessories of Dress,* ©1940 by Katherine Morris Lester and Bess Viola Oerke, The Manual Arts Press, Peoria, Illinois, at page 112.
44. *Ancient Greek, Roman and Byzantine Costume & Decoration,* Second Edition, ©1947 by Mary G. Houston, Adam & Charles Black, London.

A newspaper writer adds another possible angle to the story: "The Byzantines in the 10th century layered on the glistening finery. Bracelets, necklaces and dangling earrings (even for men) were worn for the glory of God."[45]

It is unknown as to what her source was for earrings and other jewelry being worn "for the glory of God." One book uses surprisingly similar language, but omits the preceding phrase: " . . . the Byzantines layer on bracelets, necklaces, dangling earrings (even for men), as well as combs and hairpins of ivory and gold."[46]

Middle Ages

According to *Jewelry, 7000 Years*, there is no evidence for earrings (i.e., male or female) in Northern Europe during medieval times.[47] (The medieval times were from A.D. 700–1500.) To similar effect is the book *Earrings: From Antiquity to the Present* at page 19. The time period stated is from A.D. 1000–1600. At variance with these claims is *Accessories of Dress*, which comments that the peasantry continued to wear earrings during the Middle Ages.[48]

Both sexes of the Russian aristocracy wore crescent-shaped "kolty" or temple rings. The rings were hung from headbands or ceremonial headdresses, and gave an appearance similar to earrings (but without the ear piercing). Photographs of these temple rings appear in *Time Frame A.D. 1000–1100, Light in the East,* Time-Life Books, ©1988, at pages 130 and 131. Additional "kolts" made out of both gold and silver are shown in *Jewelry, 7,000 Years* at pages 136 and 137. Those kolts are dated as from the 1100s.

45. "Bangles Should Jangle, Not Dangle on the Wrists," by Wanita Bates, *The Ottawa Citizen*, November 11, 1993, Style; Shop Talk; page E5. Reprinted with permission.
46. *Let There Be Clothes*, ©1991 by Lynn Schnurnberger, Workman Publishing, New York, at page 117.
47. See page 138.
48. *Accessories of Dress*, ©1940 by Katherine Morris Lester and Bess Viola Oerke, The Manual Arts Press, Peoria, Illinois, at page 112.

A sixth-century mosaic in the Church of San Vitale located in Ravenna, Italy, shows a male with two dangle earrings or kolts below each ear of a male wearing a headdress.[49] The point of attachment is not clear in the mosaic.

During the Middle Ages, fierce Tartar warriors invaded European Russia from central Asia. These Tartars were of Mongol descent and were led by Batu Khan, the grandson of Genghis Khan. The Mongol occupation lasted from approximately 1240 until 1480. The film *The Kremlin*, ©1963, National Broadcasting, Inc., and released as part of The Jarvis Collection, shows some Kremlin art that depicts the invading Tartar warriors. One close-up shows a Tartar warlord wearing a very large (one-and-a-half-inch) and thick gold hoop earring in his right ear. The left ear is not visible. The scene is approximately sixteen minutes into the film. (These Mongols merged with the Tatars and other Turkish people and became Muslims. It is presumed that they eventually substituted silver earrings for their gold earrings because of their new religion.)

The Khanate of the Golden Horde was the name given to the Mongol state in south Russia. Although various encyclopedias state that the name Golden Horde is derived from the colorful tents of the Mongol camps, it is possible that the name was actually derived from their golden earrings.

49. *20,000 Years of Fashion*, Expanded Edition, by Francois Boucher with a chapter by Yvonne Deslandres, ©1987, Harry N. Abrams, Incorporated, New York, at page 152.

TWENTY-SIX
Ear Piercing—Middle Ages to Mid-1900s

New Zealand Maoris

When Capt. James Cook visited New Zealand in 1769, the Maori males were wearing earrings, one in each ear. Sketches made during that journey depict very large, dangling earrings.[1] The earrings were two-and-a-half- to three-inches long (six to eight centimeters), of a simple, tapered design, and approximately one-half inch (1.5 centimeters) wide at the thickest part.

One book reports the bizarre practice of Maori men using live birds as ear ornaments, sticking their beaks through holes in their earlobes.[2]

Isles of the Pacific

The photograph of an older Polynesian navigator appears in a December 1974 *National Geographic* article.[3] The background sky is visible through a large hole in his right earlobe, and a small, hoop earring was worn through a similar size hole in his left earlobe.

Males and females in the Marquesas Islands wore earrings carved from single pieces of whale ivory. The earrings were very similar, but with different carvings.[4]

Caribbean Indians

On his first voyage to America in 1492, Christopher Columbus visited the Bahamas and then Cuba, Haiti, and the Dominican Republic. During that voyage, Columbus maintained a log that has been

1. *The Story of New Zealand,* by Judith Bassett, Keith Sinclair, and Marcia Stenson, ©1985, Reed Methuen Publishers Ltd, Auckland, New Zealand. See sketches at pages 21, 22, 27, and 38.
2. *Ethnic Jewelry,* edited by John Mack, ©1988 The Trustees of the British Museum, Harry N. Abrams, Incorporated, New York, at page 129.
3. "Isles of the Pacific—II, Wind, Wave, Star, and Bird," by David Lewis, *National Geographic,* December 1974. See photograph at page 746.
4. *Ethnic Jewelry,* edited by John Mack, ©1988 The Trustees of the British Museum, Harry N. Abrams, Incorporated, New York, at page 123.

translated into English. See *The Log of Christopher Columbus* by Robert H. Fuson.[5] Various journal entries show an obsession with his search for gold. In his log he makes occasional reference to gold nose rings. For Saturday, 13 October 1492, he wrote: "I have seen a few natives who wear a little piece of gold hanging from a hole made in the nose" (pages 77–78).

For Wednesday, 17 October 1492, he wrote: "One man was found who had a piece of gold in his nose, about half the size of a castellano, and on which my men say they saw letters" (page 86).

For Sunday, 21 October 1492, he wrote: "A few brought pieces of gold hanging from their noses, which, with good will, they gave for a hawk's bell or small glass beads" (page 91).

Columbus also reported seeing a male wearing a silver nose ring (page 99).

The Indians questioned about their gold nose rings told of a distant place where people wore gold "around the neck, in the ears, and on the arms and the legs" (page 102, see also page 107). A female was also mentioned as wearing "a small piece of gold in her nose" (page 133).

Earrings are referenced, mainly with regard to his search for gold. For Tuesday, 16 October 1492, he writes: "I gave the man . . . two hawks' bells, which I placed on his ears" (page 81).

Hawks' bells are mentioned as being used in trade in several other log entries (see pages 90, 122, and 153).

For Sunday, 16 December 1492, he wrote: "[S]ome of them wore grains of very fine gold in their ears and noses, which they gave away willingly" (page 136).

Columbus never mentioned in his log whether he wore an earring or earrings. An artist's sketch in the book by Robert H. Fuson depicts a sailor wearing a large hoop in his left ear (page 114). Another artist's sketch shows Columbus placing a silver finger ring on an Indian. Columbus is depicted wearing a small hoop in his right ear, and the Indian wearing a one-inch (two and a half centimeters) circular earring (page 160). Columbus probably was used to earrings on sailors, so he was not moved to write about them, except in conjunction with his search for gold. On the other hand, nose rings were undoubtedly novel to Columbus, so he mentioned them with greater prominence.

5. ©1987, International Marine Publishing Company, Camden, Maine.

It is not known whether Columbus in fact wore an earring or earrings. An article appearing in the January 1992 issue of *National Geographic* states that the actual appearance of Columbus remains a mystery. The article includes twelve posthumous artist portraits of Columbus, all of which are completely different. None of the portraits show Columbus wearing an earring.[6] However, some writers claim that Columbus wore an earring or earrings in accordance with the custom of that time. For example, earring wearer Kyle Petty writing in *The Atlanta Journal and Constitution* stated: "Sailors in the 17th and 18th century, like Columbus, pierced their ears and wore a gold hoop for every sea they crossed. When they died the earrings paid to bury them."[7]

Note that Kyle Petty is several centuries off in his reference to Columbus, who actually sailed in the fifteenth century.

North American Indians

Male as well as female Indians of North America generally had both ears pierced. This was true of the Eskimo tribes in the Arctic to Indian tribes ranging geographically from Alaska and throughout the entirety of the United States and into Mexico. The ear holes ranged in size from the diameter of a cactus thorn used for piercing, to the one-quarter-inch to three-eighths-inch size hole favored by Egyptians and other early cultures, to large slits that extended around most of the ear.

Ear piercing was frequently done in a ceremonial setting. Some tribes did ear piercing as part of the naming ceremony after birth, and others did ear piercing at or near puberty. Although female ear piercing was generally universal, some tribes reserved ear piercing for males of special promise.

6. "Search for Columbus," by Eugene Lyon, with photographs by Bob Sacha, *National Geographic*, January 1992. Various artist renderings of Columbus appear at pages 16 and 17.
7. "Coca-Cola 600 You Can Drive Straight Even with an Earring," by Kyle Petty, *The Atlanta Journal and Constitution*, May 29, 1994, Sports; Section E; page 8. Reprinted with permission from *The Atlanta Journal* and *Constitution*. Reproduction does not imply endorsement.

William Duncan Strong, the author of *Aboriginal Society in Southern California,* which was originally published in 1929,[8] described ear piercing among Southern California Indians:

All the girls of a clan were tattooed on the chin when they were in their tenth or eleventh year. . . . Boys of approximately the same age, sometimes a year younger, were also decorated at this time. These boys, not necessarily the net's sons but of promising material, had the nasal septum pierced and three links of deer bone inserted in the opening. Later these boys had their ears pierced with cactus thorns. The piercing of the nose was called multavavepi, that of the ears for both sexes hemnakalmumhanwin. The decorating of the boys in this manner was only done on rare occasions when a boy of great promise appeared and when his clan was able to afford such a ceremony. Such boys, said my informant, nearly always became famous as leaders or hunters and the bearers of such distinctions were honored even among the Mohave and the Chemehuevi. The tattooing of the girls, however, and the piercing of their ears, was a regular ceremony. This ceremony was accompanied by a night of singing with a feast. Should the holes pricked in the ear lobes fail to stay open they were not reopened again. These customs have long gone out of vogue and I did not see actual evidences of any of the above-named practices among the present population.

The male Chumash Indians, who lived along the California coast from Ventura to Point Conception, came up with a very practical use for their earrings. They carried tobacco in them! A writer by the name of Font wrote in 1775:

Some of them have the cartilage of the nose pierced, and all have the ears perforated with two large holes in which they wear little canes like two horns as thick as the little finger . . . in which they are accustomed to carry powder made of their wild tobacco . . . (1930:250–251).[9]

An 1850 photograph of a male California Nisenan Indian wearing a large wooden stick through each earlobe appears at page 136 of *The*

8. ©1972, Malki Museum Press, Morongo Indian Reservation, Banning, California. Reprinted from the University of California Publications in American Archaeology and Ethnology, Vol. 26, 1929. Quotation following is from page 80.
9. *Handbook of North American Indians,* Volume 8, "California," ©1978, Smithsonian Institution, Washington, D.C., at page 509.

American Indians, The Indians of California by Time-Life Books, Alexandria, Virginia, ©1994. The caption to the photograph is silent about the earrings.

Ear-piercing practices and fashions among the Chimariko Indians, who lived in Trinity County in northern California, were described as follows:

> A child's ears were pierced at two years.
> On ceremonial occasions men wore round haliotis ear ornaments or dentalium pendants. Women wore rectangular haliotis pendants.[10]

The Apache Indians routinely pierced the ears of both sexes within several months after birth. Author James L. Haley, in *Apaches: A History and Culture Portrait*,[11] describes the practice among the Chiricahuas branch of the Apaches:

> Among the Chiricahuas, it was necessary to pierce the ears during the first few months, a task usually performed by the maternal grandmother. This was accomplished by applying a heated object to the earlobe, following quickly with a sharp puncture by a bone sliver or thorn. "When the ears are not pierced," it was said, "the child cannot be controlled; he will be wild and go to the bad." Children after the procedure were believed to hear things sooner and grow faster.

Those beliefs are not too much different than the perception today that a male who gets his ear(s) pierced somehow becomes "kinder and gentler." Author Thomas E. Mails in *The People Called Apache*[12] added the following information to the above account:

> Earrings of turquoise or white beads were then hung in the child's ears, and he would continue to wear earrings throughout his life.

According to the *Handbook of North American Indians,* Volume 11, "Great Basin," among the Western Shoshone Indians, "[e]ars of both

10. *Handbook of North American Indians,* Volume 8, "California," ©1978, Smithsonian Institution, Washington, D.C., at page 207.
11. ©1981, Doubleday & Company, Inc., Garden City, New York. The quotation is from page 127.
12. ©1974, 1993, BDD Illustrated Books, New York, at page 75.

sexes were often pierced to receive ornaments."[13] Among the Southern Paiute Indians, the same work states:

> The ears of recalcitrant children were perforated (Chemehuevi, Las Vegas, Moapa). Moreover, Coyote ruled that without pierced ears it would be impossible after death to cross the chasm to the other world. An added inducement was the association of ear perforation with longevity. Small sticks, stones, or shells were used as earrings (page 375).

Among the Omaha Indians in the 1800s, ear piercing was a costly ceremony. Each hole represented the gift of a horse to the man who did the piercing. Thusly, earrings were a sign of their wearers' wealth.[14]

A photograph of Chief Mankato of the Dakotas (the namesake of Mankato, Minnesota) wearing large dangling earrings appears at page 34 of *War for the Plains*,[15] which is one volume in the series of books titled *The American Indians* published by Time-Life Books.

Males in the Cherokee Indian Nation favored large slits in their earlobes. The Royal College of Surgeons of England contains paintings of several Indians wearing dangling, ear ornaments made of silver. The earrings are circular and contain cutout, six- and eight-pointed stars of a two-to-three-inch diameter (five to eight centimeters). These Indians were painted in 1790 and 1791 in London and were part of a group led by a William Augustus Bowles. Photographs of two paintings showing members of this group with these earrings appear in *The Cherokee Indian Nation: A Troubled History*.[16]

Ear-piercing practices among male Cherokees were described by Thomas E. Mails in his book *The Cherokee People*:[17]

> Men's ears were split with knives and stretched to enormous size by the insertion of stone or bone earplugs, after which they were hung with earrings made of stone, shell, lead, and later on, silver pendants and rings. The operation for this is described as one of incredible pain, with

13. ©1986, Smithsonian Institution, Washington, D.C., page 269.
14. *Ethnic Jewelry*, edited by John Mack, ©1988 The Trustees of the British Museum, Harry N. Abrams, Incorporated, New York, at page 155.
15. ©1994 by Time Life Inc.
16. ©1979, University of Tennessee Press, edited by Duane H. King. See Figures 13 and 14.
17. ©1992, Thomas E. Mails, Council Oak Books, Tulsa, Oklahoma. Quotation is from pages 48 and 49.

the patient thereafter being unable to lie on either side for nearly forty days. To avoid this, some people had only one ear slit at a time. As soon as the patient could bear it, the outer edge of the ear was wound round with wire and the expansion plugs were inserted.

Males of the Delaware Indians also had the helix of their ears cut and hung earrings from the resulting loop of flesh. As stated in *Handbook of North American Indians,* Volume 15, "Northeast," page 229:

This loop sometimes got torn, and in the nineteenth century men, like women, generally wore simple earrings in pierced ears (fig. 12), or, in the case of acculturated men, gave up ear decorations entirely.[18]

Jack Harry, the Western Delaware leader who lived from 1853 to 1900, is shown at page 230 of the same text in a photograph "in everyday dress with earrings." The earrings were medium-size hoops with dangles attached and were worn in each ear. Also on the same page is a photograph of a painting of an assistant chief by the name of Nonondagumun, which was painted in 1831–32 by George Catlin. The painting shows Nonondagumun wearing dangle earrings in each ear about twelve inches (thirty centimeters) long, as well as a nose ring. The painting is contained in the National Collection of Fine Arts, Smithsonian.

The subject of ear piercing among Indian tribes living in the Southeastern United States is extensively discussed in *The Indians of the Southeastern United States* by John R. Swanton.[19] With respect to North Carolina coast Indians, " 'some of the children of the kings brother and other noble men, have five or sixe in either eare' (Burrage, 1906, page 232)." (page 510).

Author John R. Swanton writes that males wore various types of earrings: claws of birds stuck through the ears, shells with pearl drops, fish-bladders dyed red and then inflated, wood ear buttons finished to look like eyeballs, hard stones fastened with deer's sinew, and hammered silver coins hung from a silver wire.

In describing the Florida Indians, author Swanton quotes another

18. ©1978, Smithsonian Institution, Washington, D.C., at page 229.
19. ©1979, Smithsonian Institution Press, Washington, D.C.

author who wrote: " 'All the men and women have the ends of their ears pierced.' "

A painting by Jacques le Moyne, which depicts Florida's Timucua Indians in a 1564 French expedition, with males and females all wearing inflated fish-bladder earrings, is reproduced in *The American Indians, The European Challenge* at pages 6 and 7.[20]

In 1903, three Nez Perce (pierced nose) Indian warriors posed for a portrait. Although they had apparently abandoned wearing nose rings by that time, all three of them wore circular, disk earrings hanging from their earlobes. See *National Geographic,* March 1977, "Chief Joseph," by William Albert Allard, at page 429. A photograph of Chief Joseph also taken in 1903 appears at page 408, and shows him wearing a medium-size hoop earring in each ear, together with a 1.5-inch (four centimeter) circular disk suspended from each hoop.

Various paintings and illustrations of male Indians wearing earrings appear in *After Columbus: The Smithsonian Chronicle of the North American Indians:*[21]

At pages 66 and 67, a painting by Edward Hicks depicts Quaker William Penn concluding a treaty with Delaware Indians in 1682. Some of the male Indians are shown wearing several types of earrings.

At page 87, an 1817 painting by Russian artist Mikhail Tikhanov shows an Aleut man wearing a medium-size hoop earring with a small dangle in his right ear. (His left ear is not visible in the portrait.)

At page 98, a drawing of Ottawa Chief Pontiac in 1760 offering the peace pipe to Maj. Robert Rogers. Chief Pontiac is shown wearing a medium-size hoop in his left ear. (His right ear is not visible in the drawing.)

At page 108, an early eighteenth-century Iroquois war chief is shown in an artist's rendering wearing a drop earring in each ear.

20. *The American Indians, The European Challenge,* ©1992, Time-Life Books, Alexandria, Virginia, at pages 6 and 7.
21. By Herman J. Viola, ©1990, Smithsonian Institution.

At page 121, a painting depicting a peace treaty at Fort Greenville in 1795 shows three chiefs wearing large, hoop earrings.

At page 128, Mandan Indians near the Missouri River are depicted touching York, the black slave of Capt. William Clark during the Lewis and Clark expedition of 1804 to 1806. The Indian touching York is wearing a large hoop in his right ear (his left ear is not visible), as is York with a smaller size hoop in his right ear (his left ear is also not visible).

At page 131, a Shawnee Indian warrior is shown wearing multiple earrings in each ear.

At pages 138 and 139, a group of Cherokee Indians are shown being herded to the Oklahoma Indian Territory. Several of the male Indians are wearing a large, dangling earring in each ear.

At page 168, a photograph appears of Sioux Chief Gall around 1868. He was wearing a medium-size hoop with a dangle in each ear.

At page 230, a photograph appears of present-day Navajo singer Hosteen Klah. An ear hole is visible in his right ear, but he is not wearing an earring.

A collection of 111 photographs of American Indians appears in *Native American Portraits, 1862–1918*.[22] The photographs were collected by Kurt Koegler, a New York attorney, beginning in 1979. A significant number of the photographs show earrings being worn by male Indians, with always one earring in each ear. The earrings shown in the photographs are mostly hoop earrings, one to three inches (2.5 to 7.5 centimeters) in diameter and some with dangles from the hoops. Some of the notable photographs are described as follows:

At page 33, Buckskin Charlie, the Head Chief of the Utes, is shown with his wife. Both Charlie and his wife are wearing the same size 1-inch

22. ©1990 by Nancy Hathaway and Kurt Koegler, Chronicle Books, San Francisco.

(2 1/2 centimeters) hoop earrings but with different shape shell charms. Hers are rounded and about two inches (5 centimeters) in diameter, and his are pyramid-shaped and about 4 inches (10 centimeters) in length, and tapered from 3/4 inch (2 centimeters) wide at the top to 1 1/2 inches (4 centimeters) at the bottom.

At page 35, Buckskin Charlie is shown alone wearing the same earrings.

At page 44, a Navajo scout with Lieutenant Wright is shown wearing extremely thick, 2 1/4 inch (6 centimeters) diameter hoops.

At page 93 and on the front cover, a young Navajo man is shown in 1905 wearing somewhat wide, dangling earrings.

At page 94, an elderly Osage Indian by the name of Bear Legs is shown in 1902 wearing thick, 1-inch (2 3/4 centimeters) diameter hoop earrings. His ear holes had turned into long slits, which extended close to the bottom of his earlobes.

At page 100, a middle-aged male Indian is shown in 1910 with 2-inch (5 centimeters) diameter hoops, as well as with long hair braids.

Various photographs of American Indian males wearing earrings may also be found in the series of books by Time-Life Books titled *The American Indians*. The volume titled *The First Americans*, ©1992, contains various photographs of earrings, including an Apache chief wearing 1.5-inch (four centimeters) diameter hoops with 4.5-inch- (11.5 centimeters) long dangles attached to the hoops. The volume titled *The Spirit World*, ©1992, shows an Osage Indian wearing 1.5-inch (four centimeters) diameter hoops. (See page 111.)

The white settlers even manufactured shell earrings for the Indian trade. The manufacture of shell hair pipes, which are basically sea shells the thickness and length of the little finger, began during the 1770s and continued until around 1850.[23] Colonial silversmiths also crafted silver earbobs for the Indian trade. The earbobs consisted of a silver wire

23. Ethnic Jewelry, edited by John Mack, ©1988 The Trustees of the British Museum, Harry N. Abrams, Incorporated, New York, at page 129.

hooked into a silver ball at the bottom, from which was suspended a long, dangling triangle.[24] These practices seem somewhat hypocritical, because white men at the Bureau of Indian Affairs later prohibited male Indian children from wearing earrings to boarding schools. Other examples of this hypocrisy are the lack of objection by American colonists to Indians wearing earrings while they were assisting in warfare against the British and other Indian tribes, and the army employing Indian scouts who wore earrings.[25]

When Lewis and Clark left in 1804 on their expedition to explore the Louisiana Purchase, they carried with them for trade purposes not only rings, brooches, iron and brass combs, silver arm-and wristbands, but also earrings and nose trinkets.[26]

By the early 1900s, the custom of male American Indians wearing earrings had largely waned. This is because of the pressure that had been placed on Indians to abandon their cultural heritage. The Gannett News Service on September 13, 1993, reported on a U.S. Senate Indian Affairs Committee hearing on the Native American Free Exercise of Religion Act. The article stated:

> University of Iowa law professor Robert Clinton also outlined historical examples from the files of the Bureau of Indian Affairs, which in the 1800s ran boarding schools for Indian children. Clinton noted that the schools outlawed traditional long hair and earrings on male students, ritual dancing, traditional burial practices, the use of medicine men and the speaking of Indian languages.[27]

Tibet

Tibetan opposition to Chinese occupation of their country led to open revolt in 1959. The Dalai Lama, the Buddhist religious leader, fled

24. *The American Indians, Tribes of the Southern Woodlands* by Time-Life Books, Alexandria, Virginia, ©1994. See photograph at page 81.
25. See photograph of Pawnee scouts, who were employed by the army to protect railroad construction crews from attacks by hostile Indians, wearing their earrings in the 1860s. *The American Indians, War For The Plains,* ©1994, Time-Life Books, Alexandria, Virginia, at page 123.
26. *Ethnic Jewelry,* edited by John Mack, ©1988 The Trustees of the British Museum, Harry N. Abrams, Incorporated, New York, at pages 167 and 168.
27. "Proposed Law Would Protect Indians' Religious Freedom," by Chet Lunner, Gannett News Service, September 13, 1993. Copyright 1993, *USA Today.* Reprinted with permission.

for his life to India along with numerous other Tibetans. The Sakya family was the first Tibetan family in the United States, and they settled in Seattle in 1960.

> "To see them when they first came, walking around with their robes and their earrings hanging down—they were very visible, very newsworthy," recalls former *Seattle Times* reporter Julie Emery."[28]

The article does not specifically state if the males in the family wore earrings; however, the inference is there. Earrings on females would not have been worthy of comment, even if they were wearing robes.

India

Male Indians customarily had both ears pierced when they were infants. This custom lasted until the 1950s, and continues at the present time in some of the villages. The book *Ethnic Jewelry* comments upon this custom as follows:

> In all Indian communities, but especially among male Hindus, the progress of the individual from birth to death in rite-of-passage events is marked by purification ceremonies, where jewellery may play an important role. . . . At the name-giving ritual, performed twelve days after birth, a stud or small ring is inserted into the child's ear, and sometimes nose, to act as a protective amulet. Children are believed to be especially vulnerable to malignant spirits, and such ornaments are believed to engage the spirit's attention and divert it from the child itself.[29]

28. "Snow Leopards in a Cultural Zoo," *The Seattle Times*, June 13, 1993, Section: Pacific, page 16.
29. *Ethnic Jewelry*, edited by John Mack, ©1988 The Trustees of the British Museum, Harry N. Abrams, Incorporated, New York, at page 72.

TWENTY-SEVEN

The Male Earring Fashion in Europe and the United States—1500s to 1800s

Most people are unaware that earrings were very fashionable for men in Europe and to a lesser extent in the United States during certain periods of time extending from the 1500s to the early 1800s. One author, in commenting about the time frame of 1500 to 1700, wrote as follows:

> The new period was resplendent with dress and jewels. Earrings were large, long, and elaborate, hanging in some instances to the shoulders. Not to be outdone, the men of the period imitated the ladies and adopted the earring. In the National Portrait Gallery, London, are several portraits of distinguished men of old England wearing this attractive ornament. The handsome Earl of Somerset, Figure 133, wears his finely kept hair in the prevailing mode, covering all but the lobes of the ear, from which hang the jeweled earrings. Queen Elizabeth's favorite, Sir Walter Raleigh, wore handsome ear ornaments (see Plate XLIX, Chapter 36). Later, the Duke of Buckingham is said to have worn diamond earrings.

> Henry III of France, called the effeminate ruler, together with his court, delighted in these fashionable ear pendants. Charles I of England, as a leader of fashion, is known to have exercised the greatest care in the selection of these ornaments. In preparing for his walk to the scaffold, he took the same pride in the earrings as in other details of his dress. Arriving there he carefully removed and handed them over to a faithful follower. Since that time they have been preserved as a highly valued relic.[1]

Another author dated the fashion for males wearing drop earrings as being in the time frame of 1450 to 1550.[2] For the time frame of 1550 to 1625, the same author commented:

1. *Accessories of Dress,* ©1940 by Katherine Morris Lester and Bess Viola Oerke, The Manual Arts Press, Peoria, Illinois, at pages 112 and 113.
2. *Historic Costume for the Stage,* ©1935, 1961 and 1963 by Lucy Barton, Walter H. Baker Company, Boston, at page 201.

Chains, earrings, brooches, and finger rings were worn in astonishing profusion by both men and women. . . .

Earrings were oftenest pear-shaped pearl drops, and men wore them in one ear only (figs. 2, 3, 7, 11). Mariners affected small gold hoops, though some of them (soldiers, too) wore instead of a hoop a black silk cord put through the lobe and tied in a knot in front (page 229).

Because there were few references in early books or other writings to the male fashion for earrings in Europe and the United States, later writers have based their conclusions and opinions in large part upon the review of portraits painted during this period. Cameras were not invented until the nineteenth century, so wealthier people would often hire an artist to paint their portraits. The problem with this is that not all males chose to have their portraits painted wearing earrings, some artists may not have liked the fashion and persuaded their customers to forego the earrings, and some portraits were later altered to remove the depicted earrings.

An early fresco (a wall painting) showing male earrings is located in the Vatican. It is entitled *The Disputation of St. Catherine* and was commissioned in 1492. Several male figures appear in the right side of the fresco wearing large earrings dangling from their left ears (their right ears are not visible). A photograph of the fresco appears in *Inside the Vatican*.[3]

Famous English and French Who Wore Earrings

Charles I, king of England, Scotland, and Ireland from 1625 to 1649, wore a large pearl drop earring. This earring was worn in his left ear.[4] Charles I was born in 1600 and was beheaded in 1649.[5] He even wore his pearl earring to the scaffold, where he removed his earring and gave

3. *Inside the Vatican,* by Bart McDowell, Photographed by James L. Stanfield, ©1991, National Geographic Society, at pages 170 and 171.
4. In *Fairchild's Dictionary of Fashion,* by Charlotte Mankey Calasibetta, Ph.D., 2nd Edition, ©1988, Fairchild Publications, New York, under definition of "earring" at page 186, the author states that the earring was worn in his right ear. However, various paintings of Charles I depict that the earring was actually in his left ear. See *Charles I, King of England,* painted by Hendrick Pot (before 1585–1657) in 1632. This painting is at the Louvre in Paris, and is contained on the laserdisc "Louvre, Volume 1, Painting, Drawing," ©ODA 1989, Distributed by The Voyager Company, at C-23, Frame 42252, and especially Frame 42255.
5. The King James Version of the Bible was completed in 1611, prior to Charles I becoming king.

it to a friend. Charles I was pictured at the age of fourteen already wearing an earring.

Louis Roupert was also portrayed wearing a large pearl earring, dangling from one ear.[6]

Sir Walter Raleigh (1552–1618) wore two large pear-shaped pearls in his left ear.[7] He founded the first English colonizing venture in America, the lost colony on Roanoke Island, Virginia.

William Shakespeare (1564–1616) wore a medium-size gold hoop in his left ear. In Shakespeare's play *The Tragedy of Othello, the Moor of Venice*, Othello wore earrings.[8] [Moors are from northwest Africa, in present-day Morocco and Algeria.]

Sir William Playters is shown in a 1615 painting located in the Ipswich Museum in eastern England wearing a long-stranded woven tassel earring in his left ear.[9]

Henry III, king of France (1551–89), delighted in wearing earrings. One author stated that he spread the fashion for drop earrings.[10] Another author stated that he owned a *pair* of diamond earrings.[11] A tapestry dated 1580 depicts Henry III with his lady sharing a pair of large, drop earrings. Only one ear of each is visible in the tapestry: Henry III wears a drop earring in his right ear, and the lady wears hers in her left ear.[12]

George Villiers, the first Duke of Buckingham (1592–1628), wore diamond earrings.[13] A Parisian reported on one of George Villiers's

6. *Jewellery*, by Diana Scarisbrick, The Costume Accessories Series, ©1984, B.T. Batsford Ltd., London, distributed by Drama Book Publishers, New York, at page 17.
7. *Accessories of Dress*, ©1940 by Katherine Morris Lester and Bess Viola Oerke, The Manual Arts Press, Peoria, Illinois. See Plate XLIX at page 475.
8. *Jewels and the Woman: The Romance, Magic and Art of Feminine Adornment*, by Marianne Ostier, ©1958, Horizon Press, New York, at page 128.
9. *20,000 Years of Fashion*, Expanded Edition, by Francois Boucher with a chapter by Yvonne Deslandres, ©1987, Harry N. Abrams, Incorporated, New York, at pages 235 and 239.
10. See *5000 Years of Fashion* by Mila Contini, ©1979, Chartwell Books, Inc., Secaucus, New Jersey, at page 64.
11. *Objects of Adornment: Five Thousand Years of Jewelry from the Walters Art Gallery*, ©1984, Walters Art Gallery and the American Federation of Arts, New York, at page 151.
12. *Let There Be Clothes*, ©1991 by Lynn Schnurnberger, Workman Publishing, New York, at page 178.
13. *Early American Dress: The Colonial and Revolutionary Periods*, ©1965 by Edward Warwick, Henry C. Pitz, and Alexander Wyckoff, Benjamin Blom, New York, at page 283 and Plate 20B.

visits in 1625–26 as royal ambassador to France that Villiers wore "a large pearl with a great diamond at the ear-clasp."[14]

Robert Carr, earl of Somerset, was painted with a double pearl in his right ear. Henry Wriothesley, a patron of Shakespeare, and third earl of Southampton wore an earring. So did Thomas Wriothesley, the fourth earl of Southampton, who became privy counselor to Charles I. He was pictured with a small hoop in his right ear.[15]

Although writers frequently comment that the male fashion for earrings died out with the beheading of Charles I in 1649, an English manuscript from 1822 titled *Male and Female Costume* described a gentleman in 1687 as wearing a wig and "silver or gold rings in his ears."[16]

The reason for male earrings falling out of fashion in England is unknown, especially since the fashion in France continued for another 150 years or longer. The later negativism in England toward males who continued to wear earrings is indicated by author Mary Ann Evans writing under the pen name George Eliot. In her 1861 book *Silas Marner,* she comments:

> It was a wonder the pedlar hadn't murdered him; men of that sort, with rings in their ears, had been known for murderers often and often; there had been one tried at the 'sizes, not so long ago but what there were people living who remembered it.[17]

Artist Rembrandt and His Paintings

The master artist Rembrandt van Rijn (1606–1669) favored wearing earrings himself and painted various portraits of himself and other males wearing them. Rembrandt was unique among artists for having painted somewhere between fifty to a hundred or more self-portraits. A number of the self-portraits painted from 1634 to 1655, when Rem-

14. *Fashion for Men: An Illustrated History,* ©1985 by Diana de Marly, Holmes & Meier Publishers, Inc., New York, at page 46.
15. *Early American Dress: The Colonial and Revolutionary Periods,* ©1965 by Edward Warwick, Henry C. Pitz, and Alexander Wyckoff, Benjamin Blom, New York, at page 283 and Plate 20B.
16. *Male and Female Costume,* by Beau Brummell [George Bryan Brummell], Benjamin Blom, Inc., Publishers, New York, 1972, at page 94.
17. *Silas Marner,* by George Eliot, 1861. Contained on CD-ROM, *Library of the Future, 3rd Edition,* Screen 104: 309, Windows Ver. 3.0. ©1990–94, World Library, Inc., 12914 Haster Street, Garden Grove, CA 92640, 714-748-7197, 1-800-443-0238.

brandt was between twenty-eight to forty-nine years old, depict him wearing an earring in his right ear. The earring was usually a good size dangle, although he also favored small gold hoops. Rembrandt must have owned a collection of earrings, since the self-portraits depict different earrings.

In at least two of the paintings, Rembrandt is depicted wearing an earring in each ear. In the painting titled *The Dead Bittern*, painted in 1639, Rembrandt is depicted holding a dead game bird. A small gold hoop is shown in each ear.

In a self-portrait painted in 1645, Rembrandt is pictured wearing what appears to be a black pearl drop earring in each ear. Pascal Bonafoux in his book *Rembrandt: Self-Portrait* ©1985, Rizzoli International Publications, Inc. comments:

> The right ear—on the spectator's left, therefore—is repeated by another in profile, barely covered by strands of hair. (At page 95.)

The earring fashion apparently extended into Eastern Europe. Rembrandt painted *Polish Nobleman* in 1637, which depicts an older man with a mustache wearing a very large pearl drop earring in his right ear. The left ear of the man is not visible in the portrait. The painting is in the Andrew W. Mellon collection at the National Gallery of Art in Washington, D.C.[18]

Rembrandt also painted *Portrait of a Man with a Turban* in 1633. The portrait shows a man in his fifties wearing a gold dangle earring in his left ear. The dangle appears to be a crescent affixed at the center of the curve to the upper part of the earring. The right ear of the person is not visible in the portrait. The painting is in the Alte Pinakothek in Munich, Germany.

The military apparently was not immune from the earring fashion. Rembrandt painted *Portrait of a Man in Armour* in 1655. A middle-age man is portrayed wearing his armour and a helmet, with a large, shiny drop earring in his left ear. The right ear of the man is not visible. The painting is in the Glasgow Museums Art Gallery & Museum in Kelvingrove, Scotland.

18. The painting is contained on the laserdisc "National Gallery of Art" ©1983, Videodisc Publishing, Inc., New York, at C-7, Frame 852.

Paintings by Steen and Rubens

Other artists also depicted males wearing earrings. Jan Steen (1626–1679) painted *Festivities at an Inn* in about 1674. A male is shown playing a violin type of instrument and wearing a pearl drop earring.[19] The painting is at the Louvre in Paris.

Master artist Peter Paul Rubens (1577–1640) painted *Hercules and Omphale* between 1602 to 1605. (This painting should not be confused with a painting by the same name by another artist.) The painting depicts Hercules getting his left ear pierced. Omphale is shown holding the top of Hercules' left ear. A person to the right of Hercules is holding an awl in one hand and a piece of string in the other.[20] It would appear that an awl was used in the 1500s to 1600s to pierce ears, and a string was inserted to keep the piercing open until it healed. The Bible mentions the awl as being used to pierce the ears of slaves. Hercules was a man in mythology who became a Greek god, and he was famous for his courage and his strength. It is interesting that the artist depicts him getting his ear pierced, because Rubens apparently did not wear an earring. At least, a self-portrait painted by him did not show an earring. This is apparently the only painting by a master that depicts an ear piercing.

Rubens also painted *Bathsheba at the Bath* about 1635. The painting depicts a bare-bosomed Bathsheba with a female servant combing her hair. In the left part of the painting is a black boy wearing a dangle earring in his right ear.

Paintings by de La Tour and others

French artist Maurice Quentin de La Tour (1704–1788) painted *Count Maurice of Saxony, Marshal of France*. The painting shows a middle-age man wearing a pewter-colored earring in his right ear. His left ear is not visible in the portrait. The painting is shown on page 131 in *Conversations on the Dresden Gallery.*[21]

19. The painting is contained on the laserdisc "Louvre, Volume 1, Painting, Drawing" at C-23, beginning at frame 42703. The earring is clearly visible at frame 42712.
20. The painting is contained on the laserdisc "Louvre, Volume 1, Painting, Drawing" at C-23, beginning at frame 42381.
21. By Louis Aragon and Jean Cocteau, ©1982, Holmes & Meier Publishers, Inc.

A 1621 painting of Sir Henry Paiton by Flemish artist Daniel Mytens shows the subject wearing a small, gold hoop in his left ear. His right ear is not visible in the portrait.[22]

Other examples of males wearing earrings can be found by reviewing art books and by being observant when visiting art museums.

French and Italian Fashion

When the fashion for male earrings died out in England, the French and Italians adopted the fashion with a fervor from the highest to the lowest in society. Although Napoleon did not wear earrings, his brother-in-law Joachim Murat apparently wore them. Napoleon made him king of Naples in 1808. The French fashion was made fun of in a 1786 English cartoon showing French officers dressing, all sporting earrings. In 1797, an English diarist Mrs. Lybbe-Powys was surprised by a French officer in Bath " 'with large gold earrings.' "[23] Based on this diary entry, it appears that French males wore an earring in each ear.

Louis-Philippe-Joseph, the duc d'Orleans, was guillotined in 1793 for his role in the French Revolution. A painting of him shows him with white-grey hair, and a small, thick gold hoop in his left ear (his right ear is not visible).[24]

A 1797 portrait painted by Anne-Louis Girodet de Roucy of Jean Baptiste Belley, a black ex-slave elected to the French National Convention, shows him wearing a medium-size gold hoop in his right ear (his left ear is not visible).[25]

It appears, therefore, that the French fashion for male earrings lasted from the mid-1500s until the early 1800s, which is nearly a three-hundred-year period. (Refer back in this chapter to the earlier comments about Henry III, king of France, who lived from 1551 to 1589.) For the most part, it appears that French males wore earrings in

22. "First Look at a Lost Virginia Settlement," by Ivor Noel Hume, *National Geographic,* June 1979. A photograph of the painting is at page 746.
23. *Earrings: From Antiquity to the Present,* by Daniela Mascetti and Amanda Triossi, ©1990 Thames and Hudson Ltd., London, and published by Rizzoli International Publications, Inc., New York, Preface at page 7.
24. *Time Frame A.D. 1700–1800, Winds of Revolution,* ©1990, Time-Life Books, Inc. A picture of the painting appears at page 143.
25. *Time Frame A.D. 1700–1800, Winds of Revolution,* ©1990, Time-Life Books, Inc. A picture of the painting appears at page 132.

both ears, unlike the English fashion where the majority of males wore only one earring.

Caricatures published in France in 1799 ridiculed the masculine fashions being adopted by women, such as skirts draped to show one leg, and "slave earrings worn by both sexes."[26] Those earrings were hoops about two inches (five centimeters) in diameter! (To understand the caricatures, one must understand that males were the first to wear short skirts with tights or silk stockings and pumps, and delight in showing off their legs. Women wore long gowns that completely covered their legs and dragged on the ground. Males were also the first to wear culottes. Later, males began wearing short pants, which were knee-length, with silk stockings below that. Eventually, females adopted all of the former male fashions, and the terms used today are miniskirts, nylons, and pantyhose. The only skirts being worn by Western males today are Scottish kilts, and by male fashion designers and others looking for publicity over their "male skirts").

In *Madame Bovary,* written by the French novelist Gustave Flaubert in 1856, one of the male characters was described as still wearing earrings:

> Charles went upstairs to see the patient. He found him in bed sweating under the blankets. He had flung his cotton night-cap to the other end of the room. He was a fat little man of somewhere about fifty, fair-complexioned, blue-eyed, and bald in front. And he was wearing ear-rings.[27]

Later in the same novel, there is a reference to a pawnbroker who "had placed Madame Bovary's gold chain along with Tellier's earrings" in the same safe (screen 499: 619). Tellier was earlier described as an old man and landlord of a café.

It would appear that there were still a few Frenchmen wearing earrings (one in each ear) in 1856. Their ear holes from the early 1800s either had not closed from nonuse, or those with ear holes could not resist the temptation to continue filling them with earrings.

26. *20,000 Years of Fashion,* Expanded Edition, by Francois Boucher with a chapter by Yvonne Deslandres, ©1987, Harry N. Abrams, Incorporated, New York, at page 341.
27. *Madame Bovary*, by Gustave Flaubert, 1856, translated by J. Lewis May. Contained on CD-ROM, *Library of the Future, 3rd Edition,* Screen 24: 619, Windows Ver. 3.0. ©1990–94, World Library, Inc., 12914 Haster Street, Garden Grove, CA 92640, 714-748-7197, 1-800-443-0238.

Reprint from a 1903 Book

Following is a reprint of a portion of a chapter from volume II, *Two Centuries of Costume in America, 1620–1820,* by Alice Morse Earle, ©1903 by The MacMillan Company, and reprinted in 1974 by Corner House Publishers. Chapter XVII is titled "Two Masculine Vanities—Muffs and Ear-rings." The text concerning male earrings starts suddenly at the middle of page 453. This text is unusual because it was written after the earring fashion had faded, and when most people would rather have forgotten about the fashion.

Muffs and Ear-rings 453

. . . . It is always a surprise to me to find a sedate old English gentleman wearing an ear-ring. Adam Winthrop, grandfather of the first governor, John Winthrop, was painted by Holbein. With his furred robe and flat citizen's cap, this dignified Master of the Guild of Cloth-workers wears an ear-ring (page 451). Philip Stubges, in his indignant outbursts at excess of fashion, says:

"Worse than all, they are so far bewitched as they are not ashamed to make holes in their ears; whereat they hang rings, and other jewels of gold and precious stones, but this is not so much frequented among women as among men."

Holinshed in his *Chronicle* confirms this statement:—"Some lusty courtiers also and gentlemen of courage do wear either rings of gold, stones or pearls in their ears."

Courtiers, it is not strange to know, wore them. That effeminate creature, Henry III of France, and his followers delighted in them, and that courtier of courtiers, the man who seems the very personification of the life of luxury, amusement, cleverness and extravagance of the English Court under James I,

454 Two Centuries of Costume

that courtier of courtiers, the Duke of Buckingham, wore diamond ear-rings.

In the reign of Charles I ear-rings continued in fashion; for the king hung

a beautiful pearl in his ear; he even wore it on his way to the scaffold. There he took it from his ear and gave it to a faithful follower, and ever since it has been carefully preserved as a sacred relic, and is now owned by the Duke of Portland. This pearl was given to the Earl of Portland by King William, with an attestation in the handwriting of the Princess of Orange. It is pear-shaped, about five-eighths of an inch long, mounted with a gold top, with a wire to pass through the ear, and a tiny knob to place behind the ear to hold it in place. It is shown in a portrait of the King when he was but fourteen years old.

Many of the portraits of men of the sixteenth and

seventeenth century show ear-rings, usually pearls. A great pearl is in the left ear of Thomas Dutton (nat. 1507, ob.1582), the founder of one branch of the Cheshire family of his name; his right ear is not shown; generally but one ear was pierced. I have a fine old print of the infamous Earl of Somerset which has a double pearl in the right ear. This portrait of him is in the National Portrait Gallery. In it he wears a ruby ear-ring.

It must not be held that the wearing of ear-rings was only by men of "dandaical body," as Carlyle would say; they hung at the ears of men of action, of men of parts—of Sir Walter Raleigh, of Shakespere, of the Earl of Southampton. Two great pear-shaped pearls, one an inch and a quarter certainly in length, dangle in Raleigh's left ear in a well-authenticated portrait, while the portrait of the Earl of Southampton (facing page 190) shows a goodly ear-ring. His friend Shakespere, in the so-called Chandos portrait (see page 452), is shown with a mustache and beard, and an ear-ring like a sailor's. He wrote:

Her beauty hangs upon the cheek of night
Like a rich jewel in an Ethiop's ear.

This passage in "Romeo and Juliet" refers to the custom of "Ethiops"— African negroes—wearing ear-rings.

Sailors and fishermen, as did the Ishmaelites of the Bible, commonly wear ear-rings. They have a belief that piercing the ears will both cure and prevent sore eyes. I find that a hundred years ago American

men who "followed the sea" often had their ears pierced and wore ear-rings. On page 457 is a copy of a miniature portrait of Captain George Taylor, a Salem ship-owner, a man of wealth, who wore earrings. This was painted in Lisbon in the year 1800. It was a safe inference, until recent times, that an American man who wore earrings had seen the world and been round the Horn; and I am told that it was as common for seafarers (whether ship captains or supercargoes, or men before the mast) to have their ears pierced as to be tattooed.

I have seen a splendid portrait by Gilbert Stuart of a New England gentleman who wore ear-rings and was painted in ear-rings. The presence of the ear-rings in the portrait so annoyed a granddaughter, that she has had them painted out. Many portraits of French gentlemen have earrings.

In the play "Cupid's Revenge," when the old duke tries to play the gallant, he has his ears pierced. In the Saint Memim portraits, which were painted in America in 1797 to 1810, are several

Muffs and Ear-rings 457

with ear-rings bearing French surnames, dated 1798 to 1805. A copy of one of these is given on page 456. As Saint Memim was a gentleman, a nobleman, I cannot doubt that his friends were also men of note, but some of them look like Brussels sailors.

Lady Morgan, as late as 1816, noted the gold ear-rings worn by men in France. These were not only on the customhouse officials, but she remarked specially upon the Duc de Biron Gontaut, whose resemblance to the portrait of his ancestor, the Duc de Biron, who was decapitated by Henry IV, was much increased by the fact that both wore "very long gold earrings."

More singular still to me, even than ear-rings, are the black silken strings tied in holes made in the edge of the ear. There is a portrait at Hampton Court with these ear-strings, which is said to be of Shakespere, but with no authority.

Planche gives, from "Desiderata Curiosa," an account of a fray in Gray's Inn, in 1612, when one quarrelsome gentleman seized another "by a black

string which he wore in his ear, a fashion then much in use." Planche also gives a portrait of Henry, Prince of Wales, at that date, with this black string in his ear; and he conjectures the peculiar fashion may have travelled to England from Denmark with Anne, mother of this Prince Henry, for a portrait at Hampton Court shows Christian, King of Denmark, wearing this ear-string.

Frequent reference to these ear-strings are found in old plays by Jonson, and Beaumont and Fletcher. In one of Marlowe's we read:—

Yet for thy sake I will not bore mine eare
To hang thy durtie silken shoo-tires there.

Another allusion is to drawing ribbons through the ear. Women also wore these ear-strings. A portrait of Anne of Denmark by Vansomer and one of Elizabeth, Queen of Bohemia, by Honthorst have them.

To wear a rose in the ear was a prettier fashion. A portrait of Thomas Lee (about 1590) shows him with a red rose over his ear. The red rose suited love-lock and pearl ear-rings then just as a red rose suits a black lace mantilla to-day.

Comment on Reprint

One wonders how many paintings were later altered to remove the offending earring when earrings fell out of fashion. One also wonders how many paintings omitted earrings of those that customarily wore them. Even today many males remove their earrings for milestone portraits, such as graduations and weddings.

Ear piercing by men is mentioned in the above-reproduced text as being more popular than among women! In case that language was missed, look again at the middle of page 453 of the reprint, in the quotation from Philip Stubbes.

American Fashion

As the above reprint points out, certain Americans, especially those who followed the sea, wore earrings. This seems to have been especially true of sailors of Dutch ancestry who settled in New York from 1623 to 1800.[28]

The book *History of American Costume, 1607–1870,* first copyrighted in 1904, discusses the earring fashion in England among males, and then states: "[T]here is not any evidence that earrings were at any time a fashion favoured by men in the Colonies of America."[29]

The key word from the above quotation is "favoured." It indicates that male earrings were not a popular fashion: it does not mean that no males wore earrings.

Various authors have commented that American fashion among the more affluent "closely followed" that of Europe throughout the 1700s, but were "less exaggerated." This was especially true of male fashions.[30]

When the earring-wearing monarch, King Charles I of England, was beheaded in 1649, a large number of his followers fled either to the European continent or to Virginia in the American colonies. The Virginia governor Berkeley invited the royalist fugitives to settle in his colony. They came in large numbers until restoration of the monarchy in England in 1660. The fugitives flaunted their Cavalier fashions in Virginia as a badge of allegiance to their beheaded king.[31] These fashions undoubtedly included the wearing of earrings by males.

When Charles II ascended to the throne in 1660, the fashions from his father's reign continued, and these fashions continued to be worn "at the governor's court in Jamestown and among the more modish planters."[32] The social pressure was such that planters must have the latest fashions from London every year.

28. *Early American Dress: The Colonial and Revolutionary Periods,* ©1965 by Edward Warwick, Henry C. Pitz, and Alexander Wyckoff, Benjamin Blom, New York, at pages 137 and 138.
29. *History of American Costume, 1607–1870,* by Elisabeth McClellan, ©1904 and 1910, George W. Jacobs & Company, and ©1937 and 1969 by Tudor Publishing Company, at page 52.
30. *Fashion Accessories Since 1500,* ©1987 by Geoffrey Warren, Drama Book Publishers, New York, at page 82.
31. *Early American Dress: The Colonial and Revolutionary Periods,* ©1965 by Edward Warwick, Henry C. Pitz, and Alexander Wyckoff, Benjamin Blom, New York, at page 54.
32. *Early American Dress: The Colonial and Revolutionary Periods,* ©1965 by Edward Warwick, Henry C. Pitz, and Alexander Wyckoff, Benjamin Blom, New York, at page 56.

Because the male American colonists adopted such unusual English fashions (judging by the standards of the present time) as wigs with long curled hair, muffs, silk stockings covering legs bare to the knee, lace, ribbons and bows, and high heel shoes, there is no reason to believe that the fashion for earrings was also not adopted to some extent. Yet the literature on the subject is virtually nonexistent. It is as if the earring fashion had been intentionally forgotten or suppressed. As an example, the American writer Samuel Clemens, who used the pen name of Mark Twain, was apparently unaware that Shakespeare had worn an earring. He wrote in 1869 in Innocents Abroad: "Think of Milton, Shakespeare, Washington, standing before a reverent world tricked out in the glass beads, the brass ear-rings, and tin trumpery of the savages of the plains!"[33]

Male American Indians (i.e., "savages") were still wearing earrings at the time of Samuel Clemens. Based on the above quotation, he apparently could not fathom civilized males wearing earrings.

The book Costume of Colonial Times originally published in 1894 discusses the subject of "ear-rings" in Colonial America, but gives not a hint that any males were given to wear them:

EAR-RINGS. The earliest portraits of colonial women display no ear-rings. The widow of Colonel Livingstone of New London had a "pair of stoned ear-rings" in 1735. In the Boston Evening Post of June 1755 we read of "Undressed Ear-rings, Stone, French-Pearl & Crincled Ear-rings, French Rose Ear-rings and Cristiall Ear-rings"—so they evidently had become at that date wholly the mode. In 1771 J. Coolidge, Jr. had still further styles—"Paste, enamelled, pearl, garnet, mock garnet and black ear-rings." In the Connecticut Courant of May, 1775, we read this notice: "For the Ladies: Pierc'd & Plain stone ear-rings set in gold & silver; jointed gold wires for the ears." Bernard Gratz had for sale in Philadelphia in 1760: "Fancy cluster ear-rings; French pearl, circled and points; plain open ear-rings; Garnet night ear-rings."[34]

The term "undressed" as used above and in numerous books on

33. Innocents Abroad, by Mark Twain, 1869. Contained on CD-ROM, Library of the Future, 3rd Edition, Screen 206:848, Windows Ver. 3.0. ©1990–94, World Library, Inc., 12914 Haster Street, Garden Grove, CA 92640, 714-748-7197, 1-800-443-0238.
34. Costume of Colonial Times, by Alice Morse Earle, ©1894 Charles Scribner's Sons, and republished in 1974 by Gale Research Company, Detroit, at pages 104 and 105.

costume equates today with daytime wear, whereas larger, more ornate, and especially dangling earrings would be worn in the evening with formal or party clothes. The term "night ear-rings" meant small studs that can comfortably be worn to bed, and which would keep the ear holes from closing.

Yankee Doodle

The famous tune of "Yankee Doodle" was originally written by the British to make fun of poorly dressed American troops during the beginning years of the Revolutionary war.[35] The Americans then changed the lyrics to make fun of the British. Few people today realize that the American version pokes fun of males who wore earrings. These lyrics are as follows:

Yankee Doodle went to town,
Riding on a pony,
He stuck a feather in his hat
And called it macaroni.[36]

The key word in the above verse is "macaroni." The song is not talking about pasta that one eats, but fashionable English dandies during the 1700s who adopted expensive and decorative clothing styles including earrings.

Author Marianne Ostier wrote in 1958: "But through the next century the English macaronis (fops who are mocked in our 'Yankee Doodle' song) continued to flaunt earrings upon the Puritan public."[37]

A drawing of a "foppish man" during the time period of 1720 to 1730, contained in *Fashion Accessories Since 1500*, depicts him with a dangling diamond earring in his right ear (his left ear is not visible).[38]

35. *Men and Women, Dressing the Part*, Edited by Claudia Brush Kidwell and Valerie Steele, ©1989, Smithsonian Institution Press, Washington, D.C., at page 16.
36. *Songs of Independence*, ©1973 by Irwin Silber, Stackpole Books, Harrisburg, PA, at page 76. See also pages 74 and 75.
37. *Jewels and the Woman: The Romance, Magic and Art of Feminine Adornment*, by Marianne Ostier, ©1958, Horizon Press, New York, at page 128.
38. *Fashion Accessories Since 1500*, ©1987 by Geoffrey Warren, Drama Book Publishers, New York, at page 66.

(The term "fop" refers to a man who is excessively vain and concerned about his manners and appearance.)

Sailors

When the male fashion for earrings had died out, sailors clung to their earrings for several hundred more years. One author, in commenting upon the time frame of 1625 to 1660, wrote: "Earrings for men were no longer very fashionable; though it is said that Charles I wore one to the scaffold. Seafaring men clung to their earrings for two hundred years and more; not only professional pirates, be it noted, but 'respectable' sailors as well."[39]

In Herman Melville's unfinished novel *Billy Budd, Sailor (An Inside Narrative)*, the author writes that he saw a black sailor in Liverpool, England. "[I]n his ears were big hoops of gold." The interesting part of this reference is that it was apparently based upon personal observation, since Herman Melville had been in Liverpool as an American sailor in 1839.[40]

Later Years and Sherlock Holmes

Sherlock Holmes is a fictional character created by British author Sir Arthur Conan Doyle (1859–1930). Doyle was a medical doctor before he turned to writing full time. A computer word search through his sixty Sherlock Holmes stories reveals two stories that discuss ear piercing for men. In *The Red-Headed League* written in 1891,[41] Sherlock Holmes asks:

"Have you ever observed that his ears are pierced for earrings?"

39. *Historic Costume for the Stage*, ©1935, 1961 and 1963 by Lucy Barton, Walter H. Baker Company, Boston, at page 201.
40. *Billy Budd, Sailor (an Inside Narrative)* by Herman Melville, Reading Text and Genetic Text, Edited from the Manuscript with Introduction and Notes by Harrison Hayford and Merton M. Sealts, Jr., ©1962 by The University of Chicago Press, Chicago and London, at pages 43 and 135.
41. The complete Sherlock Holmes is available on CD-ROM from World Library's *Greatest Books Collection*, ©1992, which gives the complete text of 150 historical, classical and cultural titles. World Library, Inc. is located at 12914 Haster Street, Garden Grove, CA 92640, 714-748-7197 or 800-443-0238, and Fax 714-748-7198.

"Yes, sir. He told me that a gypsy had done it for him when he was a lad." (screen 23).

The inference of this fictional account is that a few males in England were still wearing earrings in the 1890s. And, that gypsies more commonly wore earrings at that time. It should be noted that writer Doyle used the plural "ears" rather than "left ear" or "right ear."

In the story *The Adventure of the Cardboard Box*, written two years later in 1893, Sherlock Holmes investigates the mystery of a woman who was sent two human ears in a box:

> One of these ears is a woman's, small, finely formed, and pierced for an earring. The other is a man's, sun-burned, discoloured, and also pierced for an earring (screen 14).

> The string [on the package containing the ears] was of the quality which is used by sailmakers aboard ship, and at once a whiff of the sea was perceptible in our investigation. When I observed that the knot was one which is popular with sailors, that the parcel had been posted at a port, and that the male ear was pierced for an earring which is so much more common among sailors than landsmen, I was quite certain that the actors in the tragedy were to be found among our seafaring classes (screen 23).

The story does not indicate whether the right or left male ear was enclosed in the package. The significance of the story is that it was not uncommon for sailors even in the 1890s to wear earrings.

TWENTY-EIGHT
Sociology of Ear Piercing and Wearing Earrings

Females

What does it mean today for a female to wear earrings in pierced ears? The answer is, "nothing." However, in Art Nouveau circles around 1900, "earrings were thought barbaric ornaments, [and] the idea of piercing was disliked."[1] A book written in 1940 expresses disgust with ear piercing: "The most barbarous ornaments are those fastened into the body by means of piercing or mutilating the flesh—nose rings, lip pieces, and earrings."[2]

A comment in a 1984 jewelry book spoke of Etruscan (from Italy) leech earrings that were "secured by a wire that *actually pierced the flesh.*"[3] This is a pretty shocking view for as late as 1984.

Although females in all parts of the world had pierced their ears for many thousands of years, the custom gradually died out in the United States beginning around 1880. Woman wanted the right to vote, to wear pants, and be freed of wearing impractical clothing, and of barbarous customs such as ear piercing (which males did not have to undergo). Beginning around 1900, women adopted the screw-on earring for non-pierced ears, and thirty years later the clip-on earrings. Finding these new types of earrings uncomfortable to wear and easy to lose, ear piercing gradually started being revived in the 1950s.

However, young females of questionable moral character first adopted the fashion. "Cheap girls," in addition to pierced ears, also had bleached hair, and wore red and black together.[4] Fifty years earlier (around 1900) blue was a suspect color, at least with earrings. This is

1. *Jewellery*, by Diana Scarisbrick, The costume Accessories Series, ©1984, B.T. Batsford Ltd., London, distributed by Drama Book Publishers, New York. Quotation is from page 70.
2. *Accessories of Dress*, ©1940 by Katherine Morris Lester and Bess Viola Oerke, The Manual Arts Press, Peoria, Illinois, at page 106.
3. *Objects of Adornment: Five Thousand Years of Jewelry from the Walters Art Gallery*, ©1984, Walters Art Gallery and the American Federation of Arts, New York, at page 50, emphasis supplied.
4. "Betrayed by Fashion, You Can't Tell a Bad Girl by Her Ankle Bracelet," *Chicago Tribune*, May 31, 1987, Final Edition, Section: TempoWoman; page 5; Zone: C.

because earrings with blue stones were supposedly worn mainly by prostitutes.[5] Other indicators of being a bad girl in the 1950s were wearing earrings in the daytime and wearing ankle bracelets. Although these comments are humorous today, they were serious concerns at the time.

The Barbie doll was at the forefront of fashion. When she was introduced in 1959, she wore a black-and-white swimsuit, gold hoop earrings, and white sunglasses.[6]

In writing about the revival of ear piercing among young females in the early 1960s, novelist and essayist Laura Wallencheck recently wrote:

> Until relatively recently, piercing the ear(s) has been the only "primitive" permanent body alteration Western societies consider "normal," yet even this staple of adornment required a nationwide revolution to return it to favor some 30 years ago. The rituals of ardent grandmothers born in the Old Country aside, the pierced ears of most American women under age 50 can be blamed on Mia Farrow.
>
> The sight of those really cool, really darling little pearl studs Farrow wore as the perpetually dazed, fawnlike Allison MacKenzie on TV's "Peyton Place" sent young girls in the '60s stampeding off in conspiratorial pairs in search of cork, needle, thread, ice, matches and rubbing alcohol: "You do mine and, if I don't die or anything, I'll do yours."[7]

Of special interest is that a book on female jewelry published in 1958 titled *Jewels and the Woman: The Romance, Magic and Art of Feminine Adornment* totally ignored the subject of pierced earrings. The book included a chapter titled "The Earclip," which refers to clip-on earrings.[8] The author commented that only exotic dancers should wear large hoop earrings, apparently of the clip-on variety. (At page 209)

5. *The Interpretation of Dreams* by Sigmund Freud, 1900, translated by A. A. Brill. Contained on CD-ROM, *Library of the Future, 3rd Edition*, Screen 343: 1065, Windows Ver. 3.0. ©1990-94, World Library, Inc., 12914 Haster Street, Garden Grove, CA 92640, 714-748-7197, 1-800-443-0238.
6. "Hallmark ornament heralds Barbie's 35th anniversary," *Business Wire*, July 21, 1994.
7. "Ringing the Body Eccentric," by Laura Wallencheck, *Chicago Tribune Magazine*, Sunday Magazine, January 30, 1994, page 20, Zone C, Essay. Reprinted with permission from Laura Wallencheck.
8. *Jewels and the Woman: The Romance, Magic and Art of Feminine Adornment*, by Marianne Ostier, ©1958, Horizon Press, New York, at page 128.

Antiquated ideas concerning ear piercing still appear in the fourteenth edition to *Emily Post's Etiquette,* which was copyrighted in 1984:[9]

> At some point in her early teens your daughter may want to have her ears pierced. Let her, but be sure that she has it done by a physician who has had experience in piercing ears or by a reputable jeweler, and not by a contemporary self-proclaimed "expert." During the day she should wear only the tiny gold studs necessary to keep the holes open, and even when she dresses up, the thirteen-to-fifteen-year-old should wear no more than a small gold earring or perhaps one of enamel or with a tiny colored stone.

> Among some ethnic groups it is customary to pierce little girls' ears when they are babies. This is, of course, acceptable if you are a member of one of those groups, but I would not recommend that other youngsters have their ears pierced before they reach their teens.

In her book edition copyrighted nine years earlier in 1975, Emily Post wrote as above, with the exception of another sentence appearing after "expert": "It is no longer considered in bad taste for young girls to wear earrings as long as they are not dangling or ornate."[10]

When pierced earrings on females were finally accepted in the business environment, they were required to be small studs. Dangles and hoops were still reserved for evening wear. Gradually, these fashion concepts floundered as ear piercing continued to rise in popularity.

Actress Ellen Burstyn broke taboos by having one ear pierced on-camera in the movie *Twice in a Lifetime,* which was released in November 1985. A male crew member was reported as being repulsed by the idea and called the ear piercing a primitive initiation rite.[11] The movie casts Ellen Burstyn opposite Gene Hackman. They portray a middle-aged couple whose thirty-year marriage is in trouble. Gene Hackman plays a blue-collar foundry worker in Seattle who starts having an affair with Ann-Margret. Ellen Burstyn is filmed shopping

9. *Emily Post's Etiquette,* 14th Edition, by Elizabeth L. Post, ©1984, Harper & Row, Publishers, New York, at page 303.
10. *The New Emily Post's Etiquette,* by Elizabeth L. Post, ©1975 The Emily Post Institute, Inc., A Funk & Wagnalls Book, Thomas Y. Crowell, New York, at page 900.
11. "Outtakes: A Hole in One," *Los Angeles Times,* September 15, 1985, Home Edition, Section: Calendar; page 17; Calendar Desk.

with her daughter, who convinces Ms. Burstyn to get her ears pierced to wear a pair of pierced earrings the daughter wants to buy for her. The ear-piercing scene is shown approximately 1 hour and 18 minutes into a 1 hour and 51 minute movie.

In the ear-piercing scene, Ellen Burstyn sacrificed her virgin earlobes. In real life Ms. Burstyn had never had her ears pierced, like some other women in her age group. Only her left ear is shown being pierced in the movie. Later in the movie, she is shown wearing dangling, pierced earrings in both ears. After the ear-piercing gun goes off, Ms. Burstyn visibly jumps in her chair. She states under her breath, "ouw— Jesus." The camera zooms up on her left ear and the chrome-plated, ear-piercing gun. The young lady doing the piercing pushes the trigger, the four-millimeter gold ball earring is shown as having pierced the earlobe, and plastic disposable parts are shown falling from the rear of the earlobe and being caught by the ear piercer.

The dialogue goes something like this:

"O.K. Pierce my ears! Is that what you're going to do it with?"
"This is a piercing gun."
"Are you sure it's not going to hurt?"
"No, it will feel like a quick pinch."
"I'm scared. Ouw, Jesus. Did it work? Oh, I like it! O.K., let's do the other one. You scared me!" (The exact dialogue was hard to take down, because the sister, Ms. Burstyn and the ear piercer are all talking at the same time.)

It is an interesting comment on society that the filming of such a common act by females is worthy of an article in the *Los Angeles Times*. Approximately thirty years earlier, several movies had depicted simulated ear piercing off camera behind closed bathroom doors, and only the shriek was heard.

As the popularity of pierced ears has grown among women, the wearing of earrings in an office environment is often regarded as part of the required wardrobe, which includes heels, makeup, slips, hose, and hairdos.[12] Pierced ears without earrings may also generate concern.

12. "Fitness; Sweat-Powered Commutes," by Alicia C. Shepard, *The Washington Post*, September 6, 1993, Section: Style; page C5; Style Plus.

Some regard that practice as evidence of being a slob.[13] It is almost as bad as not wearing pantyhose under a skirt or dress.

Earrings on women politicians are a given. As one female writer puts it, "forced smiling, earrings and pantyhose" are part of the job.[14] The same is true for the wives of male politicians. Those without pierced ears, such as Hillary Clinton, must dutifully wear clip-on earrings. However, women politicians must still wear the right type of earrings. "No dangle earrings" is the advice given by one consultant.[15] Celinda Lake, a Democratic pollster, claimed that one younger Midwestern female congressional candidate fared poorly among older women because they disliked the big earrings she wore.[16] Women politicians are also subject to criticism if they wear the wrong type of earrings, witness the following story from Britain about "angry earrings":

> Most fascinating of all was the way the Speaker's earrings wave in wild counterpoint to her head when she is angry. As her face pumps forward in her rage, they swing back into the hair and, nano-seconds later, vice versa."[17]

Some people believe that professional women should wear smaller and more conservative earrings, and that large earrings make the woman look like a secretary. However, there are contrary views. A thirty-year-old management consultant based in London was told by her employer that she should wear brighter lipstick and larger earrings to make her appear more assertive.[18]

The reason why some consultants claim it is important for profes-

13. "Immacuholics vs. Slobs," by Cynthia Thomas, *The Houston Chronicle*, August 28, 1993, Section: Houston; page 1.
14. "Seminars, Lists Help Pave Road to Politics for Women," by Susan Feeney, Washington Bureau, *The Dallas Morning News*, July 18, 1993, Section: News; page 8A. Reprinted with permission of *The Dallas Morning News*.
15. "Women on the Verge of a Power Breakthrough," by David Finkel, *The Washington Post*, May 10, 1992, Magazine Section, page 14.
16. "Women in Office: Learning Political Facts of Life," by Peter A. Brown, *San Francisco Examiner*, July 21, 1991, page 88.
17. "An Armchair View of the Speaker's Angry Earrings," by Simon Hoggart, *Guardian*, June 16, 1994, Section: The Guardian Home Page; page 8. Reprinted with permission.*The Guardian* ©.
18. "No Way to Suit Yourself," by Susan Irvine, *Sunday Times*, July 10, 1994, Section: Features.

sional women to wear earrings is that the earrings focus male attention on the woman's face instead of her breasts or legs.[19]

Gold earrings are considered a part of the "uniform" for female government employees in Washington, D.C. In a 1994 federal government survey on prices for employee clothing, "gold earrings and crisp white shirts with minimum trim" were tabulated for females.[20]

Males

What does it mean for a male to wear an earring? The answer to that question has varied as earrings become more common and accepted. For a younger male today, it may mean conformity. For an older male, it means confidence. As expressed by a British columnist:

> I met a mate I hadn't seen for a year or so the other night, and he'd acquired an earring. . . . Imagine the confidence it takes to walk out of an earringatorium and face all those people who are sure you didn't have an earring yesterday and want to know why you have one today. What do you tell them, given that nobody believes you if you say it's an acupuncturist's anti-smoking trick?[21]

The easier question is, Why? The simple answer is that males wear earrings for adornment, the same reason as females. The next question should be, Why not? The answer to that is that many males are afraid. They are afraid of being considered unmasculine (or gay), they are afraid of what people will say, and they are afraid of their employers. As one newspaper writer stated: "When and where I grew up, men did not wear earrings. At least, straight men did not wear earrings. That was it. You could tell the men from the women because men did not wear make-up, panty hose or earrings."[22]

19. "When Success Forces You to Compromise Your Sexuality; Women at the Top/Day Three: Power Dressing, Image and Why So Many Successful Women Are Made to Sacrifice Their Femininity at Work," by Graham Turner, *Daily Mail*, July 6, 1994, page 50.
20. "How Much Do you Spend? Marylanders Are Government Test Cases," by Ellen Gamerman, *States News Service*, June 28, 1994.
21. "Something for the Weekend," by John Diamond, *The Times*, December 4, 1993, Section: Features. © Times Newpapers Ltd., 1993. Reprinted with permission.
22. "Lend Me Your Ear—What You See and Feel Isn't Always What You Get," by Don Williamson, *The Seattle Times*, May 9, 1993, Section: Issues, Don Williamson, page A13. Reprinted with permission.

The first males to traditionally wear earrings during the last century and longer were sailors who had crossed the equator, navigated Cape Horn, or who had survived a ship wreck. The cartoon character Popeye had been in the navy, so this is probably why he wore a silver cross in his right ear.[23]

In the 1950s some males in motorcycle gangs began wearing an earring. They were generally unsavory characters, and no one would dare call them a "sissy" for wearing an earring. Then, earrings became popular in the entertainment field, among the rebellious types, and in schools among students and then teachers.

The May 19, 1975, issue of *Newsweek* magazine contained an article about males wearing earrings. The article at page 93 titled "Year of the Ear" commented that men in California, New York, and elsewhere were sporting an earring in one ear. The article closed with the following comment: "The question is whether male earrings will sweep the country—or just be another piercing fancy."

A female writer for *The Washington Post,* September 16, 1983,[24] was not receptive at all to males wearing earrings. She wrote:

> For the life of me, I have no idea why any man would want to puncture a hole in his earlobe and run around with a little gold trinket dangling out of it. I know perfectly well, of course, why women do it. It is a known fact that earrings are attractive on women.
>
> Earrings have a very clear role, in my mind at least, on women. They have no role, in my mind, on men. Men and women are simply not the same. . . . You can chalk it up to social conditioning, or whatever, but it is my considered opinion that earrings on men are downright weird looking.

More than ten years later, Washington, D.C., is still regarded as ultraconservative when it comes to males wearing earrings. However, earrings are being worn by some of President Clinton's staff.

23. "Lend Me Your Ear—What You See and Feel Isn't Always What You Get," by Don Williamson, *The Seattle Times,* May 9, 1993, Section: Issues, Don Williamson, page A13.
24. "Earrings," by Judy Mann, *The Washington Post,* Final Edition; Section: Metro. ©1983 *The Washington Post.* Reprinted with permission.

Three years later in 1986, *Newsweek* magazine[25] commented that American men were "having their hair permed, their pores cleansed and their ears pierced to reap the psychic and practical benefits of looking attractive."

A 1987 *Los Angeles Times* article[26] traced earrings from a "feminine fashion detail that men used at their own risk," to a rebellion thing by hippies, and then into the creative arts (actors and musicians), and finally preppies, college students, and those who are "a big enough man."

Males who began wearing earrings early in the fashion cycle typically reported receiving adverse comments, stares, insults, heckling, ridicule, and even threats when they began wearing an earring. This is an example of society attempting to pressure conformity. For what reason, one may inquire. The answer is that conformists find security in sameness and feel threatened by individuality. The male who has serious doubts of his own masculinity finds comfort in harassing males who dare to be different. Solace to this type of male comes from inflicting pain on others, so that his inner conflict and anguish can be temporarily forgotten. These males typically act in a group to find courage for their unsocial conduct.

Corporations are also infected with similar types of male individuals. These males find comfort in corporate actions, and base their conduct on the lust for power. They are detached individuals who hide behind the corporate mantle to get ahead by stepping on someone else. They will threaten to fire a male who dares to wear an earring, or harass him into believing he will not receive a corporate advancement if he wears an earring. These individuals have no deep feelings on any subject, and are opportunists. When these individuals control a corporation, their uncontrolled egos may lead the corporation into insolvency and ruin.

As more and more males dare to wear earrings, the social mores are changing. The same thing happened recently with gold chains (i.e., necklaces) for men. Rather than being considered feminine, gold chains

25. "You're So Vain," *Newsweek*, April 14, 1986; Section: Life/Style; page 48. Reprinted with permission.
26. "Earrings Pierce the Sex Barrier," *Los Angeles Times*, August 20, 1987, Home Edition, View; Part 5; page 1; column 2; View Desk. Reprinted with permission.

have become a macho article in some circles. And the insecure males will find other things to pick on.

Without the support of females, the earring fashion for males would have remained a mere passing fad. Females have had a substantial influence in convincing males that earrings will not detract from their masculinity. The nearly universal comment by young females that they think males look "sexy" by wearing an earring adds to the allure. One female commented to the author that she found ear holes "erotic." Although sexual arousal is a very individual thing, the concept of eroticism is really not that far removed from the concept of looking sexually attractive.

A female color and design consultant, Jennifer Butler, made a positive comment about males wearing an earring in a *Los Angeles Times* article appearing on January 27, 1989: "A pierced ear can look really great on a man. But he's sending out a message about himself, and he needs to be sure it's the message he wants to convey. He's saying: 'I'm creative, I'm a free spirit. I'm not mainstream.' And that's the kind of woman he is going to attract."[27]

Another newspaper writer referred to males wearing earrings as a "harmless fad."[28] However, this characterization in 1987 has proven to be in error. The fashion continues at the present time ever more popular.

Quebec designer Marie Saint Pierre summarized changing men's fashions in late 1993: "But everyone wants lighter, softer clothes. On an international level, there is a feminizing of fashion—a lightening of fabric and a softening of structure."[29]

The same article commented that one Montreal menswear company was using 7.5 to nine-ounce wool fabrics for traditional-style men's suits, and that some European houses were using wool fabric as light as six ounces. The article continued with the following observations:

27. "Single Life: Brooks Bros. or Pierced Ears—What Do Women Like on Men?" *Los Angeles Times*, Orange County Edition, Orange County Life; part 9; page 5; column 1. Reprinted with permission.
28. "Cocaine No 'Fad,' " *Chicago Tribune*, November 15, 1987, Final Edition; Perspective; page 2; zone: C.
29. "Women's Wear; The Lines Blur as Fashion Moves to Androgyny," by Iona Monahan, *The Gazette (Montreal)*, October 5, 1993, Living; Fashion Style; page C1. Reprinted with permission.

Fashion is going through a change of life and the signs have been out there for almost a decade.

Not only in the slowly changing shape and weight of men's clothes but in the acceptance of such symbols as long hair, ponytails, earrings, lapel-pins. To say nothing of the sarongs, dhotis, tunics, long vests and big shirts that have found their way into sportswear . . . alongside such surprises as sheer fabrics, laces and crochets that were once confined to women's wear.

One of the prerequisites to a male wearing an earring may still be confidence. A "Dear Abby" column on November 5, 1988,[30] carried a letter from a twenty-year-old male college student who wrote that his girlfriend asked him to get his ear pierced. He was planning on getting a pair of diamond earrings (one to be worn by each of them), but he was worried about what his parents would think. The sage advice given by Abby was that he should wait if he was concerned what others would think. That is probably correct: a real man would not be so concerned.

What does it mean in the post-feminist age when a young male "chickens out" during the ear-piercing process? Alice Kahn broached that subject in the *Los Angeles Times,* December 7, 1988, in her article titled, "Alice Kahn: Wear That Earring Like a Man."[31] The writer took her daughter to an earring store to get her ears repierced (the holes had closed because the daughter had not worn earrings), and the customer ahead of her was a man accompanying his nine-year-old son. During the ear piercing procedure, the son cried out that he could not get his ear pierced, and the father said, "Look, Jason, we can't get our money back. Now sit still and take your earring like a man."

The writer's daughter went ahead of the boy and "took it, like a girl." The writer commented to the father, "Boys aren't raised to suffer for fashion." When the father took the boy to the corner of the store for a talking to, the writer left with her daughter looking proud. The writer closed with, "How can boys be so good at baseball but such sissies at

30. "Sometimes Mr. Right Is Mr. Wrong," *Chicago Tribune,* November 5, 1988, Weekend Chicago; Zone: C.
31. "Alice Kahn: Wear That Earring Like a Man," by Alice Kahn, *Los Angeles Times,* View; Part 5; page 1; column 6; View Desk. Reprinted with permission.

earrings?" The postfeminist age sure can be puzzling, when a boy is a "sissy" for not getting his ear pierced!

Why do parents object to their sons getting an earring? There are lots of good reasons, but the real reason is perhaps that the parent is afraid of the reflection it will have on their parenting. What will other people think (*of me*)?[32] An etiquette book copyrighted in 1987 comments on the fashion for "boys" to pierce their ears and gives the following advice to parents:

> It has even become the custom on occasion for boys to pierce their ears. However dismayed parents may be over this prospect, they probably would do best to accept the deed once it is done rather than to create an ongoing harangue over it. This is a state, and like other stages of life, one can hope that it, too, will pass. Remember that while pierced ears are permanent, the wearing of earrings is not.[33]

Some grandfathers even brag that none of their grandsons wear an earring. The purpose of this bragging is apparently to demonstrate that they did an outstanding job rearing their children, who passed that fine upbringing on to their sons. For example, multimillionaire John Crean, the chairman of Fleetwood Enterprises, the nation's leading builder of recreational vehicles and mobile homes, was quoted in 1992 as saying: "I'm very proud of my children. Why wouldn't I be? I've got nine grandsons, and none of them has long hair or an earring."[34]

Jesus Christ wore long hair, and Moses and Job undoubtedly wore earrings, so what is Mr. Crean's point? If he is proud of his children and grandchildren because they turned into decent human beings who work hard and are successful and care for their families, he should so state. Whether they wear earrings or their hair over their shirt collar is irrelevant.

As earrings have become much more common, the resistance of many parents has broken down. It has now reached the point where a

32. "Parents Follow an Inner Voice," *The Washington Post*, December 1, 1987, Final Edition, Style; page D5; Style Plus; If You Ask Me.
33. *The New Etiquette, Real Manners for Real People in Real Situations—an A-to-Z Guide*, ©1987 by Marjabelle Young Stewart and Marian G. Faux, St. Martin's Press, Inc., New York, at page 149.
34. "Behind the Glitter," by Jane Glenn Haas, *The Orange County (California) Register*, March 15, 1992, Section H, Accent, pages 1 and 4. Reprinted with permission from John Crean.

number of parents, especially mothers, are actively encouraging their sons to get their ears pierced.

The extent of the pendulum swing of attitudes toward male earrings is evidenced by a female writer who admitted to "asking men where they bought their neat earrings and that I'm at the earring counter copying their choices for myself."[35]

There is only one deterrent to even more males wearing earrings in the 1990s. Novelist and essayist Laura Wallencheck wrote in early 1994:

> There is, lamentably, just one obstacle standing between American men and their yearning to sport jewelry, especially earrings—the sociopolitical atmosphere. Today, for athletes, movie stars, rock stars and just regular guys, earrings are—like, wow—a trend. In the McCarthy Era of the early '50s, earrings were—like, grunt—an all-points bulletin summoning thugs with baseball bats to descend on the pantywaist.[36]

Earlier in the same article, Ms. Wallencheck commented that " . . . jewelry has always made the woman AND the man—no matter what the guys down at the VFW say." The term "sociopolitical atmosphere" as used in the foregoing quotation boils down to the simple element of fear by older men. Fear of being ridiculed or harassed, fear of being fired, fear of being passed over for a promotion, fear of being branded a nonconformist, fear of what others will say, and fear of fear itself.

Oliver North, the 1994 Republican Senate nominee from the state of Virginia, astutely capitalized on this fear. The following quotation spawned numerous articles in the press: "Virginians are sick and tired of a Congress run by back-slapping good old boys and a White House governed by a bunch of twentysomething kids with an earring and an ax to grind."[37]

This quotation also appeals to the public's fascination with the subject of males who wear earrings, whether they be sports figures,

35. "Nice Cleavage, Mr. Pomance," by Bonnie McGrath, *Chicago Tribune,* November 7, 1993, Womanews; page 7; zone: CN; You At Your Best. © Copyright Chicago Tribune Company. All rights reserved. Used with permission.
36. "Ringing the Body Eccentric," by Laura Wallencheck, *Chicago Tribune Magazine,* Sunday Magazine, January 30, 1994, page 20, zone C, Essay. Reprinted with permission from Laura Wallencheck.
37. "Quote of the Day," *The Hotline* by the American Political Network, Inc., June 6, 1994.

actors, politicians, or just people in the news. A high percentage of males have secretly thought of getting their ears pierced, and would do it but for the fear. This explains their interest in the subject. H'mm, maybe Oliver North secretly wants to get *his* ears pierced! The end result of all this publicity will only be to encourage more males to wear earrings.

Oliver North lost the election! However, earring-wearing Sonny Bono won a seat in the U.S. House of Representatives in the same election. According to an article appearing in the *California Journal*, April 1, 1992,[38] Sonny Bono put away his diamond-studded earring that had shocked the locals in Palm Springs, California, when he became interested in a congressional seat. Congressman Bono may be the first male ever elected to the U. S. Congress who wears (or wore) an earring.

Ken, the Barbie Doll

That male earrings are becoming mainstream is shown by Mattel's controversial introduction of Earring Magic Ken in early 1993. For those too old to play with dolls and too young to have children, Ken is the male Barbie doll. Ken has now been introduced in the Earring Magic series of dolls wearing a small silver hoop earring in his left ear. He is also wearing a lavender leatherette vest, a matching mesh shirt, and a necklace with a large ring on it. Donna Gibbs, director of media relations for Mattel, was quoted in *The (Montreal) Gazette,* February 25, 1993[39] as follows: "Ken changes just like Barbie does, not leading trends, but always right on top of them. Men are wearing earrings today, it's become a mainstream phenomenon. So Ken should have an earring, why not?"

When asked about the lavender color scheme, Ms. Gibbs replied: "Ken is a girl's product. Little girls buy it. And, time and again, a little girl's favorite color is pink and the secondary colors are lavender and light blue. Boys don't play with Ken."

Earring Magic Ken continued to generate controversy into the end

38. "Sonny Bono—Is This Guy for Real?," by Mark Henry, *California Journal*, April 1, 1992, Section: Feature. According to the article, Sonny Bono also gave up his Harley-Davidson Motorcycle, his black leather jacket, and his longer hair.
39. "Earrings? Streaked Hair? Can This Be Ken?," *The Gazette (Montreal)*, February 25, 1993, Final Edition; Living; Home; page F1/Break.

of 1993. The controversy centered as much, if not more, over his choice of clothes as over his single earring. Numerous magazine articles, newspapers and television programs have commented upon the doll. In addition, the doll had become a hot item in the male homosexual community by the fall of 1993. Earring Magic Ken was discontinued by Mattel in 1994. The company reportedly changes 98 percent of the Barbie line every year.[40]

In addition to the Ken doll with one earring, Mattel has several female dolls in their Earring Magic series. Each Earring Magic doll, including the Ken doll, comes with a pair of clip-on hoop earrings for little girls to play with if their own ears are not yet pierced. Although little boys normally do not play with Barbie dolls, they do play with little girls. The play scene of a little girl placing one of the clip-on earrings on a little boy so that he looks like Ken is easy to imagine. Little girls and little boys will grow up with the social conditioning that earrings are acceptable for both sexes.

Doll collectors should hurry to purchase the Earring Magic Ken doll, since it was discontinued for 1994.

Trolls

A photograph of a rainbow troll advertised on QVC, a home shopping channel on cable TV, was shown in mid-1993 in *Newsweek* wearing a large, bright earring stud in his left ear only.[41] This doll, however, did not generate any controversy.

Female Dolls with Earrings

Earrings on female dolls are not a new phenomenon. Female Barbie dolls have had them for years. A two-thousand-year-old terra-cotta doll from ancient Rome depicted an adult female with large earrings. This doll looks very much like a Barbie doll of today, since it has large breasts, a slender figure, and hinged legs and arms. (See

40. "Ken Stumbles into New Market," by Michael Precker, *The Dallas Morning News*, November 2, 1993, Today; page 1C.
41. "He'll Shop until He Drops, Retailing: Barry Diller Dreams of a TV Network That Would Peddle Products between Programs," *Newsweek*, July 26, 1993, page 39.

photograph in Time-Life Books, *Time Frame 400 B.C.–A.D. 200, Empires Ascendant*, ©1987 at page 54.)

Communism

Communist regimes feared ear piercing early on. Why? The wearing of earrings provided an opportunity for people to express their individualities and to show their social status. The intent was to turn people into *sexless drones* who would provide spoils and riches for the Communist party elites. When the Communists came to power, along with their other confiscation of property, they even seized jewelry from the common people. One writer stated the vileness of their stooping: "They even took away the gold earrings and chains that some of the children had. All the children's hair was cut in the same way, regardless of whether they were boys or girls."[42]

42. "Madrid on the Moskva," by Madeleine Bunting, *The Guardian*,© The Guardian Features page, Page 14. Reprinted with permission.

TWENTY-NINE
Ear Piercing in Japan

Historical Background

Japanese women have historically not worn earrings, at least during the last thousand years. As a result of influences from Europe, the United States, and the rest of the world since World War II, more and more women have started wearing clip-on earrings.

Pierced Ears for Women Frowned Upon

Although pierced ears are still frowned on by upper society as well as by corporate employers, and the wearing of pierced earrings is even prohibited in the schools, more and more younger women are becoming bold and getting their ears pierced. Ear piercing in Japan in the early 1990s is basically equivalent to the United States in the 1950s.

One of the criteria for a prospective bride for the Crown Prince of Japan was reported in the January 18, 1993, issue of *Newsweek* as being that she not have pierced ears. The article on page 38 reported the engagement of Masako Owada to the crown prince. Another news story reported that Ms. Owada had not " 'disfigured herself,' which is taken to mean that she has not had her ears pierced."[1] The story continued by stating that one prospective bride "safeguarded her liberty by having her ears pierced." Other stories reported that more than one prospective candidate resorted to that tactic.

The *Phoenix Gazette* phrased the requirements for the prospective bride in a June 2, 1993 article as follows: "She had to be a young, short, well-educated, bilingual virgin with no physical mutilations (that includes pierced ears)."[2]

1. "Blue-Stocking Princess," by Joanna Pitman, *The Times*, January 8, 1993. © Times Newspapers Ltd., 1993. Reprinted with permission.
2. "Company's Days Are Lettered," *Phoenix Gazette*, June 2, 1993, Section: Tempo, page E3. Reprinted with permission.

Growing Popularity

A story in the *Financial Times* by the Financial Times Limited, June 3, 1992, datelined Tokyo, reported that personnel departments do not like pierced ears on young women. Surprisingly, among women ages 20 to 29, they own more earrings for pierced ears than any other item of jewelry.[3] (The Japanese social dilemma is best evidenced by their keeping separate statistics on pierced earrings!) A market report stated on July 1, 1992: "Pierced earrings, until recently completely missing from the Japanese market, have become popular among teenagers and other younger age groups, but still lag far behind clip-ons in terms of volume."[4] In a market report from the same source dated May 31, 1991, the ratio of clip-on to pierced ear variety being sold in retail stores was estimated to be 70 percent to 30 percent.[5] It would probably be in error to estimate that 30 percent of females in Japan have pierced ears, since the younger women probably purchase more earrings than older women.

An article appearing February 28, 1992, in the *Phoenix (Arizona) Gazette* entitled "How to Become an Expert in Exports" stated that when businesses try to go abroad they often fail to do market research. An example cited is that one businessman wanted to sell pierced earrings in Japan "only to discover that 99 percent of Japanese women don't pierce their ears." Although the premise of the article is correct, the information was no longer correct in 1992!

Special adhesive earrings were marketed in Japan in 1989. The adhesive was good for about a week before it failed. The pierced-ear look was furnished without the piercing. If the Japanese thought that that product would discourage their young females from getting their ears pierced, the reverse effect apparently resulted.[6]

The Tale of Genji

The Japanese are also affected by their movies. *The Tale of Genji* is

3. "Japan—Jewelry Preferences," *Market Reports,* March 24, 1992 by National Trade Data Bank.
4. "Japan—Precious Metal Jewelry," National Trade Data Bank, *Market Reports,* July 1, 1992.
5. "Japan—Xmas Sales of Jewelry," National Trade Data Bank, *Market Reports,* May 31, 1991.
6. "Japan: 'Pierced Earrings, without Piercing' Proves Winning Claim," *Marketing Week,* November 24, 1989, Reuter Textline.

a Japanese novel written nine hundred years ago and parts are required reading for high school students. The lengthy novel deals with the roguish and romantic exploits of Genji, a prince. In 1987 the Japanese produced a two-hour animated cartoon movie based on the novel. The Asahi News Service reported in an article of December 21, 1987, titled "Off the Shelf and into the Theaters: Genji Adapted to Film," (Copyright ©1987, the Asahi News Service) that "there are other concessions to the modern age. Genji, for instance, is tall, delicate-featured, almost Western in appearance—and wearing red pierced earrings."

One wonders whether there is a master plan by someone for introducing pierced earrings to Japanese women and men!

Male Earrings

Surprisingly, even young men are getting their ears pierced in Tokyo. An article entitled "Earrings and Bracelets for a Modern Male Set; Scenes of Men Wearing Jewelry Boom" appeared in *The Nikkei Weekly*, June 29, 1991. The article stated that a "growing number of young Japanese men are unashamedly wearing earrings." Two young males quoted in the article were wearing aquamarine gems in their ears and were shopping for diamond studs. The males stated that they had each pierced their left ear with a safety pin to save money, although girls usually go to a doctor for the ear piercing. One twenty-two-year-old male at Tokyo University of Foreign Studies was quoted in the article as having a jewelry box "filled with earrings, rings and pendants," although he did not have pierced ears.

A young California male who traveled in Japan during May 1993 with a friend who was born in Japan reported seeing a fair number of young Japanese males wearing an earring. He saw only one Japanese male, however, who had both ears pierced.

That Japanese attitudes are slowly changing is evidenced by a December 1994 newspaper account of a twenty-six-year-old Japanese male who wears an earring in his left ear while working for the country's second-largest advertising company.[7] However, this newspaper account is still entitle "Office Rebels." More common is the attitude

7. "Office Rebels," *Mainichi Daily News*, December 1, 1994, Section: page 1; Front Page.

expressed in the same article by a taxi company spokesman that pierced ears are absolutely out of the question for its drivers.

Japanese Dance Company Sankai Juku

The Japanese dance company Sankai Juku performed at the Southern Methodist University campus in Dallas, Texas, during November 1993. A female reviewer of the performance wrote the following comments:

> My favorite [section of the 83-minute program] is the second: *Sakihai— through a rose of the sand.* Four men in hooped skirts and big dangling earrings open and close their fingers like petals and swirl along the floor, kicking up sand as they turn. . . . Suddenly, they're gone, and darkness falls.
>
> It's lovely, poetic, evocative. It hints at meaning, but the meaning is as elusive and tantalizing as a memory of a dream.[8]

So what are Japanese men doing wearing skirts and big dangling earrings, even if it comes within the privilege and security of a dance company performance? Perhaps it symbolizes changes occurring in Japanese society, that the mass hysteria of ultimate conformity is finally breaking down.

Male Contradiction

Although Japanese businessmen are ultraconservative in their dress, one liberal fashion has taken strong root. Nearly one-half, or 47 percent, of all businessmen now carry purses![9] This is a rise from 0 percent only fifteen years ago. The gent purses come in three versions: the Lady Diana clutch purse, a small shoulder-strapped purse favored by Masako Owada, the wife of Japan's crown prince, and thin brief-

8. "Dream Motion; Sankai Juku Troupe Proves to Be Difficult but Compelling Going," by Margaret Putnam, *The Dallas Morning News,* November 10, 1993, Home Final Edition; Section: Overnight; page 33A. Reprinted with permission of Margaret Putnam.
9. "Accessory Is in the Bag with Hip Japanese Men," *Orange County Register,* June 11, 1993, Image, Accent, 4.

cases with no handles. One reason for the popularity of male purses may well be to carry their small portable telephones.

Japanese Sensitivity to Gold

Although in the United States and Europe, sensitivity to nickel appears to be the big problem and sensitivity to gold is rare, sensitivity to gold is not uncommon in Japan. An article appearing in *Archives of Dermatology* 1982; 118: 608–611 (Copyright 1982, American Medical Association. Reprinted with permission.) and written by four Japanese medical doctors stated: "Probably the fact that gold earrings were worn immediately after piercing of the earlobes was important to the provocation of hypersensitivity . . . " It is suspected that when doctors pierce ears in Japan, they insert an eighteen-karat gold stud earring.[10] Since fourteen-karat earrings have been long used by the Piercing Pagoda and Plumb Gold in the United States (a chain of three hundred-plus stores) without any similar problem being reported, the above explanation appears suspect. Perhaps there might be some genetic difference that explains the sensitivity to gold in Japan.

Because of this perceived sensitivity to gold,[11] Inverness® Corporation, based in Fair Lawn, New Jersey, is selling ear piercing studs made out of titanium in Japan. This is in addition to their line of karat gold piercing studs.

Future Fashions

With the growing popularity of ear piercing in Japan, it is predicted that most females will have pierced ears within the next ten to twenty years. Pierced ears among males will find growing popularity and

10. Japanese typically prefer eighteen-karat gold jewelry and view fourteen-karat gold jewelry as inferior.
11. The term "perceived" is used, since both fourteen-karat gold and eighteen-karat gold contain other metals. Fourteen karat gold is 14/24 or 58 1/3 percent pure, and eighteen-karat gold is 18/24 or 75 percent pure. It is possible that Japanese are actually sensitive to the nickel contained in karat gold. A spokesperson for the Inverness Corporation stated to the author that persons outside the United States appear to be more sensitive to nickel than are Americans. The reason for this increased sensitivity is unknown.

acceptance. With nearly one-half of male businessmen already carrying purses, earrings cannot be far behind.

Japanese society is chaffing at the demands placed upon them in school and in the workplace, and they want to start having some fun and enjoying a more comfortable living style. Pierced ears are a symbol of their growing demands upon society.

Western Businesswomen in Japan

A female executive from the West who is in Japan on business should avoid wearing large earrings to meetings lest she is treated as a "secretary." She should also avoid bright colors, bold patterns, and red lipstick. This advice was given in *The Christian Science Monitor,* May 3, 1993.[12]

Japanese Tourists in the United States

One of the favorite activities for Japanese female tourists in the United States, and especially in Hawaii and California, is to go to a shopping mall and get their ears pierced. One reason is undoubtedly the lower cost. In Japan ear piercing is done only by a medical doctor. In the United States, piercing chains often do free ear-piercing with the purchase of the ear-piercing studs. Another reason is that Japanese tourists undoubtedly notice that it is almost universal practice for American females (including those of Japanese ancestry) to have pierced ears, and the emulation-envy factor undoubtedly comes into play.

12. "Business Success in Japan: A Plan for Western Women," by S. C. Liewelyn Leach, *The Christian Science Monitor,* May 3, 1993, Section: Economy, Books, page 8. Reprinted by permission from *The Christian Science Monitor* ©1993 The Christian Science Publishing Society. All rights reserved.

THIRTY
Current Earring Fashions around the World

Modern Cultures

Current Fashions in Asia

According to a 1987 report out of Shanghai, China: ". . . more Chinese, particularly the young, are adopting Western dress and bright, bold colors. More women are exploring newfangled delights like nylon stockings, pierced ears and eye shadow."[1]

A 1987 report out of Beijing, China, indicated a similar trend in that part of the country:

> Young women commonly curl their hair or have it styled in other ways. Some wear earrings in newly pierced ears.
>
> "This is civilization," Liu Yufen, a 24-year-old kindergarten teacher said as she displayed the loop earrings running through her lobes.[2]

According to an article in the *South China Sunday Morning Post,* May 9, 1993,[3] males in Hong Kong are starting to wear earrings. The article quoted a "chartered" accountant who started wearing an earring a year ago, and the owner of a trading company that manufactures garments for export worldwide. The trading company owner stated that he wore his earring round-the-world to see his customers without any difficulty. The article also reported on MTV DJ Danny McGill who had a problem in a Calcutta trendy nightspot that banned men with earrings. He argued that male earrings had become widely accepted,

1. "In China, Beauty Is a Big Western Nose," *The New York Times,* April 29, 1987, Lake City Final Edition, Section: Section C; page 4, column 3; Living Desk. Copyright ©1987 by The New York Times Company. Reprinted by permission.
2. "Beijing Journal; Manicures? What Would Mao Say?" *The New York Times,* April 11, 1987, Late City Final Edition, Section: Section 1; page 4, column 1; Foreign Desk. Copyright ©1987 by The New York Times Company. Reprinted by permission.
3. "How Male Earrings Found a Measure of Respectability," by Sasha Nott, *South China Sunday Morning Post,* May 9, 1993, Section: Sunday Edition, page 6. Reprinted with permission.

and he was allowed to proceed with his filming of a "musical extrava-ganza."

Another article from the *South China Morning Post*, July 21, 1993, reported on the funeral of gangster James Moody. The article stated: "His passing was attended by his family, friends and a lot of men in earrings, square-cut suits and dark glasses."[4]

Earrings on males are still rough going in South Korea. The singing group the Boys were banned from television in November 1993 after they showed up to promote their second album wearing dreadlocks, ripped jeans, and earrings.[5] An article in June 1994 stated that "it is still daring" in South Korea for a man to wear earrings. The context of the article seemed to indicate the plural form was intended, i.e., an earring in each ear.[6] The *Korea Times* complained in June 1994 that young men with ponytails or an earring were disturbing the values of the whole-some people in South Korea.[7]

The prime minister of Singapore, Goh Chok Tong, in a July 1994 Youth Day address, equated earrings on boys with the antisocial be-havior of loafing around and vandalizing public properties.[8]

Current Fashions in Australia and New Zealand

Males in Australia starting piercing both ears several years before the fashion became popular in the United States. The Australians also started the fashion for males to wear thick, large gold hoops. The Kiwis in New Zealand are more conservative, and small diamond or cubic zirconia studs are popular.

4. "Gangster Moody Finally Laid to Rest," *South China Morning Post*, July 21, 1993, Section: News; page 17. Reprinted with permission.
5. "Rap Music Symbolizes Controversy of 'New Generation' in South Korea," by Ju-Yeon Kim, The Associated Press, November 22, 1993.
6. "Can South Korea Handle the Sensitive Guy?," by Ju-Yeon Kim, Dateline: Seoul, South Korea, *AP Worldstream*, June 23, 1994, Section: International News. The entire quotation is: "In New York or San Francisco, a man wearing earrings doesn't draw a second glance, but it is still daring here." Reprinted with permission.
7. "Rapid Social Change in South Korea Creates Problems," by Georgie Anne Geyer, *The Dallas Morning News*, June 15, 1994, Section: Viewpoints; page 31A.
8. "PM Goh Confident of Today's Youth," by Chua Mui Hoong, *The Straits Times (Singapore)*, July 4, 1994, Section: page 1.

Current Fashions in Canada

In Montreal, Quebec, Canada, earrings have become the fashion for a number of young men. An article appearing in *The (Montreal) Gazette,* March 17, 1992, stated that some males have earring collections.[9]

In Calgary, located in western Canada, the earring fashion for men is also taking hold. A 1991 article appearing in the *Calgary Herald* reported:

Is conservative, right-wing Calgary joining the North American trend of men wearing earrings? Yes, say several city jewellers.

"It's more common than I've ever seen before," says Llyn Strelau, owner of Jewels by Design. "People you'd never expect are wearing them. It's not just the artist-type anymore."[10]

In northern Ontario on the Wapekeka Indian Reserve, an earring in one ear is as common as in any Ottawa high school.[11]

Current Fashions in Europe

Male earrings are popular in Great Britain—it was here that the current male fashion got its start.

The mayor of North Warwickshire in Wales wears an earring, and he has even commissioned a mayoral earring with the council motto, Govern Yet Obey.[12]

An article in *The Irish Times* commented upon a group of forty boys, four of whom wore earrings. If this sample is representative of the population, this means 10 percent of the youth there wear earrings.[13]

9. "Charmed Circles," *The Gazette (Montreal),* March 17, 1992, Section: Living; Fashion Style; page D1, the headline apparently referring to hoop earrings.
10. "Studs Thrown for a Loop," *Calgary Herald,* December 24, 1991, Final Edition, Section: Life Today; page D1. Reprinted with permission.
11. "Life Not Worth Living for Reserve's Better Teens," by Jack Aubry, *The Ottawa Citizen,* May 8, 1993, Section: News, page A1.
12. "Diary," by Maev Kennedy, *The Guardian,* July 9, 1993, Section: The Guardian Features page, page 22.
13. "Marking the Scholars Out for Distinction," *The Irish Times,* June 14, 1993, Section: Home News, page 3.

Although the male fashion for earrings is very popular throughout Europe, males are frankly cautioned to remove their earrings in Muslim Bosnia. According to one report, in the central Bosnian town of Zenica, Shari'ah law has been enforced there since 1992. Women are not allowed to wear pants or miniskirts and men are not allowed to wear earrings. Members of the Muslim defense force reportedly beat the offenders on the spot.[14] Another media report carried the account of a female who witnessed a young man shot to death by a soldier because he was wearing an earring.[15] (Interestingly, the Qur'an does not prohibit males from wearing earrings, and the ancestors of Muhammad wore gold earrings.)

Current Fashions in India

Although near universal ear piercing of males (both ears) had virtually died out in the large cities by 1950, ear piercing continued in the villages through the present time. The practice is now being revived in the large cities, much like in the United States.

Current Fashions in Israel

In Israel, earrings are becoming popular among males. The "Dear Ruthie" column in *The Jerusalem Post* on April 22, 1993[16] carried the story of a mother seeking advice as to her eleven-year-old son who wanted to get his ear pierced for his birthday. The mother wrote that her son claimed that all of his friends wore an earring. Ruthie wrote in reply that the mother might want to give in if she is only postponing the inevitable, and to padlock her jewelry box.

14. "Ethic Expulsions: Zenica Croats Report Bosnian Muslims Expelling Local Croats and Serbs," BBC Summary of World Broadcasts, September 26, 1994, Section: Part 2, Central Europe and the Balkans.
15. "Mending Shattered Lives in Exile; Bosnian Refugees in St. Louis Struggle with the Transition to American Life," by Diana Aitchison, *The Kansas City Star*, January 2, 1995, Section: National/World; page A1.
16. "Birthday Boy Wants an Earring!," *The Jerusalem Post*, April 22, 1993, Section: Features.

Current Fashions in South America

The earring fashion among males in Argentina was just beginning in mid 1992 according to a note posted on Prodigy by a female from that country.[17]

Current Fashions in the United States

The growing popularity of male earrings in the United States is evidenced by their acceptance in the White House of President Clinton. As reported in the *Washingtonian*, May 1993:[18]

> Insiders say as many as twenty men now wear earrings in the White House. Most are twentysomethings in the Old Executive Office Building, but even 37-year-old David Dreyer, deputy assistant to the president for communications, sports a diamond stud.
>
> Clinton seems to be enjoying the trend. At the March 18 Radio and Television Correspondents Association dinner, he said of his staff, "It's amazing to see . . . the formal wear, the glamorous hairstyles, the beautiful earrings—and the women look nice tonight, too."

The same article commented that males still do not wear earrings at the State Department or on Capital Hill.

When Oliver North, a Republican candidate from Virginia for the U.S. Senate for the 1994 election, began to make a campaign issue about the Clinton administration being run by "twenty-something kids with an earring," the number of earring wearers supposedly shrank to one: communications aide David Dreyer, 38, who only occasionally was reported to wear a small stud.[19] Numerous newspapers suddenly carried a story that the May 1993 article in the *Washingtonian* was in error. It is suspected that the original story was probably more accurate than the later stories, because male earrings had suddenly become a political issue.

17. Prodigy, Homelife Bulletin Board, Topic: Fashion, Subject: Man with Jewerly (sic), July 20, 1992.
18. "White House Studs Lend Their Ears," by Jeremy L. Milk, *Washingtonian*, May 1993, Section: Capital Comment. Reprinted with permission.
19. "Earring Aide," by Janice Min, *People*, July 11, 1994, Section: Style Watch; page 73. Reprinted with permission.

James P. Pinkerton, a veteran of the Bush White House, recalled that a few men had pierced ears during that administration.[20]

Even some male judges have succumbed to the fashion. The manager of the Gauntlet, a New York City piercing shop, was quoted as saying that his clients have included a "retired State Supreme Court judge."[21]

Current Fashions in Mexico

According to an article in the *Orlando Sentinel*, "many young men prefer hard rock and wear the strictly foreign fashion of long hair and an earring."[22]

Tribal Cultures

Tribal Cultures in Asia

The Yi people are China's fourth largest ethnic minority. The 5 million Yi are scattered over several of China's southwestern provinces. Both sexes of the Yi people have pierced ears, with the males having only the left side pierced, and they wear intricate gold or silver earrings.[23]

The Jino people of China live in the Jinoluoke Mountain area in Jinghong county, Yunnan province. An article appearing March 30, 1993, in *The Straits Times*[24] reported:

When a boy or girl is 14 or 15, he or she will have his or her ears pierced to wear large earrings with wooden plugs or bamboo tubes on them. The larger the holes, the more beautiful they are considered. Placing fresh

20. "Clinton's Meritocracy," by Burt Solomon, *The National Journal*, June 19, 1993, Section: The Decision Makers, Vol. 25, page 1452.
21. "Earring Aide," by Janice Min, *People*, July 11, 1994, Section: Style Watch; page 73. Reprinted with permission.
22. "Holidays Bring Forth Mexicans' Strongest Values," by Nancy Feigenbaum, *Orlando Sentinel*, June 15, 1994, Section: Special Section; page D18. Reprinted with permission.
23. "A World away from Beijing," *The New York Times*, December 20, 1987, Sunday, Late City Final Edition, Section: Section 10; page 9, column 1; Travel Desk.
24. "People without a History," *The Straits Times*, March 30, 1993, Section: Life; China's Ethnic Minorities—The Jinos; Community (Chinese); page 11.

flowers in the earrings is an indication that he or she is ready to make love among the flowers in the moonlight or in the community room.

A photograph of a Dolpo trader in northern Nepal appears in the December 1993 issue of *National Geographic* at page 15. The male trader is wearing a turquoise-colored, stone earring in his left ear. The earring appears to be seven or eight millimeters in diameter. His right ear is not visible in the photograph. The text does not comment on his earring or whether his people commonly wear earrings.

The males of the Mru tribe in Bangladesh all have both ears pierced.[25] An article in *National Geographic* stated: "'Why, Nangla, why do you wear earrings and tie blossoms in your hair? . . . The young bachelor laughed. 'Because that is what our girls like!' " (at page 267).

Males of the Murung tribesmen who live near the Burma border in East Pakistan also have both ears pierced. Young females of marriageable age have the following standard of "manly beauty": "long hair tied in a knot, rouged forehead, cheeks, and lips, and gaudy earrings in his pierced ears."[26]

Among certain primitive tribes in Indonesia, "men and women are clothed only in loincloths and headdresses, earrings and armbands elaborately decorated with bird feathers of all colors."[27]

The Lisu people live in a highland straddling the borders of Thailand, Burma, and Yunnan. The males wear a silver earring in their left ear only, bracelets on each wrist and a jacket with silver buttons.[28]

Tribal Cultures in Arabia

Various tribal men on the Arabian peninsula continue to wear silver earrings. As reported by author Heather Colyer Ross:[29]

25. "The Peaceful Mrus of Bangladesh," by Claus-Dieter Brauns, *National Geographic*, February 1973, at pages 266–286. Reprinted with permission.
26. "Problems of a Two-Part Land, Pakistan," by Bern Keating, photographs by Albert Moldvay, *National Geographic*, January 1967, at page 45. Reprinted with permission.
27. "Ov Rivers Remote and Vast," by Charles Corn, *The New York Times*, May 16, 1993, Section: Section 6, Part 2, page 53, Column 3, Sophisticated Traveler Magazine.
28. *Ethnic Jewelry*, edited by John Mack, ©1988 The Trustees of the British Museum, Harry N. Abrams, Incorporated, New York, at pages 102 and 103.
29. *The Art of Arabian Costume: A Saudi Arabian Profile*, by Heather Colyer Ross, Second Edition, ©1985, Arabesque Commercial SA, Switzerland, at pages 111 and 114.

Various tribal men on the Peninsula also have one or both ears pierced in order to suspend traditional silver ear-rings. . . . Thesiger recorded that southern tribesmen wore a ring in the right ear-lobe (page 111).

In the nineteenth century, some Arabian tribesmen wore heavy jewellery (jowaher) just as they did thousands of years ago. Even today, in remote areas, some tribal men wear traditional ornaments that take the form of silver finger-rings and ear-rings—and leather head-circlets and belts decorated with silver (page 114).

Tribal Cultures in South America

The Mehinaku, a primitive people who live in the Amazon basin in South America, perform an ear-piercing ritual on young males at puberty. Apparently, both ears are pierced. (See the *New York Times* article on May 12, 1985,[30] which reviewed the book, *The Sexual Lives of an Amazonian People* by Thomas Gregor, The University of Chicago Press.)

Males of the Kreen-Akarores and the Txukahameis Indians in Brazil wore earrings through the mid-1970s. The Kreen-Akarores had a large hole in each earlobe and wore a white, circular disk. The Txukahameis males wore dangling beads or beads on hoops, and some even wore gold or silver colored hoops (presumably obtained from trade with the outside).[31]

Males of the Txicao Indians of Mato Grosso in Brazil wear large white button studs, with attached fringes and dangling white ivory or bones.[32]

Male Yanomamo Indians who live in Venezuela along the Brazil border wear large canes through their earlobes.[33] The holes are the same size as those of ancient Egyptians.

30. "Eros by the Xingu," *New York Times,* May 12, 1985, Section: Section 7; page 15, Column 1; Book Review Desk.
31. "Brazil's Kreen-Akarores, Requiem for a Tribe?," by W. Jesco von Puttkamer, *National Geographic,* February 1975, at pages 254–269, and "Brazil's Txukahameis, Good-bye to the Stone Age" by the same author at pages 270–283.
32. *Exploring South America,* ©1990 by Loren McIntyre, Clarkson N. Potter, Inc., New York, at pages 148 and 149.
33. "Yanomamo, the True People," by Napoleon A. Chagnon, Ph.D., *National Geographic,* August 1976, pages 210–223. See especially photographs at pages 211 and 222.

Tribal Cultures in Africa

Masai warriors in Kenya, Africa, all wore earrings into at least the 1950s. *The National Geographic Magazine,* October 1954, captioned a photograph on page 495 with, "Virile Warriors in Earrings and Hair Braids Kindle a Fire with Iron Age Tools."[34] The earrings shown in the photograph consist of a rectangular bell in the normal ear-piercing position, and a large hoop at the top of the ear. These earrings are worn in both ears.

Males of the Surma tribe who live in mountainous southwestern Ethiopia were still wearing a hoop in each ear into the early 1990s. One Surma male is shown in the February 1991 issue of *National Geographic* wearing silver hoop earrings about three inches (7.5 centimeters) in diameter. Another photograph shows the female authors posed with two Surmas, each of whom is wearing very thick, medium-size gold hoops.[35]

Males of the Wodaabe people in Nigeria have their left ear pierced as little boys, and they wear an earring until they turn seven years of age.[36]

The book *Africa Adorned* by Angela Fisher contains numerous photographs of African males and females wearing their earrings.[37]

Tribal Cultures in the South Pacific

Males of the Nambas tribes in Vanuatu (formerly the New Hebrides) were wearing earrings until at least the early 1970s. [This island nation is located approximately one thousand miles northeast of Australia.] The earrings were worn in both ears and were usually medium-

34. "Spearing Lions with Africa's Masai," by Edgar Monsanto Queeny, *National Geographic Magazine,* October 1954, at pages 487 to 517. Reprinted with permission.
35. "The Eloquent Surma of Ethiopia," by Carol Beckwith and Angela Fisher, *National Geographic,* February 1991. See photographs at page 10 and the inside of the back cover.
36. *Nomads of Niger,* ©1983, photographs by Carol Beckwith, text by Marion Van Offelen, Harry N. Abrams, Inc. Publisher, New York, at page 67.
37. *Africa Adorned,* ©1984 by Angela Fisher, Harry N. Abrams, Inc. New York.

sized hoops made of an indeterminate material. The males also were pictured wearing feathers through their ear holes. (See the January 1972 issue of *National Geographic*.)[38]

38. "Taboos and Magic Rule Namba Lives," by Kal Muller, *National Geographic,* January 1972, at pages 56 through 83.

THIRTY-ONE
Conclusion

The author offers the following closing commentary for consideration by the readers of this book.

In doing the research for this book, the author acquired a lot of knowledge, much of which is not relevant to the subject of this book. Perhaps this is always true when a scholarly work is attempted. The author believes that the following social commentary is justified. Perhaps it is exaggerated to some extent, but sometimes that is the only way to get people to think about the subjects discussed.

Ignoring or Bending History

Ignoring the fashion for male earrings is what many historians have chosen to do. If the writer does not like the fashion, and does not know what to say about it, the easiest course of action is to pretend it never existed.

Writing history is more than ignoring what the author does not like, and writing about famous people and about wars. History is what the masses of people did, thought, and wore. History is telling the plain, unvarnished truth. Unfortunately, too many historians have not followed that standard.

In the book *Jewelry, 7,000 Years* edited by Hugh Tait, ©1986 by the Trustees of the British Museum,[1] the English and French fashion for male earrings was completely ignored. This is notwithstanding a separate chapter entitled "Europe, A.D. 1500–1700." The chapter states that earrings came back into fashion, especially those with dangling pearls. No reference is made to the gender of those wearing the earrings. Later in the chapter, it is stated that men of the early Renaissance "seem to have worn jewellery very sparingly" (at page 154). And, in the very next paragraph, it is stated that, "[e]ven the men were encrusted with a profusion of pearls and jewels." Although King Charles I is men-

1. The 1991 edition referenced in this chapter was published by Harry N. Abrams, Incorporated, New York.

tioned several times, nothing is said of his wearing a large, pearl, drop earring. The writers (employees of the British Museum, which is probably partially supported by taxes) may well have wanted to avoid controversy, and especially to avoid any embarrassment to the crown.

As earrings on males have become more acceptable, the subject is starting to receive more attention in published works. In the Time-Life series of books on *The American Indians* currently in publication, a number of photographs have been published showing male Indians wearing large earrings. However, the text still ignores the earrings. In the volume entitled *Cycles of Life*,[2] scant attention was paid to ear piercing, and this is the volume in which the subject should have been discussed. The index for the volume ignored the subject of ear piercing, and page 45 of the volume contains the only brief comments on the subject:

> The Apache also relied on strong corrective measures, perhaps because they, like the Crow and the Blackfeet, placed an extraordinary value on courage and strength. A small boy who misbehaved, for example, might be punished by having a hole punched in his earlobe with a needle-pointed awl.

> Early in life, Cheyenne children had both earlobes pierced, a rite symbolizing the child's capacity to listen.

The first statement is contradictory, since a larger hole would appear to be "punched," and a smaller hole "pierced." This author has never seen a "needle-pointed" awl, and none of the published accounts on American Indians contains any commentary about such a tool. The statement is also incomplete, since it does not indicate whether an earring was then inserted into the ear hole, or whether the other ear was also pierced.

The second statement is gender neutral, i.e., "children," and it mentions only one tribe. It is as if the authors were almost attempting to conceal the fact that ear piercing for males (and females) was nearly universally practiced among American Indian tribes.

2. *The American Indians: Cycles of Life,* ©1994, Time-Life Books, Alexandria, Virginia.

Motivations of the Author

The author was not able to locate a single book that has been written in the entire history of the world that is devoted exclusively to the custom or fashion of ear piercing, or that gives a detailed discussion of the subject. There seems to have been an unwritten taboo about discussing the subject, especially as to the male fashion.

Taboos breed ignorance, and with ignorance comes social and medical problems that could otherwise be avoided. Ignorance, in turn, breeds an invidious form of intolerance among leaders of society, and that unfortunately includes judges, ministers and rabbis, school administrators and school board members, police departments and officers, politicians, and heads of business and industry.

This book is designed to challenge established thinking. It is especially designed to challenge bigots whose philosophy is, "I've already made up my mind. Don't bother me with the facts."

Conformity Continues to Wreak Great Mischief upon Society

The pressure for conformity continues to wreak great mischief upon this world. There are absolutely no legitimate reasons for society to continue enforcing the stifling forms of conformity that it attempts to perpetrate upon the masses of people. The lessons of history are still not understood by most people. The pressure for conformity breeds intolerance. And, it is intolerance that breeds wars and killings. Witness all of the killings committed in the name of religion. Intolerance should be branded as the sickness that it really is. People should be judged by their *personal honesty*, regardless of race, color, creed, or sexual preference, which is what separates *worthwhile* people from *worthless* people.

Large corporations are sometimes plunged into financial ruin by executives who suffer from intolerance, and who enforce conformity for all their employees. They are the "politically astute" executives— who backstab to hurdle over fellow employees on the ladder to the top, who adopt a plan to fire employees before their pensions vest, who are obsessed with the greed for power rather than the good of their company and the good of the public. These are the executives who will increase corporate profits by calculated decisions to allow innocent people to die from faulty products that should have been designed better. These are the people who lack vision because they surround

themselves with conformist clones (i.e., "team players"), rather than employees who exercise their ability to think for themselves and for the company. These are the people who enjoy making and enforcing meaningless rules for the sake of power.

Educators and religious leaders also suffer from a lack of tolerance. The memorization aspect of education is emphasized, rather than the ability to think. There are too many young people growing up in society who spray-paint swastikas on synagogues, graffiti on buildings and freeways, beat up gays, who carry guns to schools and engage in gang shootings. The percentage of these undesirable types unfortunately appears to be increasing. Education appears to be in the hands of those who have lost the will to educate, who are obsessed with the absurd business of dictating fashion to students, and who spend large amounts of taxpayer dollars in hiring lawyers to defend and file lawsuits over trivial matters and personalities. Priorities have been misplaced and clearly need to be reevaluated.

Entertain and Educate

A successful and older wise man once told the author that he attempts to learn something new every day. It is with this philosophy in mind that this book was written. Much of the source material upon which this book is based was entertaining to the author when it was first read. It is hoped that this entertainment value comes through in reading this book.

If this book is read carefully, the reader should find many issues for further consideration and study. That is the reason for the extensive footnoting contained in this book, and the reason that the footnotes are contained at the bottom of the pages rather than at the end of each chapter or at the end of the book.

The author would appreciate receiving source material and comments that can be utilized in a future edition of this book.

Ronald D. Steinbach, Irvine, California, February 1995.
Internet E-Mail Address: fvpf49a@prodigy.com

Appendices

Appendix A

The following is a partial listing of mail-order catalogs devoted to earrings and other jewelry, or which sell specialized earrings. The listing is not in any particular order, and the author makes no endorsement of any listed company.

Simply Whispers Earrings for Sensitive Ears

> Roman Research, Inc.
> 33 Riverside Drive
> Pembroke, Massachusetts 02359-1910
> 1-800-451-5700

New Age Jewelry and Items, including Many Unique Earrings

> Pyramid Books and the New-Age Collection
> P. O. Box 3333, Altid Park
> Chelmsford, Massachusetts 01824-0933
> 1-800-333-4220
> Fax 1-800-395-1220

Diamond Essence Simulated Diamond Jewelry, including Earrings

> Diamond Essence Co.
> 6 Saddle Road
> Cedar Knolls, New Jersey 07927-9911
> 1-800-642-4367

Cat Items, including Unique Cat Earrings and Jewelry

> Cats, Cats & More Cats
> 2 Greycourt Avenue
> P. O. Box 560
> Chester, New York 10918
> 1-914-469-7877
> Fax 1-914-469-9638

Expensive Gold Jewelry, including Earrings with a Nautical Theme

(These are actually works of art.)

A.G.A. Correa
P. O. Box 401
Wiscasset, Maine 04578-9987
Office & Showroom at:
3240 Cross Point Road
Edgecomb, Maine 04556
1-800-341-0788 or 1-207-882-7873
Fax 1-207-882-9744

Nature Inspired Jewelry and Earrings

Nature's Jewelry
27 Industrial Avenue
Chelmsford, Massachusetts 01824-3692
1-800-333-3235
Fax 1-800-866-3235

Replicas of Historical Swords and Daggers with Several Unique Pairs of Celtic Earrings and Ear Cuffs

Museum Replicas Limited
2143 Gees Mill Road
Box 840
Conyers, Georgia 30207
1-800-883-8838

Fine Jewelry, Tableware and Collectibles

Ross-Simons Jewelers
9 Ross Simons Drive
Cranston, Rhode Island 02920-4476
1-800-556-7376

Fine Jewelry, Clothing and Household

Fingerhut Corporation
11 McLeland Road
St. Cloud, Minnesota 56372-0002
No telephone number listed in their catalog!

Indian Handcrafts, including Earrings

Southwest Indian Foundation
P. O. Box 86
Gallup, New Mexico 87302-0001
1-505-863-4037

Appendix B

Enactment of the Ministry of Environment, Number 854 of December 16, 1991

Chemical substances and products

REGULATION CONCERNING THE PROHIBITION OF SALE AND THE LABELING OF CERTAIN PRODUCTS CONTAINING NICKEL

By virtue of §§ 6, 22, 30, 45 and 61 of the law on chemical substances and products, and the Ministry of Environment announcement of law No. 566 dated August 15, 1989, it is enacted:

Chapter 1—Regulation

§ 1. The sale by producers or importers of the following metal objects made of alloys containing nickel or with surface coatings containing nickel is prohibited, if the nickel mobility is more than .5 μg per cm^2 per week, as determined by the test described in the appendix:

1) Earrings[1] and ear piercing studs.
2) Necklaces, bracelets, ankle chains, and finger rings.
3) Back sides of wristwatch cases, wristwatch bands and clasps.
4) Eyeglass frames.
5) Buttons, buckles, rivets, zippers and metal ornaments in garments, provided they come in frequent contact with the skin during the normal use of the garments.

§ 2a. Hairpins and other hair items, when sold to the consumer, must be labeled: "Contains nickel," if the nickel mobility is more than .5 μg/cm^2 per week.

§ 2b. The labeling mentioned in § 2a above must be written in Danish, in a prominent and legible print size, and must be indelible.

1. The Danish word *øresmykker* translates literally as "ear ornament." Therefore, any other type of earring, such as an ear cuff, would necessarily be included.

Chapter 2—Enforcement

§ 3. Inspection and enforcement of the rules in this regulation are to be carried out by the National Agency of Environmental Protection.

Chapter 3—Exceptions for special circumstances; no appeals

§ 4. Under special circumstances the National Agency of Environmental Protection may permit deviation from the rules in this enactment. The decision of the National Agency of Environmental Protection cannot be appealed to another administrative authority.

Chapter 4—Punishments and effective dates

§ 5a. Violation of §§ 1 through 2 is punishable by fine, or by imprisonment up to 1 year.

§ 5b. Violations perpetrated by corporations, co-operatives, partnerships or similar entities, are punishable by the imposition of fines against the organization.

§ 6a. This regulation will become effective January 1, 1992.

§ 6b. § 2a of this regulation will become effective April 1, 1992.

§ 6c. Commencing upon the foregoing effective dates, Regulation No. 472 issued June 27, 1989 will be repealed.

Appendix—Method of analysis

The following method of analysis is to be used to determine the amount of nickel mobility from metal objects and coatings.

The following chemical compounds are to be used:

A 1-percent solution of dimethylglyoxime in denatured alcohol. A 10-percent solution of ammonium hydroxide in water.

Two drops of each solution are to be applied to a cotton swab tip, and it is then rubbed against the test object in an even motion for 30 seconds.

The appearance on the cotton swab tip or on the object of a reddish

color, ranging from a soft pink to a vibrant cherry red, is evidence that the nickel mobility exceeds the regulation standard of .5 µg per cm^2 per week. The nickel mobility is considered to be less than .5 µg per cm^2 per week if the reddish color described above does not appear.

With a painted or a lacquered surface, the test is to be performed both before and after removal of that surface coating.

The following address is provided for those desiring further information:

National Board of Health
13, Amaliegade
P. O. Box 2020
DK-1012 Copenhagen K
DENMARK
Telephone 011-45-33-911-601
Fax 011-45-33-931-636

The response to this author came from Dr. Birthe Witt.

Appendix C

Author's Note: The following is a reprint (by permission) of diary entries made by A. Droese, a sixty-five-year-old grandfather who decided in 1990 to get his ear pierced. He lives in Santa Barbara, California.

The Beginning of a New Era

The reaction that comes forth when a sixty-five-year-old man wants to have his left ear pierced for an earring.

Just mentioning the fact that one wanted to get one's ear pierced brought mixed reactions. On a visit to my daughters in St. Louis and noticing that my grandson had an earring pushed this thing into production. My daughter and a friend of hers said go for it. I received no negative reaction from my wife. I mentioned it to some of the people at the Senior Center and received no serious reaction, except possibly a disbelief that I would have it done. A grocery clerk at Lucky's food store was all for it, and even wanted to have her husband have his ear pierced.

I mentioned it to the neighbor next door that I was going to have my ear pierced. The lady mentioned that her son said something about having his ear pierced. She said she wouldn't say anything, but while he was asleep, she would just cut his ear off.

I called an ear, nose, and throat doctor at the clinic to have my ear pierced. The receptionist mentioned that he was a surgeon. I made an appointment with the doctor and then realized that I should not waste his time on an ear-piercing. I called back and made an appointment to have the nurse pierce my ear, left ear that is.

The doctor's receptionist called to say that since the doctor was our neighbor, he would pierce my ear for me. The ear-piercing would take place at 9:00 A.M. on the 10th of January, 1990, at the clinic. I asked my daughter not to mention anything about my ear-piercing to my son. The lady next door mentioned now we don't have to worry about the teenagers, but also the senior citizens.

The alternative to a wedding ring, an earring in the left ear. Does your job prevent you from wearing a wedding ring? Get an earring instead. I had a job as a cabinet maker and in electronics, and either job could cause damage to my fingers if I wore a wedding ring. I am now retired and with support from my wife will get an earring in my left ear. Since I am over 65 years old and on MediCare, I wonder what reaction I will get from them when they receive the ear-piercing bill.

Today being Jan. 10th, I had my left ear pierced. Not too much action or reaction to my ear-piercing. I mentioned to the doctor that pierced my ear that I would be writing a paper on the reaction, and he mentioned I should try it with an earring in my right ear and see what kind of reaction I receive then.

I mentioned that it was sex discrimination that women can wear earrings and men cannot. I showed my earring to a little old Italian lady at the senior center, and this lady of many words did not have anything to say for about ten seconds. And then she did not want to have anything to do with me. She must have talked to someone and found out it was all right to wear a left earring, so she is talking to me again.

There was a young woman in her twenties that brought an elderly woman to the center for dinner and she said she never saw an older man with an earring, so I showed her mine. I thought there would be more reaction at the center to my earring, but unless they are keeping things to themselves, nothing else may be said. The senior center director thought it was great that I had an earring, but then again he is part of the younger generation. I just wonder if there is someone else out there who would like to have their ear pierced and doesn't have the gumption to do so. My son still does not know about my ear-piercing.

Our son and daughter-in-law stopped over today to pick up some things and my wife had to mention my earring. I did not want her to say anything because I wanted to wait and see if they would notice my earring by themselves. Our daughter-in-law talked about it, but my son just sat in the rocking chair and did not say anything. I am going to ask my wife to talk to our daughter-in-law to see what reaction our son had when they arrived home.

I showed a female neighbor that I had my ear pierced. I guess she did not believe me when I told her I would have it done. She said I was grounded because I went and had my ear pierced.

I went to the clinic and showed the receptionist my earring and she said you are really right on. I showed the Lucky clerk that we have come to know and she said it looked terrific. One of the ladies that sits at our table at the senior center said it looked nice and that the small gold ball that I was wearing really was in good taste. When I showed my earring to one of the nurses at the clinic, she just put her hand up to her mouth and went "oh, oh, oh!"

I talked to our friend in Florida and their daughter was there and was told that I had an earring. She asked how old I was and I mentioned almost 66 and her mother said her eyes bugged out.

My wife's sister mentioned that she had a simple solution for my birthday and Christmas present, to buy a set of earrings and give one to me for my birthday and one to me for Christmas.

One of our neighbors called one of the other neighbors and mentioned about my earring, but she knew about it because the husband was the one that installed my earring!

There is a wonderful lady that gives Dorothy and I a hug every time we leave church on Saturday night. I gave her a hug and said, "Look at my left ear." She replied, "An earring," and stood there with mouth open. I mentioned in fun that she could close her mouth now. I will see what else she has to say next Saturday night.

I met one of the gals that I used to work with at the Deli in Lucky food store and showed her my earring. The only interest she had was in asking me when I got my ear pierced.

My sister back in Wisconsin told my brother that I had my ear pierced and he just said, "Why did he do that?" Both sister-in-laws and my sister did not have to much to say about it.

The first Saturday after I told our friend at church about the earring, she did not greet us at the rear of the church but walked off away from the crowd and stayed there. The second Saturday she greeted us at the rear of the church but said she did not want to hear anything about the earring.

The girls at Glendale Federal thought my earring was real hip.

At Bingo at St. Raphael's, one of the young girls helping out thought the earring was real neat. One of the older women helpers just said, "Aren't you too old for something like that?"

I showed the earring to a neighbor lady down the block and all she said was, "Oh my goodness!"

I showed my earring to one of the guy's wives I used to work with at church on Saturday night and all she did was look at the earring and shake her head. She is one of the older generation.

My youngest grandson had his ear pierced and started to wear an earring to grade school. The school was a parochial school with a strict dress code. The principal said he could not wear an earring while he was at school. My daughter talked to the principal and said that her son's grandfather had an earring and that she did not care what Grandpa did but that there would be no earrings at this school.

I read an article that Tutankhamen, an Egyptian king of the 18th dynasty, had holes in his ears to support some type of ear ornament.

Since earrings must be purchased in sets, I decided to add another hole to my head and then I could wear a set of earrings. So on the 11th of November 1990, I had my left ear pierced just above the location of my existing earring. I now own five sets of earrings, diamonds, pearls, rubies, and sapphires with a set of emeralds waiting some place for me to find them.

Appendix D

The following is a listing of locations for Piercing Pagoda. The initials PG stand for Plumb Gold Stores, and FJD stands for Fine Jewelry Departments in other stores. The initials SS/GS stand for Silver Station/Gold Station.

Alabama

Bel Air Mall, Mobile

Arizona

El Con Mall, Tucson

California

Antelope Valley Mall, Palmdale
Bayfair Mall, San Leandro
Buenaventura Plaza, Ventura
Country Club Plaza, Sacramento
County East Mall, Antioch
Fresno Fashion Fair, Fresno
Huntington Beach Mall,
 Huntington Beach
Inland Center, San Bernardino
Lakewood Center, Lakewood
Mall at Northgate, San Rafael
Mall of Orange, Orange
Mall of Victor Valley, Victorville
Mission Viejo Mall, Mission Viejo
Northridge Mall, Salinas
Plaza Bonita, National City
Riverside Plaza, Riverside
Santa Rosa Plaza, Santa Rosa
Serramonte Center, Daly City
Southland Mall, Hayward
Stonewood Center, Downey
Sunvalley Mall, Concord
Tanforan Mall, San Bruno

Vallco Fashion Park, Cupertino
Valley Plaza, Bakersfield
Weberstown Mall, Stockton
Westminster Mall, Westminster
Whittwood Mall, Whittier

Serramonte Center PG, Daly City

Concord FJD, Concord

Santa Rosa FJD, Santa Rose

Colorado

Aurora Mall, Aurora
Cinderella City Shopping Center,
 Englewood
Crossroads Mall, Boulder
Southglenn Mall, Littleton
Villa Italia Mall, Lakewood
Westminster Mall, Westminster

Connecticut

Connecticut Post Mall, Milford
Enfield Square, Enfield
Meriden Square, Meriden
Naugatuck Valley Mall, Waterbury
Trumbull Park, Trumbull

Delaware

Christiana Mall, Newark
Concord Mall, Wilmington

Dover Mall, Dover

Florida

Altamonte Mall, Altamonte Springs
Aventura Mall, North Miami
The Avenues, Jacksonville
Boynton Beach Mall, Boynton Beach
Coastland Center, Naples
Coral Square Mall, Coral Springs
Cutler Ridge Mall, Miami
Dadeland Mall, Miami
DeSoto Square, Bradenton
Edison Mall, Ft. Myers
Florida Mall, Orlando
Galeria at Ft. Lauderdale, Ft.
 Lauderdale
Lakeland Square, Lakeland
Mall at 163rd St., North Miami
 Beach
Merritt Square, Merritt Island
Miami International Mall, Miami
Orange Blossom Mall, Ft. Pierce
Orange Park Mall, Orange Park
Orlando Fashion Square, Orlando
Paddock Mall, Ocala
Palm Beach Mall, West Palm Beach
Pembroke Lakes Malls, Pembroke
 Pines
Pompano Square Mall, Pompano
 Beach
Santa Rosa Mall, Mary Esther
Tallahassee Mall, Tallahassee
Treasure Coast Square, Jensen Beach
Tyrone Square Mall, St. Petersburg
University Square Mall, Tampa
West Shore Plaza, Tampa

Florida Mall PG, Orlando
Galleria PG Ft. Laiderdale
Orlando Fashion Square PG,
 Orlando

Palm Beach Mall PG, West Palm
 Beach
Treasure Coast Sq. PG, Jensen Beach

Casselberry FJD, Casselberry
Century Plaza FJD, Orlando
Daytona FJD, Daytona Beach
Hunt Club FJD, Apopka
Kissimmee FJD, Kissimmee

Georgia

Northlake Mall, Atlanta
North Point Mall, Alpharetta
Oglethorpe Mall, Savannah
Peachtree Mall, Columbus
Savannah Mall, Savannah

Illinois

Charlestowne Centre, St. Charles
Ford City Shopping Center, Chicago
Golf Mills, Niles
Randhurst Shopping Center, Mt.
 Prospect

Indiana

Castleton Square, Indianapolis
Green Tree Mall, Clarksville
Lafayette Square, Indianapolis
Marquette Mall, Michigan City
University Park, South Bend
Washington Square, Indianapolis

Kansas

Oak Park Mall, Overland Park

Kentucky

Turfland Mall, Lexington

Louisiana

Belle Promenade, Marrero
Pierre Bossier Mall, Bossier City

Maryland

Annapolis Mall, Annapolis
Centre at Salisbury, Salisbury
Cranberry Mall, Westminister
Eastpoint Mall, Baltimore
Forest Village Mall, Forestville
Golden Ring Mall, Baltimore
Harford Mall, Bel Air
Hunt Valley Mall, Cockeysville
Landover Mall, Landover
Prince Georges Plaza, Hyattsville
Westview Mall, Baltimore

Eastpoint Mall PG, Baltimore
Security Square PG, Baltimore

Massachusetts

Eastfield Mall, Springfield
Liberty Tree Mall, Danvers
North Shore Mall, Peabody

Michigan

Macomb Mall, Reseville
Orchards Mall, Benton Harbor
Wonderland Mall, Livonia

Missouri

Blue Ridge Mall, Kansas City

New Hampshire

Fox Run Mall, Newington

New Jersey

Bergen Mall, Paramus
Brunswick Square, East Brunswick
Cherry Hill Mall, Cherry Hill
Cumberland Mall, Vineland
Echelon Mall, Voorhees
Freehold Raceway Mall, Freehold
Hamilton Mall, Mays Landing
Monmouth Mall, Eatontown
Moorestown Mall, Moorestown
Ocean County Mall, Toms River
Phillipsburg Mall, Phillipsburg
Quaker Bridge Mall, Lawrenceville
Seaview Square Mall, Ocean
Shore Mall, Pleasantville
Willowbrook Mall, Wayne
Cherry Hill PG, Cherry Hill
Deptford Mall PG, Deptford
Echelon Mall PG, Voorhees
Garden State Plaza PG, Paramus
Hamilton Mall PG, Mays Landing
Quaker Bridge Mall PG,
 Lawrenceville
Woodbridge Center PG,
 Woodbridge

New York

Boulevard Mall, Amherst
Broadway Mall, Hicksville
Carousel Center, Syracuse
Clifton Country Mall, Clifton Park
Colonie Center, Albany
Eastern Hills Mall, Williamsville
Eastview Mall, Victor
Greece Ridge Center, Rocherster (2)
Green Acres Mall, Valley Stream
Hudson Valley Mall, Kingston
Jefferson Valley Mall, Yorktown
 Heights
Kings Plaza, Brooklyn

Latham Circle, Latham
McKinley Mall, Buffalo
Mohawk Mall, Schenectady
Nanuet Mall, Nanuet
Oakdale Mall, Johnson City
Riverside Mall, Utica
Rotterdam Mall, Rotterdam
Sangertown Square, New Hartford
Shoppingstown Mall, Dewitt
Smith Haven Mall, Lake Grove
South Hills Mall, Poughkeepsie
South Shore Mall, Bay Shore
Staten Island Mall, Staten Island
Summit Park Mall, Niagara Falls
Sunrise Mall, Massapequa
Walden Galleria Mall, Buffalo

North Carolina

Carolina Circle Mall, Greensboro
Cary Towne Center, Cary
Crabtree Valley Mall, Raleigh
Eastland Mall, Charlotte
Eastridge Mall, Gastonia
Four Seasons Town Center,
 Greensboro
Hanes Mall, Winston-Salem
Independence Mall, Wilmington
Jacksonville Mall, Jacksonville
South Square, Durham

Ohio

Eastwood Mall, Niles
Franklin Park, Toledo
Great Lakes Mall, Mentor
Great Northern Mall, North
 Olmsted
Northgate Mall, Cincinatti
Parmatown Mall, Parma
Randell Park Mall, North Randell
Richmond Mall, Richmond Heights

Salem Mall, Daytin
Sandusky Mall, Sandusky
Southern Park Mall, Youngstown
Summit Mall, Akron
Tri Country Mall, Cincinatti
Upper Valley Mall, Springfield
Westgate Mall, Fairview Park

Oregon

Rogue Valley Mall, Medford

Pennsylvania

Beaver Valley Mall, Monaca
Berkshire Mall, Wyomissing
Capital City Mall, Camp Hill
Century III Mall, West Mifflin
Cheltenham Square, Philadelphia
Columbia Mall, Bloomsburg
Coventry Mall, Pottstown
Exton Square Mall, Exton
Fairgrounds Square Mall, Reading
Granite Run Mall, Media
Greengate Mall, Greensburg
Harrisburg East Mall, Harrisburg
Johnstown Galleria, Johnstown
King of Prussia Mall, King of
 Prussia
Laurel Mall, Hazelton
Lebanon Valley Mall, Lebanon
Lehigh Valley Mall, Whitehall
Logan Valley Mall, Altona
Lycoming Valley Mall, Muncy
Mall of Steamtown, Scranton
Millcreek Mall, Erie
Monroeville Mall, Monroeville
Montgomery Mall, North Wales
Neshaminy Mall, Bensalem
Nittany Mall, State College
North Hills Village, Pittsburgh
Oxford Valley Mall, Langhorne

Palmer Park Mall, Eastern
Park City Center, Lancaster
Parkway Center Mall, Pittsburgh
Plymouth Meeting Mall, Plymouth
 Meeting
Richland Mall, Quakertown
Ross Park Mall, Pittsburgh
Schuykill Mall, Frackville
South Hills Village, Pittsburgh
Springfield Mall, Springfield
Stroud Mall, Stroudsburg
Susquehanna Valley Mall,
 Selinsgrove
Viewmont Mall, Scranton
Westmoreland Mall, Greensburg
Whitehall Mall, Whitehall
Wyoming Valley Mall, Wilkes-Barre
York Galleria, York

The Count PG, King of Prussia
Montgomery Mall PG, North Wales
Park City Center PG, Lancaster
Plymouth Meeting Mall PG,
 Plymouth Meeting

Palmer Park Mall SS/GS

Puerto Rico

Plaza Carolinas, Easton

South Carolina

Briarcliffe Mall, Myrtle Beach
Haywood Mall, Greenville
Northwoods Mall, North Charleston

Tennessee

Hickory Hollow Mall, Antioch

Texas

Almeda Mall, Houston
Barton Creek Square, Austin
Baybrook Mall, Friendswood
Central Park Mall, San Antonio
Golden Triangle Mall, Denton
Greenspoint Mall, Houston
Gulfgate Mall, Houston
Ingram Park Mall, San Antonio
Irving Mall, Irving
Killeen Mall, Killeen
Mall Del Norte, Laredo
Mall of the Mainland, Texas City
McCreless Mall, San Antonio
Memorial City, Houston
Northeast Mall, Hurst
Northline Mall, Houston
Northwest Mall, Houston
Parkdale Mall, Beaumont
Parks at Arlington, Arlington
Post Oak Mall, College Station
Richardson Square, Richardson
Richland Mall, Waco
Ridgmar Mall, Forth Worth
San Jacinto Mall, Baytown
Sharpestown Center, Houston
Sikes Senter, Wichita Falls
Six Flags Mall, Arlington
South Park Mall, San Antonio
Sunrise Mall, Corpus Christi
Valley View Mall, Dallas
Victoria Mall, Victoria
Westlakes Mercado Mall, San
 Antonio
Windsor Park Mall, San Antonio

Almeda Mall PG, Houston
McCreless Mall PG, San Antonio
Northwest Mall PG, Houston

Utah

Cottonwood Mall, Salt Lake City

Virginia

Charlottesville Fashion Square,
 Charlottesville
Chesapeake Square, Chesapeake
Chesterfield Town Center,
 Richmond
Cloverleaf Mall, Richmond
Coliseum Mall, Hampton
Landmark Center, Alexandria
Lynnhaven Mall, Virginia Beach
Manassas Mall, Manassas
Military Circle Center, Norfolk
Newmarket Fair, Newport News
Patrick Henry Mall, Newport News

Regency Square, Richmond
Spotsylvania Mall, Fredericksburg
Springfield Mall, Springfield
Virginia Commons, Richmond
Military Circle Center PG, Norfolk
Lynnhaven Mall PG, Virginia Beach

Washington

Alderwood Mall, Lynnwood
Northgate Shopping Center, Seattle
Tacoma Mall, Tacoma

West Virginia

Charlestown Town Center,
 Charleston
Grand Central Mall, Parkersburg

Appendix E

The following literature on the Inverness ear-piercing system is advertising material directed to the jewelry trade and is reprinted with the permission of Inverness Corporation. The author does not recommend any ear-piercing system. (Literature on the Inverness 2000 system was not available as of the press deadline.)

The Advantages of Inverness Piercing Earrings Vs Inexpensive Piercing Studs

*Inverness Jeweler's Quality earrings have the same post as regular pierced earrings and a sharpened tip, providing the gentlest piercing, the fastest healing period, and the most elegant appearance

*The Inverness System features a piercing instrument and disposable plastic capsules that contain both earrings and clutches. Because only the earring and capsule, and not the piercing instrument itself, touch the customer's ear, a completely sterile ear piercing is ensured every time. This feature eliminates the possibility of ever transmitting a communicable disease

*Because earrings and clutches won't fall out of instrument, you can pierce on any angle

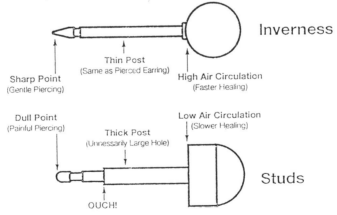

Inverness

Thin Post
(Same as Pierced Earring)

Sharp Point
(Gentle Piercing)

High Air Circulation
(Faster Healing)

Dull Point
(Painful Piercing)

Low Air Circulation
(Slower Healing)

Thick Post
(Unnessarily Large Hole)

Studs

OUCH!

**Inverness Allergy Free 14kt Gold Piercing Earrings...
An Industry Breakthrough!**

At least 20% of all people who wear pierced earrings experience allergic reaction. Their symptoms include itching, soreness, inflamation and flaking of the skin. These symptoms are commonly triggered by a chemical reaction to nickel, a base metal widely used in jewelry manufacturing today.

Nickel is absorbed through the skin and is accelerated by moisture and sweat. Consequently, many people wear their earrings for a very short period of time before they begin to experience an allergic reaction.

Further, studies show that the longer one is exposed to nickel, the greater their sensitivity becomes. Extended exposure to nickel often creates the same allergic reaction to watches, necklaces and bracelets.

Clearly, the problem is severe and requires a solution so that people may wear their jewelry items without experiencing allergic reactions... and that is to eliminate all exposure to nickel, beginning with the most delicate period... the ear piercing.

That's why Inverness, the World's largest supplier of safe and sterile piercing earrings has taken an innovative role in developing allergy free piercing earrings. Inverness has ensured their earrings to be allergy free by removing the nickel from their solid 14kt gold, as well as their 24kt plated gold piercing earrings and clutches.

The introduction of Inverness allergy free piercing earrings have dramatically reduced the incidences of nickel allergy, allowing millions of pierced ears to heal completely with no discomfort to the wearer.

Inverness believes the piercing of one's ear is of the highest importance and, thus, will continue to pioneer the innovations necessary to provide the most safe and gentle ear piercing possible.

The Benefits of Ear Piercing

*Always a low investment, high profit service for jewelers

*A plus business....Creates extra customers and extra sales volume

*Increased earring sales...None of those new customers own a single pair of pierced earrings. A 25% or more increase in earring sales can be expected as a result of offering the ear piercing service, especially when the two are tied in with promotions

*A traffic builder......People who watch a piercing often become customers too

*Greater profits...Multiple piercings are in, which guarantees more traffic and more pierced earring sales

*Word of mouth advertising...many piercings and pierced earring sales result from word-of-mouth advertising among mothers, daughters, teenagers and more

*Each piercing takes less than five minutes

*Personnel require no special training and can be taught to pierce in less than an hour with our training video, manual and demo earrings

*The Inverness Ear Piercing center is complete and compact and can be stored anywhere...a stool and a hand mirror are all that's needed

*Ear piercing has high gross margins, is a year round business, the styles always appeal to all age groups, and there are no markdowns, returns or refunds

The Advantages of the Inverness Piercing Instrument Versus Stud Guns

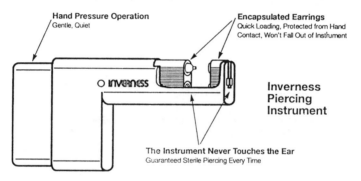

Hand Pressure Operation
Gentle, Quiet

Encapsulated Earrings
Quick Loading, Protected from Hand Contact, Won't Fall Out of Instrument

Inverness Piercing Instrument

The Instrument Never Touches the Ear
Guaranteed Sterile Piercing Every Time

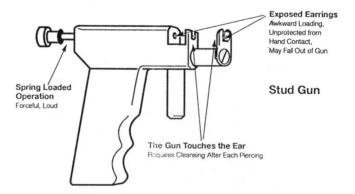

Exposed Earrings
Awkward Loading, Unprotected from Hand Contact, May Fall Out of Gun

Spring Loaded Operation
Forceful, Loud

Stud Gun

The Gun Touches the Ear
Requires Cleansing After Each Piercing

INVERNESS

presents

The profit potential in ear piercing with 14KT Gold

AVERAGE WEEKLY PIERCINGS		AVERAGE RETAIL PRICE		AVERAGE WEEKLY SALES				TOTAL YEARLY SALES PER LOCATION	PLUS NEW CUSTOMERS
20	×	$18.95	=	$379.00	×52	=		$19,708	1040 New Customers
30	×	18.95	=	568.50	×52	=		29,562	1560 New Customers
40	×	18.95	=	758.00	×52	=		39,416	2080 New Customers

Multiple door account sales potential
Based on 30 average piercings per week

5 stores	Yearly 14KT Gold ear piercing sales	$147,810
10 stores	Yearly 14KT Gold ear piercing sales	295,620
20 stores	Yearly 14KT Gold ear piercing sales	591,240

The average woman purchases 7 to 10 pair of earrings in the first year after having her ears pierced. In many cases she returns to the store where her ears were pierced to purchase them. Consider the enormous potential for increasing sales on your regular line of pierced earring jewelry.

Remember, ear piercing **creates traffic** and traffic increases sales. Join the growing number of retailers offering the permanence of 14KT Gold for ear piercing.

Inverness' 14-karat gold ear piercing system makes an already profitable service even more lucrative for the retailer.

<u>If Someone Else Pierces Their Ears, Someone Else Will Also Be Selling Them Earrings</u>

*The service of ear piercing attracts customers to your store

*Ear piercing establishes a positive relationship with the customer

*The average woman buys from 7 to 10 pairs of earring during the first year after having her ears pierced. Surveys show, she buys many of them from the same retailer who pierced her ears.
Thus, it's not just piercing that's profitable...it's the profits after piercing too!

Appendix F

The following literature on ear-piercing supplies is advertising material directed to the jewelry trade, and is reprinted with the permission of Studex, USA. The author does not recommend any ear-piercing system.

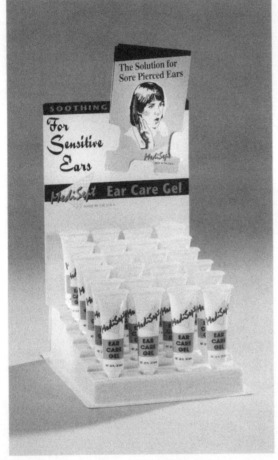

FASHION EARRINGS FOR SENSITIVE EARS

"Quality you can feel"

• Display holds 195 pairs of high fashion Hypo-Allergenic earrings.

• 100% guaranteed safe against irritation.

• Each pair is made from safe surgical stainless steel.

• 24Kt gold overlay directly on stainless with no irritating nickel strike.

• Addresses the modern womans demand for safe, comfortable earrings.

• Increases sales and returns excellent profits.

Made in U.S.A.

Designed To
Fit Any
Size Counter

Pre-packed 4-sided
Rotating Display
Includes an assortment
of:
 • Cubic Zirconias
 • Birthstars
 • Pearls
 • Impressions
 • Hoops and
 Half Hoops in Gold
 and Stainless

Specifications
9"W x 9"D x 18"H
Shipping Wt.
8 Lbs

STUDEX.

25311 SO. NORMANDIE AVE. HARBOR CITY, CA 90710 U.S.A.
(310) 539-0212 • STUDLINE 1-800-24K-STUD
FAX (310) 530-7252

FASHION EARRINGS AND ACCESSORIES FOR SENSITIVE EARS
D-420
FLOOR DISPLAY

• Display holds 420 pairs of
high fashion Hypo-Allergenic
earrings and accessories

• 100% guaranteed safe against
irritation

• Each pair is made from safe
surgical stainless steel

• 24kt gold overlay directly on
stainless steel with no
irritating nickel strike

• Addresses the modern
woman's demand for safe,
comfortable earrings

• Increases sales and returns
excellent profits
 Made in U.S.A.

Pre-packed 4-sided Rotating
Display Includes:

• 120 prs. Tiny Tips Earrings
for Kids

• 120 prs. "Switch" Quality
Earrings for Adults and
Adolescents

• 108 prs. of Ear Piercing
Studs

• 36 pkgs. Assorted
Accessories

• 9 Tubes Ear Piercing Gel

• 9 ea. Ear Piercing Marking
Pens

• 18 ea. Medisept Personal
Ear Piercers

Specifications
16"W x 16"D x 53"H
Shipping Wt.
54 Lbs

 25311 SO. NORMANDIE AVE., HARBOR CITY, CA 90710 U.S.A.
(310) 539-0232—539-STUD 1-800-24K-STUD • FAX (310) 530-7252

FASHION EARRINGS FOR KIDS

"Gentle Enough For Little Ears"

**Designed To
Fit Any
Size Counter**

Pre-packed 3-sided
rotating display, includes
3 pairs each of 36 most
popular styles

Specifications
10"W x 10"D x 22"H
Shipping Wt.
6 Lbs

- Display holds 108
 pairs of sterilized
 hypo-allergenic
 earrings for
 children.

- 100% guaranteed
 safe against
 irritation.

- 24 KT. Gold
 overlay directly on
 stainless steel with
 no irritating nickel
 strike.

- Increases sales
 and returns
 excellent profits.

- All earrings made
 in U.S.A.

STUDEX

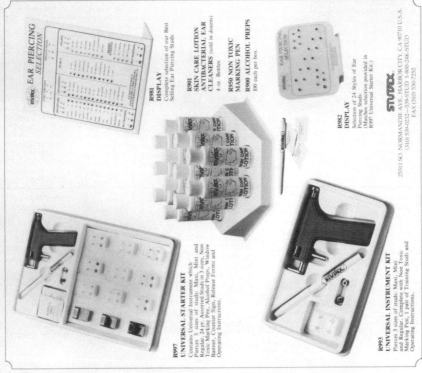